The Image of Political Power in the Reign of Nerva, AD 96–98

The Image of Political
Power in the Reign of Nerva,
AD 96–98

NATHAN T. ELKINS

Oxford University Press is a department of the University of Oxford. It furthers
the University's objective of excellence in research, scholarship, and education
by publishing worldwide. Oxford is a registered trade mark of Oxford University
Press in the UK and certain other countries.

Published in the United States of America by Oxford University Press
198 Madison Avenue, New York, NY 10016, United States of America.

CIP data is on file at the Library of Congress
ISBN 978–0–19–064803–9

9 8 7 6 5 4 3 2 1

Printed by Sheridan Books, Inc., United States of America

Divo Nervae

CONTENTS

PREFACE

Nerva rose to power at the end of the Flavian dynasty as the thirteenth Caesar. He ruled for less than a year and a half; his administration experienced tensions with the armed forces, since the common soldiery had great affection for their assassinated emperor, Domitian. As there is little art that survives from his reign, study of Nerva's principate has been the province of historians who examine sources written after he died that attest to the troubles his administration encountered and the circumstances through which Trajan was ultimately named his heir. The imperial coinage is, however, the most complete record of art from Nerva's reign. Unfortunately, it has been mishandled and treated as a historical text rather than a state-sanctioned product that necessarily presented the living emperor in a positive light and, in so doing, reflected contemporary political rhetoric (as illuminated by the "praise and blame" literature of the day) that exalted Nerva in the aftermath of Domitian's fall. In textbooks on Roman art, Nerva affords only cursory treatment, as his reign left little that is monumental. Even in surveys of Roman coinage, Nerva is easily overlooked. For example, in *The Oxford Handbook of Greek and Roman Coinage* (Oxford University Press, 2012), Nerva's imperial coinage is omitted entirely, although there are contributions dedicated exclusively to the Flavians and to Trajan and Hadrian. It is time that Nerva is given his due and that his image of political power as it was projected during his lifetime is brought to light.

The idea for this book had its genesis in Frankfurt am Main, Germany, between 2007 and 2009. The Goethe Universität is a center for developing methods in the study of coin finds and I learned much from my

enterprising colleagues when I was in residence there, first as a Deutsche Akademische Austausch Dienst (DAAD) fellow and then employed as a research associate. As my own research interests revolved around Roman imperial coin iconography and its communicative potency, I was very keen to learn about new and innovative research methods that joined this more traditional way of studying the imperial coinage with *Fundnumismatik*, the study of archaeologically recovered coin finds. A growing body of scholarly literature had indicated that in the late first and second centuries AD the Roman state was supplying certain populations in the western Roman Empire with base-metal coins bearing images relevant to their station in society. To me, this research was very exciting as we could test the more theory-based Anglo-American approach, in which assumptions are made about intended audiences, with the more empirical Germanic approach to coin finds. In the years since I was in Frankfurt, other studies have appeared that continue to suggest regionally differentiated patterns of base-metal coin circulation according to reverse iconography. The weight of the evidence currently rests on the Flavian and Trajanic periods.

Nerva is an appealing subject because his principate lies in between the periods for which there is strong evidence for audience targeting on the imperial coinage according to regionally differentiated circulation patterns. Nerva's coinage is both diverse and chronologically restricted, as he ruled for only sixteen months from September 96 to January 98. His principate thus provides a manageable—but varied—body of coin finds that could be incorporated into a database and analyzed according to reverse type. It was thus my goal to study the coinage of a single emperor to determine if it was directed at certain constituencies within the Roman Empire according to the relevance of the iconography. The project quickly grew in scope as the manageable data set also created some difficulties, namely that rare "historical types" referring to specific aspects of imperial policy in Rome or Italy are so seldom found in hoards and excavated finds that samples are often statistically insignificant, although there are still some indications of regionalized circulation patterns, especially in Rome and Italy. Ranking certain images according to their prominence in hoards and finds also provides a glimpse into what ideas were central to political rhetoric and imperial ideology during Nerva's brief reign, as these messages would have been encountered most often by the users of coins.

Finally, as I proceeded with research and writing, I discovered that Nerva's coinage has been almost completely ignored by art historians and archaeologists, and left to historians. This has led to some problematic interpretations of the imagery on Nerva's coinage that presume to

see something of Nerva's "weak" character in the imagery. Thus, most images required more positivistic reinterpretation, for imperial coinage was a medium of state-sanctioned art that glorified and exalted the living emperor just as any state-sanctioned relief sculpture in Rome would. The sources that inform the characterization of Nerva as weak and vulnerable to coercion, especially by the Praetorian and military factions, were written down only after Nerva had died, and did not govern the production of images and rhetoric while the emperor was alive. Much of Nerva's coin iconography drew upon historical precedents and was, therefore, wholly traditional and appropriate. And so, in addition to applying quantitative and empirical finds-based methods to explore the communicative properties of Nerva's coinage, it was essential to reinterpret the imagery on Nerva's coinage as a medium of state-sanctioned art and to emphasize how the images, formulated by the elites around Nerva, functioned also to praise the emperor and mirrored contemporary laudatory texts directed at the regime. By recasting Nerva's coin iconography and viewing it as reflective of contemporary political ideology and rhetoric, we gain insight into the ideas that were disseminated about his principate during the emperor's lifetime. Quantification of the imagery and attention to the distribution of finds sharpen these insights and paint a picture of a political culture that addressed a diverse group of imperial constituencies: the Senate, the *plebs urbana*, the people of Italy, and the broader population of the Roman Empire. This study of Nerva departs from historical studies that see Nerva with historical distance, characterizing him as a placeholder in imperial history and focusing on the succession crisis. Instead, the approach to Nerva deployed here for the first time illuminates the rhetoric and ideology surrounding the emperor during his own lifetime and portrays the head of state as he was publicly presented during his lifetime.

Although the idea for this project had been with me for many years, work on it did not begin in earnest until the summer of 2013 with the support of an Undergraduate Research and Scholarly Achievement (URSA) Grant from Baylor University. The grant paid for an undergraduate research assistant, Xander Gardere (art history '14), who traveled with me to Frankfurt that summer to go through numerous inventories of coin finds housed in the Institut für Archäologische Wissenschaften at the Goethe Universität. At the same time, Sha Towers, Baylor's enthusiastic and accommodating fine arts librarian and Director of Liaison Services, acquired dozens of inventories offered for sale from the library of Georges Depeyrot, which allowed Xander and me to continue to build the database through the fall. In spring 2014, another student, Amy Welch

(university scholar in art history and classics '14), joined the project to help with the input of remaining data and to refine the database. Both Amy and Xander presented on their work at Baylor's URSA Scholars Week and at the Annual Meeting of the Archaeological Institute of America in Chicago in 2014. Conner Moncrief (university scholar in art history '16) and Jackson Perry (university scholar in art history and classics '16), two very dedicated student assistants, began tracking down hoard publications and under my supervision created a new database for the silver coinage in the 2014–2015 academic year, when it became clear that I must wrestle with the *denarii*. Immense thanks are owed to Xander, Amy, Conner, and Jackson, who carried out most of the tedious, but essential, information-gathering tasks. Their contributions were foundational to this work. On a personal note, I would like to acknowledge each of these former students for their continuing friendship.

A reinvitation grant from the DAAD for three months in the summer of 2014 was instrumental to the further development of this research. It provided me with an opportunity to organize my data and my thoughts, and to begin fleshing out many ideas by writing and outlining parts of each chapter. My time was split evenly between the Goethe Universität Frankfurt and the Eberhard Karls Universität Tübingen, to exploit the strengths of those libraries and to recheck the finds inventories as needed. I am grateful to Hans-Markus von Kaenel (Frankfurt), Thomas Schäfer (Tübingen), and Stefan Krmnicek (Tübingen) for hosting me at these institutions. It is also Hans-Markus von Kaenel to whom thanks are owed for granting me access to the lists of Flavian to Trajanic coin finds from Rome. At the invitation of the Institut für Klassiche Archäologie, I returned to Tübingen in October 2014, supported by a grant from the Allbritton Art Institute at Baylor University, to deliver a lecture on the progress of my research. There I received positive, but critical, feedback from Thomas Schäfer on the question of agency behind the creation of images that greatly influenced my work for the better. At a conference at Warwick University in July 2014, I also received good feedback from Andrew Burnett and Kevin Butcher, who alerted me to anomalies in the Reka-Devnia Hoard. Baylor University granted me a research leave for fall 2015, which allowed me the time to complete research and finish the manuscript. Thanks are also owed to William E. Metcalf, Bernhard Woytek, Klaus Vondrovec, Clare Rowan, and Ted Buttrey for their input on certain questions that arose as my research continued. In September 2016, shortly before I sent off the final manuscript to enter the book-production process, I presented this research as the Archaeological Institute of America's 2016–2017

William E. Metcalf Lecturer in Numismatics and as the 2016–2017 Albert H. Clayburgh Lecturer in Archaeology. After the Clayburgh Lecture at Princeton University, Michael Koortbojian provided some helpful feedback that prompted me to look again at the significance of S C on the coinage as I considered the agency behind the imagery. Not least, many thanks are owed to the anonymous peer reviewers who made several important recommendations that improved the quality of the book.

I am also grateful to my colleagues in art history and classics at Baylor; my department chair, Mark Anderson; and my divisional and academic deans, Robyn Driskell, Kim Kellison, and Lee Nordt, for their unwavering support of my research. As the book entered the production phase, the Allbritton Art Institute at Baylor University provided me with a further grant to pay for the production of an index for this book and for some of the costs to reproduce images. And Lisa Fehsenfeld, my art history program's assiduous visual resource curator, kindly proofed the quality of images prior to submission of the manuscript and provided necessary technical assistance. Finally, I owe a debt of gratitude to Sarah Pirovitz, my editor at Oxford University Press, who received the book project with sincere enthusiasm. Her support and availability from the peer-review process through the book-production phase never ceased.

ABBREVIATIONS

BMCRE I, etc.	Harold Mattingly et al. 2005. *Coins of the Roman Empire in the British Museum*. 6 vols. Reprint of the earlier editions. London: British Museum Press.
CIL	1862–. *Corpus Inscriptionum Latinarum*. Multiple vols. Berlin: Berlin-Brandenburgische Akademie der Wissenschaften.
DEAR	1895–. *Dizionario epigrafico di antichità romane*. Multiple vols. Rome: Pasqualucci.
dFMRÖ	Digitale Fundmünzen der römischen Zeit in Österreich. http://www.oeaw.ac.at/antike/fmroe/content/suche.de.php.
EAA	Aldo Ferrabino et al., eds. 1958–1984. *Enciclopedia dell'arte antica, classica e orientale*. 7 vols. with multiple supplements. Rome: Istituto della Enciclopedia Italiana Giovanni Treccani.
FMRD	1960–. *Die Fundmünzen der römischen Zeit in Deutschland*. Multiple vols. Berlin and Mainz: Mann and Philip von Zabern.
FMRHr	2002. *Die Fundmünzen der römischen Zeit in Kroatien XVIII, Istrien*. Mainz: Philip von Zabern.
FMRL	1972–1996. *Die Fundmünzen der römischen Zeit im Großherzogtum Luxemburg*. Multiple vols. Berlin: Mann.
FMRN	1992–2002. *Die Fundmünzen der römischen Zeit in den Niederlanden*. Multiple vols. Berlin: Mann.
FMRÖ	1976–. *Die Fundmünzen der römischen Zeit in Österreich*. Multiple vols. Vienna: Verlag der Österreichischen Akademie der Wissenschaften.

FMRP	2007–. *Die Fundmünzen der römischen Zeit in Polen.* Multiple vols. Wetteren: Moneta.
FMRSl	1988–2004. *Die Fundmünzen der römischen Zeit in Slovenien.* 5 vols. Berlin and Mainz: Mann and Philip von Zabern.
FMRU	1990–1999. *Die Fundmünzen der römischen Zeit in Ungarn.* 3 vols. Bonn: Rudolf Habelt.
IFS	1993–. *Inventar der Fundmünzen der Schweiz.* Multiple vols. Lausanne and Bern: Schweizerische Akademie der Geistes- und Sozialwissenschaften.
ILS	1892–1916. *Inscriptiones Latinae Selectae.* 3 vols. Berlin: Weidmannsche Buchhandlung.
LIMC I, etc.	1981–1997. *Lexicon Iconographicum Mythologiae Classicae.* 8 vols. Zürich: Artemis & Winkler.
LTUR I, etc.	Eva Margareta Steinby, ed. 1993–1999. *Lexicon Topographicum Urbis Romae.* 5 vols. Rome: Edizioni Quasar.
PAS	Portable Antiquities Scheme Database. http://finds.org.uk/database.
*RIC*² I	C. H. V. Sutherland and R. A. G. Carson. 1984. *The Roman Imperial Coinage.* Vol. 1, *From 31 BC to AD 69.* Revised edition. London: Spink.
RIC II	Harold A. Mattingly and Edward A. Sydenham. 1926. *The Roman Imperial Coinage.* Vol. 2, *Vespasian to Hadrian.* London: Spink.
*RIC*² II.1	Ian A. Carradice and T. V. Buttrey. 2007. *The Roman Imperial Coinage.* Vol. 2, pt. 1, *From AD 69 to AD 96, Vespasian to Domitian.* 2nd fully revised edition. London: Spink.
RIC VII	Patrick M. Bruun. 1966. *The Roman Imperial Coinage.* Vol. 7, *Constantine and Licinius, AD 313–337.* London: Spink.
RPC III	Michel Amandry and Andrew Burnett. 2015. *Roman Provincial Coinage.* Vol. 3, *Nerva, Trajan and Hadrian (AD 96–138).* London and Paris: British Museum Press.
RMR Ve	1992–. *Ritrovamenti monetali di età romana nel Veneto.* Padova: Editoriale Programma and Esedra Editrice.
SSU I, II	*Sottosuolo Urbano*: an unpublished list of coin finds from the city of Rome recovered during the era of the Risorgimento.

Introduction

The Power of Images in the Reign of Nerva

AT THE ADVANCED age of sixty-five, Nerva became emperor of Rome upon the assassination of Domitian on September 18, AD 96. His reign was brief, for he died sixteen months later, on January 27, AD 98, at the age of sixty-seven. Prior to his elevation as emperor, Nerva was a senator and had been an important member of the imperial court since the reign of Nero. He served as an advisor to Nero and also counseled the Flavian emperors, holding his first consulship in 71, early in Vespasian's reign, and in 90 he held his second consulship alongside Domitian. Historians have often characterized Nerva as the "Senate's emperor," although some have advanced compelling cases that he was the candidate agreed upon by multiple factions, military and civil. The brevity of his reign limits the historical study of his principate and contributes to the common idea that his rule was a mere interlude between Domitian and Trajan, both of whom attract more intensive study.[1] What the historical sources say about Nerva is largely complimentary; he undertook many social and tax reforms that Trajan continued. Nerva's most significant challenge was, however, military unrest following Domitian's assassination. In the summer of 97, his own bodyguard, the Praetorians, besieged him in his home and demanded that the conspirators who took part in the killing of Domitian be handed over to them for punishment (Pliny, *Panegyricus* 6.1; Dio 68.3.3; *Epitome de Caesaribus* 12.6–8).

[1] There are two monographs on Nerva: Garzetti 1950 and Grainger 2003. Also relevant is the lengthy treatment of Nerva in Morelli 2014: 241–319.

Contemporary writers, such as Tacitus, Pliny, Frontinus, and Martial praised Nerva, but modern historians have generally allowed the later historical sources, such as Cassius Dio and Philostratus, both of whom wrote in the early third century, and the *Epitome de Caesaribus*, written in the later fourth century, to color their understanding of Nerva as a weak figure, vulnerable to influence and manipulation, especially by the Praetorian and military factions. The historical distance of these later writers from Nerva perhaps allowed some honest assessments regarding the political situation and the precariousness of Nerva's position. Even Nerva's contemporary, Pliny, who had high regard for the emperor, tempered his praise of Nerva in adulation of the new emperor, Trajan, implying that Nerva's tensions with the military led to Trajan's adoption and that in all things Trajan was better and more competent.[2] The limited textual sources alone do not give a very detailed sense of the political ideals disseminated to the public while Nerva was in power. To rectify this, one would normally look toward imperial building programs, portraiture, and state-sanctioned relief sculpture to reconstruct a sense of the emperor's "self-representation."

But Nerva's short reign robbed his regime of the opportunity for the emperor's imperial image to be defined in building or monumental art with the same intensity that those media had communicated ideas and messages about the principates of other emperors before him, such as Augustus or Vespasian. As far as public building is concerned, Nerva completed an imperial forum that Domitian had begun, which henceforth bore Nerva's name; he also built a granary and was responsible for some sort of work on the Colosseum (Suetonius, *Domitianus* 5; *CIL* 6.8681 = 33744 = *ILS* 1627; *CIL* 6.32254).[3] In 97, Nerva appointed the senator Frontinus as Rome's water commissioner (*curator aquarum*); Frontinus instituted several maintenance and distribution reforms and an account of his work under both Nerva and Trajan survives in his book on aqueducts. Only seventeen extant portraits of Nerva are known, fourteen of which are recut from portraits of Domitian; the only state-sanctioned relief sculptures in Rome that can be associated with Nerva are the Flavian Cancelleria reliefs upon which the portrait head of Domitian on one of the panels was later recut with Nerva's likeness, although there is no evidence that the reliefs were ever set up on

[2] Hoffer 2006.

[3] On the Forum of Nerva, also known today as the Forum Transitorium, see Morselli and Tortorici 1990; Richardson 1992: 167–169; D'Ambra 1993; *LTUR* II, 1995: 307–311, s.v. Forum Nervae (Bauer and Morselli). On the granary, see Richardson 1992: 194; *LTUR* III, 1996: 44, s.v. Horrea Nervae (Coarelli). On the inscription from the Colosseum, see Spinazzola 1907: 29.

any monument.[4] Thus, on account of the paucity of material and visual evidence available, the art historian has little to assess the political image projected about Nerva's principate during the emperor's own lifetime.

One understudied medium of state-sanctioned art in the reign of Nerva is, however, the imperial coinage, struck in Rome and within the imperial court's or Senate's sphere of influence. To date, Nerva's coinage has almost exclusively been studied in concert with the biases and prejudices of those later writers who characterized him as weak and vulnerable to coercion. Consequently, many of his coin types have been interpreted as "aspirational," "hopeful," or even "apologetic." Such an understanding of Nerva's coin iconography demands correction: as a medium of state-sanctioned art, the imperial coinage would not have drawn attention to the weaknesses of the *princeps* any more than Caligula's official portraiture would have represented the wild eccentricities or the mad character ascribed to him by the later—and biased—historical sources.[5] What attempts to read "madness" into Caligula's portraiture and "weakness" into Nerva's coinage reflect is a modern preoccupation with a search for the "character" of an emperor in the visual arts; that "character" is informed only by agenda-wielding authors who wrote after the emperor had died.[6] If one approaches Nerva's imperial coinage as a medium of state-sanctioned art on its own terms, which necessarily presented the *princeps* in a positive light and that operated independently of the biases of later Roman writers, the political image and ideals projected while Nerva was in power may be ascertained. In fact, there are a diverse number of images deployed on the reverses of Nerva's coinage during his sixteen months in office that refer to his domestic agenda and imperial ideals. These images are a treasure of visual evidence for the emperor's policies and reforms, and they also reflect contemporary political rhetoric: that is, they promote the same ideas about Nerva's principate that appear in contemporary laudatory texts by Martial, Pliny, Frontinus, and Tacitus. A reevaluation of Nerva's imperial coinage is thus in order and will illuminate the official perception, the public definition, and the public expectations of Nerva's principate during his lifetime.

[4] Portraits: Daltrop, Hausmann, and Wegner 1966: 109–114; Bergemann 1990: 82–86; Kleiner 1992: 199–201. Cancelleria Reliefs: Magi 1945; Simon 1960; Toynbee 1957; Kleiner 1992: 191–192. Both portraits and the reliefs: Bergmann and Zanker 1981; Varner 2004: 115–122.
[5] Cf. Elsner 1994 on Nero and the need to separate later (and biased) historical texts from the interpretation of contemporary building activity and art.
[6] For a corrective treatment of Caligula's portraits, see Kleiner 1992: 126–127 and Pollini 2012: 370 with further bibliography. A broader critique of this research problem in Roman imperial portrait studies is Davies 2012: 321–327.

Coinage as an Imperial Monument and as a Medium of Communication

Roman imperial coinage communicated messages to the viewer, although historians and numismatists often debate the authority, intent, and motive behind the formulation of the imagery on the coins. Some suggest that scholars have overemphasized the importance of the imperial coinage as a medium of political communication, insisting that people would have paid the images on them little attention. The eminent historian A. H. M. Jones argued that images on the coinage were incidental and communicated little to the viewer, comparing them with the repetitive designs on British postage stamps.[7] Aside from the fact that designs on the Roman imperial coinage of the first and second centuries AD were far more varied and dynamic than British postage stamps of the mid-twentieth century, when Jones wrote, one must remember that our society is saturated with visual imagery and has been for a long time. Estimates vary wildly, but the typical person in a modern industrialized nation will see hundreds or thousands of visual advertisements per day on television, in newspapers and magazines, on the Internet and in social media, on billboards, and in supermarkets and stores. Modern viewers are so bombarded with these visual messages that most do not register cognitively and are ignored. In the Roman Empire, visual messages were not as pervasive as today.

In Nerva's reign, an average person in the city of Rome would certainly have encountered hundreds of politically charged images if he were to visit the Forum Romanum, the imperial *fora*, and stroll around the Campus Martius, but he would have been much less exposed to imagery in his day-to-day life and work. Outside of major cities, like Rome, there would have been even less politically charged visual imagery. People of all social stations and throughout the Roman Empire used coinage in their daily lives and that coinage bore images. Unlike modern coinages in Europe and America that have relatively static and unchanging designs, the imagery on Roman imperial coinage was very diverse and changed often, perhaps attracting the attention of viewers by virtue of its immediacy and variety. Coins were thus an ever-changing source of visual and textual information to which most people in the Roman Empire had access, whether they were in Rome, the Italian countryside, or in the provinces. In this way, Roman coinage was one of the most important communicative media

[7] Jones 1956. More recently Duncan-Jones 2005 calls into question the communicative value of coins bearing images of gods and personifications.

in the Roman Empire when compared with the grand—but unique and stationary—monuments and relief sculptures in the capital.[8]

Textual sources suggest that viewers paid attention to images on coins, thought about them, and sometimes responded to them emotionally.[9] Cassius Dio describes the famous coin of Brutus that depicts the cap of a freedman, an attribute of Libertas, flanked by two daggers, and understands it as indicating that Brutus and Cassius had liberated Rome through their assassination of Julius Caesar (47.25.3). In an apparent case of misunderstanding, Suetonius describes Neronian coins depicting Apollo Citharoedus, but interprets them as representing Nero playing the lyre (*Nero* 25). Aside from the reverse iconography, which viewers linked with the authority on the obverse, users also made value judgments about the emperor portrayed on the obverse. Epictetus recounts a story of a man who was paid with a coin of Nero but who asked instead for one of Trajan, even though the coin of Nero had greater value (4.5). He simply preferred Trajan, the "better" emperor. Sculpted portraits of emperors who were subjected to *damnatio memoriae*, or otherwise hated after their deaths, were often defaced or recut into the likenesses of other emperors; coin portraits too were often disfigured and the legends are sometimes erased. Several extant coins of Caligula with defaced portraits, for example, demonstrate that people mutilated the coins after his death, presumably after judging the figure and his legacy (Figure I.1).[10]

Although coinage permeated social distinctions, the intelligibility of images on coins across the economic and social spectrum is a debated topic. From the litany of textual references to coinage, it is clear that the educated aristocracy, at least, considered and often understood the significance of the imagery. Beyond that, we can only speculate about what people lower on the social ladder, such as the *plebs urbana*, and in the provinces thought of the images they saw on Roman imperial coins. Nonetheless, the coins themselves offer some internal evidence that suggest their broader intelligibility. For example, imperial bronze coins tend to bear designs that are more relevant to the urban plebs, as do the *quadrantes* that circulated primarily in Rome and Italy. It would make little sense to place such designs on these coins had the users of the coinage been unable to ascertain their significance. And, typically, images on

[8] E.g., Brilliant 2007: 8–9.
[9] Further textual examples that suggest people considered and responded to coin imagery are discussed in Burnett 1987: 66–71.
[10] Jucker 1982: 114–118.

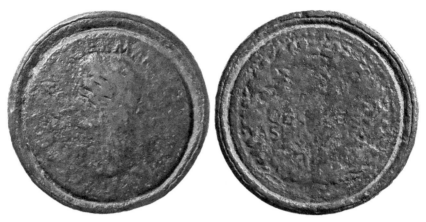

FIGURE I.I Framed *sestertius* of Caligula with gouge marks on the obverse portrait. (Museum of Art and Archaeology, University of Missouri, Gift of Mrs. Thomas O. Mabbott, 72.208.)

imperial coins were drawn from a common visual vocabulary in various forms of art, suggesting that the symbols, gestures, and figures were intelligible to a broad audience.[11] Coins found in ritual and mundane contexts also suggest the broader intelligibility of designs, even if we cannot discern specific recognition of the political value of the images. For example, the living deposited coins with images of Pax, Salus, Felicitas, and Roma in inhumation graves and burial urns at Avenches.[12] Coins with reverse types such as HERCVLI IMMORTALI, MEMORIAE AETERNAE, and MEMORIA FELIX are prevalent in Roman graves in the area of modern Cologne, apparently because of their applicable reference to the afterlife.[13] The Blackfriars shipwreck had a Domitianic coin depicting Fortuna holding a rudder on the mast-step of the ship, indicating ship-builders recognized the figure and her attribute.[14] And a *sestertius* of Domitian from 95, depicting Jupiter seated with the legend IOVI VICTORI, from the *cryptoporticus* of the Capitolium in Verona appears to have been intentionally deposited there on account of the relevance of the imagery to the temple.[15]

Roman imperial art and coinage have often been described as instruments of "propaganda." The cavalier use of the word applied to Roman antiquity is most problematic on account of its twentieth-century connotations

[11] E.g., Toynbee 1956; Sutherland 1959; Cheung 1998–1999: 54–55.
[12] Koenig 1999: 456–458 and his fig. 371.
[13] Gorecki 1975: 271–276.
[14] Carlson 2007 with further bibliography. Thüry 2016: 87–88 examines finds on the mast-step of ships as a class of archaeological finds and their significance.
[15] Perassi 2008.

that imply that organized government agencies, or the emperor himself, actively formulated images and messages to persuade or manipulate the population.[16] The Romans had no propaganda ministries and the emperor was busy managing an empire. So if the coinage was not an expression of imperial propaganda, always emanating directly from the emperor or a close agent running a propaganda ministry, how was coin iconography formulated and who "chose" it?[17] Barbara Levick and Andrew Wallace-Hadrill have argued that mint-masters formulated coin iconography and directed it at the emperor; the public was a secondary audience.[18] In this way, imperial art, built monuments, and the coinage are similar to contemporary panegyric and poetry, which also had the emperor among their audiences; the emperor was not the agent who governed the selection of coin types.[19] Most monuments built in imperial Rome were similarly dedicated *to* the emperor, not *by* the emperor, and thus directed praise at him, as did laudatory poetry or panegyric.[20] Indeed, there are many reasons to infer that the formulation of coin reverse typology occurred in the mint, not in the imperial palace. One example is the prominent S(ENATVS) C(ONSVLTO) that appears on virtually every Roman imperial base-metal coin from Augustus to the third century, and which suggests senatorial influence over the mint and type selection, although the Senate's involvement in the minting of coinage continues to be debated.[21] In the late Roman Empire, there are some practical indications suggesting the

[16] For some reactions against the understanding of art and coinage as propaganda, see, for example, Levick 1982, 1999a; Wallace-Hadrill 1986: 67; Burnett 1987: 69; Zanker 1988: 3; 2010: 108–112; Stewart 2008: 112; Noreña 2011a: 14–21.

[17] Numismatic and art historical research often imply direct imperial agency whether or not the emperor's involvement was historical fact. For example, Sutherland 1986; Wolters 1999: 255–339, esp. 290–308; 2003: 185–189; 2012: 342–346 and Beckmann 2012: 415–418 maintain the potential, or even probability, of imperial involvement in the selection of at least some coin types. Hekster 2003 takes for granted the emperor's involvement in the selection of coin iconography.

[18] In fact, Levick 1982 considers the coinage to be an "appeal" to the emperor without reference to the public. Sutherland 1986 (*contra* Levick 1982) maintains that the images were indeed meant for public consumption.

[19] Levick 1982; Wallace-Hadrill 1986; Stewart 2008: 116. See also Cheung 1998–1999; Hölscher 2014: 24–26 and throughout. See Wolters 1999: 255–339 also on the initiative of the mint. Cf. also discussion in Crawford 1983.

[20] Torelli 1997; Stewart 2008: 108–116, esp. 116; Mayer 2002; 2010; Zanker 2010: 108–115. Also of significant relevance are Hölscher 1984; Zanker 2000.

[21] On mint agency, generally see Levick 1982; Wallace-Hadrill 1986; Cheung 1998–1999: 58–59; Wolters 1999. Wallace-Hadrill explains that lack of S C on most imperial gold and silver was not because of separate authorities, as Mommsen (1860: 739–750 and 1887: 748) had postulated, but rather because most cities did not have a local precious-metal coinage that required differentiation from the state currency; on the other hand, many cities, especially in the eastern Mediterranean, produced their own base-metal coinage for local use and thus S C differentiated between what was produced by the state and what was not. Wallace-Hadrill 1986: 76 and 85 also suggests S C

initiative of the mint. In the reign of Diocletian, images of fortified camps or cities began to appear on the imperial coinage at Nicomedia to celebrate the emperor's Sarmatian victories while he was in residence there. The motif of fortified structures spread from the mint at Nicomedia to all of the imperial mints across the Roman Empire and appeared again on the imperial coinage under Constantine and again in the late fourth and early fifth centuries. The iconography later inspired Carolingian coinage and other early medieval artworks. The fortified city or city gate had been part of the local tradition of representation on the provincial coinage of the second and third centuries in Thrace and Bithynia in the decades leading up to the closure of the provincial mints and the opening of the new, broad network of imperial mints in the later third century. The first appearance of the imagery on Diocletian's imperial coinage occurred at Nicomedia, which lay in this area (Bithynia), suggesting that a local artisan conversant with a local tradition of representation—not the emperor or an agent—constructed the imagery as Diocletian established his capital in Nicomedia.[22] This does not, however, mean that the emperor or his court had no influence whatsoever on the content of numismatic imagery, but that influence must have been, at least, indirect. In this case, the imperial presence was necessary for the introduction of a new reverse type on the coinage, but again that proximity does not equate necessarily with imperial agency. The regime may have asked for coins to celebrate the Sarmatian victories and the design was created in the mint. But if coin iconography is related to panegyric and poetry, honorary monuments, and honorary inscriptions, new images could appear at the mint in the emperor's capital, without the emperor's command, solely to praise him, as a culture of adulation had always surrounded the emperor. Current events, policy decisions, news of victories, and the adulatory rhetoric of courtiers, poets, and panegyrists easily inspired the "choice" of images on the imperial coinage.

If the imagery that appears on coin reverses was solely directed at the emperor, as Levick suggests, then there are some peculiarities in the imperial coinage that arise. In the first year of Claudius's reign, coins appeared honoring the role that the Praetorians played in his accession.[23] On the

indicates the Senate as the source of honors conferred upon the *princeps*, which is similar to the interpretation of Kraft 1962.

[22] Elkins 2013.

[23] *RIC*[2] I: nos. 7–8 and 11–12 for Praetorian types in AD 41–42. The types appear in subsequent years as well (von Kaenel 1986: 233–234 and Sutherland 1987: 74–77 discuss the types). That they celebrate the role of Praetorians in Claudius's accession is sufficient evidence of imperial involvement in the selection of types for Sutherland 1951: 126–127; Wolters 2012: 344–345.

Denominations	Aureus (gold)	Quinarius (gold)	Denarius (silver)	Quinarius (silver)	Sestertius (brass)	Dupondius (brass)	As (copper)	Quadrans (copper)
Aureus	1	1/2	1/25	1/50	1/100	1/200	1/400	1/1600
AU Quinarius	2	1	1/12.5	1/25	1/50	1/100	1/200	1/800
Denarius	25	12.5	1	1/2	1/4	1/8	1/16	1/64
AR Quinarius	50	25	2	1	1/2	1/4	1/8	1/32
Sestertius	100	50	4	2	1	1/2	1/4	1/16
Dupondius	200	100	8	4	2	1	1/2	1/8
As	400	200	16	8	4	2	1	1/4
Quadrans	1600	800	64	32	16	8	4	1

FIGURE I.2 The relative value of imperial coin denominations used in Nerva's reign. Approximate diameters of the denominations: *aurei* (19 mm), *quinarii* (gold, 14 mm), *denarii* (18 mm), *quinarii* (silver, 13 mm), *sestertii* (35 mm), *dupondii* (28 mm), *asses* (27 mm), and *quadrantes* (17 mm).

coinage of subsequent emperors, including Nerva, the Praetorians were also honored. PROVIDENTIA SENATVS, the "foresight of the Senate," is also featured on the coinage of Nerva and apparently celebrated the hand that the Senate had in Nerva's accession. Such instances of representation do not, at first glance, appear to speak directly to the emperor or to glorify him as openly as other coins and have been understood by some scholars as evidence of the emperor's need to curry favor with the Praetorians or the Senate. Such images may, however, reflect the contemporary political rhetoric in the dialogue between the *princeps* and important constituencies, such as the Praetorians and the Senate, which supported and allowed his governance. The emperor provided for his constituencies and in turn they offered him thanks and praise.[24] Finally, there are different patterns of representation across the spectrum of coin denominations in the early Roman Empire[25] (Figure I.2 illustrates the relative size and value of imperial coin denominations in Nerva's reign). In the later first and early second centuries AD, bronze coinage had a tendency to bear more detailed images that denoted specific events or public building that were of significance to the *plebs urbana*. *Quadrantes*, which were struck irregularly during the imperial period and which circulated primarily in Rome and Italy, tended to refer to events that were of importance to the urban masses; they referred to tax remission (Caligula), weights and measures reforms

[24] Veyne 1976; Millar 1992: 139–144.
[25] Hekster 2003.

(Claudius), and depicted grain measures (Claudius, Nerva, and Hadrian). The mundane subject matter on these coins—the smallest of all imperial coin denominations—was relevant to their specific group of users. While a brass *sestertius* might bear an image of the emperor presiding over a distribution of money to the plebs to denote a specific event reflective of imperial generosity to a plebeian audience, a more generic message is conveyed through the personification of Liberalitas on gold and silver coinage to connote the broader idea of imperial generosity to the users of those coins.[26] On the imperial coinage of Nerva, personifications appear across the spectrum of gold, silver, and base-metal denominations, but it was exclusively the bronze *sestertii* and a single type of rare copper *as* which bore images denoting specific aspects of Nerva's imperial policy and especially events that directly affected the urban population of Rome and the inhabitants of Italy. It appears then that some numismatic imagery, including in Nerva's reign, was placed on denominations of coins that would have resonated with various groups of people on the social ladder who used those denominations. But this again does not necessarily imply imperial agency, as honorary proclamations dedicated to the emperor were simultaneously intended for public consumption and, in part, reinforced official perceptions of imperial legitimacy, expectations of the emperor, and the emperor's positive relationship with constituent groups.[27]

While it is probable that the formulation of imagery took place in the mint, the mechanisms behind the selection of messages, events, and ideals placed on the coinage remain difficult to investigate. The emperor seems to have been an audience as he was glorified by the imagery, although many images appear to have been consciously directed toward the imperial powerbase: the Senate, the Praetorians, the military, the urban masses of Rome, and the inhabitants of Italy and the provinces. Still such coins portrayed the emperor as patron and benefactor of these groups and carried his titles and portrait on the obverse. And in return for the emperor's beneficence to his constituencies and subjects, these groups in turn were often expected to reciprocate with praise, sacrifices, dedications, and honorary inscriptions and monuments. Such coins, therefore, visualize praise to the emperor for what he has done, and is expected to do, for his subjects and do not necessarily represent "advertisements" of the emperor's activities, although they naturally served to remind viewers of the positive

[26] Metcalf 1993.
[27] Noreña 2011a: 14–18.

benefits of their relationship with the emperor.[28] Even though the emperor was not the immediate agent behind the selection of coin types, the coinage bore his portrait on the obverse and users may have thus naturally perceived that the reverse iconography was chosen by the regime.[29] The above-cited description of Nero's coinage by Suetonius ascribes imperial agency to the selection of imagery on the coinage and the meaning behind it. Eusebius similarly claims that Constantine directed his numismatic portraiture to gaze prayerfully upward (*Historia Ecclesiae* 4.15).[30] Rather than falling into the quagmire of debate surrounding the "choice" and "intent" of imperial coin types at this time, it is more fruitful to assess what people were seeing in circulation and what that imagery may have meant to different Roman viewers who saw these official images as reflective of imperial ideals, expectations, and policy.[31]

Roman imperial art, monuments, and coinage were not propaganda in the modern sense of the word and in view of the fact that they, like panegyric and poetry, often had the effect of glorifying the emperor to whom they were dedicated. The images and ideals that appear on the imperial coinage frequently parallel contemporary textual discourses. The imperial coinage of Maximian from Lyons, for example, has a very close relationship with contemporary Latin panegyric.[32] In Pliny's *Panegyricus*, one may also pick out the same qualities attributed to Trajan that were featured on his contemporary coinage. Many of the same ideals that appear on Nerva's imperial coinage, such as Libertas, Aequitas, and Iustitia, are also qualities

[28] In this way the imperial coinage is generally distinctive from the provincial coinage, which had a different voice. Roman provincial coinage typically highlighted items of local significance, such as local games or festivals or the status of the city as *neokoros*, or it depicted the eponymous deity of the minting city or other figures from the local cults. Since this book is about the image of political power formulated in Rome around the emperor and then disseminated around the Roman Empire on the imperial coinage, it generally excludes the provincial coins that do not relate specifically to imperial ideals or policy. For provincial coin types struck during Nerva's principate see *RPC* III: (Melos) 55, no. 404; (Thessalonica) 78, no. 616; (Cassandrea) 80, no. 636; (Tomi) 99, nos. 774–778; (Bosporan Kingdom) 102, no. 788; (Sinope) 145–146, nos. 1214–1216; (the *cistophori* for Asia) 161–162, nos. 1298–1307; (Parium) 185–186, no. 1533; (Apollonia ad Rhyndacum) 192–193, nos. 1589–1594; (Cyme) 233–234, nos. 1927–1929; (Ephesus) 250, nos. 2045–2046; (Rhodes) 269–270, nos. 2176–2182; (Sardis, Caesarea) 297–298, no. 2390; (Ancyra, Phrygia) 315, no. 2531; (Synnada) 328–329, nos. 2618–2620; (Lycia) 337, nos. 2673–2675; (Sagalassus) 353–354, nos. 2788–2792; (Ancyra, Galatia) 359, nos. 2826–2834; (Comana) 369, no. 2920; (Caesarea) 380–381, nos. 2960–2977; (Aegeae) 423, no. 3328; (Hierapolis, Castabala) 429, nos. 3380–3383; (Epiphanea) 430–431, no. 3391; (Antioch) 450–452, nos. 3476–3501; (Alexandria) 557, nos. 4111–4119; (uncertain) 785, no. 6536.

[29] Burnett 1987: 70.

[30] Eusebius probably also misinterpreted the symbolism of the upward-gazing portrait. See, for example, Patrick Bruun in *RIC* VII: 32–33, who points out the prototypes from Hellenistic ruler portraits.

[31] Cf. Kemmers 2006: 240–241.

[32] Steinbock 2014. See also MacCormack 2012, who links late Roman art, coinage, and panegyric.

ascribed to Nerva by contemporary writers: Martial, Frontinus, Pliny, and Tacitus. While the messages and images on coins and other state-sanctioned art media were not concocted to "convince" or "persuade" viewers of imperial policy, and were created instead with the emperor's pleasure foremost in mind, the images would have been necessarily seen by the public and communicated an official perception and definition of the current regime to those viewers through a concentrated picture language and accompanying text.[33] In this way, Carlos Noreña understands the imperial coinage as something similar to "integration propaganda," which is not aimed at changing opinions but which bolsters existing public perceptions and attitudes.[34] This sort of propaganda is different from the "agitation propaganda" of the mid-twentieth century that sought to change attitudes and that implies some sort of resistance. As Noreña concludes, ideals transmitted and repeated on the coins, in inscriptions, in texts and poetry, and in public art indicate "the intensity of ideological unification within the Roman Empire, reflecting, in turn, the achievement of a finely calibrated equilibrium between two distinct, but ultimately compatible, sets of interests: those of the central state, and the imperial aristocrats who controlled it, and the empire's municipalities, and the local aristocrats who controlled them."[35] Imperial coinage, other forms of state-sanctioned art and building, and texts such as poetry and panegyric are thus unified in the repetition of certain ideas about rulership, and about specific rulers, as they reflect contemporary political rhetoric and expectation of the emperor, not appeals for public support. That rhetoric was promoted in art, coinage, and through written texts and spoken word by imperial agents, government officials, courtiers, and panegyrists to flatter the emperor, but it also reinforced public perceptions and expectations of imperial rule that were received through visual, textual, and aural media.[36]

Circulation, Quantification, and Audience Targeting

Apart from theoretical assumptions made about the communicative value of imperial coinage across the various denominations, recent research has

[33] E.g., Hölscher 1980, 1982, 1984, 2000, 2014.
[34] Noreña 2011a: 18, who draws upon the differentiation between "agitation propaganda" and "integration propaganda" made by Ellul 1973: 61–87.
[35] Noreña 2011a: 300.
[36] Hölscher 2014: 23–26 reminds that coinage and coin iconography cannot be studied in a vacuum, as it so often is.

provided empirical finds-based evidence that indicates that the mint or treasury sometimes consigned supplies of imperial base-metal coinage to certain populations within the Roman Empire according to the relevance of the reverse iconography to that population. From the later first century through the third century, images with broad appeal are also the most common on the silver coinage and it is here that Noreña's work on personifications of imperial ideals on the coinage stands out.[37] Through an analysis of Roman silver coin hoards across the western Roman Empire, Noreña quantifies the prominence of ideals and personifications on the coinage to examine trends in imperial representation across time and, in so doing, recognizes that certain ideals tended to play a greater role in imperial ideology than others. Continental scholars, especially Markus Peter and Fleur Kemmers, have significantly advanced the study of the communicative value of the brass and copper coinage by attending to site finds and discerning that certain types of coins bearing certain images on the reverse appear to have been targeted at specific audiences within the western Roman Empire.[38] In her study of the coin finds from the legionary fortress at Nijmegen, Kemmers discovered a much higher concentration of martially themed Flavian coins used by the soldiers, compared with lower concentrations of such coins in Rome and in nearby civilian settlements, indicating state-supplied consignments of base-metal coinage with relevant images to the soldiers.[39] This empirical finds-based method for examining audience targeting and the imperial coinage has since been deployed with some suggestive results in a study of architectural representation on Flavian and Trajanic base-metal coinage, which has ramifications for the popular study of such types. It demonstrates that only a tiny percentage of coins in circulation bore images of built monuments and that certain images of specific monuments may have had different circulation patterns according to the relevance of the building to the intended audience.[40] Other recent studies indicate that the Flavian base-metal coinage that circulated in Rome and Italy had a different typological makeup than the Flavian

[37] Noreña 2001, 2011a.

[38] Peter 1996 was one of the earliest studies to discern patterns in the frequency of different base-metal coin types circulating in different regions.

[39] Kemmers 2006: 189–244, esp. 219–244. Kemmers 2009 examines phenomena relating to coin supply, use, and a differentiated supply of coin types. Kemmers 2014 presses further with material evidence for the targeting of soldiers with specific types of iconography in the early Roman Empire at other locations and in other periods.

[40] Elkins 2011; 2015: 114–116. Elkins 2009a examines the potential for continued finds-based studies of coins and audience targeting.

coinage that circulated outside of it; notably, the Judaea Capta types were targeted primarily at an Italian audience.[41]

In order to examine the ideals and messages communicated by Nerva's coinage across the western Roman Empire, the quantitative and finds-based methods developed by Noreña and Kemmers are adopted and adapted here. Whereas Noreña examined trends of imperial representation across a vast period of time on the silver coinage and Kemmers has probed differentiation in base-metal coin types supplied to specific areas contrasted with others, this study joins the two methods to quantify the imperial ideals and messages that were struck and put into circulation in Nerva's reign and to determine if some of that imagery on the base-metal coinage was targeted at specific geographic audiences. This is the first attempt to study the complete imperial coin typology of a single emperor by quantifying and examining the targeting of coinage based on evidence from hoards and excavated single finds.

The use of excavated finds and hoards is preferred over other approaches, namely die studies and quantification by entries in type catalogs, such as *Roman Imperial Coinage* (*RIC*), or the holdings of museums or private collections. Die studies are at the core of numismatic studies as they often provide insight into production contexts and help to order the stages of production and structure of a coinage. Die studies may also help to chart the evolution of an image repeated on subsequent dies as they are copied. Some scholars have also used die studies to calculate or estimate the volume of coin types that were produced. A reverse type for which there are more dies than another would appear, for example, to have been produced in greater quantities. The striking of coin was, however, a laborious and mechanical process. While a single die might strike 10,000 coins, it could also break or crack after only a few strikes, potentially limiting the value of die studies for a quantitative approach to the study of coin typology.[42] Using the prominence of certain iconographic types in museums or private collections is a very flawed method for creating an impression of what images were in abundance and in circulation at any given time in antiquity. Museum curators and private collectors make several determinations to bring coins into their collections, including the rarity of the type, the condition and aesthetic quality of the specific coin, and the (modern)

[41] Barbato 2014; 2015.
[42] For experiments on coin striking, see Sellwood 1963. There is a debate about the viability of using die studies to calculate coin production. As an introduction to the two camps see Buttrey 1993; 1994; Buttrey and Buttrey 1997 (against), and the retort by de Callataÿ 1995.

interest that the curator or collector has in what the coin depicts. Common types, or types that are less interesting to a modern audience, such as personifications, may be underrepresented in collections even though they were very prominent in antiquity.[43] Finally, using the number of entries in type catalogs, such as *RIC*, as a way of calculating the prominence of types in circulation is an ill-advised and unscientific approach as type catalogs represent modern taxonomic sensibilities only and have no relationship to production volume; they only catalog different iconographic and epigraphic variations known in public and private collections.[44] In the case of Nerva, the pitfalls of that method are easily illustrated. In Nerva's first emission of coinage, there were eight different types of *denarii* that depicted personifications of Aequitas Augusti, Fortuna Augusti, Fortuna Populi Romani, Iustitia Augusti, Libertas Publica, and Salus Publica, and two variants with the legend CONCORDIA EXERCITVVM (one illustrating clasped hands and one with the clasped hands superimposed on a legionary eagle surmounting a prow).[45] Using the number of *RIC* catalog entries as an indication of frequency, one might then infer that each unique image approximated 12.5 percent of the *denarii* struck and put into circulation from that emission. But according to the Reka Devnia Hoard, the aggregate of silver coin hoards, and site finds, some types are much more common than others and thus were produced in greater numbers. The two CONCORDIA EXERCITVVM types, the Libertas Publica type, the Aequitas Augusti type, and the Fortuna Augusti type are significantly more common than the Fortuna Populi Romani, Iustitia Augusti, or Salus Publica types, which are rarer.[46] Although there are factors that affect the coins represented in excavations and hoards, such as the tendency that

[43] Hobley 1998 is a tempting source for those who wish to study the geographical distribution and quantification of bronze coinage across western Europe, but it should be used with the utmost caution. As a published dissertation, much of the find evidence was compiled many years before publication, making it up to three decades out of date. Also many regions, especially Italy, rely heavily on the holdings of local museum collections in lieu of excavated finds or hoards. While some local museum collections may, of course, represent local finds, especially if these collections were formed in the Renaissance, it is not certain. For cautionary remarks, see Noreña 1999 and Elkins 2009a: 44.

[44] A recent study of the coinage of the third century AD (Manders 2012), for example, uses the number of entries in *RIC* to quantify coin types rather than finds or hoards. Objections to the recent use of type catalogs this way have been raised by Rowan 2013a and Krmnicek and Elkins 2014: 13–14.

[45] *RIC* II: nos. 1–9; no. 8, depicting Moneta Augusti, is a forgery. See Szaivert 1978: 76; Giard 1998: 324, no. 59.

[46] Out of forty-three *denarii* from this emission recorded in the portion of the Reka Devnia Hoard stored in Sofia, Aequitas Augusti comprises about 18.03 percent (11 coins), the first CONCORDIA EXERCITVVM type is 8.20 percent (5) and the second is 13.11 percent (8), Fortuna Augusti

low-denomination and small-diameter coins will be more common in excavations and that hoards will usually contain higher-value precious-metal coins, the ground is the most objective repository that "selects" coins according to type.[47]

One must approach Nerva's precious-metal and base-metal coinage differently as the two groups of coinage had different degrees of mobility.[48] Gold and silver coinage was highly mobile, circulating across the Roman Empire's expanse, and thus it is not easy to detect a typologically differentiated supply of precious-metal coinage to find empirical evidence for audience targeting.[49] Citizens living in Rome, for instance, would have seen the same sorts of imagery on this coinage as people on the frontier. Nonetheless, it may be assumed that wealthier people used gold and silver coinage more frequently. As regionally differentiated supplies of precious-metal coin types cannot be discerned, Noreña's method of quantification is most useful here in order to determine what images and messages were most prolific on Nerva's precious-metal coinage. The relative prominence of different iconographic types on the gold coinage of Nerva is not quantifiable according to hoards or excavated finds. Nerva's *aurei* are generally absent from finds as they, along with the *aurei* of Domitian and Trajan (up to AD 101), were the heaviest *aurei* (and, therefore, the most valuable) struck after AD 64.[50] They quickly went out of circulation in keeping with the principle of Gresham's Law. For example, the substantial Feldstraße Hoard in Trier that contained more than 2,650 gold coins, deposited in AD 196 and discovered in 1993, had only fifteen *aurei* of Domitian and two of Nerva. In contrast, the hoard produced 115 *aurei* of Titus and 125 *aurei* of

is 6.56 percent (4), Fortuna Populi Romani is 6.56 percent (4), Iustitia Augusti is not present, Libertas Publica is 13.11 percent (8), and Salus Publica is 4.92 percent (3). In the aggregate of silver hoards, Aequitas drops to 7.91 percent (11), the two Concordia types rise to 25.90 percent (36) and 21.58 percent (30), Fortuna Augusti is 11.51 percent (16), Fortuna Populi Romani is 3.60 percent (5), Iustitia Augusti is 5.04 percent (7), Libertas Publica is 14.39 percent (20), and Salus Publica is 8.63 percent (12). And in the site finds, Aequitas Augusti is 17.65 percent (9), the two CONCORDIA EXERCITVVM types are 9.80 percent (5) and 23.53 percent (12), Fortuna Augusti is 9.80 percent, Fortuna Populi Romani is 1.96 percent (1), Iustitia Augusti is 5.88 percent (3), Libertas Publica is 19.60 percent (10), and Salus Publica is 11.76 percent (6). Data are derived from appendix 3.

[47] On some of the factors that affect the types of coins retrieved in excavations, see Noeske 1979. For a recent treatise on coins as archaeological objects, see Thüry 2016.

[48] On the mobility of gold and silver coinage versus base-metal coinage, these works provide an introduction: Duncan-Jones 1989; 1994: 172–179; 1999; Hobley 1998, to be used with caution (read Noreña 1999); Kemmers 2005; 2006; 2009.

[49] For the homogeneous qualities of silver coins circulating across the Roman Empire, see Noreña 2001: 151, n. 26 *contra* Duncan-Jones 1990: 41 and 1994: 175.

[50] Duncan-Jones 1994: 83, n. 49.

Trajan (the vast majority after AD 101).[51] It is thus impossible to make any direct observations about the volume of gold production or circulation in Nerva's reign according to finds-based evidence. The same reverse types deployed on Nerva's gold coinage do, however, also appear on Nerva's silver *denarii*, which are much more common in finds and hoards.

For imperial silver coinage, the massive Reka Devnia Hoard—discovered in 1929 in Marcianopolis and containing more than 80,000 silver coins from ca. AD 64 to 238—is often used by numismatists to quantify the sizes of emissions and their iconographic composition.[52] Richard Duncan-Jones and Noreña, for example, have used the Reka Devnia Hoard as evidence for the frequency of various coin types and also observed that the composition of this large hoard is generally comparable with other western European silver hoards.[53] It is, however, necessary to look at other silver coin hoards as well to compare with the Reka Devnia Hoard since there are anomalies in the part of the hoard housed and identified in Varna.[54] Owing to the complications caused by the part of the hoard identified and stored in Varna, the thirty-two coins of Nerva in Varna are omitted from statistical considerations in this study.

The movement of imperial brass and copper coinage was very different from the gold and silver coinage and thus a different approach is required. Once base-metal coinage was supplied to a region, it tended to circulate locally. As Peter and Kemmers have indicated, base-metal coinage appears to have been supplied, in some instances, to certain populations according to the relevance of the reverse iconography to that community. Nonetheless, one must remain vigilant when studying differentiated coin supplies as the semantic qualities of the imagery that coins bore was secondary to money's economic function. Historical, economic, and other external factors could affect the types of coins that are found in various regions. *Quadrantes* are the smallest of imperial coin denominations, produced irregularly in the early Roman Empire, and they tended to circulate primarily in Rome and Italy. But there are remarkable quantities of Flavian *quadrantes* along the Rhine frontier in excavations. The unusual movement of these coins into this region coincides with a need for small

[51] Gilles 2013: 130–135.

[52] Mouchmov 1934; Depeyrot 2004. The coins were split between the National Museum in Sofia and the museum in Varna: 68,783 and 12,261 coins, respectively.

[53] Duncan-Jones 1994: 134; Noreña 2001: 164, n. 96.

[54] Curtis Clay has noted (unpublished) that while the lists in Mouchmov 1934 for those coins in Sofia appear to be accurate, the coins in Varna are identified by reverse type only and they are not always assigned to different emissions. The Reka Devnia Hoard must be used with caution or in conjunction with other sources.

change in the region and the presence of the emperor and his retinue here as Domitian began his campaigns against the Chatti in 83.[55] Titus in 80/81 and Domitian (for the Deified Titus) in 81/82 struck *sestertii* depicting the Colosseum. These coins are very rare; at present approximately fifty-five are known in public and private collections. Only six of these coins are recorded from excavated contexts. Remarkably, five of these Colosseum *sestertii* were excavated within 25–30 kilometers of one another in the German region of Hessen and the Taunus-Wetterau *limes* system. The coins were found at the forts and *vici* of Butzbach (2 coins), Saalburg (2), and Nida-Heddernheim (1). The iconography of the coins would obviously have had greater meaning to a person living in Rome (and they are indeed prominent in old Italian collections, such as the Vatican, probably representing early Italian finds) and yet several of these coins were found in this small area of modern Germany.[56] The unexpected presence of several Colosseum *sestertii* here may again reflect an influx of coins from the urban circulation pool of Rome in conjunction with Domitian's presence at Mainz at the beginning of his war against the Chatti in this region in 83.[57] Another unusual case regarding the differentiated supply of base-metal coin types is that of the *asses* of Nerva bearing a reverse image of Neptune with the legend NEPTVNO CIRCENS CONSTITVT. These exceptionally rare coins have thus far only been recorded in finds in France and, especially, England. David Shotter suggests the coins may have been supplied to this region on account of the relevance of the nautical theme to the people here, who relied on trade and commerce across the English Channel.[58] This theory seems forced as the legend denotes Neptune's association with the Circus Maximus in Rome, indicating the intended audience was in central Italy. Some other historical or economic factor affected the movement of these coins to the region (see chapter 2).

Insofar as the material evidence allows, the following chapters examine the audiences at which Nerva's coins were directed and the relative prominence of various images and messages on Nerva's coinage. In cases where specific audiences are not discernable, either because there is no evidence for a differentiated supply, because the type in question is too rare to identify any meaningful patterns in the finds, or because the imagery appears on mobile gold and silver denominations, the visual and textual content of the

[55] Kemmers 2003; 2006: 218–219.
[56] On the Vatican collection representing local finds, cf. Molinari 2002: 205–213 on the concentration of Roman medallions in the Vatican.
[57] Elkins 2009b.
[58] Shotter 2013.

coin type itself may determine the intended audience. *Sestertii* depicting two mules with the legend VEHICVLATIONE ITALIAE REMISSA, for example, celebrate the remission of the obligation to support the imperial courier service in Italy and logically would have been most relevant to people living in Italy who directly benefitted from the cancellation of that burden. By quantifying the relative prominence of different images and messages in relation to one another, the ideas and concepts that played the most significant role in contemporary rhetoric during Nerva's reign are identifiable.

Within an analysis of the prominence of various types of images on Nerva's coinage, their ideological function, and their audiences, it is important to remember that coinage was struck in different emissions. Individual coins of the new emperor circulated alongside other coins of his, reinforcing similar ideas or emphasizing new ones, and they also circulated alongside the coins of his predecessors, inviting the viewer to compare or contrast the reigning emperor with his damned or deified predecessors. Most of Nerva's imperial coins are easily assigned to six emissions, according to his tribunician and consular titles that appear on them (appendices 1 and 2).[59]

Emission 1: September 96 (TR P COS II)
Emission 2: December 96 (TR P COS II DESIGN III)
Emission 3: January 97 (TR P COS III)
Emission 4: September 97 (TR P II COS III)
Emission 5: December 97 (TR P II COS III DESIGN IIII)
Emission 6: January 98 (TR P II COS IIII)

The chronology of Nerva's restoration coinage for the Deified Augustus and his *quadrantes* are more difficult as they do not bear Nerva's titles. Nonetheless, the restoration coinage is probably part of the fifth emission, while the *quadrantes* of the *modius/caduceus* type and those of the Juno/ globe type may respectively belong to the second and fifth emissions.[60]

Just as the lists of coin types in catalogs such as *RIC* were not intended to convey any information about the frequency of individual types, *RIC*'s organization by emission should not be interpreted to suggest that all emissions were the same size. Die studies, and especially hoards and finds, are better tools to determine the relative sizes of the various emissions.[61]

[59] Kienast 2011: 120–121 on chronology.
[60] See discussion and references in chapter 2.
[61] See also Carradice 1983: 74–79 on using finds and die studies to determine the sizes of emissions.

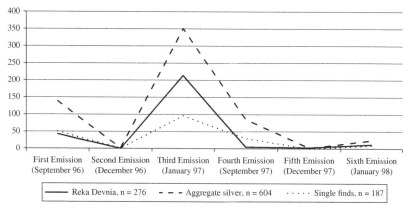

FIGURE I.3 Relative sizes of Nerva's emissions of *denarii* according to the Reka Devnia Hoard (Sofia), the aggregate of smaller silver coin hoards, and single finds of *denarii* in excavations (data derived from appendix 3).

Figure I.3 shows the relative volumes of Nerva's emissions of silver coinage according to the Reka Devnia Hoard, the aggregate of other silver coin hoards, and single finds of *denarii* from excavations.[62] In Figures I.4–I.5, the relative abundance of base-metal coins from two of the largest sample areas (Germany and Austria) indicates that the level of output of base-metal coins was proportionately similar to the output of precious-metal coins. Finds from Germany represent, however, a higher volume of *asses* from the fourth emission than any other emission, serving as a reminder that the supply of brass and copper coinage in the Roman Empire was differentiated.

The three datasets indicate that the largest precious-metal and base-metal emissions under Nerva were his first emission and especially his third emission. The first emission was necessarily large upon the emperor's

[62] The first emission was 19.06 percent of the Reka Devnia Hoard, 23.01 percent of the aggregate of hoards, and 27.27 percent of single finds. The second silver emission, not represented at all in the Reka Devnia Hoard, comprised 0.33 percent of the coins in the aggregate of silver coin hoards and 0.53 percent of the coins from single finds. In all three groups of finds, the third emission of January 97 is clearly the largest: 73.75 percent in Reka Devnia, 58.11 percent of the aggregate of hoards, and 51.34 percent of the single finds. The fourth emission was 1.5 percent of the coins in Reka Devnia, 14.24 percent of the aggregate of hoards, and 16.04 percent of the single finds. Its remarkably lower representation in Reka Devnia is an inexplicable anomaly. The fifth emission was 1.25 percent of the Reka Devnia Hoard, 0.33 percent of the aggregate of hoards, and 4.81 percent of the single finds. The final emission composed 4.35 percent of the Reka Devnia Hoard, 12.72 percent of the aggregate hoards, and 4.81 percent of the single finds. Butcher and Ponting 2014: 98 remark upon the curious absence of many coins (*RIC* II: nos. 25–33) from Nerva's fourth emission in the Reka Devnia Hoard and caution against using it without other comparative hoards.

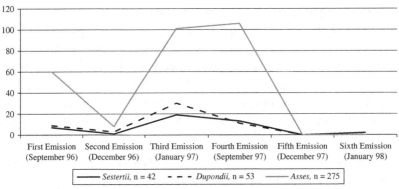

FIGURE I.4 Relative sizes of Nerva's emissions of base-metal coinage according to finds from modern Germany (data derived from *FMRD*). Note, this chart does not include the restoration types that are hypothetically attributed to the fifth emission.

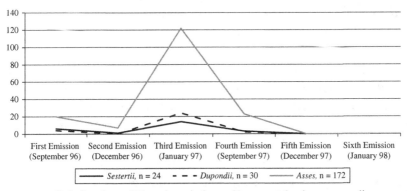

FIGURE I.5 Relative sizes of Nerva's emissions of base-metal coinage according to finds from modern Austria, the Roman province of Noricum (data derived from *FMRÖ* and *dFMRÖ*). Note, this chart does not include the restoration types that are hypothetically attributed to the fifth emission.

accession; there were often peaks in coin production when a new emperor came to power, presumably so that the emperor's image, ideals, and policies could be readily disseminated or because mint officials were eager to lavish praise on the new *princeps* and to communicate expectations of his rule.[63] The higher volume of production in the third emission in early 97 might reflect a necessity for coinage at the beginning of Nerva's first full year in office. Typologically, these two large emissions were significant.

[63] Duncan-Jones 1994: 127 on the large size of accession emissions. Domitian also had a very high level of coin production in the first months of his reign; it was, in fact, the largest emission of the first half of his reign. See Carradice 1983: 79, 88–89 (tables K and L), 91 (fig. 3), and 159.

The accession emission first introduced many of Nerva's reverse types and indicated aspects of his imperial policy and ideals. The third emission injected some important new reverse types on the base-metal coinage, reflecting the emperor's domestic policy. The *sestertii* from that emission hosted images that highlighted popular aspects of Nerva's domestic agenda accompanied by the descriptive legends PLEBEI VRBANAE FRVMENTO CONSTITVTO and VEHICVLATIONE ITALIAE REMISSA. The first type referred to a distribution of grain to the urban plebs while the second marked the remission of obligations to the imperial courier in Italy, which unfairly burdened communities alongside major thoroughfares. Another new *sestertius* proclaimed PROVIDENTIA SENATVS, honoring the Senate's foresight, and a new *as* appeared with Neptune on the reverse with NEPTVNO CIRCENSIS CONSTITVT, referring to games in the Circus Maximus. The third emission, therefore, provided an opportunity to disseminate praise of Nerva's new policy items and to celebrate recent events that had occurred since Nerva's accession several months earlier in September 96.

Although Nerva ruled for only sixteen months, his coinage exhibits a diverse array of distinct reverse types on the precious-metal and base-metal coinage. To date, what has been written about Nerva's coinage focuses primarily on his brass *sestertii*, which referred to concrete aspects of the emperor's policy, such as the remission of obligations to support the imperial courier in Italy or the end of false accusation under the *fiscus Iudaicus*, and on other rare types that celebrate the foresight of the Senate, or on the *asses* that depict Neptune. The volume of literature and references to these types is disproportionate to what was most common on Nerva's coinage across all denominations: personifications. In a recent case study of the coinage of Trajan, Duncan-Jones argued that most coin reverses, which bore images of personifications and gods and goddesses ("religious types"), had more to do with mint structure and lacked the "propagandistic" content of rarer "news types."[64] Apart from the fact that coin images did not function quite like "propaganda," the interpretation is questionable as it does not account for the ideals conveyed by the personifications and for the broader reading that an individual could bring to his understanding of an image when contrasted with denotative "news types." In fact, what skepticism regarding the communicative value of personifications reflects is a persistent modern lack of interest and boredom with these common and somewhat repetitive designs. But just because they did not denote specific

[64] Duncan-Jones 2005. A worthy retort is Beckmann 2009.

historical events or policies does not mean they lacked communicative or ideological value. Roman art and relief sculptures are replete with personifications, indicating they bore meaning.[65] Personifications were successful communicators precisely because of their relevance to a broader cross-section of society. The depiction of the emperor distributing money to the plebeians is relevant only to the *plebs urbana*, while the depiction of Liberalitas more broadly connotes the similar notion of imperial generosity. To the *plebs urbana* the *congiarium* was a specific expression of generosity; to the Senate and to provincial citizens the emperor would have expressed generosity in other ways.[66] One could see what one wished in a personification of Liberalitas, although *liberalitas* became a synonym for *congiarium*. As Noreña's work has forcefully indicated, the depiction and repetition of personifications on the imperial coinage communicated broad concepts and ideals about imperial rule to a range of elites and peoples across the Roman Empire.[67] Such images resonated with more viewers than the celebration of specific events that affected only a segment of the population in the city of Rome.

The remarkable diversity of imagery deployed in Nerva's short reign, along with the correspondence between imperial qualities ascribed to Nerva by contemporary writers and the images (accompanied by descriptive legends) that appear on the coinage, suggests that contemporary political rhetoric sought to define Nerva's principate and to differentiate him from his predecessor, Domitian. The varied themes on the coinage indicate that Nerva's coin iconography was relevant to, and targeted at, a range of audiences and important constituencies across the Roman Empire: the armed forces, the senatorial aristocracy, the *plebs urbana* and the general citizenry of Italy, and those living in the provinces. Positivistic reinterpretation of Nerva's imperial coin iconography as a medium of state-sanctioned art and consideration of the imagery with respect to contemporary laudatory texts also allows a closer look at the agents behind the selection of imperial coin iconography at the end of the first century.

[65] E.g., Hamberg 1945: 15–45.

[66] Metcalf 1993.

[67] Noreña 2001; 2011a. Some other works that have highlighted the communicative value of personifications and quantified types in Noreña's manner include Rowan 2011a and 2013b. Yarrow 2013 examines the image of Heracles in Hellenistic Italy and finds its ubiquity and repetition to be powerful.

CHAPTER 1 | Nerva as Supreme Military Commander

The great blot on our age, the deadly wound inflicted on our realm, was the time when an emperor and Father of the human race was besieged in his palace, arrested and confined; from the kindest of elderly men was snatched his authority to preserve mankind, from a prince was removed the greatest blessing of imperial power, the knowledge that he cannot be forced against his will.

—PLINY, *Panegyricus* 6.1[1]

ALTHOUGH THE HISTORICAL sources for Nerva's short principate are sparse, they emphasize above all else tension with the army and his difficulties with the Praetorian Guard, both of which were the biggest threat to Nerva's reign.[2] When Nerva was selected *princeps* to prevent a dangerous vacuum of power in the immediate aftermath of Domitian's assassination, the Praetorian Guard and the Urban Cohorts were apparently supportive—or at least accepting—of the choice, as they made no move against Nerva and the Senate. Early in his principate, Nerva replaced Domitian's Praetorian commander, a conspirator in that emperor's assassination. He appointed to the post Casperius Aelianus, who had earlier been a commander of the Praetorian Guard under Domitian (Dio 68.3.3). The conspiracy against Domitian was a highly organized plot that involved a number of individuals. It is, therefore, also possible that the Praetorians

[1] The translation is from the 1969 Loeb edition (Radice).
[2] This problem is a focus of modern studies as well. See, for example, Greer 1936: 49; Garzetti 1950: 31–42 and 81–97; Griffin 2000: 84–96; Bennett 2001: 40–41 et passim; Berriman and Todd 2001; Grainger 2003: 28–44 et passim; Morelli 2014: 251–271 et passim.

acclaimed Nerva before the Senate, even though in modern historical discourse Nerva is often assumed to have been the Senate's candidate.[3]

Initially, at the news of Domitian's death and Nerva's accession, there was much unrest among the general soldiery, as the historical sources indicate. While Suetonius records that the Senate rejoiced in the news of Domitian's assassination and the people were ambivalent, he states that the general soldiery was much aggrieved, called for Domitian's deification, and would have mutinied and marched to avenge Domitian if only their commanders would also have been inclined to do so (*Domitianus* 23). In his *Lives of the Sophists*, Philostratus gives an account of Dio of Prusa (Dio Chrysostom), exiled under Domitian after the execution of the consul Titus Flavius Clemens; Dio was in an army camp along the frontier at the time that word of Domitian's death was breaking (1.7.2). As the angry soldiers clamored for revenge, Dio stripped off his tattered clothing, jumped onto an altar, and, quoting Homer ("then wily Odysseus stripped his rags"), denounced Domitian and calmed the crowd of upset infantrymen. The account is hard to believe and is probably fictitious.[4] Nonetheless, it reflects the uncertainty of the days immediately following Nerva's accession, the potential dangers of mutinous legions along the frontier, and the threat of civil war. Galba's claim to the principate had been challenged with military force after the death of Nero and the collapse of the Julio-Claudian dynasty. Fear of the repetition of that bloody civil war must have been palpable in the days after Nerva's accession. Fortunately, Nerva, many of the senators, and veteran military commanders were old enough to remember the devastation of that conflict so that it was not repeated.

In late 96, Nerva published the consular lists and named himself and Lucius Verginius Rufus as ordinary consuls for 97. Lucius Verginius Rufus was the decorated former governor of Upper Germany and war hero who had defeated the rebel Vindex in 68; shortly afterwards, when news came that Nero had died, Rufus refused to be emperor. This consulship, bestowed by Nerva, was a high honor for Lucius Verginius Rufus, for it was his third consulship and it was Nerva's third consulship as well. Tacitus, who was suffect consul when Lucius Verginius Rufus died, delivered the old patriot's funeral oration in 97; it is recorded that Rufus's tomb bore the words "Hic situs est Rufus, pulso qui Vindice quondam imperium asseruit non sibi sed patriae" ("Here lies Rufus, who after defeating Vindex, did not put

[3] Collins 2009 provides further discussion.
[4] Jones 1979: 52; Grainger 2003: 32–34.

himself into power, but gave it to the Fatherland") (Pliny, *Epistulae* 6.10.4; cf. Dio 68.2.4). Also in the fall of 96, Nerva appointed a new governor of Upper Germany, the popular general Marcus Ulpius Traianus (Trajan), who departed from Rome for his province shortly thereafter.

These events illustrate the new emperor's sensitivity to the interests of the general soldiery and their commanders. Lucius Verginius Rufus was a war hero and respected senator, as well as a military commander, who did not seek to claim imperial power for himself in the aftermath of Nero's death; he was the ideal Roman patriot and war hero, not unlike the famous Cincinnatus of the Republic, whose patriotism and sense of self-sacrifice trumped any personal ambition. Such a choice was symbolic to the armed forces. The selection of Lucius Verginius Rufus as consul with Nerva might also have been an expression of unity in the government, as Rufus may have been one of the possible contenders for the principate before the senators, and potentially other stakeholders, agreed on Nerva as their choice. Trajan was an excellent candidate for the governorship of Upper Germany. He was loyal to Nerva and had been loyal to Domitian, for whom the armies had had great affection. Both appointments of distinguished veterans signaled unity between the emperor and the leadership of the armed forces.

Initially the Praetorians accepted Nerva's rule, but tension between the emperor and the Praetorian Guard became apparent in the summer of 97 when, led by Casperius Aelianus, the Praetorians surrounded Nerva's palace and demanded that the conspirators who killed Domitian be handed over for punishment and execution (Pliny, *Panegyricus* 6.1; Dio 68.3.3; *Epitome de Caesaribus* 12.6–8). In his desperation, Nerva indignantly bared his throat to the guardsmen, but eventually handed the conspirators over when it was clear he was impotent in the face of the demands of this armed force. This episode of defiance and lack of respect humiliated the aged emperor and exposed Nerva's vulnerabilities. The incident may have prompted Nerva to seek out a strong and well-respected military man, with a large army, for his heir in order to galvanize the support of the provincial armies as a balance to the Praetorians in Rome if his own principate was to continue.[5] And so, in the wake of the news of northern victories in the fall of 97, just a few months after the Praetorians had besieged Nerva in his palace, Nerva mounted the steps of the Temple of Jupiter Optimus Maximus and turned to the crowd and announced Trajan as his son and successor

[5] This is Pliny's implication (*Panegyricus* 6.2–4).

(Pliny, *Panegyicus* 6.3; *Epitome de Caesaribus* 12.6–8; Dio 68.3.4).[6] If Nerva were to be challenged by a usurper or threatened with arms, Trajan would have marched on the capital with the provincial legions at his back to protect his own interest in the succession. When Trajan received news that Nerva had died and that he was now the Augustus, he summoned Casperius Aelianus and the Praetorians who had shown disobedience to their emperor to his provincial capital in Colonia Claudia Agrippina (modern Cologne) on the pretext of employing them; when they arrived he dispensed with them (Dio 68.5.4).

Although there is no direct evidence that Nerva paid a donative to the Praetorians upon his accession, it is highly improbable that he would have broken this tradition as the ill-fated Galba had (Tacitus, *Historiae* 1.5). Galba's refusal to pay the donative to the Praetorians that was promised on his behalf greatly contributed to his own downfall. Nerva, who lived through the events of 68–69 and whose own elevation mirrored Galba's in many ways, would have surely learned from the mistake.[7] A unique *sestertius* in the Bibliothèque nationale de France from the first emission of 96 conveys unity between Nerva and the Praetorians (Figure 1.1). It depicts Nerva, dressed in a toga, standing on a raised platform, accompanied by two attendants, and addressing four soldiers.[8] Each soldier wears armor and the two at the left clearly carry sheathed swords on their waists; the action of the third soldier is unclear and the fourth soldier raises his left arm, perhaps to hold a military standard. There are columns and a partial roofline in the background behind the soldiers, potentially representing part of a temple or shrine, and the scene is accompanied by the legend ADLOCVT(IO) AVG(VSTI), noting a speech that the emperor had made to the soldiers, most certainly the Praetorian Guard.[9] Remnants

[6] Garzetti 1950: 81–97; Bennett 2001: 42–52; Grainger 2003: 36, 41–43, and 89–102. Some scholars argue that Trajan's adoption was forced on Nerva and that Trajan may have actively influenced Nerva to select him. See Syme 1958: 1:13 and 35; Bennett 2001: 46; Berriman and Todd 2001: 328; Eck 2002; Grainger 2003: 99; Morelli 2014: 288–294.

[7] Syme 1930: 64–65; Shotter 1983: 223; Grainger 2003: 47; Collins 2009: 100; Bingham 2013: 39–40. See also cautionary notes by Sutherland 1935, who argues that Nerva's donative may not have been as extravagant as is often assumed. On the detriment of Galba's refusal to pay the promised donative, see Murison 1993: 60; Morgan 2006: 46–50 and 64–66.

[8] *RIC* II: no. 50; Giard 1998: 325, no. 66.

[9] Grainger 2003: 39 gives an incorrect description of the coin and misinterprets its significance: "It shows Nerva standing on a platform, from which two other men behind him are speaking to a group of men standing lower down, on the ground. These auditors are dressed in togas, as citizens. The whole scene is taking place before a temple. It is entitled '*adlocutio Aug*'—'the address of the Augustus'. This is a representation of the scene of the announcement to the people of Rome that

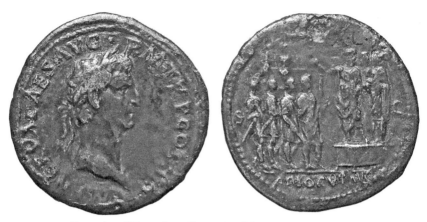

FIGURE 1.1 *Sestertius* of Nerva from September 96 with the *adlocutio* reverse type.
(© Bibliothèque nationale de France.)

of crenellation are also visible in the upper left of the coin, indicating that the imperial address to the guardsmen took place within the Praetorian camp itself. The crenellation in the background is identical to the locative fortifications visible on Nero's *sestertii* that similarly depict him addressing the Praetorians in the camp (Figure 1.2). S(ENATVS) C(ONSVLTO), "by decree of the Senate," appears on all of Nerva's base-metal denominations, as it had customarily on the imperial coinage since Augustus, to indicate the Senate's authority, nominal or otherwise, in the striking of coin.[10] The unique coin is sometimes dismissed as a forgery, but the style is correct and the specimen has been known since the seventeenth century, when high-quality forgeries were neither as sophisticated nor as prevalent as they are today.[11] Similar *adlocutio* types had been struck by Caligula, Nero, and

they had a new emperor." Seelentag 2004: 86 incorrectly describes Nerva's coin as having the same legend as Nero's *adlocutio* type: ADLOCVT(IO) COH(ORTIVM PRAETORIARVM).

[10] *RIC*[2] I: 24 and 32. Mommsen 1860: 739–750; 1887: 748 first proposed a diarchal system whereby the emperor had authority over gold and silver coinage, generally lacking S C, and the Senate's responsibility was restricted to base-metal coinage, evidenced by S C. Burnett 1977 argues for this arrangement in the early Roman Empire, especially the reign of Augustus. Even if this was the arrangement, it would have been impractical and impossible to maintain for long after Augustus. Precious-metal and base-metal coins were often simultaneously struck at Rome in the same emissions, as they were in Nerva's emissions, and bore similar imagery across the spectrum of denominations. On the significance (or insignificance) of S C on the imperial bronze and copper coinage, see also Kraft 1962; Wallace-Hadrill 1986; Wolters 1999: 115–169; 2004; Metcalf 2004: 299–301.

[11] Nony 1987: 62 condemns the unique specimen in the Bibliothèque nationale de France as a seventeenth-century forgery, based on an *adlocutio* type of Nero. But the coin does not appear to have been recut from a coin of Nero's, as his types have three soldiers while Nerva's has

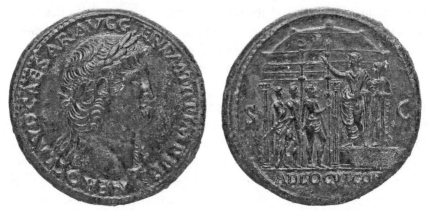

FIGURE 1.2 *Sestertius* of Nero from 64 with the *adlocutio* reverse type.
(© Bibliothèque nationale de France.)

Galba.[12] The building behind the soldiers, which is the same building represented in the background of Nero's *sestertii* that show him giving an address to soldiers with the legend ADLOCVT(IO) COH(ORTIVM PRAETORIARVM) within the fortified camp, may be the shrine to Mars in the Praetorian camp or a shrine to house the standards of the Praetorians.[13] While the iconography clearly identifies the armed audience as Praetorians, it is curious that the legend on the coin does not explicitly identify them as it did on Nero's coins ("address of the Augustus" vs. "address of/to the (Praetorian) cohorts"). The change may have been made to emphasize the new emperor, for it was struck on the accession; Nero's coins were, in contrast, struck in ca. 63/64 to 67, well after Nero had ascended to power. Nerva's *sestertius* illustrates his presentation to the guard, which might also have been the occasion upon which he was acclaimed *imperator* by the soldiers and

four. Klawans 1977: 74 states that there is a Cavino imitation of a genuine *adlocutio* type for Nerva. Thanks are owed to Bernhard Woytek for his opinion on the type and for pointing out the collecting history. R C (for Regina Christina) is inked on the reverse of the coin above the figure of Nerva; the coin comes from the collection of Queen Christina of Sweden (1632–1654). Woytek is preparing a revised *RIC* for Nerva and Trajan and a volume on Nerva in the Moneta Imperii Romani series.

[12] *RIC²* I: (Gaius) nos. 32, 40, and 48, (Nero) 95–97, 130–136, 371, 429, 489–492, and 564–565, (Galba) 462–468.

[13] Strack 1930: 81 and Lummel 1991: 65 for the suggestion of the shrine to Mars. Merlin 1906a: 63 suggested the building housed the standards; he further speculated that the two attendants accompanying Nerva are the Praetorian prefects (followed by *BMCRE* III: xlvi). Mattingly (*BMCRE* III: xlvi, n. 1) refused to speculate as to the identity of the building and did not see a similarity between the building on Nero's and Nerva's coins.

when he promised or paid the donative.[14] Although the coin has been described as emblematic of an "attempt to pacify the Praetorians," there are no indications that Nerva lacked the support of the Praetorians or had much to fear from them until the events of the summer of 97, when he was openly disrespected by them as they besieged his palace, a year after these coins were produced.[15] Indeed, a plausible—but improvable—theory is that Nerva was initially selected emperor by the Praetorians and acclaimed emperor before the Senate had the opportunity to act.[16] The *adlocutio* type was used by previous emperors who had nothing to fear from the Praetorians at the time they were struck and the type would be used again by successive emperors, such as Trajan upon his accession in 98, Hadrian in 134 to 138, Lucius Verus in 163, and Marcus Aurelius in 169–170.[17] Nerva's use of the *adlocutio* type was thus wholly traditional and appropriate. The absolute rarity of the type may suggest it was not struck for widespread circulation and was, perhaps, given to the Praetorians as a token part of their donative or to commemorate that event or their acclamation of Nerva. There is no direct evidence that the *sestertii* would be given as a donatives, and certainly the lion's share of the payment would have been made in gold or silver, but sometimes rare Flavian and Trajanic *sestertii* are found in frames indicating that they were presentation pieces and other rare *sestertii* may have been distributed at special events.[18]

Nerva's reign also produced gold and silver *quinarii* bearing on their reverses an image of Victory advancing toward the right, holding a wreath and palm (Figure 1.3), or seated toward the left, also holding a wreath and palm (Figure 1.4); both reverse types are accompanied by the legend VICTORIA AVGVST(I).[19] They were included in his first emission upon his accession, the third emission of January 97, and his final emission of January 98 (appendices 1 and 2). Nerva's three groups of *quinarii* coincide with his accession and his assumption of new consular titles: COS

[14] Cf. Merlin 1906a: 64–65; *BMCRE* III: xlvi; Seelentag 2004: 86.
[15] Shotter 1978a: 164 for the interpretation of an attempt to pacify the Praetorians. See also Belloni 1974: 1069–1071.
[16] Harvey 2002: 49–50, and, most importantly, see Collins 2009.
[17] *RIC* II: (Trajan) nos. 22 and 106, (Hadrian) nos. 908–911, and *RIC* III: (Marcus Aurelius and Lucius Verus) nos. 973, 1359, and 1491. On the Trajanic types, see also Woytek 2010: 1:200, no. 11, and 212, no. 43. Salamone 2004: 23–35 discusses *adlocutio* types.
[18] On some framed Domitianic *sestertii* representing a temple complex, probably the Templum Gentis Flaviae, see Mittag 2010: 38–40 and 135, no. 13; Elkins 2015: 84–85. On rare Flavian and Trajanic *sestertii* potentially distributed on special occasions, see Elkins 2006; Marzano 2009.
[19] *RIC* II: nos. 10, 21, 22, 45, and 46. The *quinarii*, as other coins, do not have descriptive legends in the emission of 98.

FIGURE 1.3 Silver *quinarius* of Nerva from January 98 with the VICTORIA AVGVST(I) reverse type depicting Victoria advancing with wreath and palm. Imperial titles replace the descriptive legend on this coin as it comes from the sixth emission. (© Bibliothèque nationale de France.)

FIGURE 1.4 Silver *quinarius* of Nerva from January 97 with the VICTORIA AVGVST(I) reverse type depicting Victoria seated with wreath and palm. (© Bibliothèque nationale de France.)

II in September 96, COS III in January 97, and COS IIII in January 98.[20] Often the image of Victory on the *quinarii* is characterized as indicative of Nerva's desperation to capitalize on military victories, or to flatter the army, in view of his own lack of military distinction and weak position.[21] Insistence on these apologetic interpretations overlooks the fact that war was already underway in Pannonia at the time of Domitian's death

[20] King 2007: 105.
[21] Merlin 1906a: 15–17; Shotter 1978a: 165; 1983: 224; Grainger 2003: 89. Grainger 2003: 135, n. 13, further speculates that Victory may signify hoped-for military successes or the Senate's defeat of Domitian.

and Nerva's accession and that news of victories in the north was delivered to Nerva in a "laureled letter" in the fall of 97 (Pliny, *Panegyricus* 8.2). Additionally, the prevailing view that the coins reflected a need to exploit recent military victories for political gain or to flatter the legions is informed more by the historical understanding of Nerva as an insecure emperor than with the realities governing the selection of coin types. Negativistic interpretations of Nerva's coinage extrapolate too heavily from the events of the summer of 97 and presume imperial agency in the selection of coin types.

First and foremost, the *quinarii* played only a marginal role in Nerva's imperial ideology since they are exceedingly rare, as are most imperial *quinarii* produced after Augustus. In fact, none were recorded among the hoards and site finds consulted in this study. Their great rarity may be accounted for by the increasing disbursement of military pay in brass and copper coins rather than in silver after the time of Augustus, and the preference for the *denarius* as the standard silver denomination in the imperial period.[22] Gold *quinarii* are rarer than Nerva's *aurei*, which are virtually absent from finds as *aurei* of Domitian, Nerva, and early in Trajan's reign are very heavy and were quickly driven out of circulation by *aurei* containing less gold.[23] Furthermore, the figure of Victory had been the dominant and standard figure on Roman imperial *quinarii* since the principate of Augustus and need not refer to specific victories. The images of Victory on Nerva's *quinarii* were thus conventional, traditional, and wholly appropriate for the denomination; their production upon his accession and upon the assumption of new consular titles is mirrored in the preceding Flavian use of the denomination and iconographic type (Figure 1.5 illustrates the same seated Victory on a silver *quinarius* of Domitian).[24] The types generically referred to Nerva's role as *imperator* and supreme military commander, to whom all victories were ascribed even when he himself did not take the field of battle.[25] An equestrian bronze statue from the shrine of the Augustales at Misenum originally depicted Domitian on horseback, holding a spear and dressed in a cuirass and *paludamentum* (military cloak). The sculpture was excavated near statues of the Deified Vespasian and Titus and was probably displayed with that group.[26] After Domitian's death, the face of the statue was cut off and replaced with a bronze mask with the features of Nerva (Figure 1.6).

[22] King 2007: 82.
[23] Duncan-Jones 1994: 83, n. 49.
[24] King 2007: 90–96 and 123.
[25] *BMCRE* III: xxxiv.
[26] Varner 2004: 120–122. On the statue more generally, see Borriello et al. 1987.

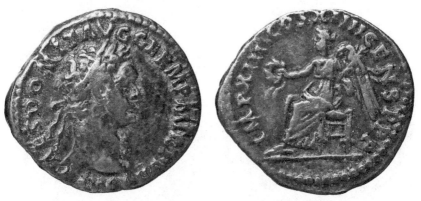

FIGURE 1.5 Silver *quinarius* of Domitian from 88 with the seated Victory reverse type. (© Bibliothèque nationale de France.)

FIGURE 1.6 Equestrian bronze statue of Domitian from ca. 95 with the face later replaced with the features of Nerva. Museo Archeologico dei Campi Flegrei, Baia. Photo: Author.

The breastplate, unaltered under Nerva, is adorned with the infant Hercules strangling snakes, vegetal patterns, sea life, and Minerva's *aegis*; the decoration symbolized Domitian's maritime and terrestrial dominion and potentially foreshadowed a campaign against Parthia. On account of the position of the statue's arm, suggesting a hunting spear rather than one used for

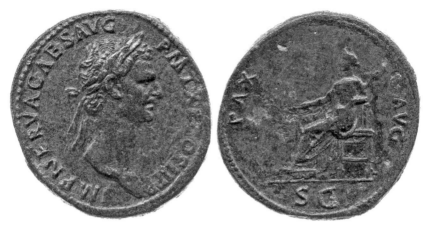

FIGURE 1.7 *Sestertius* of Nerva from September 96 with the PAX AVG(VSTI) reverse type. (© Trustees of the British Museum.)

battle, the recoiling horse, and the senatorial footwear of the rider, it has been cogently demonstrated that the equestrian bronze statue depicted the emperor in a hunt rather than in battle.[27] Nonetheless, the armor emphasizes the emperor's role as *imperator* and the act of hunting was a display of *virtus* not dissimilar to valor on the battlefield.[28]

A concept intrinsically related to *victoria* in Roman thought is *pax*. Peace is what follows successful military expeditions and preemptive conquests. The Augustan Peace, for example, was won only after much bloodshed and Roman military success. In art, Pax typically holds her main attribute: an olive branch. Sometimes she is accompanied by other implements as well such as a *caduceus* or a scepter.[29] During the imperial period, Pax was related to Concordia and Securitas, both of whom signified peace and stability in the realm of government. Pax appeared on *sestertii* in each of Nerva's emissions except for the small fifth emission of December 97. On the *sestertii* she is seated and holds an olive branch and scepter with the legend PAX AVG(VSTI) (Figure 1.7); this representation of Pax with these attributes resembles Concordia on the coinage of Galba.[30] Scholars

[27] Tuck 2005.

[28] Wolters and Ziegert 2014: 70 note that Nerva's coin portraiture does not show him in the guise of a military general, as Domitian's coins do during and after his campaigns in Germania. On the other hand, Nerva ruled for only sixteen months and so the lack of military portraiture on the coinage may be incidental rather than deliberate.

[29] On the iconography and meanings of Pax, see *LIMC* VII.1, 1994: 204–212, s.v. Pax (Simon); Schmidt-Dick 2002: 82–86; Noreña 2011a: 127–132. Salamone 2004: 117–120 treats Pax specifically in a military context.

[30] Schmidt-Dick 2002: 86. For Nerva's type, see *RIC* II: nos. 66, 88, 102, and 107.

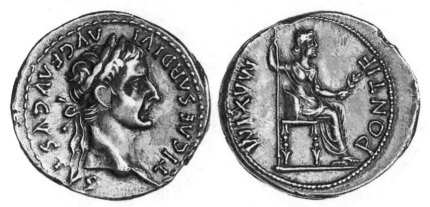

FIGURE 1.8 *Denarius* of Tiberius from 14 to 37 with the Pax-Livia reverse type. (Courtesy of the American Numismatic Society, 1935.117.357.)

often read Pax on Nerva's coinage in conjunction with the perceived military anxieties at the onset of his reign. For example, Merlin claimed they expressed hope that the empire would not be plunged into civil war once again; Shotter suggests they promised peace with the Praetorian Guard; and Grainger understands them as aspirational.[31] Mattingly felt they referred to the good relationship between Nerva and the Senate while Strack stated they indicated peace between Nerva and the Roman people.[32] The use of Pax on Nerva's coinage is, however, traditional when viewed in the context of her appearance on the coinage of previous emperors.

Some of the most common *denarii* of the first century AD are the undated *denarii* of Tiberius, struck between 14 and 37, that depict a female figure holding an olive branch and a scepter.[33] The figure is clearly Pax on account of her attributes and is usually interpreted as Livia in the guise of Pax (Figure 1.8). In the reign of Claudius, Pax-Nemesis advancing with a winged *caduceus* pointed down at a snake appeared with the legend PACI AVGVSTAE on *aurei* and *denarii* of his first emission and thereafter (Figure 1.9).[34] Pax continued to feature on the coins of the civil wars and she was depicted standing holding an olive branch and cornucopiae with the legend PAX AVGVSTI on the base-metal coinage of Vespasian at Rome from January 70 to 79.[35] When Titus became emperor after his

[31] Merlin 1906a: 48–49; Shotter 1983: 224; Grainger 2003: 47.

[32] *BMCRE* III: xlviii; Strack 1930: 54–55.

[33] *RIC²* I: nos. 25–30. The type also appeared on *aurei*.

[34] *RIC²* I: nos. 9–10, 21–22, 27–28, 38–39, 46–47, 51–52, 57–58, and 61–62.

[35] *RIC²* II.1: nos. 12, 31, 34, 53, 96–100, 135, 181–186, 242–243, 273–276, 311–312, 378–379, 393, 423–424, 458, 496, 575, 607, 651–652, 712, 737, 747, 770, 782, 814, 819, 827, 831, 880–883,

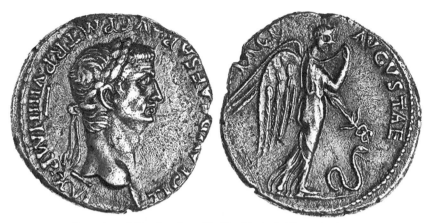

FIGURE 1.9 *Denarius* of Claudius from 49–50 with the PACI AVGVSTAE reverse type. (Courtesy of the American Numismatic Society, 2000.5.6.)

father's death, *asses* depicted the same image and legends that appeared on Vespasian's coins.[36] An image of Pax seated to the left with the olive branch and scepter, which is virtually identical to the image on Nerva's *sestertii*, features on Vespasian's *aurei* of 75 in conjunction with his obverse portrait or that of Titus Caesar (Figure 1.10).[37] Early in Domitian's principate, types were struck showing Pax holding a branch and *caduceus* while leaning against a column and Pax holding cornucopiae with the legend PACI AVGVSTAE and setting fire to arms, both of which also imitated coins of Vespasian and Titus.[38] Pax often graced the reverses of coins when a new emperor came to power in order to indicate a peaceful transition of power from emperor to emperor.[39] Even in transitions of power that involved no significant tumult or violence (i.e., from Augustus to Tiberius, Vespasian to Titus, and Titus to Domitian), Pax finds her place on the coinage. An image of Pax identical to the one on Nerva's *sestertii* also appeared on *aurei, denarii*, and *sestertii* of Trajan in his first emission to mark that peaceful transition of power (Figure 1.11).[40] To interpret the presence of Pax on Nerva's coinage as "aspirational" or reflective somehow of anxiety

907, 924–925, 992–993, 1042, and 1098. Legends vary slightly. Pax also appears in other forms and with other legends, but these most closely match Pax and the legend on Nerva's coinage.

[36] *RIC²* II.1: nos. 58–59, 62, 134, 154–158, 199–201, 229–234, 275, 288–291, 370, 377, 498, and 507–508.

[37] *RIC²* II.1: nos. 770–771 and 782.

[38] *RIC²* II.1: nos. 86, 276, 354, and 837.

[39] This is also the interpretation of the PACI AVGVSTAE coins of Claudius in conjunction with other coins of the same emission; see von Kaenel 1986: 234–235.

[40] *RIC* II: nos. 30 and 384; Woytek 2010: 1:198–199, nos. 6–9.

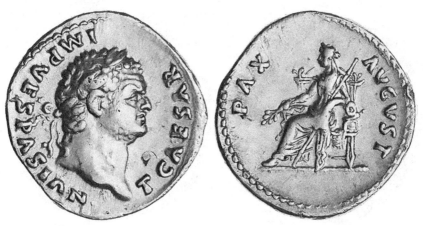

FIGURE 1.10 *Aureus* of Vespasian for Titus Caesar from 75 with the PAX AVGVST(I) reverse type. (Courtesy of the American Numismatic Society, 1967.153.127.)

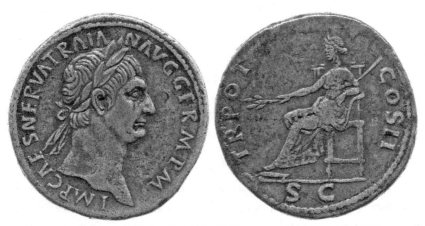

FIGURE 1.11 *Sestertius* of Trajan from 98 with Pax seated on the reverse. (© Trustees of the British Museum.)

between the emperor and the armed forces overlooks the context of her traditional pattern of representation in the first century as a new emperor rose to power and would necessitate a similar reading of her image on the coinage of Trajan as well.

The PAX AVG(VSTI) *sestertii* of Nerva are also very rare and thus probably played a minor role in the visual expression of imperial ideology and contemporary political rhetoric. Out of 297 *sestertii* of Nerva from finds recorded across Western Europe, only twelve (about 4 percent) bear the reverse type (appendix 4). The sample size is too small to come to any meaningful conclusions as to whether or not the image was targeted at any

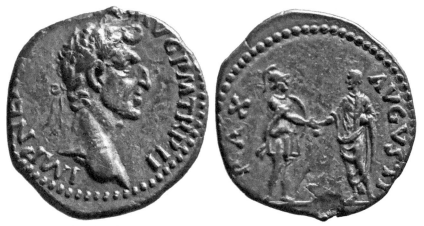

FIGURE 1.12 Modern forgery and invention of a *denarius* type of Nerva from September 97 with the PAX AVGVSTI reverse type. (Münzkabinett, Kunsthistorisches Museum, Vienna.)

particular audience, but Hobley's work suggests the type might have been more prominent in the center of imperial power, Italy, where four specimens are recorded versus his count of one from Raetia, three from Gaul, and one from Upper Germany.[41] Again Hobley's sample size is too small to be definitive and he relied heavily on museum collections for data from Italy; this, of course, creates a potential bias in favor of rarer types and the collections may or may not reflect what is found locally.

The theme of peace is present on two unique and strange *denarii* attributed to Nerva's fourth emission (September 97). Of the 121 *denarii* from Nerva's fourth emission recorded in hoards and finds in this study, none are present (appendix 3). In his second edition, Cohen described a specimen from the 1864 Gosselin Sale and one in the Münzkabinett of the Kunsthistorisches Museum in Vienna; the Gosselin specimen is no longer extant. The Vienna specimen carries the legend PAX AVGVSTI and depicts Nerva clasping hands with a "soldier" or, perhaps, Mars; the obverse depicts Nerva's laureate portrait with the legend IMP NE[RVA CAES A]VG P M TR P II (Figure 1.12).[42] In spite of the peculiarities of

[41] Hobley 1998: 35–36.

[42] *RIC* II: no. 32, based on a description by Cohen 1882: 11, nos. 125–126. No. 125 (Gosselin) is evidently described incorrectly with the reverse legend PAX AVGVST. The coin is illustrated in *BMCRE* III: pl. 9, no. 16. Cohen's description of the Vienna specimen (no. 126) incorrectly relates the obverse description as IMP NERVA CAES AVG P M TR P II COS III P P, which is not reflected on the illustration of the coin in *BMCRE*, and in Figure 1.12 in this book, where there shorter legend is evident.

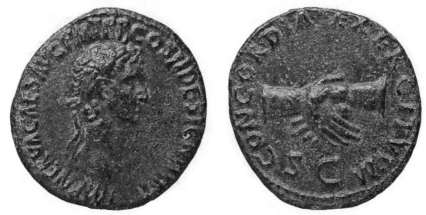

FIGURE 1.13 *As* of Nerva from December 96 with the CONCORDIA EXERCITVVM reverse type. (© Bibliothèque nationale de France.)

the coin, the type is often considered to be legitimate and scholars have interpreted the helmeted figure as Trajan himself, although this is doubtful, as it was unconventional to depict the emperor or his princes in a helmet in the first and second centuries.[43] The type is often linked with the adoption of Trajan and Nerva's need to consummate the approval of the military faction.[44] Nevertheless, the PAX AVGVSTI type must be dismissed altogether as a modern forgery. The obverse legend is highly irregular in its indication of a tribunician date without a consular date on either the obverse or reverse. Furthermore, apart from Nerva's aquiline nose, the obverse portrait is stylistically unusual.[45]

More common and widely disseminated coin images that championed the armed forces are the CONCORDIA EXERCITVVM types, which appeared throughout Nerva's reign in two varieties.[46] The first variety depicts two joined right hands, the *dextrarum iunctio*, which in Roman art signifies marriage, partnership, *concordia*, or *fides* (Figure 1.13).[47] The legend CONCORDIA EXERCITVVM ("harmony of the armies") explicitly denotes the meaning of the iconography. The second variety depicts

[43] *BMCRE* III: xliii, *contra* Cavedoni 1855: 43; Merlin 1906a: 88–91.

[44] *BMCRE* III: xliii; Shotter 1978a: 165; 1983: 225.

[45] Szaivert 1978: 76 condemned the Vienna specimen as a modern forgery. Thanks are due to Ted Buttrey who checked the Gosselin Sale entry and who volunteered his thoughts on the highly irregular and suspect type. Klaus Vondrovec at the Kunsthistoriches Museum in Vienna kindly provided a photograph of the coin, which is located in their cabinet of forgeries, and agrees it must be a modern forgery.

[46] Variety 1: *RIC* II: nos. 2, 14, 26, 48 53, 69, 79, and 95. Variety 2: *RIC* II: nos. 3, 14, 27, 49, 54–55, 70, 80–81, 96–97, and 108.

[47] *EAA* III, 1960: 82–85, s.v. Dextrarum Iunctio (Reekmans).

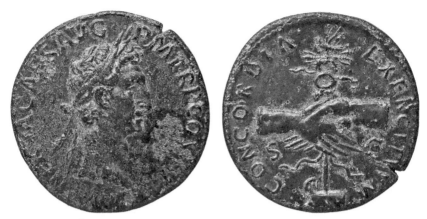

FIGURE 1.14 *Sestertius* of Nerva from January 97 with the CONCORDIA EXERCITVVM reverse type with the addition of the legionary eagle and prow. (© Bibliothèque nationale de France.)

the same image and legend, but with the addition of a military standard, specifically a legionary eagle or *aquila*, surmounting the prow of a ship, behind the clasped hands (Figure 1.14). In Nerva's accession emission, both types appeared on *aurei* and *denarii*, while the type without the standard and prow was borne also on *asses* and the type with standard and prow was also deployed on *sestertii, dupondii*, and *asses*. The message of military accord appears to have been a significant component of political rhetoric throughout Nerva's reign as the theme, in either variety, appears on coins in every subsequent emission, save Nerva's fifth.[48] In finds and hoards, the variety with the standard and prow is more common on first-emission *denarii* in the Reka Devnia Hoard and in site finds, although the variety without them is more frequent on *denarii* in later emissions (appendix 3). *Sestertii* and *dupondii* exclusively depicted the *dextrarum iunctio* in conjunction with the standard and prow while *asses* hosted both varieties and they more frequently bear the variant without the standard and prow. One should not read too much into the variants as the legend accompanying both designs clearly conveys the meaning; the addition of

[48] In the second emission (December 96), the first variety appears on *asses* and the second on *sestertii*. The dissemination of the iconography on the various denominations in the third emission (January 97) mirrors that of the first emission. The fourth emission (September 97) is also very similar to the first, although in the fourth emission the first type does not appear on *aurei* and the second does not appear on *asses*. The type does not appear in the fifth emission (December 97). In the sixth emission (January 98), the descriptive legend is replaced with the emperor's titles. In this final emission, the first type appears only on *denarii*, while the second was used on *aurei, denarii*, and *sestertii* (appendices 1 and 2).

the standard and the prow simply sharpened the meaning. Variants without the standard and prow are an abbreviation of the theme as indicated by their greater frequency toward the end of Nerva's reign and their predominance on the smallest base-metal denomination, the *as*. After the first emission, in which the type with the standard and prow is more prominent, these details may have become less prominent as viewers had become familiar with the type. *Sestertii* continued to bear the standard and prow as this denomination offered the die engraver a much broader canvas (approximately 35 mm in diameter) for detailed imagery than *denarii* (approximately 18 mm) and *asses* (approximately 27 mm). Although *dupondii* are of approximately the same diameter (28 mm) as *asses, dupondii* too tended to attract more detailed representations than the *asses*. Overall, the imagery was quite common on Nerva's imperial coinage, making up on average one-third of the reverse types on his *denarii* in the large first emission and about 21 percent on average in the third emission of January 97; it is the most common image on Nerva's *denarii* (appendix 3, part 7). On base-metal coinage, the type accounts for 7.19 percent of all *sestertii*, 11.38 percent of *dupondii*, and 20.19 percent of *asses* (appendix 4). This puts the type in third place in terms of frequency on *sestertii* and *dupondii*, and in fourth place on *asses*.

Provincial didrachms of Caesarea in Cappadocia struck under Nerva that depict the *dextrarum iunctio* on the standard and prow, replicating the contemporary types from Rome, highlight how influential that imagery was. The Greek legend on these coins, OMON CTPAT, also conveys the same idea as the Latin legend on the imperial coins. Some coins of Caesarea at this time also bear images of Fortuna (Tyche) and Libertas (Eleutheria) that mirrored their representation on the contemporary imperial coinage struck at Rome, while other types of Caesarea depict traditional local images such as Mt. Argaeus or a club. This differentiation between "Roman-style" didrachms and "local-style" didrachms suggests that the imperial mint at Rome produced some coins intended for circulation in Cappadocia.[49] *Cistophori*, which bear an *aquila* between two

[49] Metcalf 1996: 85, n. 2; *RPC* III: 376 and 798–799. For the types in question, see *RPC* III: 380–381, nos. 2960, 2966, and 2971. Metallurgical analysis proves that that "Roman-style" and "local-style" didrachms of Caesarea under Vespasian were struck respectively at Rome and Caesarea (Butcher and Ponting 1995). Although there is confirmation on metallurgical grounds under Vespasian, scientific analysis cannot confirm the place of minting for "Roman-style" didrachms under Domitian and Nerva; "Roman-style" didrachms under Trajan were struck at Rome for Caesarea (Butcher and Ponting 2014: 524–539). There is a very small sample size for Nerva's Caesarean didrachms and, seeing little stylistic differentiation themselves, Butcher and Ponting suggest Nerva's didrachms were all struck locally at Caesarea (535).

standards, were struck at Rome for circulation in Asia under Nerva. This design and others on the *cistophori* repeat, however, earlier first-century images that appeared on the *cistophori* and do not reflect the influence of Nerva's imperial coinage.[50]

Types similar to Nerva's CONCORDIA EXERCITVVM types with the clasped hands had appeared during the civil wars of 68–69 and bore the legend FIDES EXERCITVVM, "fidelity of the armies."[51] These were akin to coins struck in Spain and Gaul in the civil war that had the legend PAX or PACI P(OPVLI) R(OMANI) accompanying the *dextrarum iunctio* superimposed on a winged *caduceus*, which was sometimes depicted with grain stalks, poppies, or cornucopiae.[52] Coins of Vitellius struck at Rome repeated some of the civil war types with the joined right hands and the legend FIDES EXERCITVVM or FIDES PRAETORIANVM.[53] Bronze coins of Vespasian from Rome in 71 depicted the *dextrarum iunctio* with the standard and prow in the background and the legend FIDES EXERCITVVM (Figure 1.15) while a similar type depicted the winged *caduceus* with grain stalks superimposed by the hands and surrounded by the legend FIDES PVBLICA; the FIDES PVBLICA types continued through 73.[54] The FIDES PVBLICA types also resurfaced on *asses* of Titus, and the *dextrarum iunctio* on the standard and prow with the legend PRINCEPS IVVENTVTIS appeared on coins of Titus struck in the name of Domitian Caesar.[55] FIDES PVBLICA types with the *caduceus* and cornucopiae or grain stalks and poppies symbolized commercial and agricultural prosperity, while the military types no doubt projected a united front in the civil wars and after Vespasian's establishment of the Flavian dynasty.[56] The types from the civil wars hearkened back to republican prototypes depicting the *dextrarum iunctio* as an emblem of peace and harmony. Decimus Junius Brutus Albinus struck *denarii* in 48 BC bearing the head of Pietas on the obverse with the clasped hands over the winged *caduceus* on the reverse, which signified Caesar's rhetoric of reconciliation and

[50] For the type, see *RPC* III: 161, nos. 1298 and 1304. On the production of Nerva's *cistophori* at Rome, see Woytek 2008b, tentatively followed by Butcher and Ponting 2014: 479–482, on metallurgical grounds.

[51] *RIC* I: (Group IV: Military) nos. 118–22. Group V coins from the Gallic revolt (no. 131) simply have FIDES with the *dextrarum iunctio*.

[52] *RIC* I: (Group I: Spain) nos. 2, 4–7, 10, 22, and 34; (Group III: Spain and Gaul) nos. 103, 113–115.

[53] *RIC*² I: nos. 47, 52–55, and 67.

[54] *RIC*² II.1: nos. 7072, 156, 220, 300, 402, 444, 484, 507, 520, 528, 571, and 625;

[55] *RIC*² II.1: nos. 96, 224, and 382.

[56] *BMCRE* I: cxcvi, cxcix–cc; *BMCRE* II: xxxv–xxvi.

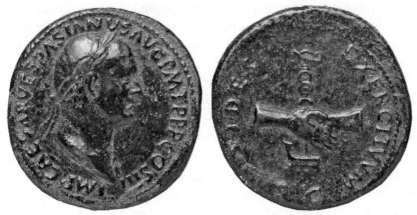

FIGURE 1.15 *Sestertius* of Vespasian from 71 with the FIDES EXERCITVVM reverse type. (© Bibliothèque nationale de France.)

concordia in the civil war between Caesar and Pompey.[57] *Quinarii* of the Caesarian moneyer Lucius Aemilius Buca in 44 BC similarly depicted the *dextrarum iunctio* on the reverse and Pax on the obverse to reflect the rhetoric of the harmony and peace that Caesar had brought about.[58] In 42 BC, Caius Vibius Varus, striking for the *triumviri*, minted *aurei* with portraits of Mark Antony, Octavian, or Lepidus on the obverse with clasped hands signifying *concordia* among the governing partners on the reverse.[59] And in 39 BC, *quinarii* from a mint that moved with Octavian bore a head of Concordia on the obverse and the clasped hands upon a winged *caduceus* on the reverse, which again suggested peace and harmony between Antony and Octavian Caesar, as the reverses bore both the names of Antony and Caesar.[60]

Mattingly described Nerva's CONCORDIA EXERCITVVM coins as striking a "dangerously apologetic note" and as a "comment on the fierce discontent of the guard."[61] Sutherland interpreted them as an appeal for military loyalty.[62] Griffin sees them as "wishful thinking" and Brennan interprets the type's legend as "frantic sloganeering."[63] Grainger

[57] Crawford 1974: 1:466, no. 450/2. See also Liegle 1935: 78 and Gelzer 1968: 201. The reverse type also appears on a *denarius* struck jointly by Decimus Junius Brutus Albinus and Caius Vibius Pansa in the same year; the reverse carries Brutus's name while the obverse bears that of the second moneyer and a head of Pan, a pun on the moneyer's name (Crawford 1974: 1:467, no. 451/1).

[58] Crawford 1974: 1:491, no. 494/24.

[59] Crawford 1974: 1:504, nos. 494/10–12 and 510.

[60] Crawford 1974: 1:532, nos. 529/4a–b.

[61] *BMCRE* III: xxxvii; Mattingly 1977: 154.

[62] Sutherland 1974: 207.

[63] Brennan 2000: 63; Griffin 2000: 90.

understands them as part "hope" and part "gratitude," once it seemed that the armies would not contest his rule.[64] Shotter suggests that the two varieties appealed to different sections of the armed forces; the type with the standard (and prow, which is not mentioned) referred to the Praetorians and the type without the standard and prow referred to the legions.[65] There is no reason to believe the two varieties were directed at different audiences on iconographic grounds. Nothing about the standard and prow makes it more appropriate to the Praetorians than to the legions or vice versa. The inclusion of the standard and prow simply added visual definition to the imagery by putting the *dextrarum iunctio* in an explicitly martial context, especially for those viewers who could not have read the legend that communicated the same message. Others have ubiquitously interpreted the imagery as directed at a military audience and, more specifically, communicating the aspirational harmonious relationship between Nerva and the armed forces.[66] Again, the historical perception of Nerva as a largely impotent personality as regards military affairs has unduly affected the interpretation of a medium of state-sanctioned art. In the realm of Roman imperial portraiture, the search for the "maniacal Caligula," the "cruel Caracalla," or the "scheming, wicked" Julia Domna has been similarly influenced by the intrinsically biased historical sources, written after an emperor's death, and has misled some historians and art historians.[67] Just as state-sanctioned portraiture would not have represented the living emperor in any other way than in a dignified and stately manner—if not exalted—so too did the coinage, another form of state-sanctioned art. The coins would not have projected any weakness in Nerva's political position, nor would they have drawn attention to any vulnerabilities.

Based on the similarity of the CONCORDIA EXERCITVVM types to earlier coins, the great frequency of Nerva's types, and their wide circulation in Rome, Italy, and the provinces (in cities, civilian settlements, and at military sites), the notion that iconography was aspirational, hopeful,

[64] Grainger 2003: 47.

[65] Shotter 1978a: 165; 1983: 223–224.

[66] See also Merlin 1906a: 43–48; *RIC* II: 221; Hannestad 1988: 145; Brennan 2000: 45; Berriman and Todd 2001: 315; Seelentag 2004: 44 and 125. Cf. Bennett 2001: 37, who sees the coins as communicating appeasement after the donative. Belloni 1974: 1071–1072 reads the coins as a propaganda campaign directed at armies and their commanders.

[67] For some recent critiques of the approach in which the psychology or character of an emperor, as relayed by ancient sources, is sought in portrait sculpture, see Davies 2012: 321–327. The popular Roman art textbook Ramage and Ramage 2009: 286 states that Julia Domna's "scheming, wicked personality" is evident in both the Severan family portrait from the Fayum and the marble bust at the Indiana University Art Museum; for an important corrective on Domna's portraiture, see Rowan 2011b.

or pleading a case to the armed forces must be abandoned. The work of Kemmers has indicated that bronze coinage supplied to the legionaries at Nijmegen in the Flavian period and in other areas on the frontier in subsequent periods had a much greater proportion of martially themed images than coins from nearby civilian settlements or from Rome.[68] But the evidence for the targeting of Nerva's CONCORDIA EXERCITVVM coins at frontier installations is lacking. From the Rome finds, there are only twelve *sestertii*, none of which are CONCORDIA EXERCITVVM types. Three *sestertii* from nineteen (16 percent) in the militarized area of Mainz and the Taunus-Wetterau *limes* are CONCORDIA EXERCITVVM types, while there is one from among the six *sestertii* (16 percent) at the fortress at Nijmegen and ten in the 145 *sestertii* (7 percent) from the Garonne Hoard.[69] Nony suggested that only a small number of CONCORDIA EXERCITVVM *sestertii* were found in the Garonne Hoard because the province of Aquitania had been long pacified and thus the martial images would not be expected here as they would be on the frontier.[70] At first glance the assumption would seem to be confirmed by the absence of these *sestertii* in the Rome finds and the presence of three from the militarized area of Mainz and the Taunus-Wetterau *limes* system and one from Nijmegen. But these samples of *sestertii*, with the exception of the Garonne Hoard, are too small to draw bold conclusions. The *dupondii*, in fact, paint a different picture: at Rome there are none of this type (but there also only six *dupondii* in total), in Mainz and the Taunus-Wetterau *limes* there are seven out of twenty-two *dupondii* (32 percent), one out of thirteen (18 percent) from Nijmegen, and three out of thirteen (23 percent) in the Garonne Hoard. Here again, most samples are rather small, although the type makes up nearly a quarter of the *dupondii* from the hoard in the pacified province of Aquitania. The *asses*, for which there are much larger samples, suggest the iconography was directed at audiences along the frontier and in settled territories deep behind the empire's frontier, including Rome and Italy. Fourteen of the forty-two *asses* (34 percent) from Rome are of the CONCORDIA EXERCITVVM type. In the area of Mainz and the Taunus-Wetterau *limes* nineteen out of ninety-six (20 percent) are of the same type and there are five out of thirty-three (15 percent) at Carnuntum.[71] The

[68] Kemmers 2006: 189–244; 2014.
[69] For the Rome finds, see discussion in chapter 2. For the Mainz and Taunus-Wetterau *limes*, see the lists in *FMRD* IV.1; IV.1.N1; V.1.1; V.1.2; V.2.1; V.2.2. For Nijmegen, see Kemmers 2006: 109. For the Garonne Hoard, see Étienne and Rachet 1984: 91–102.
[70] Nony 1987: 56.
[71] For Carnuntum, data derived from *FMRÖ* III.1.

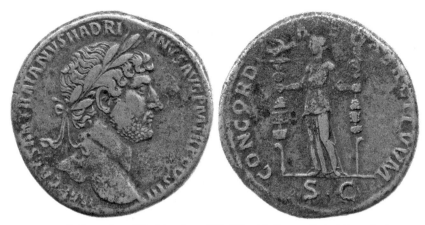

FIGURE 1.16 *Sestertius* of Hadrian from 119–121 with Concordia holding a legionary eagle and standard with the legend CONCORDIA EXERCITVVM. (© Trustees of the British Museum.)

text and imagery of these coins were thus consumed by diverse viewers across the Roman Empire and so it was not a desperate plea directed at the soldiery. Even in times of relative peace and stability, as under Hadrian and Antoninus Pius, CONCORDIA EXERCITVVM was championed on the coinage where Concordia is depicted holding a legionary eagle and a standard surrounded by the legend (Figure 1.16).[72]

Immediately upon his accession, when his first CONCORDIA EXERCITVVM types were struck, Nerva perhaps had little immediate fear of military rebellion, although his administration would naturally want to build a relationship with the legions and their commanders. Initially, Nerva may have ensured the allegiance of the Praetorian Guard through the customary payment of a donative upon his accession and the appointment of a new commander. Recent research indeed suggests that the plot against Domitian was highly organized and necessitated the agreement of multiple factions before its execution.[73] The Praetorians may have acclaimed Nerva emperor before the Senate was able to act; this is, of

[72] On the CONCORDIA PRAETORIANVM types of Vitellius, Levick 1999a: 46–47, observes the coins are not necessarily propaganda, which would have necessitated their circulation among the praetorians (improbable since they were struck in southern Gaul), but "flattered Vitellius with the idea that he had or would have the praetorians with him." Similarly, Noreña 2011a: 133, suggests that similar types on the coins of Vitellius and Vespasian need not be seen as a "desperate plea" and points to the appearance of the theme of CONCORDIA EXERCITVVM on coins struck during the very stable period of Antoninus Pius's principate. For the types, *RIC* II: (Hadrian) nos. 581a–e; *RIC* III: (Antoninus Pius) nos. 600, 657, and 678.

[73] Bennett 2001: 33–34 argues that multiple factions were involved in the organized coup against Domitian. Murison 2003 explores Nerva's relationship with the Flavians and argues that, while

course, unattested in the historical sources and unable to be confirmed, but the Praetorians had acclaimed Claudius, Nero, and Domitian before the Senate formally recognized them (Suetonius, *Divus Claudius* 10; Tacitus, *Annales* 12.69; Dio 66.26.3).[74] It was a year after Nerva's accession when his vulnerability to armed rebellion would have become painfully apparent as his Praetorian Guard surrounded his palace and forced him to deliver up those conspirators who had a hand in Domitian's murder. Even though the historical sources testify to anger and discontent among the general soldiery at the news of Domitian's death, an immediate insurrection by the legions stationed along the frontier would have been wholly impractical.[75] The conspirators would have known this, if indeed they had not sought the complicity of certain provincial governors and military commanders before the plot was carried out. The biggest armed force, and potentially the greatest threat to Nerva, was the (at least) five legions under the command of Pompeius Longinus. These legions were engaged in an active campaign beyond the Roman frontier. Had Pompeius Longinus and his men chosen to withdraw to exact revenge on behalf of the dead emperor and to challenge Nerva, he would have made his armies vulnerable to attack as they pulled out. Additionally, it would have been an unwise tactical move, for the withdrawal from active warfare and from the frontier would have allowed the enemy to invade Roman territory and retaliate for the Roman incursion; the preoccupation of the various military factions in civil wars of 68–69 had allowed incursions into Roman territory along the frontier. And if other commanders and their armies stationed along the frontier, but not actively waging war in Pannonia, had marched on Rome, they would have cut off supply and support to the legions under Pompeius Longinus, significantly compromising the war effort and endangering the safety of tens of thousands of fellow soldiers. Although Nerva lacked the respect of the common soldiery, according to the ancient sources, there was no immediate and practical threat to his power in the short term. Nerva's appointment of the loyal Trajan to the governorship of Upper Germany in the fall of 96 and later his adoption as Nerva's son and heir were active steps taken to secure his own position and the stability and continuity of the Roman government.

Nerva was the Senate's choice and knew of the plot to assassinate Domitian, he was not a conspirator; he was chosen because of his political experience and counsel to the Flavian emperors.

[74] Collins 2009: esp. 99–101. See also Harvey 2002: 49–50.
[75] On the problems with an immediate rebellion by the provincial armies, see Grainger 2003: 25 and 31–37, with further references.

Instead of reading the CONCORDIA EXERCITVVM types of Nerva as expressing an aspirational relationship with the army or pleading a case to the soldiers for acquiescence to the new regime, they must be understood as communicating with everyone—not just the armies—as touting the rhetoric of the military stability of the Roman Empire. The presence of the standard and prow on some of the coins may further bolster this interpretation. By the inclusion of the legionary *aquila* and the prow of a ship, upon which the clasped hands are superimposed, the viewer is prompted to see concord among the various military factions, such as the terrestrial armies and navy, not just between the emperor and armed forces. The prominence of the CONCORDIA EXERCITVVM type on the mobile silver coinage and the wide circulation of the *asses* bearing the message confirm the breadth of the audience. Certainly many of the empire's inhabitants would have remembered the events of 68–69 and the bloody and chaotic civil wars. Nerva's CONCORDIA EXERCITVVM coins proclaimed harmony between the military factions, some of which were actively engaged in warfare along the frontier, and the stability of Nerva's principate: there would be no repeat of 68–69. So while the iconography of these coins is martial in its content, it was not an appeal to the armed forces (and neither was the image of Victory on the *quinarii*), a problematic interpretation that implies direct imperial agency, but a message of solidarity and stability directed at the entirety of the populace residing in the western Roman Empire.[76] If one views coin iconography more properly as a medium of art akin to poetry, panegyric, and honorary inscriptions or monuments, then what the coins reflect is contemporary rhetoric about the concord among the leaders of the armed forces engaged in active campaigns along the frontier.

Beginning in his fifth emission of precious-metal coinage (around December 97) and in his sixth and final emission of precious-metal and

[76] Brennan 2000: 63 suggests that the disappearance of the descriptive legend CONCORDIA EXERCITVVM from the coins in his sixth issue (January 98), and its replacement with the emperor's normal titulature, is an indicator that the military threat to Nerva's reign had passed with his adoption of Trajan. There are three objections. (1) As a great many people in the Roman Empire would have been illiterate, we may view the text as subsidiary to the iconography that may have been the more active and successful purveyor of communication. (2) Personifications and deities dominate the coinage at the end of Nerva's reign and most appeared very early in Nerva's reign with descriptive legends on the coinage; the legends on those coins were also replaced with imperial titulature. Any literate viewer would have already been familiar with the iconography, and probably also its intended meaning from those earlier coins. (3) As argued here, the CONCORDIA EXERCITVVM types with clasped hands, most often with martial symbols, did not connote Nerva's weak state and his need for military support, but rather the harmony between the various military factions.

base-metal coinage (January 98), all of Nerva's coins bear GERM(ANICVS) as part of the emperor's titulature. Nerva's assumption of the title Germanicus does not reflect, as has been asserted, flattery directed at the legions.[77] Emperors commonly accepted such titles in the wake of conquests and military victories. Nerva, and his heir, appropriately took the title of Germanicus in the fall of 97 when Rome was celebrating victories in Germania against the Suebi.[78] The adoption of honorific names by the emperor after victories was traditional imperial practice. For example, Domitian assumed the title Germanicus in 83 for his victories against the Chatti, and Claudius was offered the title Britannicus in 43 for his conquest of Britannia, although he rejected it and gave it to his two-year-old son.

Historians have come to understand Nerva as an elderly senatorial aristocrat who had no military experience and a tense relationship with the armed forces. This is certainly a fair characterization based on the historical sources written after Nerva's death that indicate there was some concern of rebellion during his reign, although the anxiety had more to do with the military's affection for Domitian than Nerva's lack of military experience. Nonetheless, historical hindsight and understanding of Nerva's character or political weaknesses cannot be allowed to color the interpretation of state-sanctioned art formulated while Nerva was still alive and wielding imperial power. State-sanctioned art operated very differently from the historical writings of Suetonius or Dio, or even the panegyric of Pliny, who could not praise Nerva too much in his more fulsome aggrandizement of Trajan. Coinage exalted the living emperor in a manner similar to contemporary poetry and panegyric directed at the living emperor.[79] It was not propaganda of the sort where an imperial agent was concocting designs to "convince" or "persuade" the people of a certain idea, but it did reinforce official expectations and positive perceptions of the emperor as regarded his role and relationships with his various constituencies throughout the Roman Empire.[80] One of the roles of the Roman emperor was commander-in-chief of the armed forces. Since Augustus first adopted it, emperors bore the military title of *imperator* and by definition of their office held *imperium maius*, "greater power," which gave them supreme military authority.[81] The use of the title IMP(ERATOR) on Nerva's coinage and inscriptions

[77] *Contra* Shotter 1983: 224.
[78] On the victories against the Suebi, see, e.g., Bennett 2001: 48.
[79] E.g., Levick 1982; Wallace-Hadrill 1986; Wolters 2003: 185–189.
[80] Noreña 2011a: 18.
[81] E.g., Zanker 1988: 192 and 223–227, et passim. See also Campbell 1984: 59–69 and 120–133; 1994: 68–69.

followed the practice of every emperor before him and the use of martial imagery on his coinage was by no means novel. The *quinarii* bore the image of Victory who traditionally graced this denomination in times of both war and peace. Pax customarily appeared on the coinage of emperors early in their reigns to signify stability as power transitioned from emperor to emperor, even when that transition of power occurred under a peaceful dynastic arrangement. The CONCORDIA EXERCITVVM types communicated ideas about military stability, active campaigns along the frontier, and drew upon imagery deployed in the civil wars of 68–69 and under the Flavians. After Nerva's death, the CONCORDIA EXERCITVVM legend and similar iconography was also used in times of relative peace in the second century, again suggesting the coins expressed political rhetoric rather than appeals and aspirations. The resuscitation of the *adlocutio* type was also wholly traditional, following the numismatic precedents of Caligula, Nero, and Galba. Nerva's adoption of the honorific title Germanicus to celebrate the achievements of the legions under the command of his generals was also customary and appropriate in the wake of victories against the Suebi in Germania.

After Nerva, emperors who had no military experience or who were not known for their military exploits also presented themselves as supreme military commander, a role they played by the very definition of their place at the head of the Roman state and by the function of their title *imperator*. Aside from the Second Jewish Revolt, which began in 132, late in Hadrian's reign, his principate was otherwise rather peaceful. Hadrian consolidated the Roman Empire, withdrew from the eastern territories conquered by Trajan while keeping Dacia, established fortified borders, and thus put an end to the aggressive Roman territorial expansion witnessed in Trajan's principate and under various emperors of the first century. In his sculpted portraits, which are more common than any other emperor aside from Augustus, Hadrian nonetheless appears most frequently in military dress, referring to his role as supreme commander, as in the illustrated example from the Museo Nazionale delle Terme in Rome (Figure 1.17).[82] Many extant portraits of Antoninus Pius also depict him as a military commander, bedecked in fine armor and a military cloak, although his long reign is also known as a period of peace.[83] The coinage of these two emperors, who presided over decades of relative tranquility after Trajan's militaristic reign, also bears martial imagery. For example, a series of coins

[82] Wegner 1956: 63–73 et passim; Kleiner 1992: 238–241.
[83] Wegner 1939: 15–25 and 100–105; Kleiner 1992: 268–269.

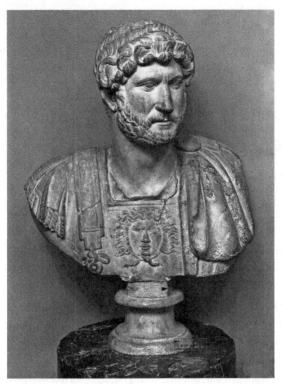

FIGURE 1.17 Bust of Hadrian (c. 119) wearing a breastplate, adorned with a gorgon's head, and *paludamentum*. (Rome, Museo Nazionale delle Terme, Inv. 8618. DAI Fotothek Neg. 55.204, Photo by R. Sansaini. Reproduced courtesy of the Deutsches Archäologisches Institut, Rome.)

referring to Hadrian's travels depict the emperor addressing the individual armies of Britannia, Cappadocia, Dacia, Germania, Hispania, Mauretania, Moesia, Noricum, Raetia, and Syria.[84] In the reign of Antoninus Pius, martial imagery is uncommon on the coinage but Victory appears on *denarii* in 143–144 when he was acclaimed *imperator* for the second time, the rationale for which may have been victories in Britannia won at the hands of his general Urbicus in 142–143.[85] Therefore, the deployment of martial iconography on Nerva's coinage and his adoption of the title Germanicus in the fall of 97 must be understood in the context of the emperor's customary role as *imperator* and supreme military commander and his traditional representation as such, not as blandishments directed at the armed forces.

[84] *RIC* II: nos. 912–937.
[85] Rowan 2013b: 223.

CHAPTER 2 | Nerva, the Senate and People of Rome, and Italy

The people received the news of his death with indifference, but the soldiers were greatly grieved and at once attempted to call him the Deified Domitian; while they were prepared also to avenge him, had they not lacked leaders. This, however, they did accomplish a little later by most insistently demanding the execution of his murderers. The senators on the contrary were so overjoyed, that they raced to fill the House, where they did not refrain from assailing the dead emperor with the most insulting and stinging kind of outcries. They even had ladders brought and his shields and images torn down before their eyes and dashed upon the ground; finally they passed a decree that his inscriptions should everywhere be erased, all record of him obliterated.

—SUETONIUS, *Domitianus* 23.1[1]

WHEN NERVA BECAME emperor after Domitian's assassination, his government had to manage and address the various constituencies within the Roman Empire: the military, the inhabitants of the provinces, and the citizens of Rome and Italy, where the senatorial aristocracy and the *plebs urbana* were particularly important. Nerva's administration was especially involved with domestic policy in Rome and Italy, as indicated by both his coins and the historical sources that describe various tax reforms and social policies that he implemented. The close attention paid to Rome itself is perhaps explained in the context of Suetonius's observation that upon

[1] The translation is from the 1950 Loeb edition (Rolfe).

the news of Domitian's death the people were ambivalent, the senators were jubilant, and the general soldiery was discontent. Many of Nerva's actions certainly promoted the interests of the *plebs urbana* as well as common Romans in Italian towns and in the countryside. To the poorest, Dio claims, Nerva gave lands worth 60 million *sestertii* (68.1–2). The taxes and policies that Nerva reformed had been associated with Domitian and, as such, Nerva's reforms would have also pleased senators who saw them as attacks on Domitian's memory; popular reforms may also have prompted the *plebs urbana* to perceive Nerva as a preferable alternative to Domitian to whom they had been generally apathetic, at least according to Suetonius.

Nerva, the Urban Plebs, and the People of Italy

Nerva's coinage bore many different reverse images that denoted specific aspects of imperial policy that reflected Nerva's involvement with the *plebs urbana*. To some scholars, the focus of the coinage on policy and events that affected the people of Rome, and to a lesser degree the people of Italy, implies imperial agency in the selection of coin imagery, although the role of the emperor or his court in the selection of themes and images on the coinage remains a controversial subject.[2] An alternative scenario is that mint-masters formulated designs with popular themes, reflecting contemporary rhetoric and panegyric that would have presented Nerva as more generous and beneficent than his predecessor, whose coins would have circulated alongside Nerva's new coinage.[3] This could have the effect of creating the illusion of imperial agency on the coinage, as recent policies, events, and demonstrations of beneficence are trumpeted on the coinage, but it is also for these things that emperors were praised by equestrian and senatorial poets and panegyrists. For example, Martial's *Liber Spectaculorum* lauded the emperors Titus and Domitian for their lavish games and Pliny praised Trajan for his public building and popular initiatives (e.g., *Panegyricus* 26–28 and 51).

[2] For example, Brennan 2000 repeatedly describes Nerva's coinage as "courting" the plebs in the face of military anxiety. On the selection of coin types and the function of imperial coin iconography, see discussion in the introduction.

[3] Wolters and Ziegert 2014: 70 point out that Nerva's base-metal coinage clearly differentiates him from his predecessor by the discontinuance of the monotonous Minerva types and the new focus on popular themes and specific aspects of Nerva's progressive domestic agenda.

FIGURE 2.1 *Sestertius* of Nerva from December 96 with the CONGIAR(IVM) P(OPVLO) R(OMANO) reverse type. (© Bibliothèque nationale de France.)

The first two emissions in Nerva's reign, of September 96 and December 96, produced *sestertii* that depicted on their reverses the emperor seated on a high platform presiding over a distribution of money (*congiarium*). In front of Nerva, an attendant hands money to a citizen who is sometimes accompanied by a youth; in the background are statues of Minerva and Liberalitas (Figure 2.1).[4] Minerva often appears on coins depicting *congiaria* as patron of the distribution and potentially because distributions may have taken place near her shrine.[5] Liberalitas personifies imperial generosity and in the second century the word *liberalitas* eventually replaced *congiarium*.[6] The scene is clearly intelligible on account of the accompanying legend: CONGIAR(IVM) P(OPVLO) R(OMANO), "the distribution of largess to the Roman people."[7]

The depiction of the *congiarium* commemorates the payment of 75 *denarii* to eligible citizens in the city of Rome at the beginning of Nerva's reign. The Chronographer of 354 confirms that Nerva gave a *congiarium* of 75 *denarii* upon his accession and also established a fund, the *funeraticum*, that would contribute 62.5 *denarii* for individual funeral costs for the

[4] *RIC* II: nos. 56–57 and 71. *Congiaria* were originally distributions of wine and oil.
[5] On the possible location of distributions, see van Berchem 1939: 164–176; Spinola 1990: 29–30 and 37–44.
[6] *DEAR* IV.2, 1946: 838–877, s.v. Liberalitas (Barbieri); Metcalf 1993; Schmidt-Dick 2008.
[7] Kubitschek 1933: 15 reconstructs the legend as CONGIAR(IVM) PR(IMVM). This is untenable, see *BMCRE* III: xlviii, who suggests CONGIARIVM P(OPVLI) R(OMANI). Szaivert 1978: 61 insists CONGIARIVM P(OPVLO) R(OMANO DATVM), following Neronian precedent. Whatever the exact reconstruction, Kubitschek's impossible version aside, the sense remains the same.

FIGURE 2.2 *Sestertius* of Nero from 64 commemorating his second *congiarium* with the CONG(IARIVM) II DAT(VM) POP(VLO) reverse type. (Courtesy of the American Numismatic Society, 1954.203.156.)

plebs urbana. The coins must have resonated specifically with the *plebs frumentaria* as only urban plebs enrolled in the *plebs frumentaria* were able to participate in the *congiarium* (Fronto, *Principia Historiae* 210). Although imperial distributions of grain and money are sometimes viewed cynically by scholars as mere bribes or as a part of a popular welfare program, they served to distinguish this privileged subset of plebs who lived in the city of Rome from noncitizens and from those who lived in *coloniae, municipia*, and the countryside. From the late first to the second centuries, the *plebs frumentaria* were considered clients of the emperor and state.[8] In the first century it had become customary for emperors to make a payment of cash to the urban plebs in celebration of certain occasions, such as imperial marriages and imperial triumphs. Previously, *congiaria* were marked on *sestertii* of Nero in 63/64 (recalling distributions in 51 and 57) (Figure 2.2) and of Titus, as Caesar under Vespasian, in 72.[9] Nerva was the first emperor to hold a *congiarium* at his accession. That precedent was followed by subsequent emperors, including Trajan.

Nerva's payment and his fund for funeral expenses represented immense largess to the *plebs urbana* in view of the fact that they amounted to more

[8] van Berchem 1941–1942: 184–187, and see especially Brennan 2000: 48–55 with further bibliography. On the important relationship between emperor and plebs in the Julio-Claudian period, see Yavetz 1969: 103–129, and for considerations on Nerva, see Yavetz 1987: 144–148. Flaig 2002; 2010 credits Nero's loss of popularity among the urban plebs with his ultimate downfall.

[9] *RIC*[2] I: nos. 100–102, 151–162, and 394; *RIC*[2] II.1: nos. 420 and 456; Spinola 1990: 29–32.

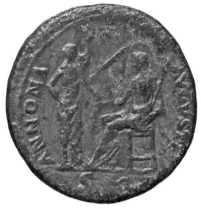

FIGURE 2.3 *Sestertius* of Nerva from September 96 with the ANNONA AVGVST(I) reverse type. (© Bibliothèque nationale de France.)

than half of what Domitian had doled out in fifteen years over three *congiaria*.[10] It is estimated that approximately 150,000 citizens were eligible for the *congiarium*, requiring a total state expenditure of 11.25 million *denarii* (45 million *sestertii*) in that single act of largess.[11] It would have been impractical to make the entire payment of 75 *denarii* to every individual in the form of 300 *sestertii*, and so these coins were probably not paid out at the *congiarium* itself, unless there was some token distribution.[12] Indeed, Nerva's *congiarium sestertii* are extremely rare, indicating that they were not produced in large quantities; only five specimens of the *congiarium* type (three from the first emission and two from the second) are recorded among 297 identifiable total *sestertii* from the regions surveyed (appendix 4). Notably, one of these rare coins was among the small group of *sestertii* from excavations in Rome.

Sestertii from the first, second, and third emissions reflect the new regime's responsibility for the grain supply, a concern shared by Rome's urban poor. These coins depict Annona standing on the left side facing Ceres, who is seated on the right and facing her (Figure 2.3).[13] Ceres holds stalks of wheat and a torch while Annona holds cornucopiae. Between the two figures is a *modius* (grain measure) on an altar and the prow of a ship

[10] On monetary distributions, see Strack 1930: 84–89; Syme 1930: 62–63; van Berchem 1939: 141–169; Carradice 1983: 154 (on Domitian only); Duncan-Jones 1994: 248–250.

[11] For the estimate, see van Berchem 1939: 29. The estimate is generally still accepted by scholars today, e.g., Duncan-Jones 1994: 248–249.

[12] Beckmann 2015: 194–197 identifies Liberalitas's attribute as an aid for counting, presenting, and distributing the payment and suggests payments would have been made typically in *denarii*.

[13] *RIC* II: nos. 52, 68, and 78.

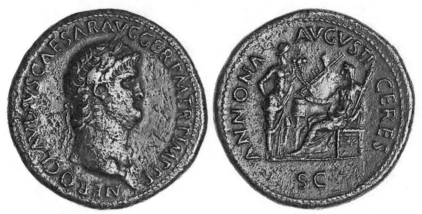

FIGURE 2.4 *Sestertius* of Nero from 64 with the ANNONA AVGVSTI CERES reverse
type. (Courtesy of the American Numismatic Society, 1944.100.39729.)

is in the background. Annona, the personification of Rome's grain supply,
was an imperial innovation; she typically appears in art in conjunction
with the related goddess, Ceres, who reigns over agricultural success.[14]
The *modius* denotes the supply of grain itself and the prow of a ship alludes
to the regular shipments of grain from Egypt on which Rome's massive
population depended. If the Egyptian grain fleet stopped, there would
be famine in Rome. The accompanying legend ANNONA AVGVST(I)
underscores imperial involvement and responsibility for the guarantee of
the urban grain supply. Near-identical reverse types had appeared earlier
on *sestertii* of Nero from 63 to 67 (Figure 2.4) and of Domitian from 85
and 86.[15] The appearance of the Annona type at the beginning of Nerva's
principate indicated a stable supply of food in the aftermath of the sudden,
violent, and unexpected transition of power from Domitian to Nerva. Even
so, these coins are quite rare and thus would not have played a significant
role in Nerva's public image. In the sample of 297 *sestertii* of Nerva from
recorded find spots, only one coin (in the Garonne Hoard) bore the Annona
reverse type (appendix 4).

While the Annona types generally assured the stability of the grain sup-
ply for the people of Rome, and asserted the emperor as guarantor of that
stability, other types again targeted the subset of the urban plebs known as

[14] On the iconography and significance of Annona, see *BMCRE* III: xlvi–xlvii; Rickman
1980: 257–267; Fears 1981: 8; *LIMC* I, 1981: 795–799, s.v. Annona (D'Escurac); Schmidt-Dick
2002: 23–26.
[15] *RIC*² I: (Nero) nos. 98–99, 137–142, 372, 430–431, 493–497, and 566–572; *RIC*²
II.1: (Domitian) nos. 349–350, 396, and 462.

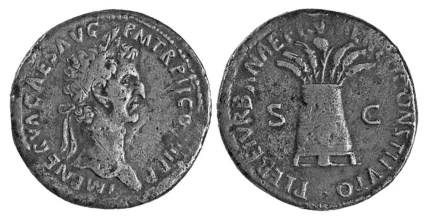

FIGURE 2.5 *Sestertius* of Nerva from September 97 with the PLEBEI VRBANAE
FRVMENTO CONSTITVTO reverse type. (Courtesy of the American Numismatic
Society, 1944.100.42661.)

the *plebs frumentaria*, who were also eligible to receive the *frumentum* (an
imperial distribution of grain) in addition to the *congiarium*. Regular dis-
tributions of subsidized grain in Rome began in 123 BC when the populist
politician Gaius Gracchus successfully implemented the *lex frumentaria*
(e.g., Plutarch, *Gaius Gracchus* 6). Distributions became more organized
and politicized toward the late Republic and by the imperial period were
an expectation of the imperial government.[16] As admission to the *plebs
frumentaria* was a right extended only to citizens in Rome, some people
moved to Rome in order to become eligible for the *frumentum*; this, in
turn, led to caps placed on the maximum number admitted to the *plebs
frumentaria* in the reign of Augustus.[17] Imperial distributions of subsi-
dized grain occurred monthly and took place at the Porticus Minucia.[18]
Beginning in the third emission (January 97), and again in the fourth
emission (September 97), the mint struck *sestertii* bearing the image of a
modius containing six ears of wheat and a poppy, with the legend PLEBEI
VRBANAE FRVMENTO CONSTITVTO (Figure 2.5), which Mattingly
translated as "the fixing of supplies of corn [grain] for the plebs of Rome."[19]
The type is unique in all of the Roman imperial coinage as the only type
that ever explicitly named the *plebs urbana*.[20]

[16] van Berchem 1939: 15–116; Rickman 1980: 156–197.
[17] Rickman 1980: 182–185 *contra* van Berchem 1939: 34–45, who had argued that familial roots in
the city of Rome were a basis for admission to the *plebs frumentaria*.
[18] van Berchem 1939: 84–95; Rickman 1980: 192–197.
[19] *RIC* II: nos. 89 and 103; *BMCRE* III: xlviii.
[20] Brennan 2000: 51.

The significance of the coins is debated. Mommsen surmised that Nerva had suspended grain distributions after his accession and that the coins marked their restoration in early 97, although there is no evidence for a suspension of grain distributions, nor do the coins say anything about a restoration.[21] Cavedoni proposed they referred simply to monthly grain distributions and Nerva's construction of a granary.[22] As Nerva's granary is one of two known buildings to have been completed during his short reign, a reference to the Horrea Nervae has been a popular interpretation of the coins, often in conjunction with presumed reforms concerning the distribution of grain. Strack assumed these coins and the Annona *sestertii* intimated some difficulties with the grain supply.[23] The most logical and substantiated interpretation of the coins is Brennan's; he points out that the phrase *frumento constituto* is used by Ulpian and carries the legal sense of a promise or an obligation (*Digest* 13.5.1.5).[24] The coin's legend is, therefore, better reconstructed as "the promised distribution of grain to the urban plebs," indicating some extraordinary distribution of grain. As with other *sestertii* referring to imperial concern for the *plebs urbana*, these are also quite rare. There are only five out of the 297 with recorded find spots (appendix 4).

As under Augustus, Caligula, Claudius, Nero, and Domitian before him, Nerva's mint also produced copper *quadrantes*. Most of Nerva's *quadrantes* depict a *modius* on the obverse, with anywhere between two and four stalks of wheat emerging from it, and a winged *caduceus* on the reverse (Figure 2.6).[25] The *modius* is the same subject that appears on the PLEBEI VRBANAE FRVMENTO CONSTITVTO *sestertii* that communicates the imperial provision of grain and, more generally, the imperial responsibility for the security of the grain supply. In the context of the *sestertius* type, they could also refer to imperial distributions of free or subsidized grain. *Modii* previously appeared on the *quadrantes* of Claudius.[26] The winged *caduceus*, an attribute of Mercury, symbolized

[21] Mommsen 1844: 193. Mattingly in *BMCRE* III: xlviii–xlix counters the interpretation.

[22] Cavedoni 1855: 42, followed by Merlin 1906a: 87; Szaivert 1978: 62; Shotter 1983: 222; Grainger 2003: 57; *BMCRE* III: xlix. On perceived reforms regarding distributions, not necessarily connected with the construction of the granary, see Sutherland 1935: 154 *contra* Syme 1930: 62, who suggests the coins indicate extra distributions of grain; *LTUR* IV, 1999: 132–137 (136), s.v. Porticus Minucia Frumentaria (Manacorda). On evidence for the granary, see Richardson 1992: 194; *LTUR* III, 1996: 44, s.v. Horrea Nervae (Coarelli).

[23] Strack 1930: 66–67; Garzetti 1950: 69.

[24] Brennan 2000: 51.

[25] *RIC* II: nos. 109–113.

[26] *RIC*² I: nos. 84, 86–88, and 90.

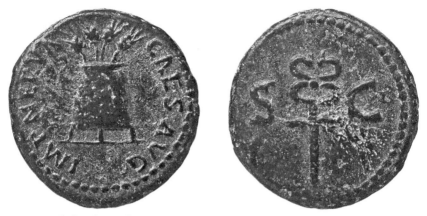

FIGURE 2.6 *Quadrans* of Nerva from December 96(?) with the *modius* obverse / winged *caduceus* reverse type. (© Bibliothèque nationale de France.)

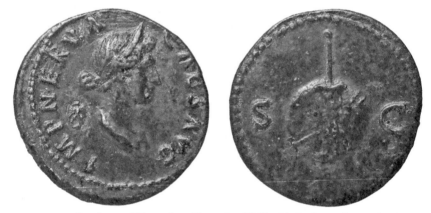

FIGURE 2.7 *Quadrans* of Nerva from December 97(?) with the Juno obverse / rudder on globe reverse type. (© Bibliothèque nationale de France.)

commercial prosperity. A rarer type of *quadrans* that appeared under Nerva depicts a bust of Juno on the obverse and a rudder on a globe on the reverse (Figure 2.7). Here Juno appears as the protector of the state since the rudder and globe suggest guided administration over the Imperium Romanum.[27] Throughout the first century, *quadrantes* typically bore images that related to the day-to-day concerns of urban life in Rome: tax forgiveness, weights and measures reforms, and the grain supply. The mint issued *quadrantes* irregularly and they circulated primarily in Rome and central Italy among the common people. Nerva's *quadrantes* cannot

[27] *RIC* II: no. 114; *BMCRE* III: 1.

FIGURE 2.8 *As* of Nerva from January 97 with the NEPTVNO CIRCENS(IBVS) CONSTITVT(IS) reverse type. (Yale University Art Gallery, ILE 2013.17.70, Promised Gift of Ben Lee Damsky.)

be dated any more closely than the general dates for Nerva's reign as they do not bear the more precise imperial titulature that allows tighter chronologies for the emperor's other coinage. Eva Szaivert assigns, however, the *modius/caduceus* type to the second emission of December 96 and the Juno/globe type to the fifth emission of December 97 in her study of imperial mint organization in the reign of Nerva.[28] According to survival rates in excavated finds, the *modius/caduceus* type is much more common than the Juno/rudder on globe type; there are twenty-three of the former and just one of the latter (appendix 4). Nerva's *quadrantes* clearly were intended for the urban circulation pool according to the abundance of *quadrantes* in the finds from the city of Rome in contrast to other regions. Over 95 percent (18/23) of Nerva's *quadrantes* were recovered in Rome.

Nerva's involvement with popular entertainments is the subject of some coins from the third emission in January 97. Rare *asses* depict Neptune standing holding a trident and a ship's prow while a smaller figure reclines to his left (Figure 2.8). In two variants, Neptune appears either facing or standing in profile to the right; the variants appear to come from only two different reverse dies.[29] The figure to Neptune's left may be Consus, whose buried altar was in the Circus Maximus, but the probable identity

[28] Szaivert 1978: 55 and 57–58. The argument stems from the placement of the *modius* type in *officinae* 4–6 as a special issue, explaining the variants depicting between two and four stalks of wheat. The reverse imagery of the rudder on a globe on the other *quadrantes* can be associated with similar imagery on the reverses of some restoration coins, which she assigns to the fifth emission.

[29] Shotter 2013: 92–93.

of the figure is instead Triton.[30] The scene is accompanied by the legend NEPTVNO CIRCENS(IBVS) CONSTITVT(IS). Undoubtedly, the coins refer to Neptune's association with horse racing in the Circus Maximus as the legend makes explicit reference to circus games; the cult of Consus had been conflated with Neptune early on in the valley of the Circus Maximus.[31] Mattingly and Hill proposed that the coins commemorated the erection of a statue of Neptune in the Circus Maximus on account of the locative figure of Consus at Neptune's feet; that interpretation is, as Woytek indicates, untenable in view of the more probable identification of the figure as Triton.[32] There is also nothing about the figure of Neptune himself to suggest that he is meant to be a statue (e.g., he does not stand on a base), nor does the legend make any reference to a statue. In view of Dio's statement that Nerva abolished horse races as part of an austerity program (68.2.3), Mommsen read the coins as marking a restoration of races after their temporary abandonment.[33] Mommsen had applied a similar interpretation to the contemporary appearance of Nerva's *sestertii* marking a distribution of grain, although there is absolutely no evidence to suggest that Nerva ever cancelled or reduced grain distributions in the first place. One must also be cautious of Dio's brief treatment as a historical source for Nerva as it was written over a century after the emperor's death and may contain some inaccurate or imprecise information. The Neptune coins and the PLEBEI VRBANAE FRVMENTO CONSTITVTO types were introduced in the same emission and, incidentally, use the same verb in their respective legends. The legend on the Neptune coins should therefore be translated as "promised Circus games to Neptune" and thus refers to an extraordinary set of games, perhaps enhanced Neptunalia.[34]

The Neptune type has often been dismissed in the past as a forgery, although several specimens are known in recorded finds.[35] The Neptune

[30] *RIC* II: 288* for the type. The identification of the figure of Consus at first makes much sense in view of the apparent association with the Circus noted on the coin and since Consus was Neptunus Circensis/Neptunus Equester (e.g., Livy 1.9.6; Tertullian, *De Spectaculis* 5; Varro, *De Lingua Latinae* 6.20). Woytek 2008a: 119–124 identifies the figure as Triton by paying closer attention to the bearded figure who appears to hold a shell or fish. The appearance of Consus, who is Neptunus Circensis, would also be redundant.

[31] E.g., Humphrey 1986: 61–62.

[32] Woytek 2008a: 119–123 *contra BMCRE* III: 1 and Hill 1989: 89.

[33] Mommsen 1844: 193–194.

[34] Woytek 2008a: 119–123; cf. Grainger 2003: 54.

[35] Merlin 1906a: 145–146; *RIC* II: 228*; and Szaivert 1978: 77 hastily condemn the type as a forgery, following earlier condemnations by Eckhel and Cohen. Shotter 2013 counts all known specimens and illustrates fourteen of the sixteen, including those with known find spots; de Loye 1984 had earlier discussed known find spots of the type.

coins are very rare: only one was counted in the 712 *asses* from the sample sets consulted for this study (appendix 4). David Shotter's focused study of the type counts sixteen specimens extant in public and private collections, many of which were found in England. The most recent discovery was by a metal detectorist in 2012 near the English village of Mollington, which lies near the Roman road between the legionary fortress at Chester and the emporium at Meols. Shotter notes that other specimens were earlier found in Colchester in 1766, near London Bridge between 1830 and 1841, in Castleford in West Yorkshire at the site of a Roman fort and *vicus* in 1980, and Tarascon-sur-Rhône in Provence, France, in 1980. Further examples have tentative find spots: a specimen possibly found at Cirencester, one possibly found in Chester before 1886, and one sold by a Viennese auction house in 2011 was rumored to have had a Balkan find spot. Based on the concentrations of examples with known find spots in England, the rare coins appear to have been supplied to Britannia and, indeed, there are no recorded specimens of the type in Rome or Italy.[36]

A deliberate consignment of these coins to Britannia would be highly unusual, as the reference to games in the Circus Maximus would resonate most with people in Rome. Shotter's solution is to hypothesize that supplies of the coins were sent to Britannia as the image of Neptune of would have meant something to the people there who relied on seafaring and trade across the English Channel. The theory is doubtful as the coins' legend very clearly explains the meaning of the iconography, although one must wonder what the people of Roman Britain must have thought of the imagery. Coins were primarily economic instruments and historical factors also affected the movement of coinage; not all supply decisions would have been deliberate or based on iconography. Other explanations merit consideration. One is that the mint created a coin type about some new "promised" games and, if Dio's comment on the cancellation of horse races is to be trusted, the plan changed on account of Nerva's austerity. The coins could hardly be introduced in Rome heralding games that the emperor had cancelled and so they were consigned to a province in a corner of the Roman Empire where few cared what did or did not happen in the Circus Maximus. But this scenario is also improbable; in such a case, the mint probably would have simply destroyed the coins rather than to put them into circulation, even in Britannia. There is another consideration: Nerva founded Colonia Nervia Glevensium (Glevum), modern Gloucester, and

[36] For discussion of the known find spots with further references, see de Loye 1984; Shotter 2013.

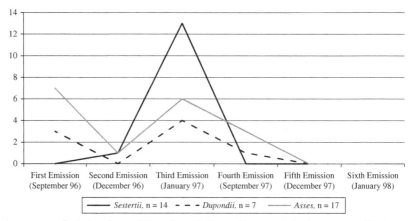

| | First Emission (September 96) | Second Emission (December 96) | Third Emission (January 97) | Fourth Emission (September 97) | Fifth Emission (December 97) | Sixth Emission (January 98) |

——— *Sestertii*, n = 14 − − − *Dupondii*, n = 7 ——— *Asses*, n = 17

FIGURE 2.9 Relative sizes of Nerva's emissions of base-metal coinage according to finds from modern England and Wales (data derived from the PAS database, October 2013). Note, this chart does not include the restoration types that are hypothetically attributed to the fifth emission.

settled it with veterans in 97, the same year that the Neptune coins were struck.[37] These coins may have arrived with the settlers or a consignment of coinage may have accompanied the colonization operation. Indeed, according to finds recorded by the Portable Antiquities Scheme (PAS) in England, there is a remarkably high number of Nerva's rare *sestertii* from 97 that bear denotative images one would expect to find instead in Italy (appendix 4). For example, out of the total of thirteen *sestertii* attributable to the third emission in the PAS finds, there are three *frumentum* types, one *vehiculatio* type, one ROMA RENASCENS type, and one FORTVNA POPVLI ROMANI type. When contrasted with the numbers of *sestertii* from the areas of modern Germany and Austria (Figures I.4 and I.5), there is a much more pronounced spike of third-emission *sestertii* in the British sample (Figure 2.9). Most of Nerva's *sestertii, dupondii*, and *asses* in the British sample are found within approximately seventy miles of modern Gloucester, according to PAS records. The observation suggests some wider anomaly in the supply of Nerva's coinage to Britannia by which coins from the Italian circulation pool traveled to Britannia, perhaps

[37] On Glevum, see Hurst 1976; Hurst 1988 with further references. There is some debate as to whether the colony was founded by Nerva or if it was established by Domitian and simply renamed after his *damnatio memoriae*. Unfortunately, archaeology is unable to answer the question definitively as the site was already occupied at the time it became a colony (for two perspectives, see Hassal and Hurst 1999).

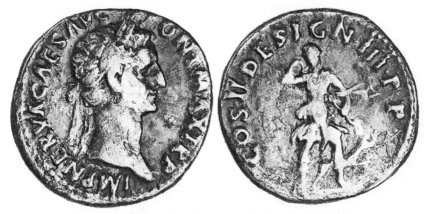

FIGURE 2.10 *Denarius* of Nerva from December 96 with the Diana reverse type. (Courtesy of the American Numismatic Society, 1984.36.1.)

related to the movement of people in Nerva's reign, as would be connected with the foundation of Colonia Nervia Glevensium.[38]

In addition to coins referring to the grain supply and grain distributions, games, and distributions of cash, *denarii* of Nerva depicting Diana seem at first glance to have had the aim of popular appeal. They depict Diana in a hunting pose, advancing to the right and drawing an arrow from her quiver, as a hunting dog follows behind her (Figure 2.10). These coins were struck only in Nerva's second emission in late 96 and are very rare. One is recorded in the aggregate of hoards compiled for this study and one is recorded as an excavated find (appendix 3); additionally, there are only four extant specimens known in collections.[39]

The representation of Diana on these coins is similar to coins of Augustus from 11–10 BC that commemorate her role in the victory at Naulochus (Figure 2.11), but they more closely resemble coins from the civil wars after the death of Nero (Figure 2.12). A rebel mint in Spain or Gaul revived the Augustan type in honor of the Deified Augustus.[40] The rebel coins show Diana in a much more dynamic pose, similar to Nerva's *denarii*; the figure of Diana on Augustus's coinage is rather static. Diana in an active hunting pose, but without the dog, also appears on the reverse of undated Trajanic *semisses* that also have a bust of Minerva on

[38] Elkins 2017a.
[39] *RIC* II: no. 12. Hoard find: MacDonald 1934: 10 (Falkirk); excavation find: *FMRP* I (Braniewo). For the numbers in public collections, a communication from William E. Metcalf is noted by Brennan 2000: 58, n. 72.
[40] *RIC²* I: (Augustus) nos. 181–183; (Civil Wars: Group III) no. 98.

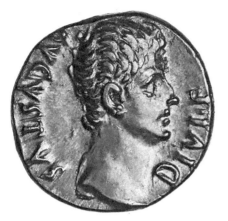
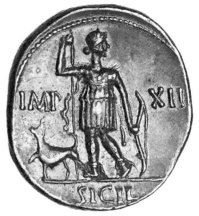

FIGURE 2.11 *Denarius* of Augustus from 11–10 BC with Diana on the reverse. (Courtesy of the American Numismatic Society, 1944.100.39108.)

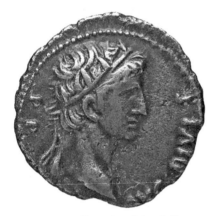

FIGURE 2.12 *Denarius* of the civil wars, struck in honor of the Deified Augustus, from a mint in Spain or Gaul in 68 with Diana on the reverse. (© Bibliothèque nationale de France.)

the obverse (Figure 2.13).[41] Nerva's Diana also resembles the "Diana of Versailles" statue type, which the Romans widely copied from a Greek original (Figure 2.14).[42] A more domestic version of Diana appears in the frieze of the Forum of Nerva.[43] The appearance of Diana, the goddess

[41] Woytek 2010: 1:161 and 488, no. 605. There is also an *aureus* of Trajan with Diana standing on the reverse, holding a long torch in her right hand and arrows in her left hand (Woytek 2010: 1:305–306, no. 226), although this type does not resemble the depiction on Nerva's coinage as closely as the *semisses*.

[42] Brennan 2000: 56–58 compares Nerva's coins with Augustus's and with the "Diana of Versailles" statue type; he overlooks the restored type of Deified Augustus in the civil wars.

[43] D'Ambra 1993: 66–68.

FIGURE 2.13 *Semis* of Trajan depicting Diana on the reverse. (Yale University Art Gallery, 2008.83.33, Ruth Elizabeth White Fund with the assistance of Ben Lee Damsky.)

FIGURE 2.14 Engraving of the statue known as the "Diana of Versailles" from the *Tableaux du Cabinet du Roy*, 1669. (© Trustees of the British Museum.)

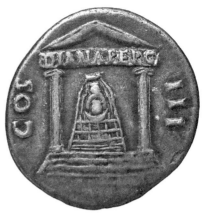

FIGURE 2.15 *Cistophorus* of Nerva from 97, struck in Rome for circulation for Asia Minor, with the Temple of Diana at Perge on the reverse. (© Bibliothèque nationale de France.)

of the hunt, on Nerva's coinage may relate to the emperor's potential involvement with the establishment of new animal spectacles at Rome, as one very late source claims that Nerva abolished gladiatorial shows and replaced them with hunting spectacles (Malalas, *Chronographia* 10.349). An alternative is to read Diana's appearance on the coinage as a nod to the urban plebs since her old cult on the Aventine was particularly popular among them. Others have suggested that Nerva's family had a connection with Diana, or that Diana simply was a retort to the repetitive appearance of Minerva on Domitian's coinage, assuming that Nerva may have adopted Diana as his tutelary deity.[44] Shortly after this type was struck, the Rome mint also began striking silver *cistophori* that were supplied to Asia Minor for local circulation there.[45] In 97, a new *cistophorus* type was introduced that depicted the Temple of Diana at Perge with a Latin legend identifying the temple in the architrave (Figure 2.15).[46] The significance of the introduction of this new *cistophorus* type is not known

[44] For the various interpretations: Merlin 1906a: 10–11; Shotter 1978a: 162; *BMCRE* III: xl. Read the interpretation of Jentoft-Nilsen 1985: 167–179 with caution and in conjunction with Brennan 2000: 56–59. Both authors note that Nerva and Trajan both held office at Aricia, where Diana Nemorensis had her cult, and that Diana appears on both Nerva's and Trajan's coins. Jentoft-Nilsen reads Nerva's coins as an assurance to the plebeians while Brennan sees them as a replacement of the monotonous Minerva types of Domitian. For the prominence and significance of Minerva on Domitian's coins, see Morawiecki 1977; Girard 1981.

[45] Woytek 2008b, followed by *RPC* III: 157, convincingly attributes all of Nerva's and Trajan's *cistophori* to the mint of Rome, although they were designed for circulation in Asia.

[46] *RPC* III: 161–162, nos. 1301 and 1306. On the history of the Diana of Perge type, see Woytek 2008b: 92–96, with further references.

and there are only some speculative suggestions. Perhaps the appearance of the new type reflects some new interest in Diana, alongside the *denarii*, in Nerva's brief reign. While a definitive explanation for the *denarius* type is lacking, a reference to Augustus seems appropriate as Nerva modeled his principate after Augustus's in terms of senatorial cooperation and he sported an early Julio-Claudian hairstyle. Coins later in Nerva's reign celebrated the Deified Augustus, who was portrayed with Nerva's features, and in Martial's eleventh book, written in Nerva's reign, it is said that Augustus is restored to the earth in the person of Nerva (11.3.9). The closest numismatic model on which Nerva's Diana coins are based is also the rebel coinage celebrating the Deified Augustus, suggesting again the intent to connect Nerva with Augustus. The use of Diana would have additionally been a neat retort to Domitian's Minerva. In contrast to her overwhelming prevalence on Domitian's coinage, Minerva is completely absent on Nerva's coinage and only rarely appears, with no special status, on Trajan's coinage. The pairing of Minerva and Diana on Trajanic *semisses* may reinforce the speculative notion that Diana was used a riposte to Domitian's use of Minerva, although a reference to the Deified Augustus was probably the intent behind the introduction of the type.

Fortuna appears in two guises on Nerva's coinage. In the first instance, Fortuna stands holding a rudder and cornucopiae and is accompanied by the descriptive legend FORTVNA AVGVST(I); this Fortuna connotes the fortune that flows from and guides the emperor (chapter 3). In the second version, the more precise of the two, Fortuna is seated and holds stalks of wheat and a scepter. She is differentiated from the other Fortuna by these attributes and by the legend FORTVNA P(OPVLI) R(OMANI). This Fortuna denotes the good fortune of the *populus Romanus*—the Roman state—but also suggests the fortune of the common citizenry of Rome to whom the *congiarium* and *frumentum* were given.[47] She appears on *aurei* (Figure 2.16), *denarii*, and *sestertii* (Figure 2.17) in Nerva's first and third emissions and then only on *denarii* and *sestertii* in his fourth emission.[48] It is notable that Fortuna Populi Romani holds stalks of wheat and a scepter, as Fortuna's typical attributes are a rudder and cornucopiae. Wheat is symbolic of Ceres and connoted Nerva's involvement with the grain supply, already highlighted by other coin types and his construction of a granary.

[47] *Contra* Shotter 1983: 222–223, who suggests that Fortuna Populi Romani is a message for the Senate. On the iconography and significance of Fortuna, see Champeaux 1987; *LIMC* VIII.1, 1997: 125–141, s.v. Tyche/Fortuna (Rausa); Arya 2002; Schmidt-Dick 2002: 55–60; Noreña 2011a: 136–140; Mastrorosa 2012.

[48] *RIC* II: nos. 5, 17, 29, 62 and 85.

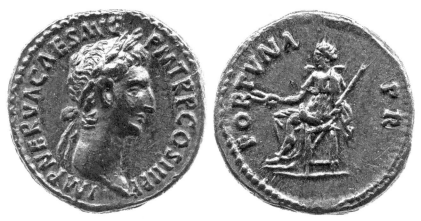

FIGURE 2.16 *Aureus* of Nerva from January 97 with the FORTVNA P(OPVLI) R(OMANI) reverse type. (© Trustees of the British Museum.)

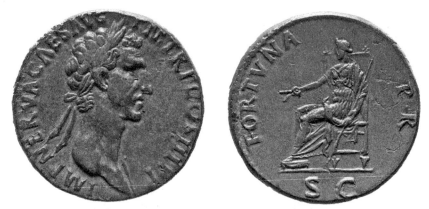

FIGURE 2.17 *Sestertius* of Nerva from January 97 with the FORTVNA P(OPVLI) R(OMANI) reverse. (Yale University Art Gallery, 2001.87.5880, Transfer from the Sterling Memorial Library, Numismatic Collection.)

The scepter may be the *pertica*, a measuring rod normally associated with Aequitas that symbolized the measures of fairness. Fortuna's extraordinary attributes expressly underscored the popular benefits of Nerva's principate: just treatment and imperial provision for the people. This type, as so many others directed toward the urban population, is uncommon. In the first emission, the type makes up between 2 and 6.5 percent of *denarii* from the various groups of finds, 3 and 7 percent in third emission, and about 3.5 percent in the fourth emission (appendix 3). On *sestertii*, the type is no more prominent, appearing on twenty specimens (6.73 percent) from a total of 297 (appendix 4). One of these rare *sestertii* was among the twelve *sestertii* from the Rome finds.

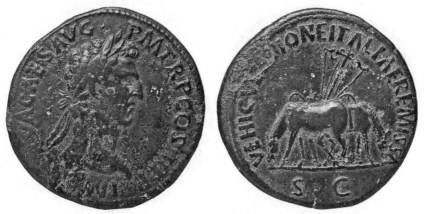

FIGURE 2.18 *Sestertius* of Nerva from January 97 with the VEHICVLATIONE ITALIAE REMISSA reverse. (© Bibliothèque nationale de France.)

Other coin types of Nerva communicated messages not only to the common people of Rome but also to the broader population of Italy. At the beginning of 97 and again in September 97, in Nerva's third and fourth emissions, a new *sestertius* type appeared depicting two grazing mules, with a cart turned on its end behind them, accompanied by the explanatory legend VEHICVLATIONE ITALIAE REMISSA, "the remission of the *vehiculatio* in Italy" (Figure 2.18).[49] The type is also known from a unique medallion (a framed *sestertius*) that was discovered in Nida-Heddernheim, just outside modern Frankfurt am Main, Germany. The medallion may well have been presented by the emperor, an agent, or some other politician to some high-ranking official, presumably in Italy, as medallions were typically given as gifts.[50] The imperial courier (*vehiculatio*) was established by Augustus to convey government information and military commands across the Roman Empire. Municipalities along major thoroughfares on which the couriers would travel were obligated to provide vehicles and guides, and to accommodate credential-carrying couriers as they traveled. Sources indicate that the system was abused and that communities were also uncertain as to the level of provisions they were required to provide. Continued monitoring and reform of the *vehiculatio*

[49] *RIC* II: nos. 93 and 104.
[50] The medallion is of the same type as *RIC* II: no. 93. It weighs 60 grams, more than double the typical weight of a normal *sestertius*, and is 44 mm in diameter. See Schubert 1984: 28–29, where it is illustrated, and *FMRD* V.2.2: 181, no. 268 and 229, n. 268. There is also some discussion in Komnick 2001: 107. This medallion was overlooked in Mittag 2010: 40. On the function of Roman medallions, see Toynbee 1986 as an introduction.

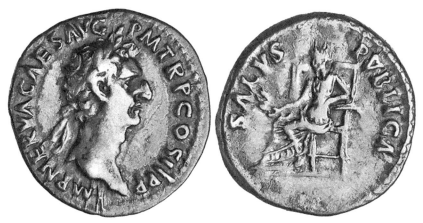

FIGURE 2.19 *Denarius* of Nerva from September 96 with the SALVS PVBLICA reverse type. (Courtesy of the American Numismatic Society, 1905.57.331.)

was a significant regulatory concern for imperial and provincial governments alike.[51] Nerva's coins announce the freeing of Italian communities from all burdens associated with the *vehiculatio*. After Nerva's apparent reform, Trajan and Hadrian gradually assumed full imperial responsibility for the imperial courier. Apart from the relief that Nerva's remission afforded Italian communities along the highways, the forgiveness of the burdens associated with the *vehiculatio* was also an assault on Domitian, to whom abuses would have been attributed.[52] There are fifteen specimens of this type accounted for in the sample of 297 *sestertii* from hoards and finds, indicating that the type is quite scarce (appendix 4). One of these rare *sestertii* was also present in the group of twelve *sestertii* excavated in the city of Rome.

Salus Publica, labeled as such, and who personifies public health, is not a common image on *denarii* from Nerva's first emission and on *aurei* and *denarii* in his third and fourth emissions (Figure 2.19).[53] In the first emission she appears on between 5 and 12 percent of *denarii* and between 5.5 and 11.5 percent in the third emission; the volume of the fourth emission is comparatively negligible and no observations can be made (appendix 3). Salus is seated and holds stalks of wheat, as did Fortuna Populi Romani, alluding also to abundance and security through the provision of grain. *Publica* is, however, a more inclusive designation than *populus Romanus*,

[51] On the *vehiculatio*, see Kolb 2000; 2015: 660–664, with further bibliography.
[52] Merlin 1906a: 79; *BMCRE* III: xlix.
[53] *RIC* II: nos. 9, 20, and 33.

which on Nerva's other coin types was specifically directed toward the urban population of Rome.[54] Perhaps the coins conveyed the notion of the economic health and stability of the broader population of Italy, although viewers in the provinces could certainly have interpreted "public health" from their own vantage point in view of the many privileges and benefits Nerva extended to the provinces.

For Italy, Nerva remitted the burdens of the *vehiculatio*, granted lands worth 60 million *sestertii* to the poor (his *lex agraria*, with which the founding of Colonia Minervia Nervia Augusta Scolacium in Bruttium may be connected), and also instituted the *alimenta*. The *alimenta* provided government support to the poor children of Italy. Trajan is often credited with the introduction of the program in view of Nerva's short reign, although it appears to have been Nerva's innovation as it is in line with his other policies and attributed to him in the *Epitome de Caesaribus* (12.4).[55] Nerva's *alimenta* may also have included grain provisions for eligible citizens of Italy as Pliny mentions Trajan's extension of this sort of *alimenta* (*Panegyricus* 26–28).[56] The mint struck coins under Trajan referring to the alimentary program.[57] Precious-metal types depict Trajan standing with two children (Figure 2.20), while the brass and copper coins represent Abundantia with a child holding a roll or a woman with two children standing before the seated emperor. *Roman Imperial Coinage* lists a *sestertius* of Nerva from the third emission (January 97) that depicts Nerva extending his right hand toward a personification of Italy, as a boy and girl stand between them with the legend TVTELA ITALIAE, "the guardianship of Italy," which has been interpreted as a reference to Nerva's *alimenta*. This coin is, however, a modern invention.[58]

As far as the SALVS PVBLICA type is concerned, we may best interpret Salus's significance on the coins as generally communicating the results or intended outcomes of Nerva's various initiatives under his domestic agenda in Rome and Italy: social health and prosperity. This interpretation is strengthened by attention to the appearance of Salus on coins of

[54] Cf. Merlin 1906a: 27.

[55] Attribution of the *alimenta* to Domitian is untenable. The *Historia Augusta* (*Hadrianus*, 7.8 and *Pertinax*, 9.3) credits Trajan with its foundation as do three inscriptions marking individual schemes (*CIL* 9.1455, 11.1147, 6.1492).

[56] Further discussion on the *alimenta* and its foundation can be found in Paribeni 1927: 137–138; Garzetti 1950: 70–74; Bourne 1960; Duncan-Jones 1982: 291–300; Bennett 2001: 81–84; Grainger 2003: 59–62; Seelentag 2008.

[57] *RIC* II: nos. 93, 230, 243, 459–461, and 604–606; Woytek 2010 dates the types to 111 (1:368, no. 345; 372–374, nos. 354–358; and 383, no. 376).

[58] *RIC* II: no. 92. For condemnation of the type: Merlin 1906b (in Merlin 1906a: 81–84, he had treated the type as authentic); *BMCRE* III: xlix; Szaivert 1978: 77.

FIGURE 2.20 *Aureus* of Trajan from 111 with the ALIM(ENTA) ITAL(IAE) reverse type. (Courtesy of the American Numismatic Society, 1954.256.15.)

Trajan. Trajan's coinage has been notoriously difficult to date precisely since many coins bear only the emperor's consular titles, such as the coins dated with COS V, putting them anywhere between 103 and 111.[59] In his fifth consulship, Trajan's mint struck *aurei* bearing reverses of Salus standing, holding a rudder and a *patera*, with her foot on a globe and an altar at her side (Figure 2.21). The legend accompanying the design reads SALVS GENERIS HVMANI, "the health of humankind."[60] Emperors were sometimes described as the "parent of humankind" on account of their largess and public initiatives. The description was applied to Nerva by Pliny (*Panegyricus* 6.1: "imperator et parens generis humani"). Recently, in a monumental work on the coinage of Trajan, Woytek has ascribed tighter chronologies to Trajan's coinage using a combination of portrait analysis and die studies. The Trajanic Salus type appears in his "group 11" coins from 111 and went into circulation alongside other coins that refer to social development initiatives and public works, including the *alimenta* types, types depicting Trajan as the restorer of Italy, a type showing the domestic goddess Vesta, and coins celebrating the construction of a new water source for Rome—the Aqua Traiana.[61]

Nerva's Salus Publica type, with the attributes of Ceres, was struck alongside other contemporary coins referring to the imperial provision

[59] This is how *RIC* II dates Trajan's COS V coinage. For Trajan's imperial titulature and chronology, see Kienast 2011: 122–124.
[60] *RIC* II: no. 148B; Woytek 2010: 1:371, no. 351. A variant in the legend is SALVS GEN HVMANI.
[61] Woytek 2010: 1:132–134 and 368–380.

FIGURE 2.21 *Aureus* of Trajan from 111 with the SALVS GENERIS HVMANI reverse. (© Bibliothèque nationale de France.)

of grain and championing Nerva's popular initiatives in Rome and Italy, emphasizing the great importance of the stability of the grain supply to the city and Italian countryside. The importance of the grain supply might be reiterated by the appearance of another type, if the authenticity of the type were able to be confirmed. A unique, but lost, *denarius* depicts a standing figure of Ceres holding stalks of wheat.[62] None are recorded from hoards or excavations; the type is known only from a specimen described in the collection of Count Wiczay.[63] The relatively miniscule output of Nerva's fifth emission from late 97, the only emission in which this type appeared, may account for the survival of only a single specimen, if it is truly an ancient type. A total of only four *denarii* of Nerva from his fifth emission are recorded from the hoards and site finds consulted, which contrasts greatly with the 233 *denarii* from the first emission and the 660 *denarii* from the third emission (appendix 3). As no image of the type survives, only Cohen's and Wiczay's descriptions, it cannot be confirmed. Their descriptions may have been based on an incorrect interpretation of another standing figure, perhaps Libertas. Their reading of some other figure as Ceres may have been encouraged by the lack of explanatory legends on the coins of the fifth emission.[64]

[62] *RIC* II: no. 38.

[63] Wiczay 1814: 145, no. 73; the type is described by Cohen 1882: 8, no. 82, who personally examined Wiczay's collection.

[64] Thanks are owed to Bernhard Woytek, who generously imparted his knowledge on the history of the specimen and searched his files for visual confirmation of the type.

A group of coins struck under Nerva replace the emperor's obverse portrait with a portrait of the Deified Augustus and imitate types struck during Augustus's lifetime or that honored the deified emperor after his death. Titus and Domitian had struck a series of restored coinage in their reigns. Legends on the obverses of this series in Nerva's coinage proclaim DIVVS AVGVSTVS or DIVVS AVGVSTVS PATER and denote Augustus's divinity, as does his bare head (on most coins). On Nerva's *dupondii*, the Deified Augustus wears a radiate crown. By contrast, the living Nerva always wears the laurel crown on all denominations, except, as had been the precedent since Nero, on *dupondii* where he wears the radiate crown in order to help distinguish that denomination from the *asses* of similar diameter. The radiate crown on the *dupondii* for the Deified Augustus simultaneously refers to Augustus's divinity, as the crown was an attribute of Sol and Apollo, and marks the denomination.[65] The coins are attributable to Nerva's reign since they carry his name and indicate they restore types of the Deified Augustus through the reverse legends: IMP(ERATOR) NERVA CAES(AR) AVG(VSTVS) REST(ITVIT). As they do not bear tribunician or consular dates, they cannot be dated more closely than September 96 to January 98 based on the coins themselves. According to tribunician and consular dates on the dated coinage alone, it appears that Nerva's fifth emission at the end of 97 produced only precious-metal types and was the only one that did not include bronze. The undated restoration coins, therefore, probably belong to that emission.[66] The different restored types for the Deified Augustus struck under Nerva are as follows.[67]

1. *Denarius.* Bare head of Augustus right / comet with eight rays and a tail (based on *denarii* of Augustus from Spain in 19/18 BC; *RIC*² I: nos. 37 and 102).
2. *Denarius.* As before / Capricorn right under which are a globe, rudder, and cornucopiae (based on *denarii* of Augustus from Spain in 18–17/16 BC; *RIC*² I: no. 126) (Figure 2.22).
3. *Denarius.* As before / butting bull right (based on *denarii* of Augustus from Lugdunum in 15/13 BC; *RIC*² I: no. 167a) (Figure 2.23).

[65] Bergmann 1998 on the symbolism of the radiate crown in Roman art.

[66] Gros 1981: 606; Komnick 2001: 108–109, following Szaivert 1978: 57–58.

[67] *RIC* II: nos. 126–137 has an incomplete list of known restored types struck under Nerva. See instead the list in Komnick 2001: 100–104. *RIC* II: no. 138 is a type restored for Agrippina. It is a forgery and should be disregarded (Komnick 2001: 104). Sometimes CAESAR is spelled out in full in the reverse legends.

FIGURE 2.22 *Denarius* of Nerva in honor of the Deified Augustus from December 97(?) with the Capricorn reverse type. (© Trustees of the British Museum.)

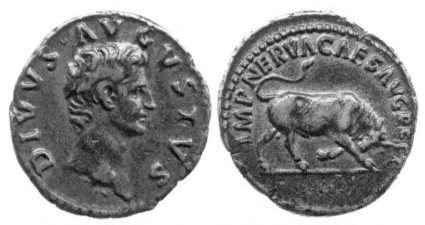

FIGURE 2.23 *Denarius* of Nerva in honor of the Deified Augustus from December 97(?) with the butting bull reverse type. (© Trustees of the British Museum.)

4. *Sestertius*. Laureate head of Augustus right / large S C surrounded by legend (Figure 2.24).

5. *Dupondius*. Radiate head of Augustus right (or left) / rudder on globe (based on *asses* of Tiberius for the Deified Augustus; *RIC*² I: no. 52) (Figure 2.25).

6. *As*. Bare head of Augustus right / eagle on thunderbolt (based on a reverse type for the Deified Augustus restored by Titus; *RIC*² II.1: nos. 468–469).

7. *As*. As before / eagle on globe (based on *asses* of Tiberius for the Deified Augustus; *RIC*² I: no. 82) (Figure 2.26).

FIGURE 2.24 *Sestertius* of Nerva in honor of the Deified Augustus from December 97(?) with the S C reverse type. (American Numismatic Society, 1995.90.3.)

FIGURE 2.25 *Dupondius* of Nerva in honor of the Deified Augustus from December 97(?) with the rudder on globe reverse type. (American Numismatic Society, 1995.110.27.)

8. *As*. As before / winged thunderbolt (based on *asses* of Tiberius for the Deified Augustus; *RIC*² I: no. 83) (Figure 2.27).
9. *As*. As before / the Ara Providentia (based on *asses* of Tiberius for the Deified Augustus; *RIC*² I: no. 80) (Figure 2.28).

According to Holger Komnick's comprehensive study of the restoration coins, the *denarius* types in Nerva's reign must have been produced in very limited quantities as all were struck with the same obverse die and there are only four extant specimens. None of these types are known from excavations or hoards. The small number of restoration *denarii* fits well

FIGURE 2.26 *As* of Nerva in honor of the Deified Augustus from December 97(?) with the eagle on globe type. (American Numismatic Society, 1944.100.42670.)

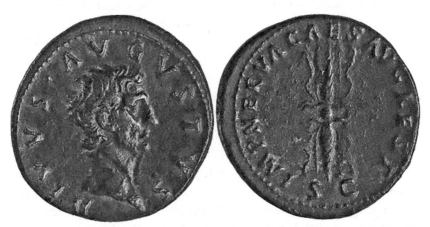

FIGURE 2.27 *As* of Nerva in honor of the Deified Augustus from December 97(?) with the winged thunderbolt reverse type. (American Numismatic Society, 1944.100.42671.)

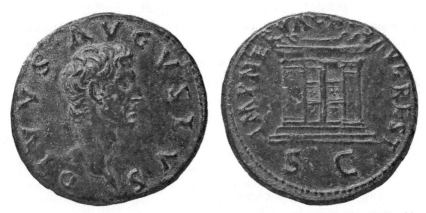

FIGURE 2.28 *As* of Nerva in honor of the Deified Augustus from December 97(?) with the Ara Providentia reverse type. (© Bibliothèque nationale de France.)

with the slight output of the fifth emission of December 97. The base-metal types are more common than the *denarii* according to obverse die counts (eighty-eight),[68] although these are relatively uncommon in hoards and finds when compared against Nerva's regular coinage. From the sample of 297 *sestertii* from hoards and finds, sixteen are restoration types. Eight out of 167 *dupondii* are restoration types, and fourteen out of 712 *asses* are restoration types (appendix 4). One explanation for the rarity of the restoration types in comparison with more common types may, again, be their issuance from the paltry fifth emission (Figures I.3–I.5). Komnick has already observed that the restored coinage of Titus, Domitian, Nerva, and Trajan are more prominent in Italian finds than in the provinces, suggesting the coins were intended for Italian circulation and for an Italian audience; perhaps the memory of the Deified Augustus was more strongly felt in Italy.[69]

There are a couple of ways to interpret the significance of the restoration series in Nerva's coinage. Nerva came to power not as a result of dynastic succession, but as the candidate agreed upon by various factions upon the assassination of Domitian. He had been a Flavian loyalist and an advisor to the Flavian emperors, but he had no familial claim to imperial power. Nerva was thus the first emperor to maintain that power successfully without a dynastic claim since Vespasian had established a new dynasty after the civil wars of AD 68–69, when Nero's maladministration forced the provinces to rebellion and the emperor's suicide left the Julio-Claudian dynasty bereft of an heir. An important part of Vespasian's political program as he set about establishing his authority was linking his principate with the ideals and memories of well-remembered Julio-Claudians such as Augustus and Claudius. For example, the *lex de imperio Vespasiani*, from which the new emperor derived his authority, invokes the names and powers of the Deified Augustus, Tiberius, and the Deified Claudius (*CIL* 6.930 = *ILS* 244). Early in his reign, Vespasian dutifully completed the Temple of the Deified Claudius, which Nero had allowed to languish. He restored for public use the Aqua Claudia and the Aqua Anio Novus, water sources that Claudius had dedicated, but which Nero had diverted for use in his Golden House. Vespasian and Titus both placed inscriptions on the Porta Maggiore that announced restorations of the Aqua Claudia

[68] Komnick 2001: 105–106.
[69] Komnick 2001: 153–154 and 179–180. Nerva's restored types are not, however, as prominent as Titus's, which appear to have been produced in greater numbers. Titus's coins are clearly more abundant in Italian finds (146–153 and 165–171).

and associated themselves with the memory of the Deified Claudius (*CIL* 6.1257–1258). One pretext for Vespasian's construction of the Colosseum was that Augustus had apparently wanted a grand amphitheater in the heart of Rome, but was unable to realize it (Suetonius, *Divus Vespasianus* 9.1).[70] Titus's own restoration coins of prominent Julio-Claudian emperors visualized a connection between the Julio-Claudian and Flavian dynasties, and his Colosseum *sestertii* alluded to the Deified Claudius.[71] In a similar way, Nerva's restoration coins may reflect efforts to promote the new regime's legitimacy by going back to the founder of the Roman Empire, bypassing the Flavian dynasty from which Nerva's maligned predecessor, Domitian, came.[72] Although Nerva's family was linked with Augustus through the marriage of Octavius Laenus and Rubelia Bassa (the great granddaughter of Tiberius), that was probably not the reason that the Deified Augustus appeared Nerva's restoration coins.[73]

Many scholars have tended to read Nerva's coin types through a senatorial lens, as he had been a senator and had empowered the Senate during his brief reign. And, indeed, some of Nerva's coinage clearly communicated messages to the senatorial aristocracy. An ideological component of Nerva's restoration series is that Augustus served as a model for Nerva in his desire to govern in concert with the Senate, and thus the coins may have communicated such an ideal to that body.[74] One of the restoration types simply depicts a large S C surrounded by the standard reverse legend (Figure 2.24) and may also have communicated to the emperor the expectation to rule in the mode of Augustus, especially if we consider the probability that the emperor was not the agent behind the construction of the imagery and if S C indicated the Senate as the source of honors for (and expectations of) the emperor.[75]

It is tenable that the restoration coins made parallels between Nerva and the Deified Augustus and communicated that his rule would emulate

[70] Levick 1999b: 71–74 discusses further associations between Vespasian and Augustus and Claudius.

[71] See Elkins 2014a: 90–107; 2015: 80–82. The triumphant image of Titus seated among the captured arms of the Jewish War on the reverse of the Colosseum *sestertii* imitates the depiction of Claudius surrounded by the arms of conquered Britons on *sestertii* struck in his reign; the depiction of the Colosseum on most of the *sestertii* may have been based on a vantage point from the Temple of the Deified Claudius. Additionally, there are indications of cultic connections between the Colosseum and the Temple of the Deified Claudius.

[72] Nony 1987: 59–60.

[73] For the family link, see Syme 1958: 2:627–628; 1982: 83.

[74] D. Mannsperger 1974: 967–968; Shotter 1983: 220–221.

[75] Wallace-Hadrill 1986: 76 and 85, following interpretation of Kraft 1962 on the significance of S C as regards the honors bestowed upon the emperor.

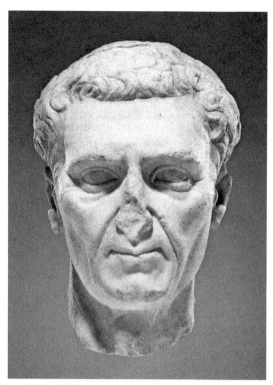

FIGURE 2.29 Portrait head of Nerva. (Image Courtesy of the Getty's Open Content Program. The J. Paul Getty Museum, Villa Collection, Malibu, California.)

that of Augustus. It is very apparent, for example, that the portraits of the Deified Augustus on Nerva's restoration coins look like Nerva in both his numismatic portraits and his portraits in the round (Figure 2.29). Nerva has an angled forehead and a strong, but small, chin. His most distinctive features are a prominent hooked nose and a large Adam's apple. It is not insignificant that Nerva's hairstyle is a throwback to the lightly tousled locks of Augustus and the early Julio-Claudians; Nerva's portraits do not adopt the youthful idealization of the more classicizing Augustan and early Julio-Claudian portraits, but instead convey his advanced age and experience through republican verism.[76] His portraits, therefore, hearkened back to Augustus and perhaps to the Republic as well, although verism had already been revived in later Julio-Claudian and Flavian portraiture. On the restored coinage for the Deified Augustus, the viewer is unsubtly asked to see Nerva in Augustus, and Augustus in Nerva. But it

[76] Daltrop, Hausmann, and Wegner 1966: 109–114; Kleiner 1992: 200; Varner 2004: 118–119.

is not necessarily Nerva himself who was aligning his image with that of the Deified Augustus. Contemporary laudatory poetry portrayed Nerva as a second Augustus. In praise of Nerva, Martial wrote that the gods "have restored Augustus to earth" (Martial 11.3.9: "cum pia reddiderint Augustum numina terris").[77] The language of restoration here also closely mirrors the text used on Nerva's restoration coins. The hairstyle of Nerva's portrait sculptures, the restoration coins for the Deified Augustus, and contemporary adulations all drew parallels between Nerva and Augustus, illustrating a confluence of spoken and written rhetoric and art.

The assignment of the restoration coins to the fifth emission, late in 97, perhaps also enhances the reading of these coins further, as they appear to have been a specially commemorative issue. That the restoration coins marked a specific event may be further indicated by the fact that there are extant medallions of Nerva that depict the Deified Augustus with the S C reverse.[78] It was around October 27, 97, that Nerva adopted Trajan at the Temple of Jupiter Optimus Maximus as his heir in the wake of news of victories in Pannonia (Pliny, *Panegyricus* 8.1–3; *Epitome de Caesaribus* 12.9). The reverse types on the restored coins are of a dynastic quality: the comet marked Julius Caesar's deification (Suetonius, *Divus Iulius* 88); Capricorn symbolized Augustus's conception and the attributes on the coin (the globe, rudder, and cornucopiae) evoked the benefits of Augustan rule (Figure 2.22). Others perhaps alluded to war, victory, and the security of the state: the butting bull (Figure 2.23) may have symbolized the war god Mars; the eagle of Jupiter alighting upon a globe (Figure 2.26) or thunderbolt, and the winged thunderbolt alone (Figure 2.27), invoked the state and Jupiter as the authority from which imperial power is derived (and Jupiter played a major role in Trajan's selection in Pliny, *Panegyricus* 8.1–3); the rudder on the globe (Figure 2.25) was emblematic of guided government. One informative type depicts the Ara Providentia (Figure 2.28), dedicated by Tiberius, which symbolized the designation of a successor on Roman imperial coinage.[79] The restoration coins present Nerva as the founder of a dynasty in the vein of Augustus.[80]

[77] The translation is from the 1978 Loeb edition (Ker).

[78] Mittag 2010: 40 and plate 17 (Ner 1). One medallion from an old sale was 91.3 grams and the edges are raised. It was struck from normal coin dies. A cast in the British Museum depicts a typical coin portrait of Nerva on a medallic flan, but the reverse of the coin was not cast and so it is impossible to say what that medallion celebrated (Mittag 2010: 40, n. 97 and plate 17 [(Ner 2)]). For discussion on the medallions of Nerva of the restored types, see Toynbee 1986: 26, but especially Komnick 2001: 106–108.

[79] Cox 2005; Elkins 2015: 70, 77–78, and 80.

[80] Komnick 2001: 172–175.

Nerva and the Senate

Historians have often maintained that Nerva was the "Senate's man," although some have hypothesized more recently that he was acclaimed by the Praetorians before the Senate or that he was the candidate agreed upon by multiple factions involved in the conspiracy to assassinate Domitian. Whatever the case may be, Nerva came from a noble republican family, the Cocceii Nervae, and many of his ancestors had been prominent in republican politics, such as M. Cocceius Nerva (consul in 36 BC).[81] Nerva's family was also close with the Julio-Claudian emperors; his father was a personal friend of the emperor Tiberius. Although a Flavian loyalist himself, Nerva witnessed firsthand how Domitian compromised the authority and dignity of the Senate. Domitian's apparent disdain for the senatorial aristocracy and his autocratic style are underscored by the use of his imperious title *"Dominus et Deus,"* "Master and God" (Suetonius, *Domitianus* 13.2; Dio 67.4.7).[82] The Senate also suffered under Domitian's rule, as many were executed or exiled on various pretexts.[83] Nerva took a very different approach. He granted senators freedom from the fear of wild accusations and execution. His principate also witnessed the empowerment of senators in imperial government. For example, Nerva appointed senators to his economic commission and his agrarian commission and he consulted with the Senate throughout his brief reign.[84] Three reverse types on Nerva's imperial coinage addressed a senatorial audience specifically.

Suetonius famously quipped that the senators were overjoyed at the news of Domitian's death while the military faction was angered and the plebs were simply ambivalent. The Senate resented Domitian's autocratic style of governance and the abuses that the nobility had suffered in his reign. In particular, the senators under Domitian feared the influence of the informers (*delatores*) who used the Jewish Tax as a weapon against their masters and political enemies. The power of the informers was so great that Tacitus describes armed men surrounding the Senate as fearful members of that body passed the death sentences that the emperor demanded (*Agricola* 45). Vespasian first levied the tax against the Jews as a punishment after the Jewish Revolt. Under the terms of the *fiscus Iudaicus*, the

[81] E.g., Grainger 2003: 28.

[82] On Domitian and the Senate, see Jones 1992. Jones 1992: 109 argues that *Dominus et Deus* was not a title that Domitian formally took for himself but one that sycophants used to address the emperor.

[83] In general, see Jones 1992: 180–192.

[84] E.g., Garzetti 1950; Grainger 2003: 62–63 et passim, with further bibliography.

annual half-shekel tax that Jews had paid for the upkeep of the Temple in Jerusalem (*Exodus* 30:13), which Titus destroyed in 70, was now replaced with the equivalent tax of two drachms, or two *denarii*, for the maintenance of the Temple of Jupiter Optimus Maximus in Rome (Josephus, *Bellum Iudaicum* 7.218; Dio 65.7.2). Domitian exacted the tax rather harshly. According to Suetonius, *delatores* made accusations against "those who led a Jewish life without publicly acknowledging that faith" (i.e., Jewish sympathizers and gentile Christians) and Jews who "concealed their origin and did not pay the tribute levied upon their people" (i.e., apostate Jews and Jewish Christians) (*Domitianus* 12.1–2). Senators were often left destitute or eliminated upon an accusation under the *fiscus Iudaicus*.[85] In 95, just months before Domitian's assassination and Nerva's rise to power, Domitian ordered the execution of the consul Titus Flavius Clemens and several others on the accusation of atheism, a charge with which Jews were sometimes condemned (Dio 67.14.1–2). Apart from the opportunity such episodes allowed for the emperor to dispense with political enemies in the Senate, the state and the informers profited handsomely from the confiscation of senatorial estates when one was found guilty; even when the victim of an accusation was not put to death, his property was typically confiscated. If someone accused of evading the *fiscus Iudaicus* was fortunate enough to be found innocent, the interrogation process itself was nonetheless rather humiliating as the accused faced a public inspection to determine if he was in fact circumcised. Suetonius recounts: "I recall being present in my youth when the person of a man ninety years old was examined before the *procurator* and a very crowded court, to see whether he was circumcised" (*Domitianus* 12.2).[86]

Sestertii of Nerva from his first three emissions depict a palm tree, a Roman emblem of Judaea and Judaism, with the legend FISCI IVDAICI CALVMNIA SVBLATA (Figure 2.30).[87] Much has been made of these coins by modern scholars, as they are a testament to the relations among the Roman government and Jews and Christians in the later first century. Even so, these coins are quite rare according to finds, suggesting they had limited appeal to the majority of viewers within the Roman Empire. Only eighteen are recorded from the 297 *sestertii* from finds and hoards

[85] For detailed discussion of the victims of the *fiscus Iudaicus* under Domitian, various prosecutions, and the confiscation of property, see Heemstra 2010: 32–64 and 134–136. More generally on Jewish and Christian prosecutions/persecutions under Domitian, see Jones 1992: 114–119.

[86] The translation is from the 1950 Loeb edition (Rolfe).

[87] *RIC* II: nos. 58–59, 72, and 82.

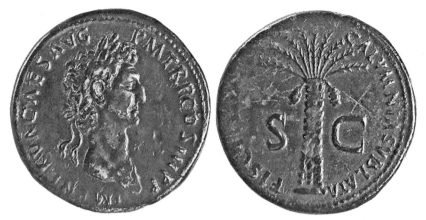

FIGURE 2.30 *Sestertius* of Nerva from January 97 with the FISCI IVDAICI CALVMNIA SVBLATA reverse type. (Courtesy of the American Numismatic Society, 1944.100.42654.)

consulted for this study (appendix 4). How exactly the legend on the coins should be translated has been the subject of debate. In Latin, *fiscus* is not a tax itself, but rather an exchequer or treasury that handled certain imperial revenues and expenses, while *Iudaici* is a genitive noun that refers either to Judaea or the Jews.[88] *Calumnia* is a legal term that denotes a false accusation, and *sublata*, the feminine passive participle of *tollo*, referred to the removal of the *calumnia*. The most straightforward translation of the legend is "the removal of the wrongful accusation of the *fiscus Iudaicus* (Jewish treasury)."[89]

Nerva's *fiscus Iudaicus sestertii* have been interpreted by some to mean that the new emperor completely abolished the tax and the *fiscus Iudaicus*.[90] Others have viewed the coins as indicating a repeal of the tax for Italy only, as other contemporary coin types reflected domestic initiatives in Rome and Italy.[91] *Ostraca* from Egypt that date to very early in Trajan's reign record that Jews there paid the tax and thus there is neither any evidence that Nerva abolished the tax nor is the notion compelling that Nerva only relaxed its enforcement for Roman citizens or Jews in Italy.

[88] Goodman 2007; Heemstra 2010: 69–74; 2012.

[89] Heemstra 2012: 187 for the translation.

[90] Goodman 2005: 176; 2007: 81–89 and followed by Gambash 2015: 166–167. Goodman posits a temporary abolition of the tax by Nerva and then its later reinstatement. To support his case, he points to Egyptian records of the collection of the tax that do not include any receipts from Nerva's reign. Heemstra 2010: 74 points out that Nerva's reign is so brief that their absence is not statistically significant in view of records from much longer reigns, such as Trajan's.

[91] Kubitschek 1933: 9–10; Bruce 1964: 45.

Another theory, which translates *calumnia* as "insult," suggests the coins celebrate Vespasian's exaction of the tax to support the Temple of Jupiter Optimus Maximus, as the Romans were the only valid taxing authority and the previous collection of the tax to support the Temple in Jerusalem had been an insult.[92] This is, however, untenable in view of the legal sense of *calumnia* and the fact that the coin was struck decades later by Nerva, not by Vespasian, who instituted the tax after the destruction of Jerusalem's Second Temple. The coin legend refers specifically to "false accusation," *calumnia*; the fact that the coin uses the singular noun *calumnia*, and that it should be translated as a singular noun, is significant. Heemstra argues that Nerva's reforms required the state to exact the tax using a purely religious definition of Judaism rather than one that was based on ethnicity, ending the abuse of the weaponized charge of atheism that became prevalent under Domitian.[93] It is clear from the evidence of Suetonius and Dio that under the *fiscus Iudaicus* the slippery charge of atheism was abused as a means to an end: to confiscate property to augment the coffers of Domitian and the *delatores*. The coins were struck at Nerva's accession and in the subsequent two emissions to differentiate Nerva's mode of governance from Domitian's. Indeed, Dio suggests that one of Nerva's earliest acts was to decree the release of all who had been on trial for treason (*maiestas*) and the restoration of exiles, and to order the deaths of slaves and freedmen who had informed against their masters; he also forbade accusations of tax evasion under the *fiscus Iudaicus* (68.1.2). Nerva further ordered that disputes between private individuals and the *fiscus*, which had hitherto been adjudicated by a *procurator*, be transferred to a new *praetor* (*Digest* 1.2.2.32). As the *procurator* stood to enhance his own treasury if the accused before him were found guilty, the transference to judgment by a *praetor* allowed for a fairer trial. This reform is almost certainly connected with Nerva's curtailing of abuses under the *fiscus Iudaicus*, but it would have helped complainants with other taxes as well.[94]

Although people across the Roman Empire may have benefitted from Nerva's end to the abuses of the *fiscus Iudaicus*, the primary audience must have been the nobility in Rome and Italy who were most vulnerable to accusation under Domitian and who could lose both their valuable properties and their lives if found guilty. The rarity of the type would also suggest that the

[92] Hendin 2010: 458, which summarizes the otherwise unpublished theory by David Vagi.
[93] Heemstra 2010: 32–66; 2012: 189–195. The most affected group was Jewish sympathizers and gentile Christians, who were the primary victims of the *fiscus Iudaicus* in Domitian's reign.
[94] Heemstra 2010: 71.

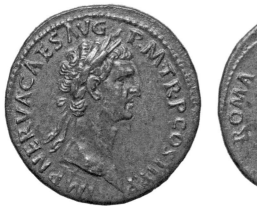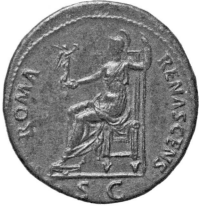

FIGURE 2.31 *Sestertius* of Nerva from September 96 with the ROMA RENASCENS reverse type. (© Bibliothèque nationale de France.)

image had a rather narrow audience. It merits noting also that, although the coin type is quite rare, the reform it marks had profound implications for world history. The removal of the *calumnia* necessitated that the government define Judaism in a religious way rather than to make ethnic distinctions. Nerva's reign thus marks a point when the Roman state began to differentiate more precisely between Jew and Christian.[95]

Sestertii depicting Roma seated holding a spear and a Victoriola with the legend ROMA RENASCENS, "Rome Reborn," are very rare despite the fact that they were struck in Nerva's largest emissions: the first and the third (Figure 2.31).[96] Out of 297 *sestertii* from recorded finds, there are only five bearing this reverse type (approximately 1.68 percent of the total; appendix 4). In Roman art, Roma typically appears as an Amazon-like figure with a short tunic and exposed right breast or in a long dress, more like Minerva; she can also appear as a sort of hybrid with an exposed breast and a long dress.[97] Curiously, Nerva's type is often misconstrued in specialist literature as representing Roma in the guise of Minerva as guardian of the city, as she wears the longer dress. This has led to speculation that the reverse type was somehow related to Nerva's dedication of

[95] Heemstra 2010: 32–66; 2012: 189–195. The distinction is typically referred to as the "parting of the ways." The removal of false accusation under the *fiscus* may also have incentivized Christians to differentiate themselves more from Jews to escape the burden of the tax, e.g., Williams 2013: 165–166.

[96] *RIC* II: nos. 67, 91

[97] Vermeule 1959; *LIMC* VIII.1 (supplement), 1997: 1048–1068, s.v. Roma (Balestrazzi); Schmidt-Dick 2002: 96.

the Forum of Nerva with its Temple of Minerva or that "Minerva-Roma" connoted Nerva's pacific outlook, as "Amazon-Roma" is presumably a more belligerent figure.[98] In the latter interpretation, one again observes an insistence on reading something of Nerva's perceived "weak" character into his coinage; such an approach is flawed if a theorized understanding of state-sanctioned Roman art is to be deployed. In any case, there are no grounds on which to identify the figure as "Minerva-Roma." On well-preserved specimens of this rare coin type, it is clear that Roma's right breast is exposed like "Amazon-Roma," although she wears the longer dress associated with Minerva; she is thus a hybrid figure in a technical or formal sense, not to be conceived of as a literal melding of the two deities as "Minerva-Roma."[99] On coinage, Roma tends to wear a longer dress in the second and third centuries, as on coins of Hadrian and Antoninus Pius, the Severans, and the "soldier emperors," where she is seated holding a Victoriola and spear with the legend ROMA AETERNA. The longer dress is attributable to iconographic variation without any significant ideological meaning behind it. That Roman viewers would have thought something different of Roma simply because her knees are covered, that is, that she would be a pacifist while she still wears a helmet and bears emblems of war and victory, would be inordinately subtle.

The depiction of Roma along with the explanatory legend ROMA RENASCENS denotes the general meaning of the type: Rome is reborn under Nerva's rule, an idea also intimated in Martial's contemporary poetry, in the eleventh and twelfth books, where Nerva is portrayed as a liberal monarch in opposition to Domitian, Augustus restored to the earth, or a Numa (e.g., 11.2.6; 11.3.9; 11.5.1–4; 12.3.7–12[6.7–12]; 12.5[2+6.1–6]). Under Galba and Vitellius, coins bearing the legend ROMA RENASC(ENS) and representing Roma advancing carrying a Victoriola on a globe and a spear must be read as a retort to Nero, who was cast a tyrant.[100] Nerva's type was directed toward a senatorial audience who, according to Suetonius, already viewed Domitian as a tyrant and who had suffered under his principate.[101] Nerva's reign promised something different for the Senate; it offered freedom from prosecution and accusations by

[98] Merlin 1906a: 41–43; *BMCRE* III: xlviii on the pacific interpretation. Shotter 1983: 221 on a connection with the Forum of Nerva.

[99] Schmidt-Dick 2002: 100 makes the same observation on this type.

[100] *BMCRE* I: cxciii; Ramage 1983: 207. For the types, see *RIC*[2] I: (Galba) nos. 24–29, 160–162, 194–197, and 200–204; (Vitellius) no. 45; (Civil Wars) nos. 8–9, and 10.

[101] Shotter 1983: 221 and Grainger 2003: 59 imply a senatorial audience for the type.

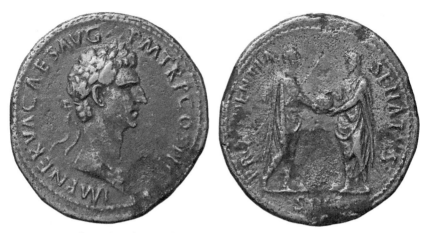

FIGURE 2.32 *Sestertius* of Nerva from January 97 with the PROVIDENTIA SENATVS reverse type. (© Bibliothèque nationale de France.)

informers, and it saw the enfranchisement of senators in Nerva's administration. For the Senate, Rome truly was reborn.

Sestertii from Nerva's third emission in early 97 depict Nerva and the *genius* of the Senate holding a globe between them with the legend PROVIDENTIA SENATVS, "foresight of the Senate" (Figure 2.32).[102] The coins are very rare as only two were recorded in the 297 *sestertii* from hoards and finds consulted for this study: a specimen in Germany and a specimen in France in the Garonne Hoard (appendix 4). The type is thus one of the rarest of Nerva's *sestertii*, alongside his *adlocutio* type and his Annona type. The rarity of the type is understandable in view of the small number of senators living in Rome when compared with the vastness of the city's population and, of course, the exponentially larger populations of Italy and the provinces. In view of Nerva's inclusive treatment of senators in his governance, the coin type is sometimes read as reflective of a sort of "joint rule" between the *princeps* and the *senatores*.[103] Mattingly observed that the *genius* of the Senate has both hands on the globe as he passes it to Nerva, signifying only a partial transference of power to Nerva, but, rightly, viewed the coins in the context of an earlier type of Titus that depicts Vespasian passing a globe to Titus with the legend PROVIDENT(IA) AVGVST(I), "foresight of the Augustus."[104] Understanding the coins as expressions of "hope" for stability at the beginning of the New Year are wholly untenable

[102] *RIC* II: no. 90.
[103] Merlin 1906a: 56–60; Strack 1930:45–48; implied by Hannestad 1988: 145–146.
[104] *BMCRE* III: xlix; *RIC*² II.1: nos. 161–162.

based on anything the coins represent.[105] In Roman thought, *providentia* meant "foresight" and also had dynastic connotations. The appearance of the Ara Providentia on coins of Tiberius in honor of the Deified Augustus and on coins of the civil wars and of Vespasian symbolized the establishment of a new dynasty.[106] Mattingly overinterpreted the coins in his reading that the Senate passes only a share of the administrative burden to Nerva, refusing to give him the whole globe.[107] After Nerva's death, Trajanic *denarii* depict a globe passed to the emperor by the *genius* of the Senate with the legend PROVID(ENTIA); some *sestertii*, which do not bear a descriptive legend, depict the exact same scene as Nerva's *sestertii* with both of the *genius*'s hands on the globe passing it to Trajan.[108] A diarchal interpretation of Trajan's coin is, of course, absent from the scholarship, despite the exactitude with which it replicates Nerva's *sestertii*, because scholars have continued to read something of an emperor's personality or character into the coinage and Trajan is characterized as strong whereas Nerva is perceived as vulnerable and weak. But Nerva's and Trajan's coins depict the same thing: the designation of the *princeps* by the Senate. On Titus's coins, Vespasian was depicted transferring power, as Titus succeeded by means of dynastic succession. The Senate was responsible for Nerva's succession and Trajan's coins also acknowledged the role the Senate played in the investiture of imperial power.[109]

The PROVIDENTIA SENATVS *sestertii* appeared only in Nerva's third emission of around January 97. This is unusual, as the *adlocutio* types, which marked Nerva's imperial acclamation by the Praetorian Guard, appeared in his accession emission. The type celebrating the Senate's role in Nerva's elevation to *princeps* would seem to have been more appropriate in the accession emission as well.[110] Nonetheless, the historical

[105] *Contra* Shotter 1978a: 164, who states the type presents "the hope of ordered government, and thus the opportunity for indicating the desired nature of that ordered government." And *contra* Shotter 1983: 221, who views the coins as expressing a "hope that with the opening of the year, stability might be achieved." These interpretations are supported neither by the iconography nor the legend. It is also negative reading of Nerva's coin iconography, which as a medium of state-sanctioned art would have been necessarily more positivistic. Mischaracterizations such as these have these have plagued the interpretation of Nerva's "military types" with suggestions that the coins expressed "hope" or were "aspirational" or "apologetic" (chapter 1).

[106] Cox 2005.

[107] Diarchy is more tentatively suggested by Charlesworth 1936: 116.

[108] On Trajan's *providentia* types, for the identification of the second figure as the *genius* of the Senate (not Nerva), see Méthy 2000: 378–380; Seelentag 2004: 78–87. See also Morelli 2014: 317–318 with reference to Nerva.

[109] Pliny, *Panegyricus* 71 describes the Senate's acclamation of Trajan as emperor.

[110] Cf. Seelentag 2004: 68–87, who reads Trajan's *providentia* types and his *adlocutio* types as complementary with one another as they both appeared in 98 in his accession year.

context may provide some explanation as to the Senate's recognition on the coinage in early 97. Nerva formed a commission of five senators to evaluate a potential economic crisis in view of increased expenditures (Pliny, *Epistulae* 2.1.9; *Panegyricus* 62.2). The reality of a potential crisis is debated and the formation of the commission may have been showmanship, although it illustrates Nerva's inclusiveness of the Senate in imperial governance.[111] It is known that an offer of membership was made to Lucius Verginius Rufus, who refused it as he had broken his hip. The offer to Rufus helps establish a timeline for the formation of the commission: he died in late 97, after which the suffect consul, Tacitus, delivered his funeral oration; Rufus had broken his hip preparing a speech of thanks to Nerva for his consulship (Pliny, *Epistulae* 2.1.5–9). The offer must have been extended between March and October 97, which makes the formation of the commission contemporary with Nerva's third emission of coinage that began in January 97 (the fourth emission began in September 97).[112] Dio states that Nerva also formed a senatorial commission to purchase and distribute lands worth 60 million *sestertii* to the poorest of Roman citizens (68.2.1), and one might assume another senatorial commission for the *alimenta* program.[113] Based on the popular initiatives undertaken for Rome and Italy early in Nerva's reign, the establishment of these commissions may be dated to late 96 and early 97. It was also at the beginning of the New Year that many senators took up their new gubernatorial posts in the provinces to which they were appointed by Nerva.[114] After his accession, Nerva made some important appointments in Rome, including a new Praetorian prefect, potentially a new urban prefect, and a new *curator aquarum*. In fact, the new *curator aquarum*, Frontinus, ascribes his investigations and improvements in the efficiency of Rome's water supply to Nerva's *providentia* (*de Aquis* 64; 87).[115] Imperial and senatorial visions of foresight were thus part of the contemporary political rhetoric as regards the public dialogue between the *princeps* and the Senate. The theme of senatorial foresight on the coinage does not necessarily derive from the emperor or a close advisor to curry senatorial favor. It could, instead, have originated from the adulatory rhetoric and praise in senatorial circles in recognition

[111] Syme 1930; Sutherland 1935: 150–153; Grainger 2003: 54–65.

[112] For the date, see Syme 1930: 61; 1958: 1:150 and 416–417; Grainger 2003: 56.

[113] Grainger 2003: 66.

[114] Grainger 2003: 62–65 with further bibliography on urban and provincial appointments from among the Senate.

[115] See also the discussion by Peachin 2004: 114 on Nerva's *providentia* with regard to the water supply.

of Nerva's inclusion of them in imperial governance, and also as a sort of self-aggrandizement for the body that selected an enlightened *princeps*.

Coin Finds and Audience Targeting in Rome and Italy

The iconography and accompanying legends on many of Nerva's coins indicate that messages were directed toward specific audiences in Rome and Italy, namely the *plebs urbana*, the Italian public, and the Senate. All of these coins that bore specific messages about Nerva's policies and how they affected these constituent groups are also quite rare in excavated finds, save for the common *quadrantes* that circulated in Rome. The *quadrantes* aside, this suggests that these coins were not produced in the same volume as coins bearing more generalized images such as Libertas Publica, Aequitas Augusti, Fortuna Augusti, and so on (chapter 3). If one accepts that images and texts on coins carried ideological messages and that communication was an important function of Roman imperial coin iconography, the comparative rarity of many of these types is easily explained. The senatorial nobility would have numbered only around 600 following Augustus's reorganization of the Senate; the *plebs frumentaria*, who benefitted from the *frumentum* and *congiarium*, numbered approximately 150,000; and the more general *plebs urbana* was somewhat higher than that. The population of Italy included millions of people, although only a fraction would have been citizens. All of these population numbers are, however, rather insignificant when considered in the context of the population size and geographical extent of the Roman Empire. Coins directed toward the Senate, the *plebs urbana*, and the population of Italy are rare because they were a very small target audience when compared with the rest of the Roman Empire, even though the Senate and common citizens in Rome and Italy were clearly very important audiences.

The assumption that these coins resonated most with constituent groups in Rome and Italy, and were targeted specifically at them, may be tested by attending to coin finds in Rome and Italy and comparing the typological makeup with coins found in provincial cities and regions outside of Italy. In doing so, complications arise. As precious-metal coinage was more mobile than base-metal coins, such regional comparisons must focus on the base-metal coinage. One cannot easily break down the base-metal coinage by emission, as one does with large hoards of *denarii*, because Nerva's short reign limits the number of base-metal finds from individual sites and large accumulations in hoards tend to be composed of

precious-metal. Historically, coin finds are typically better recorded in northwestern Europe than in Italy and thus evidence is skewed toward the provinces where there are larger samples. It is harder still to access a significant number of coins from the city of Rome. During the Italian Risorgimento, when many of Rome's ancient monuments were cleared, coins and other artifacts were removed en masse without any useful degree of identification for typological analysis. Late nineteenth-century Italian journals typically provided the most basic of identifications—for example, "32 *asses* of Vespasian"—that do not inform most studies well.[116] But a significant group of over 38,000 coins, recovered from construction along the coast of the Tiber River in Rome and from excavations in the city between 1877 and 1890, was identified by the Fundmünzen der Antike group, led by Maria R.-Alföldi, in 1990 and 1991. The coins were stored in five wooden boxes at the Museo Nazionale alle Terme in Rome, where they had been since 1936 when these low-quality coins were destined to be melted at the behest of Mussolini's government. That, fortunately, never happened. These coins are referred to as the "*sottosuolo urbano* I" (SSU I) complex. In the first decade of the twentieth century, the keeper of the coin cabinet at the Museo Nazionale in Rome had already sorted out and accessioned 11,300 well-preserved coins into the collection. The series of coins has great historical significance and is by far the largest group of coin finds from the city of Rome.[117] "*Sottosuolo urbano* II" (SSU II) is a smaller group of coins that were stored in the Capitoline Museums and not picked through.[118] For a typological analysis, there are concerns owing to the history of the SSU I finds complex, while SSU II represents an unadulterated sample. Not only were better-preserved coins, and probably more rare and visually interesting types such as those that relate to concrete aspects of policy, sorted out of SSU I for the coin cabinet's collection, there are indications that people were allowed to purchase coins from the Rome finds stored at the Museo Nazionale in the late nineteenth and early twentieth centuries.[119] As coins were removed by the curator and by collectors before the group of finds was properly inventoried, this

[116] See also Bertoldi 1997.

[117] Lists of the coin finds remain at present unpublished, although they have been made available to researchers. Thanks are owed to Hans-Markus von Kaenel for granting me access to the Flavian to Trajanic lists for my research. Holger Komnick was responsible for the identification of the Flavian finds, including Nerva, and David Wigg-Wolf was responsible for the Trajanic finds.

[118] See Lanna and Molinari 2015 on the SSU II finds.

[119] On the historical circumstances of the SSU I find complex and the selection processes affecting it, see von Kaenel 1984: 85–90; R.-Alföldi 1991; Komnick 2000: 544.

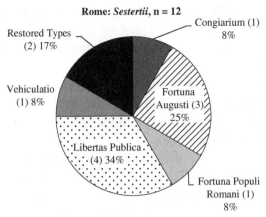

FIGURE 2.33 The typological makeup of *sestertii* from Rome (data derived from SSU I and II).

certainly creates a bias against the representation in the lists of rarer and denotative types, that is, the types that hypothetically were targeted at the *plebs urbana*, Italians, and the Senate. Although there are negative selection processes affecting the SSU I finds, it would be impractical to dismiss them from consideration as the SSU II complex is too small on its own to make any meaningful observations on Nerva's short reign.

Even with the two complexes combined, there are only twelve identifiable *sestertii* from Nerva's reign in the Rome finds. Although this number is small, it is very difficult to find so many of Nerva's *sestertii* from any single site in the western Roman Empire in view of his sixteen months in office. And, indeed, it is the *sestertii* that typically carried the defined messages relevant to the urban plebs, the Senate, and Italian citizenry. *Sestertii* are generally rarer in excavations when compared with smaller denominations, on account of their greater value, which would have caused people to search harder for lost *sestertii* and the larger diameter of the coins that assisted in their recovery.[120] Figure 2.33 represents the typological makeup of *sestertii* from the city of Rome. One Fortuna Populi Romani type, one *congiarium* type, one *vehiculatio* type, and two restored types of the Deified Augustus are present. Each of these types is quite

[120] An exception is the coinage recovered from Roman Britain under the Portable Antiquities Scheme, where there is a remarkable prominence of *sestertii* (22) when compared with *dupondii* (16) and *asses* (27) (appendix 4). This has nothing to do with the coin supply to Britannia or the greater frequency of *sestertii* there in antiquity. Instead, it is a reflection of the fact that artifact hunters using metal detectors will more easily pick up a signal from a large coin like a *sestertius* (Walton 2012: 29).

rare when viewed in the context of their frequencies within the aggregate group of 297 *sestertii* (appendix 4), making their appearance in the Rome finds quite remarkable in spite of the rather statistically insignificant size of Rome's sample.

In the provinces, modern Austria and Germany present some of the most extensive records of coin finds from excavated sites, especially sites that witnessed much activity in the late first and second centuries. Even so, *sestertii* of Nerva do not appear in significant numbers from any single site. For example, at Mainz there are five identifiable *sestertii*, seven in the area of modern Frankfurt am Main, and five from the settlement at Carnuntum. As Rome's number of *sestertii* is already low, it is worth considering the total number of *sestertii* from the militarized area of Mainz and Taunus-Wetterau region as a whole. Figure 2.34 illustrates the typological breakdown of the nineteen *sestertii* from this active region. This larger sample contains one restored type for the Deified Augustus, one Roma type, one *fiscus Iudaicus* type, and one *vehiculatio* type. Although the numbers in the two datasets are small, it is perhaps not coincidental that nearly half of the *sestertii* from Rome are uncommon types that carried specific messages aimed at an urban and Italian audience while about 20 percent of such coins appeared in the group from Mainz and the Taunus-Wetterau area.

The largest single find of Nerva's *sestertii* is the Garonne Hoard from southern France, in the Roman province of Aquitania. There are 145

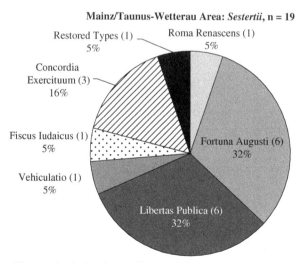

FIGURE 2.34 The typological makeup of *sestertii* from the area of Mainz and the Taunus-Wetterau (data derived from *FMRD* IV.1; IV.1.N1; V.1.1; V.1.2; V.2.1; V.2.2).

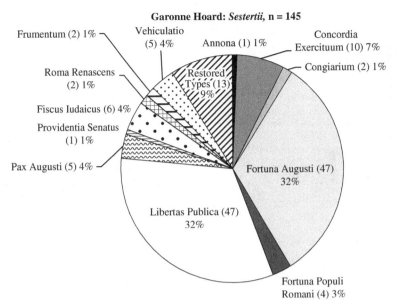

FIGURE 2.35 The typological makeup of *sestertii* from the Garonne Hoard (data derived from Étienne and Rachet 1984).

sestertii of Nerva in this group of coins and so it naturally represents a greater variety of types one might expect to have communicated best with an audience in Rome and Italy: one of the exceedingly rare Annona types, two *frumentum* types, six *fiscus Iudaicus* types, five *vehiculatio* types, two *congiarium* types, one of the very rare PROVIDENTIA SENATVS types, two ROMA RENASCENS types, four Fortuna Populi Romani types, and thirteen restored types for the Deified Augustus (Figure 2.35). Nonetheless, when considered in proportion to the size of the sample, about 25 percent of the *sestertii* from the Garonne Hoard have images relevant to Italians and the urban audience of Rome, which contrasts with the much greater proportion of such types from the smaller sample in Rome, which is composed of nearly 50 percent of such types. One is reminded as well of the negative selection processes affecting the Rome finds (SSU I): well-preserved and rare types were accessioned into the Museo Nazionale's collection before the group was set aside for destruction, and collectors may have had the opportunity to purchase coins from the group; collectors also typically prefer rarer types that refer to concrete aspects of history, such as the *congiarium* type or the *vehiculatio* type, over more common images such as Libertas Publica or Fortuna Augusti that connoted generic ideals. Such types aimed at the urban and Italian audience must have been even more prominent in the sample prior to its pilfering.

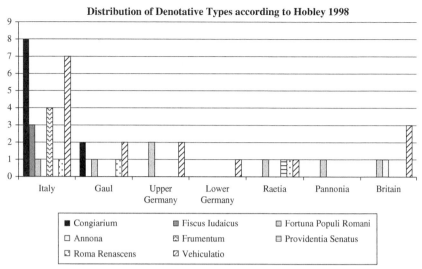

FIGURE 2.36 The find spots of denotative *sestertius* types (data derived from Hobley 1998: 35–36).

Hobley's collation of finds, which must be used with some caution as the material from the northwestern provinces is several decades out of date and the Italian numbers are largely based on museum collections, also implies that *sestertii* with more denotative images are more abundant in Italy than elsewhere (Figure 2.36). This, of course, assumes that Italian public collections were built on local finds and indeed many were established long ago.[121] But curators will also have preferred to acquire visually interesting and rare historical types of the sort that communicated with audiences in Rome and Italy, and so the argument easily becomes circular.

With the exception of the Neptune *as* and the restoration types, Nerva's *dupondii* and *asses* bore reverse images and legends that generally connoted broader ideals about Nerva's principate (chapter 3). One would expect the Neptune *asses* to be more prominent in Italian finds, although they are completely absent in Italy, while finds are concentrated in Britannia. In this case, there is an apparent anomaly in the coin supply to Britannia, perhaps related to the founding of the colony of Glevum under Nerva. The Neptune *asses* are remarkably rare with only sixteen extant types known; the denomination itself is otherwise abundant. Owing to the relatively poorer state of recorded finds from Italy until recently, it is of little surprise that no specimens have yet been recorded in Italy. Some *sestertii,*

[121] Collections Hobley consulted include Padova, Milan, Aquileia, and Naples; see Hobley 1998: 2.

dupondii, and *asses* also represented the Deified Augustus, restoring his coin types or those of Tiberius or Titus, linking Augustus's establishment of a dynasty with Nerva's own Augustan style of governance and Nerva's adoption of Trajan as his heir. It is apparent in the *sestertii* found in Rome that the restored types for the Deified Augustus are proportionately more predominant in Rome, as Komnick has already observed. Comparison between the typological composition of the *dupondii* and *asses* from the *sottosuolo* complexes in Rome and from other sample areas also illustrates different concentrations of the restored coinage in Rome versus the provinces (for *dupondii*, compare Figure 2.37 with Figure 2.38; for *asses*, compare Figure 2.39 with Figures 2.40 and 2.41, although Carnuntum's number of restored *asses* is congruent with Rome).

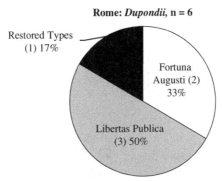

FIGURE 2.37 The typological makeup of *dupondii* from Rome (data derived from SSU I and II).

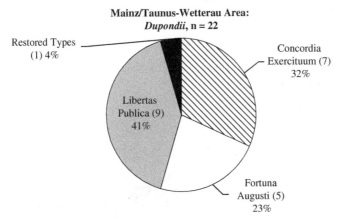

FIGURE 2.38 The typological makeup of *dupondii* from the area of Mainz and the Taunus-Wetterau (data derived from *FMRD* IV.1; IV.1.N1; V.1.1; V.1.2; V.2.1; V.2.2).

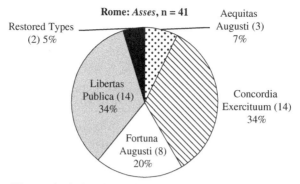

FIGURE 2.39 The typological makeup of *asses* from Rome (data derived from SSU I and II).

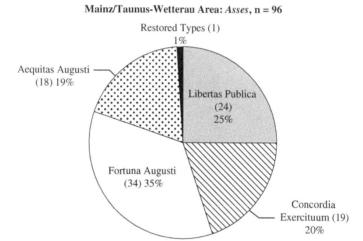

FIGURE 2.40 The typological makeup of *asses* from the area of Mainz and the Taunus-Wetterau (data derived from *FMRD* IV.1; IV.1.N1; V.1.1; V.1.2; V.2.1; V.2.2).

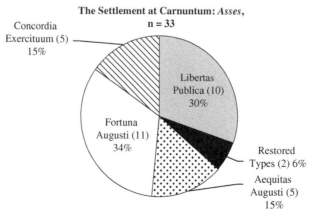

FIGURE 2.41 The typological makeup of *asses* from the settlement at Carnuntum (data derived from *FMRÖ* III.1).

The rarity of types aimed at the urban audience of Rome coupled with the short duration of Nerva's reign compound the difficulties in identifying target audiences according to various find complexes, which present their own problems. While the evidence available is not unequivocal, it is nonetheless suggestive of the predominance of these relevant types in Rome and Italy. The people of Rome and Italy and the Senate were important government constituencies, but the sizes of those populations were dwarfed by the numbers of citizens and subjects living in the provinces. The vast majority of coins struck in Nerva's reign bore images of personifications that broadly connoted imperial values and ideals. These broader concepts not only could be relevant to an extra-urban and extra-Italian audience but also allowed the opportunity for all people to bring their own meaning to the images and ideals represented.

CHAPTER 3 | Nerva and the Roman Empire

Nerva Caesar mingled things formerly incompatible: the principate and liberty.

—TACITUS, *Agricola* 3.1

THE MOST COMMON images on Nerva's imperial coinage conveyed general ideas about Nerva and his administration through the depiction of personifications with their various attributes: Fortuna clasps her directional rudder and bountiful cornucopiae; Aequitas carefully holds her balance and cradles cornucopiae containing the benefits of fairness; Iustitia appropriates Pax's olive branch and scepter to show her role in the preservation of peace and stability; and Libertas grasps the rod with which she frees slaves before presenting them with a freedman's cap, an emblem of their new status.[1] Symbols of priesthoods also appear on Nerva's coinage to convey imperial piety. Imagery on Nerva's coinage was not unique in its emphasis on generic ideals communicated visually through the representation of personifications and symbols. Indeed, personifications of divine qualities and ideals commonly appeared on the art and coinage of the Roman Republic and was a practice inherited from the Greeks.[2] From the latter part of the first century through the third century, such images dominated the imperial coinage and also mirrored a shift in historical texts in which

[1] The attributes that personifications carried were critical for their intelligibility to a viewer in the absence of explanatory labels, although textual evidence indicates ancient viewers sometimes misinterpreted personifications (Hughes 2009: 8–11). Nerva's coinage typically bears denotative legends making the personifications immediately intelligible, at least to literate or semiliterate populations.

[2] Hölscher 1980: 273–279; Clark 2007: 11–13 et passim. Cf. Shapiro 1993.

subjects are judged by their qualities.[3] Nonetheless, the proliferation of personifications on the imperial coinage in general, and their repetition across denominations and reigns, has led modern viewers to characterize them as boring, uninteresting, or repetitive. Worse, this modernizing sentiment has been imposed upon their ancient function as some have declared them to have been meaningless and to have been relatively ineffective communicators of imperial ideology.[4] But if Roman imperial coinage is to be understood as a medium of state-sanctioned art, which was above all else a visually communicative system, personifications and their associated symbols must have communicated at least as potently as "historical types" that denoted specific events such as victories, public building, monetary and grain distributions, games, and so on.[5] Images of personifications communicated different things in different contexts and could have had a powerful impact on viewers and social constructs on account of their "pervasive banality" in any particular period.[6] Under Nerva, contemporary writers ascribed to the emperor many of the same qualities we see heralded on his coinage: *pietas, libertas, providentia, aequitas,* and *iustitia.* The coinage thus reinforced the political rhetoric that was prominent in both text and speech during Nerva's principate. Personifications and emblems not only successfully communicated broad imperial ideals to audiences across the Roman Empire; they were the most successful communicators precisely because of their nonspecific character that allowed the empire's diverse population to bring its own meaning to the images according to the nature of its interface with the central regime and the sorts of benefits it received from imperial rule.

The proliferation of imperial ideals on the coins, sometimes referred to as "imperial virtues," in the latter part of first century and in the second century reflects, as Burnett observed, the tendency in the literary culture in that era to judge a ruler by his "good" or "bad" qualities. A trope in the age of Nerva, Trajan, and Hadrian across various literary genres, including Martial's epigrammatic poetry, Frontinus's book on aqueducts, Pliny's panegyric and letters, Tacitus's historical texts and his funeral oration of Agricola, and Suetonius's biographies, was to praise the current regime

[3] Burnett 1987: 78–79; Noreña 2001; 2011a; Weil 2005. Personifications are also common on Roman imperial relief sculpture, especially in the second century; see, for example, Hamberg 1945: 15–45.

[4] E.g., Burnett 1987: 79 on the third century; Duncan-Jones 2005.

[5] Beckmann 2009 *contra* Duncan-Jones 2005. On the communicative value of personifications on the imperial coinage, Noreña 2001 and 2011a are most essential.

[6] Cf. Yarrow 2013: 349 et passim on the pervasiveness of Heracles on western Hellenistic coinage.

by pointing to the positive qualities of virtuous emperors and to blame bad emperors for their vices (*epideixis*), both of which served as positive and negative exempla for those living in the present; for these writers, the ghost of Domitian as a sort of scapegoat loomed especially large.[7] Even Juvenal's satires adopt the trope and, in so doing, satirize it.[8] Pliny quite explicitly explains the purpose of his "praise and blame" technique:

> All that I say and have said, Conscript Fathers, about previous emperors is intended to show how our Father (Trajan) is amending and reforming the character of the principate which had become debased by a long period of corruption. Indeed, eulogy is best expressed through comparison, and, moreover, the first duty of grateful subjects towards a perfect emperor is to attack those who are least like him: for no one can properly appreciate a good prince who does not sufficiently hate a bad one. Furthermore, no service of our emperor's has spread so far in its effects as the freedom he allows us to criticize bad rulers with impunity. Have we already forgotten in our troubles how Nero was but lately avenged? Can you imagine that he (Domitian) would have allowed the breath of criticism to fall on Nero's life and reputation, when he avenged his death? Would he not guess that anything said against one so like himself could be applied to him? And so in your case, Caesar, alongside all your other benefits and above many of them, I set our freedom to avenge ourselves daily on the evil emperors of the past, and to warn by example all future ones that there will be neither time nor place for the shades of disastrous rulers to rest in peace from the execrations of posterity. With all the more assurance, Conscript Fathers, can we therefore reveal our griefs and joys, happy in our present good fortune and sighing over our sufferings of the past, for both are equally our duty under the rule of a good prince. This then must we make the subject of our private talk, our public conversation and our speeches of thanks, never forgetting that an emperor is best praised in his lifetime through criticism of his predecessors according to their deserts. For when an evil ruler's survivors hold their peace, it is clear that his successor is no better. (*Panegyricus* 53)[9]

[7] E.g., Syme 1958: 1:86–99 and 217–235; Wallace-Hadrill 1983: 142–174 *et passim*; Ramage 1989; Mellor 1993: 47–67; Coleman 2000; Freudenburg 2001: 209–242; Nauta 2002: 440; Flower 2006: 262–270, and more generally 234–275 on the shadow of Domitian; Spisak 2007: 70–71; Gibson 2011; Keane 2012; Pernot 2015.

[8] E.g., Freudenburg 2001: 256–258; Keane 2012: esp. 411–412.

[9] The translation is from the 1969 Loeb edition (Radice). Cf. also *Epistulae* 3.18.2, where Pliny writes that the *Panegyricus* is meant to recommend virtues to the emperor. The "praise and blame" trope had also been a component of the literature of the Roman Republic, for example, see Smith and Covino 2011; Pernot 2015: 8–9.

Pliny's endorsement and deployment of the epideictic technique here attacks Domitian who punished assaults on Nero since such criticisms could be interpreted as attacks on himself.[10] This theme of *libertas* restored was integral to the laudatory and epideictic rhetoric of Nerva's and Trajan's Rome, and was taken up not only by Pliny throughout his panegyric but also by Martial in his eleventh and twelfth books, and by Tacitus in the *Agricola*, at the outset of *Historiae*, and in the *Annales* to praise the emperors of the new era. Martial's eleventh book, written early in Nerva's reign around December 96, has as its subject the Saturnalia and the spirit of license and liberty now permitted by Nerva (esp. 11.2).[11] So great is Nerva in this respect that he has surpassed his republican forbearers, and Martial reckons that even Cato would be a Caesarian accepting of this prince (11.5).[12] Martial points to Domitian's negative qualities to contrast him with Nerva's positive characteristics, as in his description of Domitian as "harsh" and Nerva as "mild" (12.3.11–12; 12.5.3).[13] Writing in the reign of Trajan, Tacitus too praised the emperors of the present by criticizing those of the past. In the opening lines of the *Historiae*, Tacitus refers to the ghosts of the past and promises to write in his old age a history of Nerva's and Trajan's reigns, something he could do owing to the rare happiness of the age in which people may "feel what they want and say what they feel" (1.1).[14] The *Annales* similarly has *libertas* as a major theme and the history of the "good" and "bad" emperors and characters serve as exempla for the present, while Domitian's tyranny is contrasted with Nerva's mingling of the principate and *libertas* in the *Agricola* (3.1).[15] Frontinus's *de Aquis* attributes the significant administrative reforms he implemented as *curator aquarum* to Nerva and Trajan, whose qualities such as foresight (*providentia*) and justice (*iustitia*) made them better and more commendable than Domitian and his corrupt administration.[16] In the minds of writers at the end of the first century and at the dawn of the second century, Nerva and Trajan were Domitian's antidotes in their provision of *libertas* and license and through their possession of positive qualities that Domitian had lacked. Personifications of positive imperial

[10] Coleman 2000: 22–23; Bartsch 2012: 160–161.
[11] Kay 1985: 1–6 et passim; Sullivan 1991: 219; Morford 1992; Coleman 2000: 33–35; Nauta 2002: 437–440; Fearnley 2003: 622–626; Rimmel 2008: 162–180.
[12] Gowing 2005: 105; Rimmel 2008: 164.
[13] Spisak 2007: 70–71; Rimmel 2008: 166.
[14] Sailor 2008: 119–121. Of course, that promised history was unfortunately never delivered.
[15] Coleman 2000: 23–25; Sailor 2008: 66–69 et passim; Mellor 2010: 78–92; Woodman and Kraus 2014: 8 and 21 et passim; Penwill 2015; Strunk 2016.
[16] Peachin 2004: 114–127.

FIGURE 3.1 *Denarius* of Nerva from January 97 with priestly emblems on the reverse. (Yale University Art Gallery, 2005.6.221, Gift of James H. Schwartz.)

qualities on the Roman imperial coinage of this era thus reflected the same ideals and qualities for which the living emperors were praised by historians, poets, and panegyrists, but also underscored expectations of these emperors in contrast with the maligned administration of Domitian, who by comparison lacked qualities such as *libertas* or *iustitia*.

Pietas

Some *aurei* and *denarii* of Nerva depict priestly emblems, specifically a *simpulum* (ladle), sprinkler, *praefericulum* (ewer), and *lituus* (crooked wand) (Figure 3.1).[17] The images were struck on *denarii* beginning in the second emission around December 96 and continued through Nerva's sixth and final emission in January 98; the same images appeared on *aurei* from the third emission at the beginning of 97 through his last. The legends on the reverses of these coins only continue the emperor's titles from the obverse of the coin and do not denote the meaning of the imagery, which has caused some disagreement as to the significance of the symbols. Merlin argued that the coins celebrated the emperor's customary election to the four highest priestly colleges: the *pontifices* (symbolized by the *simpulum*), the *augures* (who carried the *lituus*), the *quindecimviri sacris faciundis* (with the sprinkler as a substitute for the more traditional attribute of the tripod), and the *septemviri epulones* (with the *praefericulum*

[17] *RIC* II: nos. 12, 23–24, 41, and 47.

FIGURE 3.2 *Aureus* of Claudius for Nero Caesar from 51–54 with priestly emblems on the reverse. (Courtesy of the American Numismatic Society, 1954.256.7.)

replacing the *patera*).[18] The symbolism of the *simpulum* and *lituus* are immediately clear as the implements of the *pontifices* and *augures*, respectively, although that of the sprinkler and *praefericulum* required Merlin to see them as substitutes. Kubitschek rejected the explanation and instead read the coins as a general reference to religious piety.[19] Mattingly examined the types within the context of similar images on the earlier coinage of the Republic and of the Julio-Claudian and Flavian periods in order to discern the meaning of the imagery on Nerva's coinage.[20] Typically such images are not accompanied by an explanatory legend, but *aurei* and *denarii* of Claudius struck for Nero as Caesar with the descriptive legend SACERD COOPT IN OMN CONL SVPRA NVM EX S C indicate Nero's admission to the four priestly colleges (Figure 3.2).[21] These coins depict the *simpulum* and *lituus* alongside a tripod (for the *quindecemviri sacris faciundis*) and a *patera* (for the *septemviri epulones*). Vespasian had struck coins with the *simpulum*, sprinkler, *praefericulum*, and *lituus*, the same emblems on Nerva's coinage, although as with most occurrences there is no descriptive legend.[22] Mattingly's list of types similar to Nerva's suggests that the iconography simply varied from its republican and early imperial form since from Vespasian onward the *praefericulum* and sprinkler are more common, although they too are substituted for other things

[18] Merlin 1906a: 5–9.
[19] Kubitschek 1933: 13–14.
[20] *BMCRE* III: xl–xliii.
[21] *RIC*² I: nos. 76–77; *BMCRE* I: cliv–clv.
[22] *RIC*² II.1: nos. 42–43, 342–343, 346, 356, 698, 1553.

later on. It is probable that the immediate impetus behind the striking of the coin types was the emperor's standard admission to these four priestly colleges, explaining their first appearance in the second emission as Nerva would have been admitted to these colleges a short time after his accession and his assumption of more important and customary titles. But the diverse inhabitants of the Roman Empire probably would have been less interested in, or even unfamiliar with, the complex hierarchies of priesthoods in Roman state religion, as the general lack of explanatory legends for such coin types imply. Instead, the image of the priestly implements on the coinage generally conveyed *pietas*, religious obligation and duty. The average viewer, or "man on the street," may not have recognized the specific priestly colleges connoted by each individual implement, but together they were easily intelligible as ritual instruments. In Nerva's largest emission, the third emission, this imagery appears on between 11 and 15 percent of the *denarii* (appendix 3). It is, on average, the fifth most common reverse type on Nerva's *denarii*. As the imperial silver coinage was highly mobile in contrast with base-metal coinage, Nerva's *pietas* must have been a theme intended for the consumption of audiences across the Roman Empire. Nerva's piety, by virtue of his reverence for what is right and fair, is a theme undertaken by Martial 11.5.1–4, where the poet calls him a Numa, the legendary pious second king of Rome, suggesting a new golden age after the death of Domitian.[23]

Fortuna Augusti

The gamut of denominations (from *aurei* down to *asses*) under Nerva depict Fortuna standing and holding her usual attributes, a rudder and cornucopiae, with the legend FORTVNA AVGVST(I) (Figure 3.3). The rudder symbolizes Fortuna's purposeful direction and guidance while the cornucuopiae underscore the material blessings she and the emperor provide. The image appeared on coins in each of Nerva's emissions, except for the small fifth emission.[24] This traditional representation of Fortuna with the explanatory legend denotes Fortuna as a sort of guardian spirit for the emperor and the force that brings good luck to imperial subjects on

[23] E.g., Kay 1985: 68–69. Cf. Rimmel 2008: 162–180 on Nerva's rule as a return to a golden age.
[24] *RIC* II: nos. 4, 16, 28, 35, 42, 60–61, 73–74, 83–84, 98–99, and 105. *Sestertii* and *asses* carry the image in all emissions except the fifth; *dupondii* also have the reverse type in the first four emissions. *Aurei* and *denarii* depict the Fortuna with the rudder and cornucopiae reverse type only in the first, third, and fourth emissions (appendices 1 and 2).

FIGURE 3.3 *Denarius* of Nerva from January 97 with the FORTVNA AVGVST(I)
reverse type. (© Bibliothèque nationale de France.)

account of his positive rule; this Fortuna, therefore, communicated a differ-
ent message than Fortuna Populi Romani, who resonated more with Roman
citizens, especially in Rome and Italy (chapter 2).[25] In Pliny's *Panegyricus*,
Fortuna is named dozens of times as a result of Trajan's rule, as a spirit
that influenced Trajan, and as a benefit to the people on account of Trajan's
principate. Pliny records that fortune gave much to Nerva that the frugal
emperor denied himself (*Panegyricus* 51.2–3: "Praeterea pater tuus usibus
suis detrahebat quae fortuna imperi dederat, tu tuis quae pater," "especially
as in his case he was denying himself personal enjoyment of what the haz-
ards of empire had brought him [literally, 'what the fortune of power had
given him'], whereas your self-denial is applied to what came from him").[26]
The deployment of the image of Fortuna across the spectrum of denomina-
tions and her appearance in all emissions, save the fifth, suggest that the
good luck flowing from Nerva's principate to his subjects was an important
message.[27] That the image of Fortuna was some sort of "appeal" must be
rejected in view of the use of Fortuna on the coinage of previous emper-
ors and her relative abundance on the coinage in general.[28] Vespasian and
Domitian, for example, struck coins with identical representations and the

[25] On the significance and representation of Fortuna, see Champeaux 1987; Billington 1996;
LIMC VIII.1, 1997: 125–141, s.v. Tyche/Fortuna (Rausa); Arya 2002; Schmidt-Dick 2002: 55–60;
Noreña 2011a: 136–140, esp. 138.
[26] The translation is from the 1969 Loeb edition (Radice).
[27] Merlin 1906a: 12–14; Shotter 1983: 222, although he suggests a connection with the cult of
Augustus and Roma.
[28] *Contra* Grainger 2003: 47 and Sutherland 1974: 207, who states that Nerva "desperately needed
Fortuna" in view of military unrest.

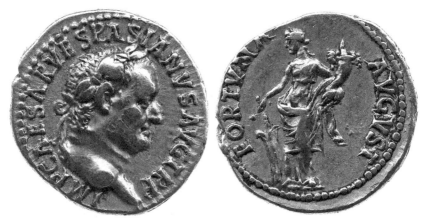

FIGURE 3.4 *Aureus* of Vespasian from 71 with the FORTVNA AVGVST(I) reverse type. (© Trustees of the British Museum.)

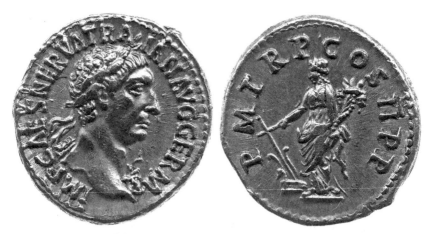

FIGURE 3.5 *Aureus* of Trajan from 98 with Fortuna Augusti on the reverse. (© Trustees of the British Museum.)

legends FORTVNA AVGVST(I) or FORTVNAE AVGVSTI (Figure 3.4).[29] She also appeared on the coinage of subsequent emperors as on coins of Trajan from 98, immediately after Nerva's death (Figure 3.5).[30] By quantifying the prominence of Fortuna on the coinage from the Flavian period through the early third century, Noreña has proved that she communicated a generic—but important—message on the imperial coinage and confirmed

[29] *RIC*² II.1: (Vespasian) nos. 682, 691, 699, and 1116; (Domitian) nos. 157, 290–291, 370, 380, 415, 479–480, 487–488, 535–536, 544–545, 629, 643, 648, 705, 707, 753, 755, 801, and 805.
[30] *RIC* II: no. 14; Woytek 2010: 1:205, no. 22.

that she communicated with the masses as she appears much more frequently on base-metal coinage than on gold *aurei* and silver *denarii*.[31] On Nerva's *denarii*, Fortuna Augusti accounts for between 6.5 and 11.5 percent of all images in the large first emission and between 18 and 23 percent in the larger third emission; in total, she is the second most common image on *denarii* behind the CONCORDIA EXERCITVVM types (appendix 3, part 7). By contrast, she appears on one-third of all *sestertii*, half of all *dupondii*, and nearly one-third of all *asses* recovered from excavations and hoards in the sample areas, making her the single most common image on all three base-metal denominations (appendix 4). Fortuna was, therefore, one of most common images on Nerva's imperial coinage that viewers would have seen. The importance of Fortuna in Nerva's reign is also visible on the didrachms of Caesarea in Cappadocia, perhaps struck at Rome for circulation in Cappadocia, on which she is identical to the imperial coinage, save for the Greek legend (ΤΥΧΗ ϹΕΒΑϹΤΟΥ) that communicates the same sense as the Latin legend on the imperial coins.[32] Coins of Ancyra in Asia also bore an image of Tyche (Fortuna) with a rudder and cornucopiae that closely resembled the imperial representations of Fortuna Augusti on the imperial coinage and Tyche on the Caesarean coinage.[33]

In his examination of the distribution of bronze coinage across the western Roman Empire, Hobley suggested Fortuna was most common in Britannia and Gaul, while she was much less common in Italy, Lower Germany and Pannonia, and more common again in Upper Germany and Raetia.[34] In the decades since the data for that study were compiled, the number of recorded finds has significantly increased through published inventories such as *FMRD* and *FMRSI*; for Italy, Hobley had also relied on museum collections rather than recorded finds. Today the available evidence suggests that the image of Fortuna on Nerva's base-metal coinage was widely distributed across the various regions of the western Roman Empire and prominent in all areas. On *sestertii*, Fortuna comprises 46 percent (15/32) of all specimens recorded in Austria, 36 percent (8/22) of examples recorded by the Portable Antiquities Scheme in England, 32 percent (47/145) of the Garonne Hoard from the province of Aquitania (Figure 2.35), and 25 percent (3/12) of the finds from the city of Rome (Figure 2.33) (data from appendix 4). On *dupondii*, Fortuna is generally

[31] Noreña 2011a: 145–146.
[32] For the types, potentially struck at Rome for circulation in Cappadocia, see *RPC* III: 380–381, nos. 2961, 2967, and 2972.
[33] *RPC* III: 315, no. 2531.
[34] Hobley 1998: 34.

more prominent: 67 percent of finds from Austria (29/43), 44 percent (32/72) from Germany, 25 percent (4/16) from England, 54 percent (7/13) from the Garonne Hoard, and 33 percent (2/6) from Rome (Figure 2.37). She maintains a high degree of visibility on the *asses*: 34 percent (66/192) from Austria, 26 percent (7/27) from England, 32 percent (113/354) from Germany, 27 percent from Slovenia (13/49), and 34 percent (8/41) from Rome (Figure 2.39). Compared with other regions, Fortuna Augusti is marginally less common in the finds of *sestertii* and *dupondii* from the city of Rome; this may be attributed to the comparably small sample size from Rome for these denominations coupled with the fact that *sestertii* circulating in Rome tended to bear more denotative themes referring to imperial involvement with the *plebs urbana* and senatorial affairs. There the more specific Fortuna Populi Romani would have played a greater role on the coinage, usurping the more generic Fortuna Augusti. The relative prominence of Fortuna Augusti on the *asses* in Rome is clearly commensurate with other regions. At individual sites in the provinces, Fortuna Augusti remains a common image on Nerva's base-metal coinage. In the area of Mainz and the Taunus-Wetterau *limes* system, 32 percent (6/19) of *sestertii*, 23 percent (5/22) of *dupondii*, and 35 percent (34/96) of *asses* bear her image (Figures 2.34, 2.38, and 2.40). At Carnuntum, the type is one third (11/33) of the *asses* (Figure 2.41). And at the legionary fortress at Nijmegen, Fortuna makes up 33 percent (2/6) of the *sestertii*, 54 percent (7/13) of the *dupondii*, and 15 percent (3/20) of the *asses*.[35] Questions about the intelligibility of the iconography on imperial coins beyond elite and literate viewers, and the agents behind the creation of images, continue to invite speculation in academic discourse. Nonetheless, the high production volume of coins bearing Fortuna Augusti in Nerva's reign and their broad geographical distribution suggest the powerful resonance of this incredibly generic message. Indeed, a Domitianic coin bearing Fortuna found on the mast-step in the shipwreck at Blackfriars indicates that shipbuilders could recognize the imagery and personalize it.[36]

Aequitas Augusti and Iustitia Augusti

Aequitas graces the reverses of a number of Nerva's coins in precious-metal and base-metal denominations in all years of his reign (Figure 3.6).

[35] Kemmers 2006: 109 for data from Nijmegen.
[36] Carlson 2007.

FIGURE 3.6 *As* of Nerva from January 97 with the AEQVITAS AVGVST(I) reverse type. (Yale University Art Gallery, 2001.87.5875, Transfer from the Sterling Memorial Library, Numismatic Collection.)

In Nerva's first, third, and fourth emissions, she appears on *aurei* and *asses*; she also appears on *denarii* in all emissions except the second.[37] She stands to the left, holding scales in her right hand—only with the index finger and thumb so as not influence the outcome—and cornucopiae in her left hand, with the descriptive legend AEQVITAS AVGVST(I).[38] A parallel for the depiction of Aequitas in art contemporary with Nerva's coinage comes from a relief in the Forum of Nerva depicting the punishment of Arachne in the presence of Aequitas (Figure 3.7); the appearance of Aequitas in this context may well relate to the use of the Forum of Nerva for adjudication and her relationship with justice.[39] As an imperial quality, *aequitas* connoted equity or fairness, especially in legal and judicial contexts and, in this way, is often linked with *iustitia*.[40] For example, Lactantius characterizes *aequitas* as the other side of *iustitia* (*Institutiones Divinae* 5.14.15–20). The personification of Iustitia also appears on Nerva's coinage on *aurei* in the third and fourth emissions, *denarii* in the first, third, and fourth

[37] *RIC* II: nos. 1, 13, 25, 37, 40, 44, 51, 77, 94.

[38] On the iconography of Aequitas, see generally *LIMC* I, 1981: 241–243, s.v. Aequitas (Belloni); Schmidt-Dick 2002: 15–17. Cf. R.-Alföldi 1999: 132 on the way Claudian *quadrantes* depict a hand holding scales. Well-preserved specimens of Nerva's coins show Aequitas holding the balance the same way.

[39] D'Ambra 1993: 58–59 and 79. The reliefs are, of course, probably Domitianic, as archaeological evidence suggests that the vast majority of work was completed in Domitian's reign before Nerva inaugurated it as the Forum of Nerva after he came to power.

[40] Noreña 2011a: 63–65 discusses in detail the Roman concept of *aequitas* with reference to multiple literary texts. Belloni 1974: 1074–1074 reads Iustitia on Nerva's coinage in conjunction with the appearance of Libertas as a message for the Senate, promising just treatment in contrast to Domitian.

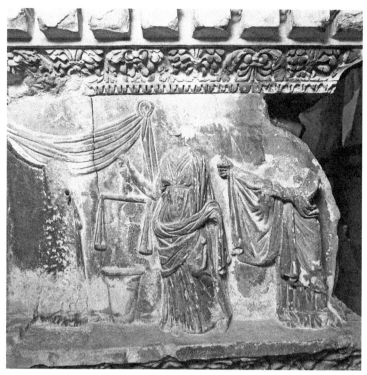

FIGURE 3.7 A section of the frieze from the Forum of Nerva depicting Aequitas in the context of the judgment of Arachne. (Fototeca Unione, American Academy in Rome.)

emissions, and on *dupondii* in the first emission.[41] Iustitia thus appeared on Nerva's imperial coinage *only* when coins depicting Aequitas were also produced. On the reverses of the coins, Iustitia is seated to the right holding an olive branch and scepter and labeled IVSTITIA AVGVST(I) (Figure 3.8); the appearance of Iustitia with the branch on Nerva's coins underscores her role in the maintenance of peace, as an antidote to tyranny, as the branch and scepter are also attributes of Pax.[42] To the Romans, *iustitia* referred to the close observance of the law, especially in judicial matters; epigraphy suggests further that *iustitia* was a virtue expected of municipal administrators.[43] In Nerva's reign, Iustitia probably also resonated well with the senatorial aristocracy who had felt the abuses of justice promulgated by administrators and the *delatores* under Domitian, and by

[41] A unique *aureus* from the third emission was recently seen in the trade (appendices 1 and 2).
[42] Béranger 1953: 270–271; Lummel 1991: 15. On the iconography of Iustitia more generally, see Lichocka 1974; *LIMC* VIII.1 (supplement), 1997: 661–663, s.v. Iustitia (Caltabiano); Schmidt-Dick 2002: 66. For the types, see *RIC* II: nos. 6, 18, 30, and 63.
[43] Forbis 1996: 68–69.

FIGURE 3.8 *Denarius* of Nerva from September 96 with the IVSTITIA AVGVST(I) reverse type. (Yale University Art Gallery, 2001.87.2749, Gift of Josiah H. Peck, LL.B. 1894, Transfer from the Sterling Memorial Library, Numismatic Collection.)

Domitian himself.[44] Nerva's end of the abuse of false accusation under the *fiscus Iudaicus*, his punishment of the *delatores*, and his mandate that individual disputes with the *fiscus* be handled by a *praetor* rather than a *procurator* may be attributed to Nerva's exercise of *iustitia* and, more generally, his regard for *aequitas*.

The message of *aequitas* on Nerva's coinage is often interpreted as celebrating Nerva's fairness in legal and judicial contexts, alongside his *iustitia*. Shotter suggests the Aequitas type and the Iustitia type are best understood in the aftermath of Domitian's death and the Senate's desire for vengeance against Domitian's memory, confidants, and informers (Dio 68.1.1–2). The desire for retribution under Nerva became so intense that senators were accusing one another, prompting the consul Catius Fronto to observe "that it was bad to have an emperor under whom nobody was permitted to do anything, but worse to have one under whom everybody was permitted to do everything," which in turn led Nerva to order a cessation of these activities (Dio. 68.1.3).[45] Grainger interprets Aequitas and Iustitia on Nerva's coinage as referring to his balanced approach to policy as in his remission of obligations to the *vehiculatio* in Italy, which unfairly burdened

[44] Shotter 1983: 219–220.
[45] The translation is from the 1925 Loeb edition (Cary). On Aequitas and Iustitia, Shotter 1978a: 163–164; 1983: 218–219, where he also suggests Aequitas may have been more general in symbolizing "good government" and Nerva's balance of firmness and generosity. Belloni 1974: 1074–1075 generally connects the themes of *libertas, aequitas, iustitia,* and *fortuna* as a response to Domitian. Morelli 2014: 249 states Iustitia communicated just treatment of senators, a contrast with Domitian.

those who lived near the major highways.[46] Merlin was an exception; he argued that Aequitas's connotation of fair dealings, in conjunction with her visual similarities to Moneta, celebrated a restoration of power-sharing between the emperor and the Senate in the minting of coins. His interpretation is, however, untenable, since it is based on an outdated understanding of a diarchal separation between the precious-metal and base-metal mints.[47] Recognizing the identical representation of Moneta and Aequitas, Wallace-Hadrill argues that Aequitas was Galba's response to the appearance of Moneta on the coins of the rebels and that Aequitas, like Moneta, referred to the control of the mint, treasury, and tax collectors.[48] Noreña has developed Wallace-Hadrill's interpretation of Aequitas and applied it to her appearance on coins from the Flavian through Severan periods.[49] While *aequitas* in literature and thought evoked fairness in judicial or legal proceedings, Aequitas on the coinage was intended, he says, to communicate control of state finances, a guarantee of the purity of the coinage, and command over financial officials. This concord between medium and message is suggested as well by Noreña's observation that there is a general inverse relationship between the frequency of the Aequitas type and the purity and silver content of the *denarius* from the later first century through the Severan period.[50]

[46] Grainger 2003: 54.

[47] Merlin 1906a: 33–40. In conceiving of diarchal division between the minting of precious-metal coins, under the authority of the emperor, and of base-metal coins as the prerogative of the Senate, Merlin was influenced by Mommsen (1860: 739–750), who had advanced this theory. If the nominal division of authority was the arrangement in the Augustan period, it could not have been practically maintained since bronze and precious-metal coins were often struck in the same emissions in Rome and bore similar images, particularly in the later first century and under Nerva. See, for example, Wolters 1999: 115–169; 2004; Metcalf 2004: 299–301.

[48] Wallace-Hadrill 1981: 36. He built on earlier work that recognized similarities between Aequitas and Moneta, such as Mattingly in *BMCRE* III: xxxv–xxxvii *contra* Strack 1931: 154–164, who insisted that Aequitas on the coinage always communicated fairness. Del Rivero 1927 and Lange 1932: 302–305 also identified similarities between Aequitas and Moneta. The representation of Moneta on Domitian's coins is identical to Aequitas on Nerva's coinage, although they are differentiated by their respective legends. On Domitian's coins, she is labelled MONETA AVGVSTI; for Domitian's types, see *RIC*[2] II.1, nos. 207, 221–223, 303, 383–384, 417, 492–493, 546–548, 630, 649, 708, 756, and 806. In the reigns of Hadrian and Antoninus Pius, the attributes of Moneta and Aequitas became distinct from one another.

[49] Noreña 2001: 157–158; 2011a: 65–70. In turn, Noreña's interpretation of Aequitas is applied to representations on third-century coinage by Manders 2012: 182–183. Butcher and Ponting 2014: 418 speculate that Aequitas on Nerva's coinage may have communicated an assurance of continuity of the quality of the coinage or that it may have reflected some financial stress as the purity of the silver coinage fell slightly from Domitian's standard. Morelli 2014: 247 has also applied Wallace-Hadrill's reading of Aequitas as Moneta to Nerva's coinage.

[50] Noreña 2011a: 68–70.

But the idea that Aequitas on the coinage would refer *solely* to a guarantee of financial stability has been overdeveloped and overstated. There is no evidence to suggest Nerva's Aequitas coins had to be read exclusively as a reference to the purity of the coinage and control of the economy. After all, in addition to comprising a significant proportion of Nerva's reverse iconography on the precious-metal coinage, Aequitas is prominent on his copper *asses*, and surely the guarantee of good coin would be irrelevant on this fiduciary denomination. Furthermore, it is not incidental that Iustitia appeared on Nerva's coinage only in tandem with the striking of Aequitas, as they were related concepts in Roman thought, and that Aequitas appears on the relief depicting the judgment of Arachne in the Forum of Nerva, a venue for adjudication.[51] This does not necessarily mean that the Aequitas type did not communicate, among other things, a promise for a stable economy. After all, imperial finances appear to have been a concern in the months immediately following Nerva's accession. Domitian had a healthy treasury at the time of his death, but Nerva's popular tax reforms and abolitions, his donative to the Praetorian Guard, his *congiarium*, and his expanded public welfare programs would have caused a decrease in revenues and an increase in expenditures.[52] In 97, Nerva appointed a committee of five senators to deal with the potential economic crisis (Pliny, *Epistulae* 2.1.9; *Panegyricus* 62.2), although there are no real indications there was an imminent financial crisis and the commission may simply have been political theater. But if we turn to the textual sources, *aequitas* and *iustitia* are qualities specifically attributed to Nerva by contemporary writers in contrast with Domitian, indicating that the coins reflected contemporary political rhetoric and connoted the meaning of fairness and justice in their traditional, literary sense.

Martial compares Nerva's great reverence for right and fairness (*recti reverentia ... at aequi*) with that of the pious Numa (11.5.1), justifying his proclamation that Augustus has been restored to the earth (11.3.9), an apparent response to Domitian's lack of *aequitas* and *iustitia*.[53] Frontinus similarly writes about Nerva's fiscal reforms regarding the rental of water rights and the restoration of an income of approximately 250,000 *sestertii* to the Roman people, owing to Nerva's sense of justice (*iustitia Divi*

[51] Lange 1932: 309–310 on the related concepts.
[52] On Nerva's economy and commission, see Syme 1930; Sutherland 1935: 150–153; Grainger 2003: 54–65. On Domitian's finances and the state of the treasury at his death, see Syme 1930; Sutherland 1935; Carradice 1983; Rogers 1984; Jones 1992: 79–89.
[53] Kay 1985: 69: "There is an implicit contrast with Domitian"; Ramage 1989: 648; Fearnley 2003: 625; Rimmel 2008: 162.

Nervae), as Domitian had allowed that money to be squandered through poor management and a lack of oversight (*de Aquis* 118).[54] Nerva's fairness is also a theme undertaken by Pliny in regard to his discussion of reforms of the inheritance tax and his praise of Trajan's *aequitas* in that way (*Panegyricus* 38). In his adulation of Trajan's *iustitia* in presiding over spectacles, Pliny implies that *iustitia* was a quality that Domitian had lacked (*Panegyricus* 33).

Aequitas and Iustitia on the coinage echo the contemporary epideictic rhetoric emanating from the aristocracy and political elite around Nerva, just as Martial and Frontinus verbalized and recorded *aequitas* and *iustitia* in their adulations of the emperor; these two qualities were evidently ascribed to Nerva to praise him and his actions as superior to Domitian. The appearance of the image of Aequitas on Nerva's coinage alongside coins championing the more defined quality of *iustitia* demands that she not be divorced from her literary connotations and the implications of contemporary laudatory rhetoric.[55] It is improbable that a literate viewer who saw Aequitas on the coinage would interpret that figure differently than when he read about *aequitas* in a contemporary scroll or heard the word in a speech.

Iustitia is relatively uncommon on Nerva's coinage when compared with the frequency of Aequitas. On *denarii*, Iustitia accounts for only between 5 and 6 percent of all images in Nerva's first emission and only 1.7–2.3 percent in his large third emission; she barely registers 1 percent of images in Nerva's fourth emission. In total, she is one of the rarest images on *denarii*, representing just 2.18 percent of all *denarii* from hoards and finds (appendix 3, part 7). *Iustitia* is no more common on Nerva's *dupondii*: 1.2 percent (i.e., two specimens out of 167 from hoards and excavations) (appendix 4). Iustitia had only appeared on these brass coins in Nerva's accession emission, probably to communicate the end of Domitian's juridical abuses to a senatorial audience. Aequitas comprises between 8 and 18 percent of all reverse images on *denarii* from the first emission, between 11.5 and 14.4 percent in the third emission, and between 15 and 20 percent in the small fourth emission. She is the fourth most common image on *denarii* at 14.20 percent of all specimens from finds and hoards (appendix 3, part 7).[56] On copper *asses*, Aequitas's image is rather

[54] Peachin 2004: 118.

[55] Elkins 2017b.

[56] Compared to the prominence of Aequitas on first-emission coins in the aggregate of hoards and site finds, Reka Devnia's representation of her seems to be low. There are concerns about how that hoard was recorded and the accuracy of some identifications. See comments in the introduction.

abundant, consisting of approximately 20 percent of all the *asses* recorded from hoards and single finds, making her the third most common image on these copper coins (appendix 4). In the area of Mainz and the Taunus-Wetterau *limes*, she appears on 19 percent (18/96) of all the *asses* found (Figure 2.40), 15 percent (5/33) of those from Carnuntum (Figure 2.41), and 20 percent (4/20) from the fortress at Nijmegen. She is less prominent in the finds from Rome, where she represents 7 percent (3/41) of the *asses* (Figure 2.39). It may be tempting to see a potential preference for Iustitia in the circulation pool there, since she had a more defined meaning relevant to those who personally witnessed and experienced Domitian's abuse of the courts and the *fiscus*.[57] This is, however, unprovable. In view of the more pointed meaning of *iustitia*, referring to close adherence of the law, the image of Iustitia was most resonant with elites who had been subjected to juridical abuses under Domitian.[58] It is, therefore, not coincidental that Iustitia was more frequent on coinage in the first emission than in subsequent emissions, as Nerva acted immediately upon his accession to correct Domitian's abuses of justice aimed at the senatorial aristocracy, as exemplified by Nerva's reform of the *fiscus Iudaicus*. Aequitas, who more generally connoted fair treatment in legal and judicial contexts, had broader relevance to the population of the Roman Empire. The disparity between the rarer coins bearing images of Iustitia and the more abundant representation of Aequitas is thus explicable.

Libertas Publica

One of the most prolific images on the reverses of Nerva's imperial coins, from his accession until his death, is Libertas. She, like Fortuna (Tyche) and the *dextrarum iunctio*, also appeared on the didrachms of Caesarea that may have been struck at Rome for circulation in Cappadocia.[59] The figure of Libertas must have had some special significance to imperial ideology in Nerva's reign since her image was so widely disseminated during his reign, although she generally appeared relatively infrequently on Roman imperial coinage.[60] It is worth tracing the appearances of Libertas

[57] Hobley 1998: 34–36 counts only one *dupondius* depicting Iustitia and locates it in Italy. His quantification of types also suggests Aequitas is less prevalent in Italy than in the provinces, although his different data collection methods for each region must be considered.
[58] Lichocka 1974: 110–111.
[59] *RPC* III: 380–381, nos. 2965 and 2970, with the legend ΔΗΜΟΥ ΕΛΕΥΘ.
[60] Noreña 2011a: 176–177 on the general infrequency of Libertas compared with other personifications on the imperial coinage.

and her attributes on the republican and imperial coinage, and what she meant in different periods and contexts, in order to discern what she would have communicated to different viewers in the reign of Nerva, and who those viewers might have been. In the Roman world, *libertas* was primarily conceived of as freedom from mastery, especially as not having the status of a slave.[61] The Atrium Libertatis in Rome underscores the notion that *libertas* was the opposite of slavery; it was the headquarters of the censors, a place where slaves could be tortured, and foreigners could be held as hostages, but it was also the place where slaves could be manumitted and become *liberti*, and the place where non-Romans might access citizenship.[62] On imperial coinage, Libertas is most often personified with the attributes of a *vindicta* (rod) and *pilleus* (the cap of a freed slave), both of which refer to the manumission ceremony in which a slave would be touched with the *vindicta* and presented with the *pilleus*, an emblem of his new status as a *libertus*.[63]

The concept of *libertas* also had political connotations in the late Roman Republic and early Roman Empire, as Libertas appears on the coinage as a retort to tyranny or refers to political protection.[64] Libertas was prominent on the coins of M. Junius Brutus. In 54 BC, ten years before he would become one of Caesar's primary assassins, he struck two *denarii* that trumpeted the theme of liberty. On the first *denarius*, the head of Libertas appears on the obverse while the reverse depicts the consul L. Junius Brutus, founder of the Republic, escorted by an *accensus* and

[61] Wirszubski 1950: 1–3; Hammond 1963: 93; Arena 2012: 14–44. On the Roman view of *libertas* more generally, see also Hellegouarc'h 1963: 542–565; Stylow 1972; Fears 1981: 869–875; Brunt 1988: 281–350; Roller 2001: 220–233.

[62] Hölkeskamp 2005: 23; Arena 2012: 43–44. On the Atrium Libertatis more generally, see Richardson 1992: 41 and *LTUR* I, 1993: 133–135, s.v. Atrium Libertatis (Coarelli), both with further bibliography.

[63] Schmidt-Dick 2002: 70–72 accounts for all depictions of Libertas on the Roman imperial coinage. In the Republic, Libertas often appears wearing a diadem of victory, or is accompanied by Victory, who crowns her; Victory and Libertas are linked ideals and the Temples of Jupiter Victor and Jupiter Libertas shared dedication dates (Arena 2012: 76–77). On her iconography, see also *LIMC* VI, 1992: 278–284, s.v. Libertas (Vollkommer).

[64] Fears 1981: 871–874 discusses the importance of Libertas on Roman republican and early imperial coinage (through Claudius); his understanding of republican types is largely derived from Crawford 1974. Early examples of Libertas and the subject of liberty on republican coinage are coins of 126 BC referring to the *lex Cassia tabellaria* (Crawford 1974: 1:290, no. 266/1) and 125 BC where they celebrate legal protections (Crawford 1974: 1:293, no. 270/1). Both types are discussed by Arena 2012: 40–42. Coins of 76 and 75 BC used Libertas to express anti-Sullan sentiments (Crawford 1974: 1:405–406, nos. 391/1a–3 and 392/1a–b; for historical relevance see Wirszubski 1950: 51–52; Lintott 1999: 210–212; Arena 2012: 53, 140–141, and 245); the new dates come from the Mesagne Hoard, see Hersh and Walker 1984: 133, table 2. On the depiction of the Temple of Jupiter Libertas on coins of 76 BC, see Fuchs 1969: 19–20; Zehnacker 1973: 1:588–590; Elkins 2015: 26.

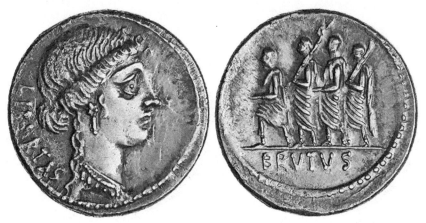

FIGURE 3.9 *Denarius* of M. Junius Brutus from 54 BC with a head of Libertas on the obverse and L. Junius Brutus escorted by *accensus* and lictors on the reverse. (Courtesy of the American Numismatic Society, 1937.158.223.)

two lictors with *fasces* (Figure 3.9). The other *denarius* depicts the head of L. Junius Brutus on the obverse and the head of C. Servius Ahala, Cincinnatus's Master of the Horse and slayer of the tyrant Maelius, on the reverse. M. Junius Brutus, adopted into the *gens* Junii Bruti, claimed descent from the expeller of kings and founder of the Republic as well as from Ahala, who had similarly saved Rome from tyranny. Brutus's overt display of Libertas and the highlighting of his family's tradition of standing against tyranny appeared in the same year that rumors were circulating that Pompey sought the dictatorship. Brutus's coins thus announced his opposition to Pompey's alleged ambitions.[65] Just a year earlier, Pompey's opposition had cried *libertas* (*eleutheria*) (Plutarch, *Pompeius* 52).

After the defeat of Pompey by Caesar's forces, Caesar presented himself as liberator of the Republic from Pompey's tyranny.[66] In his *Bellum Civile*, Caesar frequently invokes *libertas*. The Senate also decreed a temple to Libertas and that Caesar be called liberator after the Battle of Munda (Dio 43.44.1). Moneyers under Caesar's dictatorship displayed Libertas on the coinage to portray Caesar as a liberator and to call attention to his popular reforms. *Denarii* struck by Vibius Pansa in 48 BC celebrated Caesar's victories by placing the head of Libertas on the obverse and depicting Roma, crowned by Victory, seated on a pile of arms, on the reverse. In 45 BC, M. Lollius Palicanus struck *denarii* with a head of Libertas on the obverse

[65] On the coins and their meaning, see Crawford 1974: 1:455–456, nos: 433/1–2.
[66] Weinstock 1971: 140–145.

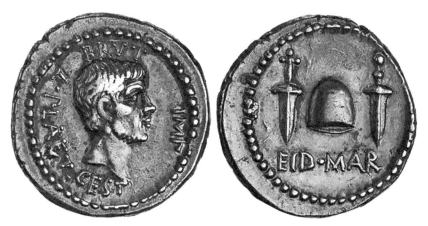

FIGURE 3.10 *Denarius* of M. Junius Brutus from 43–42 BC with the *pilleus* flanked by daggers on the reverse. (Courtesy of the American Numismatic Society, 1944.100.4554.)

and a tribune's bench upon the Navalia on the reverse. While the bench referred to the moneyer's father's tribunate, it also alluded to Caesar's strengthening of the tribunate.[67]

The republican faction, led by Brutus and Cassius after the assassination of Caesar, also invoked *libertas* as their battle cry at Philippi in 42 BC (Dio 47.42.3–43.1). The coinage of Brutus and Cassius struck after the death of Caesar prominently represented Libertas on *aurei, denarii,* and *quinarii*. The best-known instance of Libertas's invocation on the coinage of the Republic are the coins of Brutus that bear his portrait on the obverse and a *pilleus* flanked by two daggers and the legend EID MAR on the reverse (Figure 3.10). It is a powerful visual celebration of Brutus's role in the assassination of Caesar and his claim to have guaranteed *libertas* and the status of nonslavery to the citizens of the Republic through tyrannicide.[68]

After the end of the war between Octavian and Antony and Cleopatra, Ephesus struck *cistophori* in 28 BC that depict a bust of Octavian with the legend IMP(ERATOR) CAESAR DIVI F(ILIVS) CO(N)S(VL) VI LIBERTATIS P(OPVLI) R(OMANI) VINDEX ("the general Caesar, son

[67] B. Mannsperger 1974; Fears 1981: 873. For the types, see Crawford 1974: 1:464–465, no. 449/4, and 482–483, no. 473/1. For the identification of the structure as the Navalia, as opposed to the more popular identification of it as the Rostra, see Coarelli 1968, significantly improved upon by Schäfer 1989: 94–97.

[68] Arena 2012: 42–43. For the types, see Crawford 1974: 1:513–518, nos. 498–508, and discussed on 2:741, and 1:518, no. 508/3 (the EID MAR type).

FIGURE 3.11 *Cistophorus* of Octavian from 28 BC with the obverse legend
IMP(ERATOR) CAESAR DIVI F(ILIVS) COS VI LIBERTAS P(OPVLI) R(OMANI)
VINDEX and Pax on the reverse. (© Trustees of the British Museum.)

of the deified [Caesar], six times consul, champion of the liberty of the
Roman People"); the reverse of the coins show Pax, labeled thus, standing
upon a *parazonium* and holding a *caduceus* with a snake emerging from
a *cista mystica* behind her (Figure 3.11). The type must have celebrated
the end of the civil wars, the restoration of peace to the Roman East, and
the restoration of provincial government in Asia in the aftermath of Mark
Antony's dominion there.[69] The aspect of political settlement alluded to
by the type has been greatly enhanced by the discovery and publication
of rare *aurei* struck at an Asian mint that bear the same obverse titula-
ture as the *cistophori* (i.e., IMP CAESAR DIVI F COS VI) with a laure-
ate portrait of Octavian. The reverse of the coins depict Octavian seated
on a curule chair, holding a scroll as a *scrinium* lays upon the ground
(Figure 3.12).[70] The reverse legends reads LEGES ET IVRA P(OPVLI)
R(OMANI) RESTITVIT and refers to the restoration of laws and rights
after Antony's defeat.

Following the conferral of additional powers onto Octavian and his
assumption of the title Augustus in 27 BC, Libertas appeared relatively
infrequently on coinage minted during the principate, perhaps on account
of the intrusion of the *princeps* into the constitutional government.[71] It
has been posited that since the powers that had formerly been distributed

[69] Grenade 1961: 64–65; Hammond 1963: 94–96; Sutherland 1970: 89–90. For the type, see *RIC*[2]
I: no. 476.

[70] Rich and Williams 1999. On the discovery of a second specimen, see Abdy and Harling 2005.

[71] Noreña 2011a: 176–177 on the general infrequency of Libertas compared with other
personifications on the imperial coinage. The use of *libertas* was also strongly associated with the

FIGURE 3.12 *Aureus* of Octavian, minted in Asia, from 28 BC with the reverse legend LEGES ET IVRA P(OPVLI) R(OMANI) RESTITVIT. (© Trustees of the British Museum.)

among the offices, senators, and various organs of the Republic were now concentrated into the hands of one man, *libertas* evolved from evoking civic liberties and the independent Republic to connote the operation of good monarchical government and presented the emperor as a guardian and guarantor of liberties.[72] During the imperial period, the first reference to Libertas appeared on copper *quadrantes* of Caligula, minted at Rome between AD 39 and 41. They depict on the obverse Libertas's chief attribute, the *pilleus*, accompanied by the emperor's titles. On the reverse is RCC, also surrounded by the emperor's titles (Figure 3.13).[73] RCC has most widely been understood as *Remissa Ducentisima*, referring to Caligula's abolition of the unpopular ½ percent tax on auction sales that fed the military treasury (*aerarium militare*).[74] The association of the theme of Libertas with freedom from taxation is present in literature as, for example, in Livy, where *libertas* is not possible in the presence of the

political rhetoric of the Republic (e.g., Gallia 2012: 12–46; Arena 2012), potentially making the theme of *libertas* awkward or disadvantageous for the emperor, as Noreña suggests.

[72] Wirszubski 1950: 107–123; Hammond 1963; Fears 1981: 874–875.

[73] *RIC*[2] I: nos. 39, 45, and 52.

[74] E.g., Willrich 1903: 424–425; Baldson 1934: 152, 186–187; Stylow 1971; Nony 1986: 264; *RIC*[2] I: 105; Wilkinson 2005: 12–123. Eckhel 1796: 224 first associated the coin with the tax, but understood the *pilleus* as a reference to Caligula's return of popular elections to the *comitia*; this is, however, unlikely since they soon thereafter again became the prerogative of the Senate. Eckhel's interpretation is followed by Mattingly (*BMCRE* I: cxlvii). Most authors have traditionally associated both sides of the coin with the tax. Objections raised by Barrett 1989: 249–250; 1998; Wood 2010, claiming that the *quadrantes* must be related to something else other than tax remission, cannot be maintained and exaggerate the need to find an alternative. See Elkins 2014b

FIGURE 3.13 *Quadrans* of Caligula from AD 40–41 with the *pilleus* on the obverse and RCC on the reverse. (Private collection, formerly in the Archer M. Huntington Collection, Hispanic Society of America, ANS 1001.1.11806.)

tax collector and burdensome taxation (45.18). Coins of Galba also clearly referred to the remission of a tax in conjunction with the personification of Libertas (see below), suggesting that Libertas on the coinage could indeed refer to freedom from taxation.

After the assassination of Caligula, *asses* in Claudius's first two emissions of bronze coins, respectively in 41/42 and 42/43, featured Libertas standing, facing toward the left, extending her right arm, and holding the *pilleus* in her left hand, and the legend LIBERTAS AVGVSTA (Figure 3.14).[75] Other types in the earliest Claudian emissions relate to the circumstances of Claudius's accession and thus the Libertas type must be understood as a retort to Caligula and a promise of freedom under the new regime.[76] In this type, one also sees how Libertas, through the proclamation of Augustan *libertas* in the legend, is now personalized as a quality bound to the personage of the emperor as a guarantee of good government.[77] The message must again have been directed at the masses on account of Libertas's appearance on copper *asses* and since they are common in hoards and excavations.[78] In the Tiber finds from Rome, they

for a rebuttal of Barrett and Wood and for additional evidence to associate the *quadrantes* with the tax on auction sales.

[75] von Kaenel 1986: 258. For the types, see *RIC*[2] I: nos. 97 and 113.

[76] For *libertas* as part of the political rhetoric early in Claudius's reign and after Caligula's death, see Ramage 1983: 202–203.

[77] E.g., *BMCRE* I: clvii.

[78] *Contra* Levick 1990: 94, who characterizes Libertas as a message to the Senate and Claudius as their partner. On *libertas senatoria* more generally, see Raaflaub 1987: 29–31.

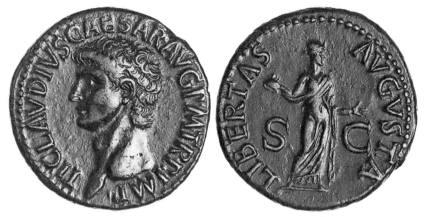

FIGURE 3.14 *As* of Claudius from 42/43 with the LIBERTAS AVGVSTA reverse type. (Courtesy of the American Numismatic Society, 1944.100.39387.)

are in fact the second most prominent type, just behind the *asses* depicting Minerva, and they tend to trend that way in other find complexes.[79]

During the rebellion against Nero, and in the wake of his suicide and the consequent collapse of the Julio-Claudian dynasty, Libertas was commonly depicted on the imperial coinages of Spain and Gaul during the civil wars of 68–69.[80] Some representative legends on this coinage include LIBERTAS P(OPVLI) R(OMANI) and LIBERTAS RESTITVTA. Mommsen had surmised that the various revolts, as indicated in part by the iconography of the associated coins, intended to restore the Republic following the death of Nero, while Schiller thought the rebels aimed to establish a Gallic empire.[81] Indeed, one remarkable type that depicts the *pilleus* flanked by two daggers imitates Brutus's coins from 43/42 BC and could be read in an anti-imperial way. But as Kraay has proved, the Libertas types did not indicate a wish to return to the old Republic or to create an empire independent of Rome, for they are struck alongside other types, such as the oak-wreath types, that indicated a new reign is a commencing.[82] The Libertas types must be read as suggesting an intended transition from Nero to a better government, headed by a new *princeps*.

Libertas was also a prominent theme and figure on the coinage of Galba. Coins struck in Spain in 68 and in Gaul in 68–69 depict Libertas standing, holding the *pilleus* and *vindicta*, accompanied by the legend LIBERTAS

[79] von Kaenel 1984; 1986: 161.
[80] *RIC*[2] I: nos. 24–28, 64–6, and 132–133.
[81] Mommsen 1878; Schiller 1872: 261–276, followed by Henderson 1903: 395–405.
[82] Kraay 1949.

FIGURE 3.15 *Sestertius* of Galba from 68 with the LIBERTAS PVBLICA reverse type. (Courtesy of the American Numismatic Society, 1944.100.39861.).

PVBLICA on various denominations (Figure 3.15).[83] The inclusion of the two attributes makes the reference to freedom from slavery explicit. At Rome in 68–69, Galba's coinage also bears this image with the legends LIBERTAS P(OPVLI) R(OMANI), LIBERTAS PVBLICA, or LIBERTAS AVGVSTA. Another type graphically depicts Galba as an active restorer of liberty as he physically raises Libertas from a kneeling position on the ground before him as Roma stands in the background; Galba's role as restorer of liberty is made more explicit with the legend LIBERTAS RESTITVTA. Some of Galba's base-metal denominations with Libertas standing with the *pilleus* and *vindicta*, each of which has the legend LIB(ERTAS)AVG(VSTA), or some variant thereof, also bear R(EMISSA) XL, *quadragensuma remissa*, in the legend (Figure 3.16).[84] The *quadragensuma remissa* types refer to Galba's remission of the 2 ½ percent customs duty on goods entering Gaul (Tacitus, *Historiae* 1.8); for this reason, these coin types may be better assigned to a mint in Gaul than to Rome.[85]

While Galba did not intend to restore the Republic, he came from a very old and distinguished republican family, the Sulpicii Galbae. He wore the

[83] Kraay 1956: 56–57 accounts for the prominence of the Libertas imagery on Galba's coinage here and at Rome through the large number of dies used to strike the coins.

[84] For the Spanish and Gallic types, see *RIC*[2] I: nos. 22–23, 37–39, 56, 68–76, 136–137 and 139, for the LIBERTAS P R, LIBERTAS PVBLICA, and LIBERTAS AVGVSTA types (often abbreviated) from Rome, see nos. 157–159, 237, 275–276, 293–296, 309, 318, 327–328, 346–349, 363–367, 372, 387–391, 423–427, 438–443, and 459–461. For Galba raising Libertas, see nos. 479–480; and for types referring to the remission of the tax, see nos. 293, 296, 327, and 438–441.

[85] Kraay 1956: 29–30.

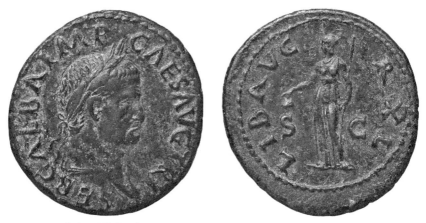

FIGURE 3.16 *As* of Galba from 68 with the LIB(ERTAS) AVG(VSTA), R(EMISSA) XL reverse type. (© Bibliothèque nationale de France.)

mantle of *libertas* in that republican sense of freeing Rome from tyranny; in his case, that was the tyranny of Nero.[86] The great mass of Galba's coins that feature Libertas are better understood in the historical and political context of Galba's brief rise to power. In the spring of 68, at the urging of Vindex, who had already taken up arms against Nero, Galba took leadership against Nero in a dramatic display, when he mounted a tribunal during a ceremony for the manumission of slaves and spoke against the sad state of imperial affairs while surrounded by the images of those whom Nero had condemned (Suetonius, *Galba* 10.1–2). He was duly saluted as the emperor, but instead asserted that he was simply the legate of the Senate and Roman People. When Nero committed suicide that summer, people in Rome wore the *pilleus* and ran through the streets in celebration (Suetonius, *Nero* 57.1). From the outset, *libertas* was the watchword of the rebels and of Galba. He answered Vindex's call to be an *adsertor* of liberty and promised to deliver the Roman people from the "slavery" of Nero's tyranny, a theme underscored and echoed by Libertas on his coinage.

Upon the murder of Galba, Libertas was also paraded on the coins of Vitellius, as he too appropriated the identity of a liberator. Libertas appeared with a *pilleus* and *vindicta* in her hands, similar to the way she had appeared on Galba's coins, most often accompanied with the legend

[86] On the republican flavor of the rebels' and Galba's coinage and political image and use of *libertas*, see generally Kraay 1949; 1956; Grassl 1973: 35–36; Murison 1993: 43–44; Gallia 2012: 12–46. On Galba's use of Libertas on coins as similar to that of Claudius's, see Ramage 1983: 207–209.

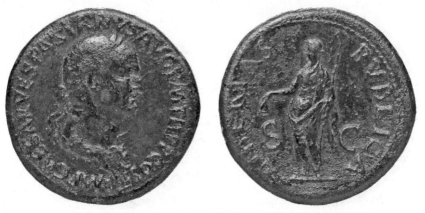

FIGURE 3.17 *Sestertius* of Vespasian from 71 with the LIBERTAS PVBLICA reverse type. (© Bibliothèque nationale de France.)

LIBERTAS RESTITVTA on gold, silver, and bronze coins, although LIBERTAS AVGVSTI appeared on some *dupondii* and *asses*.[87]

It is not surprising that Libertas reappeared on the coinage of Vespasian at the conclusion of the civil wars and Vespasian's ultimate victory. In 69–70, a Spanish mint struck *denarii* with images of Libertas holding the *pilleus* and *vindicta* and the legend LIBERTAS PVBLICA. After Vespasian's arrival in Rome in 70, the mint at Rome produced in 71 a large issue of coins with various reverse designs to herald the new dynasty. Libertas was central to this issue on the base-metal denominations (*sestertii, dupondii, and asses*), where she appeared with the legend LIBERTAS PVBLICA and the *pilleus* and *vindicta* (Figure 3.17). Some less common variants of the type include the legend LIBERTAS AVGVSTI, one of which depicts Libertas with a *vindicta* and wreath rather than with the *vindicta* and *pilleus*. Another *sestertius* type bears the legend LIBERTAS RESTITVTA and depicts Vespasian raising Libertas, who kneels before him. Also in Rome, some important *sestertii* from 70 and 71 depict an oak wreath that contains the legend SPQR ADSERTORI LIBERTATIS PVBLICAE ("The Senate and Roman People to the Assertor of Public Liberty"). At Rome, the LIBERTAS PVBLICA type continued to appear on the coinage of 72–73, while LIBERTAS AVGVSTA was depicted on *aurei* struck at Antioch and Alexandria.[88] The image of Libertas on Vespasian's coinage

[87] *RIC²* I: nos. 9–10, 43–44, 69, 80–81, 104–105, and 128.

[88] For the Spanish mint, see *RIC²* II.1: nos. 1339, 1345–1347, and 1384; for LIBERTAS PVBLICA types from Rome, see nos. 52, 63, 83–87, 137, 141, 173–174, 237, 272, 309–310, and 377; for the LIBERTAS AVGVSTI types from Rome, see nos. 170–172; for the LIBERTAS RESTIVTA

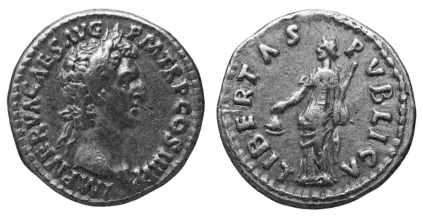

FIGURE 3.18 *Aureus* of Nerva from January 97 with the LIBERTAS PVBLICA reverse type. (© Bibliothèque nationale de France.)

is identical to the design on Galba's coinage, whose memory was recalled. It was, of course, expedient for Vespasian's coinage to take cues from his vanquished predecessor as he aligned himself with his image and was presented as Galba's avenger (Tacitus, *Historiae* 4.40.1). It is also noteworthy that just as Libertas was a prominent image on the coinage of the rebels and of Galba, Libertas was clearly the most common image appearing on Vespasian's coinage in 71.[89] The title of *adsertor libertatis* on some of his coins also recalled Vindex's charge to Galba. Those types celebrated the award of an oak wreath to Vespasian from the Senate and Roman People for saving the lives of citizens. At the conclusion of the civil wars, it was Vespasian who prevailed and who took credit for the restoration of liberty following Nero.

It was in this context of cultural memory and historical use of the iconography of Libertas that the mint deployed her image on Nerva's coins when he was made *princeps* in September 96, after Domitian's assassination. Libertas appeared on Nerva's gold *aurei* (Figure 3.18), silver *denarii*, brass *sestertii* (Figure 3.19) and *dupondii*, and copper *asses*. She stands

types from Rome, see nos. 88–89; for the SPQR ADSERTORI LIBERTATIS PVBLICAE types (sometimes abbreviated as PVBLIC) from Rome, see nos. 35, 121–124, 207–210, and 252. For Antioch, see no. 1543; and for Alexandria, see no. 1522.

[89] On the relationship between Vespasian's coinage and Galba's coinage, as well as Vespasian's alignment with and sympathies toward Galba, see Kraay 1978: 51–52 and 56, who also provides evidence of the frequency of the Libertas imagery on Vespasian's coinage. For further studies on Galba's memory in the Flavian period and beyond, see Gagé 1952; Bianco 1968: 185–200; Ramage 1983: 209–212; Zimmerman 1995; Gallia 2012: 44–46. Titus also struck a restored coin for Galba during his reign, indicating how important Galba was to the Flavian political image, see *RIC*[2] II.1: no. 496 and discussion in Komnick 2001: 166–169.

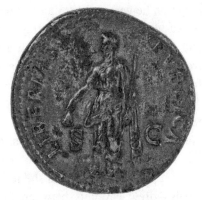

FIGURE 3.19 *Sestertius* of Nerva from December 96 with the LIBERTAS PVBLICA reverse type. (Private collection, formerly in the collection of Consul E. F. Weber, sold in 1909: J. Hirsch 24, no. 1313.)

to the left and holds a *vindicta* in her left hand and a *pilleus* in her right hand; the legend LIBERTAS PVBLICA accompanies her, except on the coins from the fifth and sixth emissions, when the emperor's titles replace the legend.[90] This image of Libertas is copied directly from Galba's coinage (Figure 3.15), which in turn had been imitated by Vespasian's coinage (Figure 3.17). Indeed, there were significant parallels between Galba's and Nerva's accessions. First and foremost, they were both emperors who came to power following the collapse of dynasties, and their predecessors had been unpopular with the Senate. Thus, their rise to power was not the result of dynastic succession. Although Galba's initial claim to power came from the force of arms, he at first preferred to present himself as the legate of the Senate and Roman People, and did not make himself emperor but waited for the Senate to make him so; this, as well as his descent from an old senatorial family, his character, and his experience made him commendable to the senatorial aristocracy (Dio 63.23; 63.29.5–6). Galba's appointment of Lucius Calpurnius Piso Licinianus, another senator from an illustrious background, rather than his reestablishment of a hereditary monarchy, provided a certain hope and sense of freedom for the Senate. After Augustus, the nobles of Rome had been excluded from the highest office—*princeps*—and certain duties and honors associated with it, on account of Augustus's dynastic arrangement. This renewed ability to aspire to the head of state was for the senators a restoration of liberties they had not been able to hope for since the Republic. When Nerva was made

[90] *RIC* II: nos. 7, 19, 31, 36, 39, 43, 64–65, 76, 86–87, 100–101, and 106.

emperor, he was a senator agreed upon by fellow senators and, like Galba, he was descended from a distinguished republican family. He had no sons and was far too old to establish a dynasty. He would name a successor from among the *nobiles*, as Galba had done, again opening that freedom for competition and cooperation with the Senate.

Scholars have thus tended to interpret the theme of *libertas* in Nerva's reign and Libertas's image on his coinage from this aristocratic point of view and as a message directed at the Senate alone.[91] Surely, the invocation of *libertas* on the coins of Claudius, Galba, Vespasian, and Nerva had a republican flavor and the imitation of Galba's Libertas—and other ideals—drew parallels between the two and communicated a constitutional message to the Senate. For the Senate, *libertas* would have implied the Senate's partnership with the emperor, freedom from Domitian's tyranny, and that one of their own could attain the highest office. Looking beyond the coinage, it is evident that *libertas* was an important part of the political and epideictic rhetoric from the outset of Nerva's reign and that the freedom to praise and blame, feel and write, was a theme undertaken by Tacitus, Martial, and Pliny. Tacitus (*Agricola* 3.1) famously wrote that "Nerva Caesar mingled things formerly incompatible, the principate and liberty" ("Nerva Caesar res olim dissociabiles miscuerit, principatum ac libertatem"), which has been the subject of much scholarly discussion as to the meaning of *libertas* in political thought in the late first century. Martial (11.2.6) also proclaims freedom in praise of Nerva on the occasion of the Saturnalia in December 96: "et licet et sub te praeside, Nerva, libet." He also asserts that if the Elysian Fields were to be emptied, prominent men from Rome's past would come to praise the great Nerva, now cast as the pious second king of Rome, Numa. Camillus, the champion of liberty, he says, would worship him: "te colet invictus pro libertate Camillus" (11.5.7). In 11.6.4, Martial addresses "*pilleus*-wearing Rome," "pilleata Roma," which of course refers to the custom of donning the *pilleus* on

[91] Syme 1939: 155, "The *libertas* of the Roman aristocrat meant the rule of a class and the perpetuation of privilege." On Nerva's use of Libertas as a message to the Senate, see Garzetti 1950: 46–47; Hammond 1963: 103; Belloni 1974: 1074; Shotter 1978a: 164; 1978b; 1983: 221 (and throughout on the constitutional change); Lummel 1991: 14–17; Lyasse 2003: 65–66; Grainger 2003: 47; Morelli 2014: 247–248; *RIC* II: p. 221. Indeed, Libertas on the coins of earlier emperors, especially Claudius and Galba, have often been understood as making a statement about constitutional government to the Senate (e.g., Levick 1990: 94; Murison 1993: 43–44; *BMCRE* II: xlvii–iii.). Scholars have long recognized that the image of Libertas on Nerva's coins, as well those of other personifications, was inspired by the coinage of his predecessors, especially Galba; in addition to those sources already cited, see Merlin 1906a: 20–24; Zehnacker 1987: 325–326 et passim; Bennett 2001: 37; Gallia 2012: 217–218; *BMCRE* III: xliv.

the occasion of the Saturnalia, but in the context of preceding epigrams addressing Nerva, it too harped on the rhetoric of *libertas* that was actively promoted in art, text, and spoken word. Pliny also refers the restoration of *libertas* after Domitian's murder (*Epistulae* 9.13.4) and takes up the theme throughout the *Panegyricus*.[92] There is also an honorary inscription from Rome (recorded only in the Einsiedeln codex), dedicated by the Senate and Roman People to the restoration of *libertas* by Nerva upon the initiation of his principate:[93]

LIBERTATI AB IMP[ERATORE] NERVAE AVG[VSTO] ANNO AB
VRBE CONDITA DCCCXXXXIIX XIIII [K(alendas)] OC[T(obres)] RESTITV[TAE]
S(enatus) P(opulus) Q(ue) R(omanus)

Very clearly the coins visualized the same ideology and written and spoken rhetoric espoused immediately after Domitian's death. But Libertas on Nerva's coinage could not have been a message intended for the Senate alone, an idea that has largely developed in the background of Tacitus's statement in the *Agricola*, which was intended for a noble audience.[94] Coinage had the potential to reach a broader audience than written texts. It is not insignificant that Libertas appears on the full range of precious-metal and base-metal coins (except *quinarii* and *quadrantes*) struck in Nerva's reign and adorned multiple denominations in each of his emissions, except for the fifth where her image was struck only on *denarii* (appendices 1–2). Additionally, find evidence proves that Libertas was one of the chief images on Nerva's coins that circulated in Rome, Italy, and across the Roman Empire.

On the mobile silver *denarii*, Libertas comprises between 13 and 19 percent of all coins in his accession emission from the Reka Devnia Hoard, the aggregate of hoards, and site finds. In Nerva's largest emission of coinage, the third emission, Libertas ranges between 11 and

[92] Gowing 2005: 120–125.

[93] *CIL* 6.472 = *ILS* 274. Several scholars have casually taken the inscription as evidence for the dedication of a temple to Libertas (e.g., Merlin 1906a: 23, n. 1) or a rebuilding of the Atrium Libertatis (e.g., Platner and Ashby 1926: 56–57; Garzetti 1950: 54–55; Richardson 1992: 41). This cannot be the case as it does not seem to have the formula of a building inscription, nor is there any other evidence that would attest such activity in Nerva's reign. It was perhaps a dedicatory inscription for something less monumental, such as a statue or statue group. Garzetti 1974: 302 also rejects the assumption that this is a building inscription and views it simply as an honorary inscription.

[94] There have been only a couple of suggestions that Libertas on Nerva's coinage communicated a more popular message. Hammond 1963: 104 points out the legend on Galba's and Nerva's coins is LIBERTAS PVBLICA and thus has a broader connotation than POPVLI ROMANI; he equates the message with that of *securitas*. Grainger 2003: 47 suggests that Libertas communicated something different to the plebeians, perhaps freedom from the Senate, but does not pursue it.

14.25 percent of all *denarii*. She is the third most common image on *denarii* (appendix 3, part 7). Libertas is also universally prominent on the base-metal coinage in regional samples. On the base-metal coinage, she is the second most frequent image on all denominations. On *sestertii* she comprises 28.28 percent (84/297) of all specimens from hoards and finds, surpassed only by Fortuna Augusti at 31.31 percent (93/297). On *dupondii*, where she represents 31.74 percent (53/167) of finds, and on *asses*, where she is 27.39 percent (198/723), she is again second only to Fortuna Augusti at 50.90 percent (85/167) and 31.12 percent (225/723), respectively (appendix 4). In the finds of *asses* from the modern regions, Libertas is universally prominent (27 percent in Germany, Austria, Luxembourg, and Slovenia; 25 percent in Hungary; and 23 percent in England). At the site-specific level, the trend continues as she is prominent in the capital, civilian, and militarized areas. At Rome, in the combined SSU 1 and SSU 2 complexes, Libertas appears on 32 percent (6/19) of *sestertii*, half (3/6) of the *dupondii* and 34 percent (14/41) of *asses* (Figures 2.33, 2.37, and 2.39). In the Garonne Hoard from Aquitania, she constitutes 32 percent (47/145) of the total of *sestertii* (Figure 2.35). Libertas represents 32 percent (6/19) of the *sestertii*, 41 percent (9/22) of the *dupondii*, and 25 percent (24/96) of the *asses* from the area of Mainz and the Taunus-Wetterau *limes* (Figures 2.34, 2.38, and 2.40). At the fortress at Nijmegen, Libertas makes up half (3/6) of the *sestertii*, 46 percent (6/13) of the *dupondii*, and 20 percent (4/20) of the *asses*. Libertas's prominence on the coinage, surpassed only by the very generic message connoted by Fortuna Augusti, indicates that she delivered an important message about Nerva's principate intended for a diverse audience across the Roman Empire.

Coupled with the prominence of Libertas's image in the find complexes, it is notable that she is always labeled LIBERTAS PVBLICA on Nerva's coins, a slogan used on the coins of Galba and Vespasian; she is not LIBERTAS SENATVS. Her representation could not have been a message solely for the Senate—a body of around 600 old men in Rome—as so many scholars have intimated or asserted.[95] What exactly does this "public liberty" refer to on Nerva's coinage? In addition to freedom from slavery or tyranny, the coins of Caligula (Figure 3.13), which marked the remission of the ½ percent tax on auction sales in Italy, and of Galba (Figure 3.16) that announced the cancellation of the 2 ½ percent customs duty

[95] On Augustus's reduction of the Senate to 600, see, for example, Talbert 1996: 325.

on goods entering Gaul, indicate that the imagery of Libertas could also refer to freedom from anything burdensome in the imperial period, especially taxes and duties.[96] Indeed, Livy (45.18) casts provincial tax farmers (*publicani*) as instruments of oppression and enslavement, in whose presence *libertas* is not possible. And free cities (*civitates liberae*) often enjoyed immunities from taxation.[97] Nero's liberation of Greece from direct rule and taxation alluded to the deeds of Titus Quinctius Flaminius, who had earlier liberated Greece. When Nerva took power, he launched many popular initiatives, no doubt intended to present him as the opposite of Domitian and to position himself as a champion of the people, who Suetonius tells us were indifferent at the news of Domitian's death (*Domitianus* 23). As we have already seen, some of Nerva's coins celebrated the end of abusive prosecutions of the *fiscus Iudaicus* that took place under Domitian (Figure 2.30), a reform that probably benefitted wealthier Romans and especially the senatorial aristocracy. But Nerva also reformed the very unpopular inheritance tax (*vicesima hereditatum*) that was instituted by Augustus to fund the military treasury (Dio 55.25.5); it was so unpopular that Augustus made exemptions for direct heirs and inheritors of large estates, but these exemptions benefitted few Romans (Pliny, *Panegyricus* 2.3, 16.1, 63.2, 85.6; Tacitus, *Historiae* 4.7). Nerva added some more popular exemptions for bequests involving mothers and their free children as long as all parties were citizens. He also allowed exemptions for bequests between fathers and free sons, who were not required to be under the father's parental authority (Pliny, *Panegyricus* 53.3; 76.1–3). Nerva also decreed that disputes with the *fiscus* should be adjudicated by a *praetor*, rather than in procuratorial courts as had been the traditional practice (*Digest* 1.2.2.32); the change presumably favored the complainant over the *fiscus*. Nerva remitted the *vehiculatio* obligations in Italy, which burdened communities located along major thoroughfares, and celebrated that on his *sestertii* (Figure 2.18). Also in Nerva's principate, the provinces offered reduced tribute and were granted a number of

[96] The suggestion that *libertas* is associated with freedom from taxes, and other burdensome fees, is also offered by R.-Alföldi 1999: 131–132, although it is not substantiated further. Mario Torelli similarly claims that the burning of debt records and the *congiarium*/*adlocutio* represented on the Anaglypha Traiani suggests *libertas plebeia* through the representation of both Marsyas and the *ficus Ruminalis* that both symbolized that concept. See Torelli 1982: 105–106; *LTUR* IV, 1999: 95–96, s.v. Plutei Traianei (Anaglypha Traiani) (Torelli).

[97] Bernhardt 1980 elucidates the connection between *civitates liberae* and freedom from taxation (*immunitas*). Although it does seem that free cities typically received relief from taxes, Bernhardt's argument is overstated; free cities were sometimes required to pay taxes, especially in emergencies. Buraselis 2000: 136–137, n. 75 provides a critique and further bibliography.

privileges.[98] He also changed the law to make it easier for cities to inherit from citizens (*Epitome de Caesaribus* 12.4; *Digest* 35.2.1–3), an apparent response to popular demand for it. Finally, he forbade the castration of boy slaves and any man (Dio 68.2.4); Domitian did this as well, although he maintained eunuchs under his care (Dio 67.2.3; Suetonius, *Domitianus* 7).

The power of the representation of imperial ideals on Roman imperial coinage lies in their generality. Unlike a coin that might celebrate a very specific event, such as the construction of a building or a distribution of money to the people, an ideal refers generally to imperial policy and could be understood in different ways by different users. To the emperor, who was an audience, the representation of Libertas echoed the epideictic rhetoric spoken by the elites around him and communicated the expectation that he would rule differently and more liberally than Domitian. And while a senator might relate the image of Libertas on Nerva's coins to the new equitable partnership between the Senate and the *princeps*, and a restoration of senatorial freedom after Domitian's death, other viewers in the Roman Empire could also associate the image with Nerva's extension of legal protections and freedoms from taxation. Already, Libertas had been explicitly associated with freedom from taxation on the coinage of Galba, and Libertas's *pilleus* on the *quadrantes* of Caligula marked the remission of a tax. Roman viewers could thus associate her representation with such relief. The prominence of Libertas on Nerva's precious-metal and base-metal coins and their ubiquity in find complexes across Western Europe proves that Libertas was a message directed at the whole of the Roman population that could be interpreted in different ways by various users. To Italian municipalities along the Via Flaminia, frequently traveled by the imperial courier, Libertas evoked the remission of the burdens of the *vehiculatio*. To other Romans, she would have called to mind reforms applied to the inheritance tax and to the handling of disputes with the *fiscus*. Provincials could view Libertas as reflective of their reduced tributes and new privileges that Nerva extended to them. Libertas was thus a much broader message than has been recognized and was a most poignant message disseminated during Nerva's reign, and also widely publicized in the literary culture and epideictic rhetoric of Nerva's and Trajan's Rome.

[98] Syme 1930: 63–65.

Conclusion
The Visualization of Political Rhetoric

THE IMPERIAL COINAGE is the most complete record of state-sanctioned art that survives from Nerva's reign and yet it has been an underexploited source of material for reconstructing political ideology and rhetoric in his principate. Instead, the imagery on Nerva's coinage is mischaracterized as "apologetic," "aspirational," or "desperate," reflecting the emperor's need to cultivate the affections of various imperial constituencies, namely the armed forces, and the *plebs urbana* as a balance to the military. Such readings of the coinage attempt to see something of Nerva's "weak" character in the visual arts and do not account for the agency behind the formulation of imagery on imperial coinage. Contemporary coinage glorified the living emperor and portrayed him as the praiseworthy and unassailable head of the Roman state, and also communicated the positive expectations and benefits of his rule. The biases of ancient authors, who wrote about the Praetorian Guard's disrespect of Nerva and the looming military anxiety only after Nerva died, did not govern the creation of images during the emperor's lifetime. It was the positive rhetoric generated in the elite circles around the person of the emperor from which the coinage drew immediate inspiration. Reexamined as a medium of state-sanctioned art, and in conjunction with contemporary texts, Nerva's coinage was traditional and, like the coinage of previous emperors, also presented him as a progressive head of state involved with many different segments of the empire's population.

Nerva's "military types" drew upon historical prototypes in each case and properly represented Nerva as the supreme military commander, by right of his title *imperator* and his possession of *imperium maius*; that title and that power were carried by every emperor before him since Augustus

instituted the principate more than a hundred years before Nerva rose to command the reins of the Roman Empire. Later, Hadrian and Antoninus Pius, both of whom presided over long periods of relative peace and stability, were also regularly presented in the guise of a military commander, as was consistent with their place at the head of the Roman state.

Nerva's "historical types," which denoted very specific events, such as the *congiarium* (Figure 2.1), or rather precise ideals, such as Fortuna Populi Romani (Figures 2.16 and 2.17) or the *providentia* of the Senate (Figure 2.32), resonated most with the urban plebs and the Senate in Rome. Other images, as on the coins celebrating the remission of burdens associated with the *vehiculatio* (Figure 2.18), were targeted at Italian communities. Modern scholarship has emphasized the influence of the coinage of the civil wars, and particularly of Galba, on the imagery disseminated under Nerva. And it is true that Nerva, as did Galba, lacked a dynastic claim to legitimacy, became emperor upon the sudden and violent end of a dynasty, and was a member of the senatorial aristocracy. But closer examination reveals that Julio-Claudian and Flavian precedents also exerted influence on the designs and messages that appeared on Nerva's coinage. Nerva's coinage is remarkable, in part, for its strong emphasis on popular initiatives, celebrated especially on his *sestertii*, which is something his coinage has in common with his successor, Trajan. Under Nerva, some images and messages on the coinage were innovative. But since the reign of Nero, and again under the Flavians, the coinage had emphasized popular themes such as the security of the grain supply and the emperor's role therein, *congiaria*, and public building.[1] Nerva followed in the footsteps of emperors who furthered the interests of the urban plebs, and indeed Nerva's popular types appear to have drawn heavily from the coinage of Nero, whose coinage also had attested to the emperor's concern for plebeian interests.

On account of the diverse array of *sestertii* from Nerva's reign that speak to issues important to the urban plebs, and their circulation in Rome, it is tempting to ascribe direct imperial agency to the coinage, as so many scholars tend to do. There is, of course, no evidence that the emperor was directly involved in the formulation of imperial coin iconography and indeed the imperial coinage appears to have been honorific in the sense

[1] Wolters and Ziegert 2014: 62–66. On the proliferation of diverse, but uncommon, coin types celebrating public building in Rome from Nero to Trajan, see Elkins 2015: 108–113. Buildings for popular use are prominent on coins of Nero and had been absent on earlier Julio-Claudian coins that depicted only temples and honorary monuments, such as arches, as there was a new focus on popular building in the reign of Nero (e.g., Thornton and Thornton 1989: 41 and 121 et passim).

that the emperor himself was one of the audiences at whom the imagery was directed. It is more probable that officials in charge of the mint formulated designs and their accompanying legends on imperial coinage, which explains both the representation of certain images and ideals across reigns and the fact that the coinage generally glorifies the emperor. Occasionally, imperial coins carried legends with the emperor's name and titles in the dative case; the phenomenon is ubiquitous on Trajan's coinage of 103 and later. An example is the Trajanic *aureus* with the legend IMP TRAIANO AVG GER DAC P M TR P / COS V P P SPQR OPTIMO PRINC, "The Senate and Roman People *to* the emperor Trajan Augustus, Germanicus, Dacicus, Pontifex Maximus, Holder of the Tribunician Power, Consul for the Fifth Time, Father of the Fatherland, the Best Prince" (Figure 2.20). The formula is similar to dedicatory inscriptions that appear on triumphal arches voted *to* the emperors *by* the Senate and Roman People.[2] While certain major projects, such as the construction of new imperial *fora* in Rome, almost certainly had input from the emperor and/or his agents, it is unlikely and impractical to assume the emperor had much direct involvement in the execution of the minutiae pertaining to every single building constructed during his reign (especially on honorific monuments), approved every likeness and the subtleties therein, and obsessed over the details of each and every relief sculpture.

What these monuments—and the coins—represent is the work of skilled artisans employed and directed by state actors to manufacture appropriate and stately images and monuments using an adaptable, but mostly traditional, picture language that had matured during the late Republic and early Roman Empire. The agents behind those honorific monuments were imperial constituencies, especially the Senate and the Roman People.[3] Just as the emperor was expected to serve the interests of the state and its constituencies, the Senate, the *plebs urbana*, the citizenry of Italy and the provinces were expected to reciprocate in turn with honors and praise directed at the emperor.[4] The commonalities between Nero's and Nerva's coinage, insofar as the *sestertii* often bear popular themes, thus does not indicate that Nerva or one of his agents consciously reached back to Nero for inspiration (or, for that matter, that Nero himself directed his coinage to bear designs relevant to the *plebs urbana*). Instead, the similarities

[2] E.g., the inscription on Arch of Trajan at Beneventum, *CIL* 9.1558.
[3] Torelli 1997; Stewart 2008: 108–116, esp. 116; Mayer 2010; Zanker 2010: 108–115. Cf. Mayer 2002, in which late Roman imperial monuments are understood as part of a "panegyric milieu."
[4] E.g., Veyne 1976; Millar 1992: 139–144.

between Nerva's and Nero's coinage in this regard result from the mint officials drawing from the imagery of that period to aggrandize Nerva as a champion of the common people, just as mint officials in Nero's reign had been inspired to formulate that imagery in order to praise Nero for his efforts on behalf of the people.[5] Such an interpretation also explains why Vespasian's precious-metal coinage drew from Greek, republican, and early imperial prototypes through the civil wars as the mint sought to present the regime through traditional modes of representation and, potentially, to connect the new regime with the past.[6] The initiative of the mint in the selection of coin types is illustrated by a well-known problem in the coinage of Augustus whereby the Senate, upon Augustus's diplomatic agreement with the Parthians in 19 BC, decreed a temple to Mars Ultor on the Capitoline Hill (Dio 54.8.3). Immediately, a small temple to Mars Ultor appeared on the coins struck at the imperial branch mints operating in Spain and Pergamon.[7] Not coincidentally, the temple never appeared on the coinage struck at Rome. While scholars have suggested many creative solutions to explain the appearance of the temple on coins decades before the Temple of Mars Ultor was dedicated in the Forum of Augustus, a simpler and more probable scenario is that Augustus simply rejected the honor of a small temple on the Capitoline as he intended the larger temple for the Forum of Augustus. Rejection of the decree explains why a small temple to Mars Ultor appeared only on coinage struck outside of Rome, and only for a short time, as the mints responded to the decree honoring Augustus's political victory by striking images of the temple and then ceased when news came that the emperor had rejected the honor in that form.[8] The coins visualized an honor offered to the living emperor.

While we are fortunate to have as many texts, inscriptions, coins, portraits, reliefs, and public monuments from the Roman world as we do, we must also remember that the texts that survive to this day represent a fraction of what existed millennia ago and that many speeches, laudatory poems, panegyrics, and other texts are lost or were never written down. What the imperial coinage has in common with contemporary texts, public

[5] Cf. Elsner 1994 on the appropriateness of Nero's popular activities, and especially building; it was only after his death that his building activity was characterized negatively in the rhetoric of senatorial and equestrian authors.

[6] Levick 1982: 112–116 *contra* Buttrey 1972 who explains the antiquarian numismatic interest by suggesting that Vespasian himself had been a moneyer earlier in life. That is improbable as Vespasian was a *novus homo*.

[7] *RIC*[2] I: nos. 28, 39a–b, 64–69, 72–74, 103–106, 114–120, and 507.

[8] E.g., Rich 1998: 86; Elkins 2015: 61–63, with further bibliography.

building, and state-sanctioned relief sculpture is its honorific qualities that glorify the living emperor and express dedication from constituencies such as the Senate and Roman People. Imperial poetry and panegyric, for instance, were dedicated *to* the emperor and exalted him. While they may be characterized as "propaganda" only in the sense that they portray the emperor positively as he wished to be seen, they do not have direct imperial agency behind them; such texts were instead formulated by authors such as Martial and Pliny. Pliny and his contemporaries Frontinus and Tacitus were, however, part of the upper echelons of imperial government and were closely involved with the living emperor; the poet Martial was not a politician, but he walked among the elite circles of Rome and sought imperial and noble patronage. Their exaltations of the emperor, therefore, reflect political rhetoric between the emperor and his constituencies and the contemporary public discourse concerning the emperor's political program. This is the way the imperial coinage ought to be understood. It preserves a record of political rhetoric that is often incomplete in surviving texts.[9] When there are surviving contemporary texts, correspondence between the two media is easily discernible.

A confluence of contemporary images and texts flourished throughout Roman imperial history. Under Augustus, for example, the coinage visualizes the same ideas and rhetoric repeated in contemporary text and poetry, and the Parthian settlement is a key theme in both.[10] Under Tiberius, *moderatio, clementia, iustitia, pietas*, and *concordia* were imperial ideals to which the contemporary authors Velleius Paterculus and Valerius Maximus (and later Tacitus) paid much attention; not without coincidence, these ideals are promoted on Tiberian coinage too, echoing contemporary rhetoric about Tiberius's mode of governance.[11] The virtue of *clementia* was celebrated widely in Tiberius's principate and reverses of his *dupondii* depict a laureate bust on a shield surrounded by the legend CLEMENTIAE (Figure C.1) (Valerius Maximus 5; Tacitus, *Annales* 2.31.4, 3.50.3, 3.68.2,

[9] Pliny states that the distinguished veteran Lucius Verginius Rufus fractured his hip while rehearsing his speech of thanks to Nerva for the third consulship that he would serve alongside the emperor (*Epistulae* 2.1.5). The text of the speech is lost, but it is no stretch to suggest it deployed epideictic rhetoric and praised Nerva for positive qualities that Domitian did not possess, such as *aequitas* and *iustitia*, and communicated expectations such as *libertas*, as did the texts by Martial, Frontinus, Pliny, and Tacitus, and the coinage. On Rufus's lost *gratiarum actio* as epideictic rhetoric, see Coleman 2000: 26; Pernot 2015: 25.

[10] Lamp 2013: 80–108. See also Zanker 1988.

[11] Levick 1999c: 82–91. See also Rogers 1943: 35–88 on *clementia* and *moderatio*. For the coin types, see RIC^2 I: (*clementia*) no. 38; (*moderatio*) nos. 39–40; (*pietas*) no. 43; (*iustitia*) no. 46; (*concordia*) nos. 74–76.

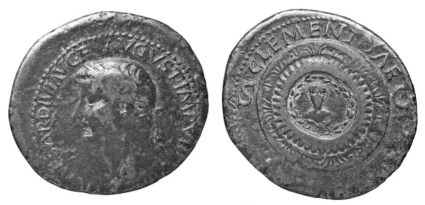

FIGURE C.1 *Dupondius* of Tiberius from 16–22 with the CLEMENTIAE reverse type. (© Bibliothèque nationale de France.)

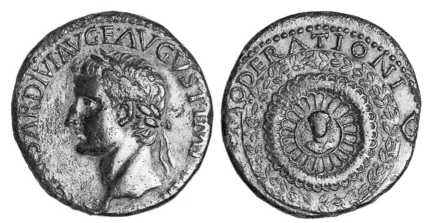

FIGURE C.2 *Dupondius* of Tiberius from 16–22 with the MODERATIONI reverse type. (Courtesy of the American Numismatic Society, 1944.100.39284.)

6.25.4). The Ara Clementiae was dedicated by the Senate in 28 in honor of Tiberius and Sejanus (Tacitus, *Annales* 4.74).[12] Other *dupondii* bear a similar design with a facing bust and the legend MODERATIONI (Figure C.2), naming the important imperial ideal of *moderatio* that was discussed in contemporary Tiberian texts (Valerius Maximus 4.1; Velleius Paterculus 2.122.1; see later: Suetonius, *Tiberius* 32.2; Tacitus, *Annales* 1.7.6, 1.14.3, 2.36.2, 3.12.1, 3.50.2, 3.56.1,4, 3.69.8, 4.38.4). A bust of Iustitia adorns the obverses of *dupondii* (Figure C.3) and this imperial ideal was also a core component of political rhetoric in Tiberius's reign according to

[12] *LTUR* I, 1993: 30, s.v. Ara Amicitia (Torelli).

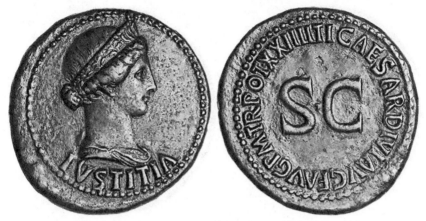

FIGURE C.3 *Dupondius* of Tiberius from 22–23 depicting a bust of Iustitia on the obverse. (Courtesy of the American Numismatic Society, 1944.100.39280.)

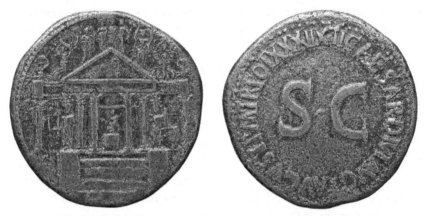

FIGURE C.4 *Sestertius* of Tiberius from 35–36 depicting the Temple of Concord on the obverse. (© Bibliothèque nationale de France.)

Valerius Maximus (6.5) and Velleius Paterculus (2.126.2). In the aftermath of the conspiracy of Libo Drusus, public dedications were made to Concordia, whose temple Tiberius had rebuilt in the reign of Augustus and which decades later appeared on his *sestertii* (Figure C.4) (Tacitus, *Annales* 2.32.2).[13] Pietas was important to Tiberius's rule, as exhibited by his devotion to the memory of the Deified Augustus and demonstrated on his coinage honoring his deified father; Suetonius also recounts that during Augustus's lifetime the surname "Pius" was recommended to Tiberius

[13] On the public dedications: *CIL* 6.91–93, 904, 3674 (3075 = 30856); *ILS* 3783.

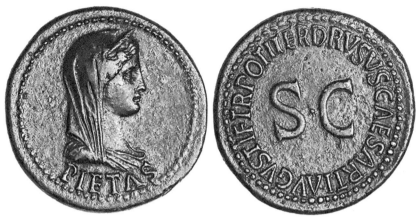

FIGURE C.5 *Dupondius* of Tiberius from 22–23 depicting a bust of Pietas on the obverse. (Courtesy of the American Numismatic Society, 1947.2.419.)

although Augustus denied it so he could take his own *cognomen* (*Tiberius* 17.2). Tiberian *dupondii* champion *pietas* as an imperial quality by representing the veiled head of Pietas (Figure C.5). Although Tiberius's imperial coinage is known for a noticeable lack of variety during his lengthy reign, there is a remarkable coherence between the images and the rhetoric in contemporary texts.

A more coetaneous example of the relationship between laudatory text and coin images stems from the reign of Nerva's predecessor, Domitian. In two of his epigrams, Martial recounted the once-in-a-lifetime and awesome display of a rhinoceros in his aggrandizement of "Caesar," who is probably Domitian and not Titus (*Liber Spectaculorum* 11[9] and 26 [22 + 23]).[14] In the reign of Domitian, *quadrantes* depicted a rhinoceros on the obverse and basic imperial titulature on the reverse: IMP DOMIT AVG GERM, dating them to not before 83 (Figure C.6).[15] At Rome, the display of rhinoceroses at games was a very rare and exotic event as the large creatures weighed up to three or four tons, making them difficult to transport. The extraordinary appearance of the rhinoceros at Domitian's games merited celebration on coinage that circulated among the masses and immortalization in Martial's laudatory epigrams on spectacles. Another extraordinary display of games and imperial munificence is marked by *aurei* and *denarii* of Septimius Severus, Caracalla, and Geta from about

[14] On Martial, Domitian, and the rhinoceros display, see Coleman 2006: xlv–lxiv, 101–111, and 186–194; Buttrey 2007.
[15] *RIC*[2] II.1: nos. 248–254.

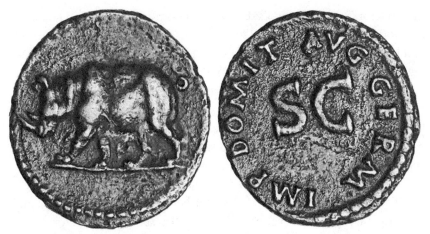

FIGURE C.6 *Quadrans* of Domitian from ca. 84–85 depicting a rhinoceros on the obverse. (Courtesy of the American Numismatic Society, 1921.100.8.)

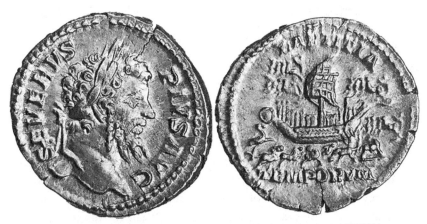

FIGURE C.7 *Denarius* of Septimius Severus from 202–210 with the LAETITIA TEMPORVM reverse type. (Courtesy of the American Numismatic Society, 1944.100.50203.)

201–209 that depict the barrier of the Circus Maximus disguised as the hull of a ship, with the obelisk serving as the mast, and surrounded by animals; the reverse legend, LAETITIA TEMPORVM, proclaims the happiness of the times (Figure C.7).[16] The coins represent a spectacle from Severus's *decennalia* in which the barrier of the Circus Maximus was staged as a ship, rigged to collapse, from which beasts theatrically emerged for a hunt; Dio witnessed the event and described it in praise of

[16] *RIC* IV.1: (Septimius Severus) no. 274; (Caracalla) nos. 133, 157; and (Geta) no. 43.

the emperor (77.1.4–5). Dio's description is similar to a Severan honorary inscription, the *acta*, dedicated to Septimius Severus; the inscription also proclaims "pro temporum laetitia et felicitate sanctissimorum," mirroring the legend LAETITA TEMPORVM on the coinage.[17] Here again is a striking similarity between the coinage, written praise directed toward the emperor, and an honorific inscription. Imperial coin imagery thus appears to have been formulated in a manner similar to gratulatory poetry and panegyric as it reflects much of the same ideas and events expressed in contemporary texts and similarly exalts the emperor.

Examples may also be drawn from the principate of Nerva's successor, Trajan, to illustrate the relationship between coin iconography and contemporary political rhetoric. Many of the same policies for which Pliny lauds Trajan, such as his *alimenta* program, are trumpeted also on the coinage, and certain qualities ascribed to Trajan's principate in Pliny's *Panegyricus* and *Epistulae* find parallels on the contemporary coinage of Trajan.[18] Libertas, for example, appears on the early Trajanic coinage and *libertas* is a major theme in Pliny's *Epistulae* and *Panegyricus*, mirroring the representation of Libertas on Nerva's coinage and the rhetoric of *libertas* in Nerva and Trajan's reign.[19] Libertas was thus something of an axiom in the political rhetoric in the decade or so after Domitian's assassination.

There is, of course, a correspondence between text and image in Nerva's reign as well. Extant texts confirm many of the same events denoted on Nerva's coinage, such as the *congiarium* and his ending of false accusation under the *fiscus Iudaicus*. In fact, the "historical types" depicting Nerva's largess and gifts to the people, to which so many attribute imperial agency in the selection of imagery, are things for which emperors were praised, as, for example, Pliny praises Trajan for his popular initiatives. Nerva's portraits in-the-round depict the aged emperor with a Julio-Claudian hairstyle (Figure 2.29), and his restoration coinage for the Deified Augustus (Figures 2.22–2.28) portray Augustus with the features of Nerva. The reverse legends on the restoration coinage proclaim restoration, REST(ITVIT), mirroring Martial's flattering statement that, in Nerva, the gods had restored Augustus to the earth (11.3.9: "cum pia

[17] Carlson 1969; Rowan 2011a: 51–52. On the *acta*, see *CIL* 6.32326–32335, the phrase "pro temporum Laetitia et felicitate sanctissimorum" is in *CIL* 6.32326 = Pighi 1965: 143, I.26.

[18] E.g., Méthy 2000 and Schowalter 1993: 93–99, who suggests a connection between the coins and Pliny via their attestations of concord between *princeps* and Senate.

[19] On *libertas* in text in Trajan's reign, see, for example, Whitton 2010. The Trajanic coins bearing images of Libertas are Woytek 2010: 1:240, no. 102; and 341, no. 292, dated to 101–102 and 108–110, respectively.

reddiderint Augustum numina terris").[20] The imperial ideals expressed on the coinage through personifications, or solely through the invocation of their names in the legends, are also ascribed to Nerva by writers who lived during his principate and who associated with him: *providentia* (Frontinus, *de Aquis* 64, 87, although the coins refer to the Senate's *providentia*), *pietas* (implied by Martial 11.5.1–4 who calls him a Numa), *aequitas* (Martial 11.5.1; implied by Pliny, *Panegyricus* 38), *iustitia* (Frontinus, *de Aquis* 118; implied by Pliny, *Panegyricus* 33), and *libertas* (Pliny, *Epistulae* 9.13.4; Tacitus, *Agricola* 3.1; Martial 11.2.6, 11.5.7, 11.6.4; *CIL* 6.472 = *ILS* 274).

Relationships between contemporary rhetoric and the subject matter of images and messages on the coins, and the similarity of dedicatory inscriptions to the format of Trajanic coin legends, imply that images and legends on imperial coins emanated from the same sorts of people who erected honorary monuments and dedications in Rome, typically the Senate, and who composed adulatory poetry, panegyric, and historical prose dedicated to the emperor. Although their work was recorded after Nerva had died, Frontinus and Tacitus were prominent senators who served under Nerva and who were thus part of his inner administrative circle; Tacitus was a suffect consul in 97 and Frontinus was appointed *curator aquarum* and was one of only five senators selected to serve on Nerva's economic commission. Martial, a member of the equestrian order, was a poet who sought imperial and senatorial patronage and so he was socially close to the center of the regime's power.[21] Pliny, born an equestrian, had risen through the ranks under Domitian, became the prefect of the treasury housed in the Temple of Saturn under Trajan in 98, and in 100 was consul. Pliny, too, was part of the imperial service and close to the person of the emperor. Senators and equestrians holding important posts, or who were close to the emperor and his circle, were the agents behind the creation of epideictic rhetoric, in text and spoken word, which extolled the emperor's qualities and the nature of his political programs and contrasted them with his maligned predecessors. But if the agency behind the creation of images

[20] In 11.20, Martial quotes a verse of erotic poetry ascribed to the Deified Augustus and addresses Nerva, again inviting comparison between Augustus and Nerva, whose liberality allows much of the bawdy content of his eleventh book. See discussion and further references in Coleman 2000: 33–35 and Rimmel 2008: 167–168. Nerva, too, had poetical predilections, as Martial attests in 8.70, where Nero had praised him for being the "Tibullus of our time," and in 9.26, where his poetic skills are again suggested.

[21] On Martial's efforts at winning Nerva's patronage, see Sullivan 1991: 46–47, more generally 116–130 et passim.

and text on coinage is ascribed to the mint and its overseers, would those people have also been as close to the emperor and walked among the same elite political and social circles as Tacitus, Frontinus, Pliny, and Martial?

In the Republic, the *tresviri monetales* were appointed annually. They oversaw the striking of coinage and were responsible for the designs on the coinage, as the themes that appear on republican coins most often related to the great deeds of a moneyer's ancestors or to the origin of his family. Under the emperors, the *tresviri monetales* continued to exist through the third century, although who they were and what their function was during the principate remains a mystery. There was a new office in the imperial period: the *procurator monetae*, an equestrian in the imperial service who administered the mint.[22] There is no tangible evidence for the existence of a *procurator monetae* before the first mention of one in early in the reign of Trajan, although the post was almost certainly created before then.[23] The first recorded equestrian *procurator monetae* is Lucius Vibius Lentulus, who had been tribune of *Legio VII Geminae* from 88–89, and who, there-fore, served with Trajan. It is probable that he came to know Trajan dur-ing this service, won his favor, and that when Trajan became emperor he elevated him to procuratorial posts.[24] After serving as *procurator monetae*, he became *procurator* of Pannonia and Dalmatia, and then *procurator* of Asia. He ended his career as *procurator a rationibus*, which is something similar to a chief minister of finance. The *procurator monetae* answered to the *procurator a rationibus*. Whether or not the formulation of imag-ery and text on the coinage came from the *procurator a rationibus*, the *procurator monetae*, or the anonymous moneyers under them is an unan-swerable question, as the nature of the separation of their duties is unclear in the imperial period; their administrative duties were at least distinct from the technical workers attested by a famous Trajanic inscription.[25] As a minister of finance, Lucius Vibius Lentulus surely would have been an

[22] Peachin 1986.

[23] Peachin 1986: 101 and n. 40 *contra* Pflaum 1950: 56 and 80.

[24] Pflaum 1960–1961: 157–158; Peachin 1986: 95, n. 5. Pflaum assigns the beginning of his post as *procurator monetae* to 102; Peachin ascribes it to 96–102, although this is surely a typographical error as Trajan became emperor in 98.

[25] Woytek 2013: 256 (the inscription is *CIL* 6.44). Levick 1982: 107–108, following Voelkel 1953, suggests that at least in the Flavian period, the *procurator a rationibus* would have been responsible for coinage and its imagery, in view of Statius, *Silvae* 3.3.86–105. Wolters 1999: 290 rightly points out, however, that Statius does not discuss the selection of iconographic types. Burnett 1977 argues for a diarchal minting system, at least in the early Roman Empire under Augustus, in which the *tresviri monetales* were responsible for base-metal coins issued under the purview of the Senate and an *a rationibus* was responsible for precious-metal coins minted under imperial authority. Claes 2014 argues the a *rationibus* constructed imagery on behalf of the emperor.

essential member of Trajan's "cabinet" later in his career. Those in charge of the mint were, therefore, as close to the emperor as other notable equestrians and senators, such as Martial, Pliny, Frontinus, and Tacitus, who actively participated in a culture of adulation, and thus they were aware of the contemporary political rhetoric and in a position to visualize that rhetoric. Coins also visualized the rhetoric between the emperor and important constituencies, such as the Senate, reflecting the promotion of these groups by association with imperial power, just as Pliny's *Panegyricus* not only lauded Trajan but aggrandized the consular author in the process, and as Martial's praise of Nerva also served as a courtship for patronage.[26] The coinage, like the literature, attests the culture of expectation, praise, and exchange between the emperor and constituent groups.

In Nerva's principate, text and image sharply coalesced around the iteration of imperial ideals. On the coins, this necessitated the depiction of personifications who embodied the ideals themselves and who bore symbolic attributes. Aequitas held scales evoking fairness and cornucopiae emblematic of the benefits thereof. Iustitia grasped a scepter and branch to signify the necessity of close adherence to the law to maintain peace. Fortuna clutched her steering oar to direct positive outcomes and cradled cornucopiae from which her blessings flowed. And Libertas displayed the *vindicta* and *pilleus* as the instruments through which men are freed. To negate any confusion, these ideals were boldly labeled (up until the penultimate emission of December 97): AEQVITAS AVGVST(I), IVSTITIA AVGVST(I), FORTVNA AVGVST(I), and LIBERTAS PVBLICA. According to hoards and finds, these generic messages, with the exception of Iustitia, who connoted a more defined message than Aequitas, formed the bulk of images impressed upon the coins in Nerva's reign and they circulated widely among the population of the Roman Empire. In fact, personifications are among the most common images on imperial coinage from the Flavian period through the second and third centuries, which mirrors the development in contemporary texts in which emperors and prominent Romans were increasingly judged and praised according to their qualities rather than their specific actions.[27] The development of imagery and subjects in accordance with texts of this period indicates that the coinage adapted to this mode of adulation. The representation of imperial ideals was also more politically expedient. "Historical types" celebrated specific events

[26] Sullivan 1991: 46–47; Nauta 2002: 437–440; Noreña 2011b.
[27] Burnett 1987: 78–79. Noreña 2011a quantifies the prevalence of personifications on coins during this period.

or aspects of imperial policy and conveyed clearly defined messages, such as the PROVIDENTIA SENATVS *sestertii* (Figure 2.32), the *congiarium sestertii* (Figure 2.1), or the *vehiculatio sestertii* (Figure 2.18), but the specificity of these messages limited their resonance. The Senate consisted of around 600 men in the city of Rome; the *plebs frumentaria* numbered around 150,000 in Rome; and the remission of obligations to the *vehiculatio* had no relevance outside of the Italian peninsula. In contrast to these denotative images with their limited appeal, the imprecision of personifications of imperial ideals is precisely what made them the most potent visual communicators.

In Fortuna Augusti (Figure 3.3), a senator could visualize his freedom from unfair accusation under Domitian brought about by the arrival of a new and better *princeps*, plebs in Rome could recall Nerva's generous *congiarium* or his *frumentum*, a Praetorian might think of the donative, and a provincial citizen might reflect on reduced tribute. Aequitas (Figure 3.6) and Iustitia (Figure 3.8) similarly connoted to senators their renewed equitable and just treatment under Nerva, while to the broader population Aequitas alluded to other reforms that potentially benefitted them, such as the adjustments made to the inheritance tax or the transference of individual disputes with the *fiscus* to judgment by a *praetor*. Libertas (Figures 3.18 and 3.19) proclaimed to senators their relief from Domitian's tyranny, freedom from the burdens of the *vehiculatio* to Italian communities, and freedom from or the reduction of various taxes and tributes to citizens and inhabitants of the provinces. The personifications of imperial ideals bore universal relevance and reached a wider audience than more specific types referring to the *congiarium, frumentum, vehiculatio,* or senatorial *providentia.*

Modern analogies with Roman practice are often rife with difficulty on account of the immense linguistic, cultural, social, technological, and religious changes that have taken place in the intervening millennia. But perhaps something of a modern parallel with the Roman deployment of abstract qualities in coinage, art, and text is exemplified in recent American visual culture and political rhetoric. At the beginning of 2008, Senator Hillary Rodham Clinton and Senator Barack Obama were battling to become the Democratic nominee for president of the United States. In January of that year, Shepard Fairey, who had been known in part for the activist and political content of his artwork, and who had been very critical of George W. Bush and the Iraq War, created one of the most iconic images of the early twenty-first century. He appropriated an Associated Press photograph of Senator Obama by Mannie Garcia and made serigraph prints

(limited to an edition of 350) that portrayed Obama in red and two shades of blue on a cream speckle-tone paper (Figure C.8). This patriotic portrait erased Obama's racial identity, which had energized both support for and opposition to his candidacy, and his upturned gaze was aimed at portraying him as a providential figure in the vein of Abraham Lincoln. The twist of the neck and the farsighted gaze also has a long history in political portraiture in Western art that can be traced back to Alexander the Great. The proclamation PROGRESS is imposed on the bottom of the image. Shepard Fairey fans immediately purchased what prints were available and the financial proceeds supported a statewide poster campaign that the artist had planned. Fairey, a "street artist," had some history with the police for tagging and pasting buildings with artwork and did not want his support of Obama to damage his campaign. The artist had been in contact with the Obama campaign to seek approval to proceed with a poster campaign in the months before his creation of *Progress*; in early February, after the release of the *Progress* prints, Fairey received approval for his creation

FIGURE C.8 *Progress*, January 2008, serigraph fine art print, by Shepard Fairey, 24 × 36 inches, limited edition of 350. (Courtesy of Shepard Fairey, ObeyGiant.com.)

FIGURE C.9 *Hope*, February 2008, poster, by Shepard Fairey, 24 × 36 inches. (Courtesy of Shepard Fairey, ObeyGiant.com.)

and dissemination of campaign posters with the portrait of the prodigious candidate. The campaign's core message and rhetoric revolved, however, around "hope" and "change," and so to make the poster more in line with the campaign's messaging, and apparently at its request, Fairey jettisoned PROGRESS and substituted it with HOPE (Figure C.9); other posters he formulated for the campaign also bore CHANGE.[28] He sold signed *Hope* prints to raise further funds, but most importantly he printed at least 300,000 unsigned and unnumbered posters and one million stickers, and the image was available for free download from his website. The image and message had immediate resonance with people across the country. It was, and still is, universally recognizable and widely appropriated and parodied; it is now one of the most iconic and historically significant artworks of our century.

[28] On the *Progress* and *Hope* images, see Fairey 2009; Gross 2009; Beer 2009; De Gregori 2011: 127–173; Schneider 2012.

Not only does the *Hope* poster represent a perfect confluence of political rhetoric and image/text in a contemporary moment of time, just as *libertas* or *aequitas* and *iustitia* did for Nerva, it is the artist's visual panegyric directed toward the promising presidential candidate. The success of the image, its broad resonance, and wide consumption lay partly in its graphic aesthetic that particularly appealed to a youthful audience, but also in the generically positive message that it communicated: HOPE. The poster does not define what that hope is but leaves it open to the viewer's interpretation. To some, *Hope* connoted an end to aggressive American involvement in the Middle East, the end of human rights violations perpetuated by the Bush administration, or the end of other perceived presidential abuses of justice, and the repair of America's image around the world. For others, *Hope* meant a renewed focus on domestic and social issues, immigration reform, attention to economic issues such as Wall Street reform, or to urgent global dangers such as climate change. And for still others, *Hope* suggested the historic opportunity to elect the first African American president, which would signal how far America as a nation had come in view of its checkered past regarding race relations.[29] Not unlike Fairey's *Hope*, the rhetoric of Nerva's *pietas, fortuna, libertas, aequitas, iustitia,* and his proclamation as the new Augustus, were touted in contemporary text and speech, and visualized on his coinage in adulation of his qualities; the representation of these imperial ideals and their accompanying labels allowed each viewer to bring his own meaning and interpretation to the image that would be dictated by who he was, where he lived, and how exactly Nerva's *principate* would benefit him. These expectations also differentiated Nerva's positive qualities from the negative qualities of his predecessor.

The art created during Nerva's sixteen months in office paints a very different picture of the emperor than the historical figure whom we are accustomed to seeing: an elderly man vulnerable to coercion by force of arms and manipulation by politically savvy military strategists. This is the image of an emperor informed by historical distance. Instead, the coinage—the most complete record of state-sanctioned art to have survived from Nerva's principate—shows us how the regime wished to be seen and, more accurately, how politicians and writers around Nerva wanted him to be seen while he actively wielded imperial power. It provides an image of an emperor defined very differently than his autocratic predecessor,

[29] Cf. also De Gregori 2011: 147–151 on the dimensions of *Hope*.

cast as a tyrant who lacked *aequitas*, abused *iustitia*, and was antithetical to *libertas*. Nerva was Domitian's antidote, exercising the qualities that Domitian did not have. By virtue of his convictions and the expectations placed on him, he acted to restore the dignity of the Senate and promoted the interests of the common citizenry in Rome and in Italian and provincial communities alike. The coinage does not record the real trials and tribulations that Nerva's principate faced, and upon which later authors focused; instead, it visualizes the adulatory rhetoric directed toward the regime by the upper echelons of Rome's political elite who stood close to the emperor and lauded him for his qualities and his dutiful care of his people. Some spoke and inked that praise on scrolls, but others had it carved into steel dies and struck it firmly upon gold, silver, brass, and copper coinage. That money was a facet of daily life for most Romans, from the highest senator to the lowest peasant and to slaves. Coinage thereby permeated the Roman Empire's highly diverse populations, separated by vast geographical distances, and reinforced positive expectations and perceptions of Nerva and his regime in an infinitely more effective way than Martial's or Frontinus's scrolls ever could.

| The Typological Makeup of Nerva's Imperial Coin Emissions

Each of Nerva's coin emissions produced gold, silver, and base-metal coinage, except for the second emission, which comprised only silver and base-metal coins; although the fifth emission put out no base-metal coins, according to *RIC*, the undated restoration coins for the Deified Augustus may be assigned to the fifth emission. Many types that appeared in Nerva's first emission of September 96 became standard and reappeared in subsequent emissions throughout his reign. All standard imperial coin denominations appeared in Nerva's first emission.

1. First Precious- and Base-Metal emission, September 96 (TR P COS II)

LEGEND/TYPE	AUREI	DENARII	QUINARII	SESTERTII	DUPONDII	ASSES
AEQVITAS AVGVST	X	X				X
CONCORDIA EXERCITVVM (clasped hands only)	X	X				X
CONCORDIA EXERCITVVM (clasped hands with standard and prow)	X	X		X	X	X
FORTVNA AVGVST	X	X		X	X	X
FORTVNA P R	X	X		X		
IVSTITIA AVG		X				
LIBERTAS PVBLICA	X	X		X	X	X
SALVS PVBLICA		X				
VICTORIA AVGVST			X			
PAX AVG				X		

LEGEND/TYPE	AUREI	DENARII	QUINARII	SESTERTII	DUPONDII	ASSES
ADLOCVT AVG				X		
ANNONA AVGVST				X		
CONGIAR P R				X		
FISCI IVDAICI CALVMNIA SVBLATA				X		
ROMA RENASCENS				X		

The second emission in December 96 produced no gold coinage and was more restricted typologically. CONCORDIA EXERCITVVM was featured only on *sestertii* and *asses*, while FORTVNA AVGVST(I) was placed only on base-metal denominations and LIBERTAS PVBLICA only on *sestertii* and *asses*. The only reverse types to appear on *denarii* in this emission are of Diana and priestly emblems, both of which lack an accompanying descriptive legend. *Sestertii* again hosted themes that were in the first emission: PAX AVG(VSTI), ANNONA AVGVST(I), CONGIAR(IVM) P(OPVLI) R(OMANI), FISCI IVDAICI CALVMNIA SVBLATA, and ROMA RENASCENS. One *sestertius* type that does not reappear in this or any subsequent emissions is ADLOCVT(IO) AVG(VSTI). *Quadrantes*, bearing a *modius* on the obverse and a winged *caduceus* on the reverse, have been assigned to this emission according to their probable association with three *officinae*, identifiable by the variable number of wheat stalks emerging from the *modius*.[1]

2. Second Precious- and Base-Metal Emission, December 96 (TR P COS II DESIGN III)

LEGEND/TYPE	DENARII	SESTERTII	DUPONDII	ASSES	QUADRANTES
CONCORDIA EXERCITVVM (clasped hands only)				X	
CONCORDIA EXERCITVVM (clasped hands with standard and prow)		X			
FORTVNA AVGVST		X	X	X	
LIBERTAS PVBLICA		X		X	
Diana	X*				
priestly emblems	X*				
PAX AVG		X			
ANNONA AVGVST		X			

[1] Szaivert 1978: 55 and 57–58.

LEGEND/TYPE	DENARII	SESTERTII	DUPONDII	ASSES	QUADRANTES
CONGIAR P R		X			
FISCI IVDAICI CALVMNIA SVBLATA		X			
ROMA RENASCENS		X			
Modius / Winged *caduceus*					X*

* indicates no descriptive legend on the reverse.

Nerva's third emission in January 97 saw the return of *aurei* and reverse types that had not been repeated in the second emission: AEQVITAS AVGVST(I) on *aurei, denarii,* and *asses,* FORTVNA P(OPVLI) R(OMANI) on *aurei, denarii,* and *sestertii,* IVSTITIA AVG(VSTI) on *denarii,* SALVS PVBLICA on *denarii,* and on *aurei* for the first time, and VICTORIA AVGVST(I) on silver *quinarii.* CONCORDIA EXERCITVVM appeared again on all standard denominations, as did FORTVNA AVGVST(I) and LIBERTAS PVBLICA, while the priestly emblems were featured on *aurei* and *denarii. Sestertii* continued to host PAX AVG(VSTI), ANNONA AVGVST(I), FISCI IVDAICI CALVMNIA SVBLATA, and ROMA RENASCENS. The *congiarium* type was not revived in this emission nor in any other emission after the second. Some new types appeared on the base-metal coins of this emission: PLEBEI VRBANAE FRVMENTO CONSTITVTO, VEHICVLATIONE ITALIAE REMISSA, and PROVIDENTIA SENATVS on *sestertii* and NEPTVNO CIRCENS(IBVS) CONSTITVT(IS) on *asses.*

3. Third Precious- and Base-Metal Emission, January 97 (TR P COS III)

LEGEND/TYPE	AUREI	DENARII	QUINARII	SESTERTII	DUPONDII	ASSES
AEQVITAS AVGVST	X	X				X
CONCORDIA EXERCITVVM (clasped hands only)	X	X				X
CONCORDIA EXERCITVVM (clasped hands with standard and prow)	X	X		X	X	X
FORTVNA AVGVST	X	X		X	X	X
FORTVNA P R	X	X		X		
IVSTITIA AVG	X^2	X				

[2] An *aureus* of this type from this emission is not recorded in *RIC* II, but a unique specimen has appeared in the trade: Obolos (by Nomos) Web Auction 5 (June 26, 2016), lot 572. Unfortunately, as with so many objects from the trade, no collecting history or find data are provided.

LEGEND/TYPE	AUREI	DENARII	QUINARII	SESTERTII	DUPONDII	ASSES
LIBERTAS PVBLICA	X	X		X	X	X
SALVS PVBLICA	X	X				
VICTORIA AVGVST			X			
priestly emblems	X*	X*				
PAX AVG				X		
ANNONA AVGVST				X		
FISCI IVDAICI CALVMNIA SVBLATA				X		
ROMA RENASCENS				X		
PLEBEI VRBANAE FRVMENTO CONSTITVTO				X		
VEHICVLATIONE ITALIAE REMISSA				X		
PROVIDENTIA SENATVS				X		
NEPTVNO CIRCENS CONSTITVT						X

* indicates no descriptive legend on the reverse.

Like the second emission, the fourth emission of September 97 was more restricted in terms of typological variety. While many types were repeated from the third emission, there were no VICTORIA AVGVST(I) *quinarii* in this emission nor were there ANNONA AVGVST(I), FISCI IVDAICI CALVMNIA SVBLATA, or PROVIDENTIA SENATVS *sestertii*, nor any NEPTVNO CIRCENS(IBVS) CONSTITVT(IS) *asses*.

4. Fourth Precious- and Base-Metal Emission, September 97 (TR P II COS III)

LEGEND/TYPE	AUREI	DENARII	SESTERTII	DUPONDII	ASSES
AEQVITAS AVGVST	X	X			X
CONCORDIA EXERCITVVM (clasped hands only)		X			X
CONCORDIA EXERCITVVM (clasped hands with standard and prow)	X	X	X	X	
FORTVNA AVGVST	X	X	X	X	X
FORTVNA P R		X	X		
IVSTITIA AVG	X	X			
LIBERTAS PVBLICA	X	X	X	X	X

LEGEND/TYPE	AUREI	DENARII	SESTERTII	DUPONDII	ASSES
SALVS PVBLICA	X	X[3]			
priestly emblems	X*	X*			
PAX AVG			X		
ROMA RENASCENS			X		
PLEBEI VRBANAE FRVMENTO CONSTITVTO			X		
VEHICVLATIONE ITALIAE REMISSA			X		

* indicates no descriptive legend on the reverse.

Nerva's penultimate emission of December 97 was typologically restricted, confined only to Aequitas on *denarii*, Libertas on *denarii*, and priestly emblems on *aurei* and *denarii*. A potentially new *denarius* type in the fifth emission may depict Ceres, but the unique coin is not extant today and may have been a Libertas type misunderstood by Cohen.[4] Save for one Aequitas type, all reverses in this emission bear imperial titulature in the legends rather than descriptive labels of the figures represented. This may suggest that the label denoting the meaning of the images that had appeared in earlier emissions may have become redundant and unnecessary by the time of the final emission. The undated restoration coinage of Nerva for the Deified Augustus probably belongs to this emission as it is otherwise unique in lacking any base-metal coinage; the restoration coinage also has dynastic connotations, suggesting they may have been struck to celebrate Trajan's selection as heir, which would have been contemporary with the fifth emission.[5] *Quadrantes* depicting the head of Juno on the obverse and a rudder on a globe on the reverse are assigned to this emission according to the similarity of the reverse type to certain restoration coins depicting a rudder on a globe on the reverse.[6]

5. Fifth Emission, December 97 (TR P II COS III DESIGN IIII)

LEGEND/TYPE	AUREI	DENARII	SESTERTII	DUPONDII	ASSES	QUADRANTES
Aequitas		X/X*				
Libertas		X*				

[3] *RIC* II lists only *aurei* with the Salus reverse type in the fourth emission. *Denarii* with the reverse of Salus from the fourth emission are recorded in the trade, excavations, and hoards.

[4] Cohen 1882: 8, no. 82. Thanks also are due to Bernhard Woytek for his opinion on Cohen's description of the Ceres type.

[5] Szaivert 1978: 57–58; Gros 1981: 606; Komnick 2001: 108–109.

[6] Szaivert 1978: 55 and 57–58.

LEGEND/TYPE	AUREI	DENARII	SESTERTII	DUPONDII	ASSES	QUADRANTES
Ceres (dubious)		X*				
priestly emblems	X*	X*				
restoration types		X*	X*	X*	X*	
Juno / rudder on globe						X*

* indicates no descriptive legend on the reverse.

All of the reverse types in the final emission continued the use of imperial titulature in the reverse legends instead of descriptive legends. This emission in January 98, shortly before Nerva's death, revived the Fortuna types, the Victoria *quinarii*, and the Pax *sestertii*.

6. Sixth Precious- and Base-Metal Emission, January 98 (TR P II COS IIII)

LEGEND/TYPE	AUREI	DENARII	QUINARII	SESTERTII	DUPONDII	ASSES
Aequitas	X*[7]	X*				
Clasped hands only	(?)	X*				
Clasped hands on standard and prow	X*	X*		X*		
Fortuna	X*	X*		X*		X*
Libertas	(?)	X*		X*	X*[8]	
Victoria			X*			
priestly emblems	X*	X*				
Pax				X*		

* indicates no descriptive legend on the reverse.

[7] Although unpublished in *RIC* II, an example of an *aureus* of this type recently appeared in the trade: CNG 102 (May 18, 2016), lot 924. This raises the possibility that the "clasped hands only" CONCORDIA EXERCITVVM type and LIBERTAS PVBLICA type may have been struck in *aurei* in this emission, although none are currently known to be extant.

[8] A unique *dupondius* from this emission with Libertas on the reverse is recorded in the trade: CNG Electronic Auction 118 (July 13, 2005), lot 187.

APPENDIX 2 | Nerva's Coin Types and Their Dates of Production

Issue 1: September 96 (TR P COS II)
Issue 2: December 96 (TR P COS II DESIGN III)
Issue 3: January 97 (TR P COS III)
Issue 4: September 97 (TR P II COS III)
Issue 5: December 97 (TR P II COS III DESIGN IIII)
Issue 6: January 98 (TR P II COS IIII)

The primary data for this appendix derive from *RIC* II and *BMCRE* III. Bernhard Woytek is currently preparing a revision of the second half of *RIC* II, covering the reigns of Nerva and Trajan, to complement the revision of the Flavian material from that volume published in 2007 (*RIC*[2] II.1). Undated coinage includes the copper *quadrantes* and the restoration coinage for the Deified Augustus; neither bears tribunician or consular dates. The restored coinage for the Deified Augustus may be attributed to the fifth emission based on the otherwise lack of base-metal coinage from that emission and their probable connection with Nerva's adoption of Trajan.[1] The *quadrantes* with the *modius* obverse and winged *caduceus* reverse and with the Juno obverse and reverse with a rudder on a globe are respectively attributed to the second and the fifth emissions. The variable number of wheat stalks protruding from the *modius* may associate the type with various *officinae* in the second emission and the iconography of the rudder on a globe mirrors the iconography of a restored type for the Deified Augustus in the fifth emission.[2]

[1] Szaivert 1978: 57–58; Gros 1981: 606; Komnick 2001: 108–109.
[2] Szaivert 1978: 55 and 57–58.

1. Reverse Types and the Date of Their Emission

	96 (SEPT.)	96 (DEC.)	97 (JAN.)	97 (SEPT.)	97 (DEC.)	98 (JAN.)
AEQVITAS AVGVST						
Aurei	X		X	X		X*³
Denarii	X		X	X	X/X*	X*
Asses	X		X	X		
CONCORDIA EXERCITVVM (clasped hands only)						
Aurei	X		X			(?)⁴
Denarii	X		X	X		X*
Asses	X	X	X	X		
CONCORDIA EXERCITVVM (clasped hands with standard and prow)						
Aurei	X		X	X		X*
Denarii	X		X	X		X*
Sestertii	X	X	X	X		X*
Dupondii	X		X	X		
Asses			X			
FORTVNA AVGVST						
Aurei	X		X	X		X*
Denarii	X		X	X		X*
Sestertii	X	X	X	X		X*
Dupondii	X	X	X	X		
Asses	X	X	X	X		X*
FORTVNA P R						
Aurei	X		X			
Denarii	X		X	X		
Sestertii	X		X	X		
IVSTITIA AVGVST						
Aurei			X⁵	X		
Denarii	X		X	X		
Dupondii	X					
LIBERTAS PVBLICA						
Aurei	X		X	X		(?)
Denarii	X		X	X	X*	X*

³ A specimen recently appeared in the trade: CNG 102 (May 18, 2016), lot 924.

⁴ The recent appearance of an Aequitas type in gold from this emission may suggest this clasped-hands type and a Libertas type were also struck, although none are yet extant.

⁵ A unique specimen of this type and emission, unrecorded in *RIC* II, has appeared in the trade: Obolos (by Nomos) Web Auction 5 (June 26, 2016), lot 572.

	96 (SEPT.)	96 (DEC.)	97 (JAN.)	97 (SEPT.)	97 (DEC.)	98 (JAN.)
Sestertii	X	X	X	X		X*
Dupondii	X		X	X		X*[6]
Asses	X	X	X	X		

SALVS PVBLICA[7]

	96 (SEPT.)	96 (DEC.)	97 (JAN.)	97 (SEPT.)	97 (DEC.)	98 (JAN.)
Aurei			X	X		
Denarii	X		X	X		

VICTORIA AVGVST (seated or walking)

	96 (SEPT.)	96 (DEC.)	97 (JAN.)	97 (SEPT.)	97 (DEC.)	98 (JAN.)
Quinarii	X		X			X*

Diana

	96 (SEPT.)	96 (DEC.)	97 (JAN.)	97 (SEPT.)	97 (DEC.)	98 (JAN.)
Denarii		X*				

Ceres (dubious)[8]

	96 (SEPT.)	96 (DEC.)	97 (JAN.)	97 (SEPT.)	97 (DEC.)	98 (JAN.)
Denarii					X*	

Priestly Emblems

	96 (SEPT.)	96 (DEC.)	97 (JAN.)	97 (SEPT.)	97 (DEC.)	98 (JAN.)
Aurei			X*	X*	X*	X*
Denarii		X*	X*	X*	X*	X*

PAX AVG

	96 (SEPT.)	96 (DEC.)	97 (JAN.)	97 (SEPT.)	97 (DEC.)	98 (JAN.)
Sestertii	X	X	X	X		X*

ADLOCVT AVG

	96 (SEPT.)	96 (DEC.)	97 (JAN.)	97 (SEPT.)	97 (DEC.)	98 (JAN.)
Sestertii	X					

ANNONA AVGVST

	96 (SEPT.)	96 (DEC.)	97 (JAN.)	97 (SEPT.)	97 (DEC.)	98 (JAN.)
Sestertii	X	X	X			

CONGIAR P R

	96 (SEPT.)	96 (DEC.)	97 (JAN.)	97 (SEPT.)	97 (DEC.)	98 (JAN.)
Sestertii	X	X				

FISCI IVDAICI CALVMNIA SVBLATA

	96 (SEPT.)	96 (DEC.)	97 (JAN.)	97 (SEPT.)	97 (DEC.)	98 (JAN.)
Sestertii	X	X	X			

ROMA RENASCENS

	96 (SEPT.)	96 (DEC.)	97 (JAN.)	97 (SEPT.)	97 (DEC.)	98 (JAN.)
Sestertii	X	X	X	X		

[6] A unique *dupondius* of Libertas from the final emission was seen in the trade: CNG Electronic Auction 118 (July 13, 2005), lot 187.

[7] *BMCRE* III: 26 + describes a *dupondius* with an image of Salus for Nerva's fifth emission; it is, however, unverifiable and no specimens have appeared in the trade recently and so it is doubtful. In the fourth emission, September 97, *RIC* lists only *aurei* for the Salus type. *Denarii* with Salus in this emission have appeared in the trade, hoards, and excavations.

[8] This unique type, based on a description by Cohen 1882: 8, no. 82, who examined the specimen in the collection of Count Wiczay, cannot be confirmed. It is probable that the figure was misidentified and that the type was in fact a standard type, such as Libertas.

	96 (SEPT.)	96 (DEC.)	97 (JAN.)	97 (SEPT.)	97 (DEC.)	98 (JAN.)
PLEBEI VRBANAE FRVMENTO CONSTITVTO						
Sestertii			X	X		
VEHICVLATIONE ITALIAE REMISSA						
Sestertii			X	X		
PROVIDENTIA SENATVS						
Sestertii			X			
NEPTVNO CIRCENS CONSTITVT						
Asses			X			
Modius / winged *caduceus*						
Quadrantes		X*				
Juno / rudder on globe						
Quadrantes					X*	
DIVVS AVGVSTVS / comet						
Denarii					X*	
DIVVS AVGVSTVS / Capricorn						
Denarii					X*	
DIVVS AVGVSTVS / bull						
Denarii					X*	
DIVVS AVGVSTVS / S C						
Sestertii					X*	
DIVVS AVGVSTVS / rudder on globe						
Dupondii					X*	
DIVVS AVGVSTVS / eagle on thunderbolt						
Asses					X*	
DIVVS AVGVSTVS / eagle on globe						
Asses					X*	
DIVVS AVGVSTVS / winged thunderbolt						
Asses					X*	
DIVVS AVGVSTVS PATER / Ara Providentia						
Asses					X*	

* imperial titles in place of descriptive legend

| The Relative Frequencies of *Denarius* Types
by Emission

R ELATIVE FREQUENCIES OF IMAGES ON the reverses of Nerva's coinage are presented
in each emission according to three samples: the portion of the Reka Devnia Hoard
housed in Sofia, the aggregate of smaller silver hoards, and the aggregate of single finds
recorded in regional inventories.

1. First Emission of September 96 (TR P COS II)

(A) Reka Devnia (Sofia), n = 43.

TYPE	*RIC* II	SPECIMENS	PERCENTAGE
AEQVITAS AVGVST	1	11	18.03
CONCORDIA EXERCITVVM (hands only)	2	5	8.20
CONCORDIA EXERCITVVM (hands on standard and prow)	3	8	13.11
CONCORDIA EXERCITVVM (combined total)	2+3	[13]	[21.31]
FORTVNA AVGVST	4	4	6.56
FORTVNA P R	5	4	6.56
IVSTITIA AVGVST	6	0	0
LIBERTAS PVBLICA	7	8	13.11
SALVS PVBLICA	9	3	4.92
Total	—	**43**	**100**

(B) Aggregate of hoards, n = 139.

TYPE	*RIC* II	SPECIMENS	PERCENTAGE
AEQVITAS AVGVST	1	11	7.91
CONCORDIA EXERCITVVM (hands only)	2	36	25.90
CONCORDIA EXERCITVVM (hands on standard and prow)	3	30	21.58
CONCORDIA EXERCITVVM (combined total)	2 + 3	[66]	[47.48]
FORTVNA AVGVST	4	16	11.51
FORTVNA P R	5	5	3.60
IVSTITIA AVGVST	6	7	5.04
LIBERTAS PVBLICA	7	20	14.39
SALVS PVBLICA	9	12	8.63
unclassified	—	2	1.44
Total	—	**139**	**100**

(C) Single finds, n = 51.

TYPE	*RIC* II	SPECIMENS	PERCENTAGE
AEQVITAS AVGVST	1	9	17.65
CONCORDIA EXERCITVVM (hands only)	2	5	9.80
CONCORDIA EXERCITVVM (hands on standard and prow)	3	12	23.53
CONCORDIA EXERCITVVM (combined total)	2 + 3	[17]	[34.33]
FORTVNA AVGVST	4	5	9.80
FORTVNA P R	5	1	1.96
IVSTITIA AVGVST	6	3	5.88
LIBERTAS PVBLICA	7	10	19.60
SALVS PVBLICA	9	6	11.76
Total	—	**51**	**100**

2. Second Emission of December 96 (TR P COS II DESIGN III)

(A) There are no coins from this emission in the Reka Devnia Hoard (Sofia).

(B) In the aggregate of hoards, there is one specimen of *RIC* II: no. 11 (Diana reverse) and one no. 12 (priestly emblems reverse).

(C) In the aggregate of single finds, there is a single specimen of no. 11 (Diana reverse).

3. Third Emission of January 97 (TR P COS III)

(A) Reka Devnia (Sofia), n = 213.

TYPE	*RIC* II	SPECIMENS	PERCENTAGE
AEQVITAS AVGVST	13	34	14.40
CONCORDIA EXERCITVVM (hands only)	14	35	14.83
CONCORDIA EXERCITVVM (hands on standard and prow)	15	10	4.24
CONCORDIA EXERCITVVM (combined total)	14+15	[45]	[19.07]
FORTVNA AVGVST	16	52	22.03
FORTVNA P R	17	12	5.08
IVSTITIA AVGVST	18	4	1.69
LIBERTAS PVBLICA	19	26	11.01
SALVS PVBLICA	20	13	5.51
COS III P P (priestly emblems)	23	0	0
COS III PATER PATRIAE (priestly emblems)	24	27	11.44
Total	—	**213**	**100**

(B) Aggregate of hoards, n = 351.

TYPE	*RIC* II	SPECIMENS	PERCENTAGE
AEQVITAS AVGVST	13	48	13.68
CONCORDIA EXERCITVVM (hands only)	14	54	15.38
CONCORDIA EXERCITVVM (hands on standard and prow)	15	25	7.12
CONCORDIA EXERCITVVM (combined total)	14 + 15	[79]	[22.50]
FORTVNA AVGVST	16	64	18.23
FORTVNA P R	17	24	6.84
IVSTITIA AVGVST	18	8	2.28
LIBERTAS PVBLICA	19	50	14.25
SALVS PVBLICA	20	23	6.55
COS III P P (priestly emblems)	23	3	0.85
COS III PATER PATRIAE (priestly emblems)	24	43	12.25
Priestly emblems (combined total)	23 + 24	[46]	[13.10]
Unclassified	—	9	2.56
Total	—	**351**	**100**

(C) Single finds, n = 95.

TYPE	*RIC* II	SPECIMENS	PERCENTAGE
AEQVITAS AVGVST	13	11	11.58
CONCORDIA EXERCITVVM (hands only)	14	15	15.79
CONCORDIA EXERCITVVM (hands on standard and prow)	15	7	7.37
CONCORDIA EXERCITVVM (combined total)	14 + 15	[22]	[23.16]
FORTVNA AVGVST	16	22	23.16
FORTVNA P R	17	3	3.16
IVSTITIA AVGVST	18	0	0
LIBERTAS PVBLICA	19	12	12.63
SALVS PVBLICA	20	11	11.58
COS III P P (priestly emblems)	23	3	3.16
COS III PATER PATRIAE (priestly emblems)	24	11	11.58
Priestly emblems (combined total)	23 + 24	[14]	[14.74]
Total	—	**95**	**100**

4. Fourth Emission of September 97 (TR P II COS III)

(A) There are five specimens of *RIC* II: no. 34 (priestly emblems) in the Reka Devnia Hoard (Sofia).

(B) Aggregate of hoards, n = 86.

TYPE	*RIC* II	SPECIMENS	PERCENTAGE
AEQVITAS AVGVST	25	13	15.12
CONCORDIA EXERCITVVM (hands only)	26	15	17.44
CONCORDIA EXERCITVVM (hands on standard and prow)	27	7	8.14
CONCORDIA EXERCITVVM (combined total)	26 + 27	[22]	[25.58]
FORTVNA AVGVST	28	11	12.80
FORTVNA AVGVSTI (. . . TR POT II on obverse)	35	1	1.16
FORTVNA AVGVST (combined total)	28 + 35	[12]	[13.96]
FORTVNA P R	29	3	3.49
IVSTITIA AVGVST	30	1	1.16

TYPE	*RIC* II	SPECIMENS	PERCENTAGE
LIBERTAS PVBLICA	31	18	20.93
SALVS PVBLICA	33	2	2.33
COS III PATER PATRIAE	34	14	16.28
(priestly emblems)			
unclassified	—	1	1.16
Total	**—**	**86**	**100**

(C) Single finds, n = 30.

TYPE	*RIC* II	SPECIMENS	PERCENTAGE
AEQVITAS AVGVST	25	6	20.00
CONCORDIA EXERCITVVM	26	5	16.67
(hands only)			
CONCORDIA EXERCITVVM	27	2	6.67
(hands on standard and prow)			
CONCORDIA EXERCITVVM	26 + 27	[7]	[23.33]
(combined total)			
FORTVNA AVGVST	28	7	23.33
FORTVNA P R	29	0	0
IVSTITIA AVGVST	30	0	0
LIBERTAS PVBLICA	31	3	10.00
LIBERTAS PVBLICA	36	2	6.67
(. . . TR POT II on obverse)			
LIBERTAS PVBLICA (combined	31 + 36	[5]	[16.67]
total)			
SALVS PVBLICA	33	1	3.33
COS III PATER PATRIAE	34	4	13.33
(priestly emblems)			
Total	**—**	**30**	**100**

5. Fifth Emission of December 97 (TR P II COS III DESIGN IIII)

(A) There are two specimens of *RIC* II: no. 39 (Libertas) and one of no. 41 (priestly emblems) in the Reka Devnia Hoard (Sofia).

(B) The aggregate of hoards contains one specimen of no. 39 (Libertas) and one of no. 41 (priestly emblems).

(C) There are no fifth-emission coins recorded as single finds from the sample areas.

6. Sixth Emission of January 98 (TR P II COS IIII)

(A) Reka Devnia (Sofia), n = 12.

TYPE	*RIC* II	SPECIMENS	PERCENTAGE
IMP II COS IIII PP (Fortuna)	42	2	16.67
IMP II COS IIII PP (Libertas)	43	2	16.67
IMP II COS IIII PP (Aequitas)	44	6	50.00
IMP II COS IIII PP (priestly emblems)	47	0	0
IMP II COS IIII PP (hands only)	48	2	16.67
IMP II COS IIII PP (hands on standard and prow)	49	0	0
Total	—	**12**	**100**

(B) Aggregate of hoards, n = 24.

TYPE	*RIC* II	SPECIMENS	PERCENTAGE
IMP II COS IIII PP (Fortuna)	42	3	12.50
IMP II COS IIII PP (Libertas)	43	8	33.33
IMP II COS IIII PP (Aequitas)	44	0	0
IMP II COS IIII PP (priestly emblems)	47	7	29.17
IMP II COS IIII PP (hands only)	48	6	25.00
IMP II COS IIII PP (hands before legionary eagle)	49	0	0
Total	—	**24**	**100**

(C) Single finds, n = 9.

TYPE	*RIC* II	SPECIMENS	PERCENTAGE
IMP II COS IIII PP (Fortuna)	42	2	2.22
IMP II COS IIII PP (Libertas)	43	3	33.33
IMP II COS IIII PP (Aequitas)	44	1	11.11
IMP II COS IIII PP (priestly emblems)	47	3	33.33
IMP II COS IIII PP (hands only)	48	0	0
IMP II COS IIII PP (hands before legionary eagle)	49	0	0
Total	—	**9**	**100**

7. Relative Frequency of Reverse Types on *Denarii*

This list quantifies types from all emissions and datasets combined.

TYPE	DENARII	
	PERCENTAGE	NUMBER
CONCORDIA EXERCITVVM	26.42	279
FORTVNA AVGVST(I)	18.09	191
LIBERTAS PVBLICA	15.63	165
AEQVITAS AVGVST(I)	14.20	150
priestly emblems	11.65	123
SALVS PVBLICA	6.72	71
FORTVNA P(OPVLI) R(OMANI)	4.92	52
IVSTITIA AVGVST(I)	2.18	23
Diana	0.21	2
Total	**100**	**1,056**

Bibliography for Hoards Composing the Aggregate of Silver Hoards

This aggregate is based on that formulated for Noreña 2001. Hoards not containing *denarii* of Nerva are omitted.

Britain

Babington, Churchill. 1875. "Account of Roman Silver Coins Found at Lavenham, Suffolk, in June, 1874." *Numismatic Chronicle*, 2nd Series, 15: 140–143.

Bland, Roger, and T. V. Buttrey. 1997. "Barway, Cambridgeshire." In *Coin Hoards from Roman Britain*. Vol. 10, edited by Roger Bland and John Orna-Ornstein, 128–130. London: British Museum Press.

Bland, Roger, and Ian Carradice. 1992. "Hastings, Sussex." In *Coin Hoards from Roman Britain*. Vol. 9, edited by Roger Bland, 34–38. London: British Museum Press.

Burnett, Andrew. 1992. "Waddington, Lancashire." In *Coin Hoards from Roman Britain*. Vol. 9, edited by Roger Bland, 39–40. London: British Museum Press.

Carradice, Ian, and Andrew Burnett. 1992. "Ollerton ('Edwinstowe'), Nottinghamshire." In *Coin Hoards from Roman Britain*. Vol. 9, edited by Roger Bland, 46–49. London: British Museum Press.

Carson, R. A. G. 1948. "Roman *Denarii* from Ormskirk, Lancashire." *Numismatic Chronicle*, 6th Series, 8: 232.

Carson, R. A. G., and Andrew M. Burnett. 1979. *Recent Coin Hoards from Roman Britain*. London: British Museum Press. [Londonthorpe Hoard: 9–25]

Carson, R. A. G., and Philip Corder. 1948. "A Second Hoard of *Denarii* from Darfield." *Numismatic Chronicle*, 5th Series, 8: 78–81.

Evans, John. 1898. "A Hoard of Roman Coins." *Numismatic Chronicle*, 3rd Series, 18: 126–184.

Jenkins, Gilbert Kenneth. 1947. "The Caister-by-Yarmouth Hoard." *Numismatic Chronicle*, 6th Series, 7: 175–179.

Kraay, Colin M. 1960. "A Hoard of *Denarii* from Verulamium, 1958." *Numismatic Chronicle*, 6th Series, 20: 271–273.

MacDonald, George. 1934. "A Hoard of Roman *Denarii* from Scotland." *Numismatic Chronicle*, 5th Series, 14: 1–30.

Mattingly, Harold. 1925. "Some Roman Hoards: Allerton Bywater." *Numismatic Chronicle*, 5th Series, 5: 395–401.

Mattingly, Harold. 1934. "The Swaby Hoard." *Numismatic Chronicle*, 5th Series, 14: 216–227.

Mattingly, Harold, and R. G. Collingwood. 1927. "The Mallerstang Hoard." *Transactions of the Cumberland and Westmoreland Antiquarian and Archaeological Society* 1927: 205–217.

Mattingly, Harold, and Bertram W. Pearce. 1938. "The Bristol Hoard of *Denarii*, 1937." *Numismatic Chronicle*, 5th Series, 18: 85–98.

Pearce, J. W. E., and Harold Mattingly. 1929. "Hoards of Roman Coins: Muswell Hill." *Numismatic Chronicle*, 5th Series, 9: 315–318.

Robertson, Anne S. 1935–1937. "A Hoard of Roman Silver from Abergele, Denbigh-Shire." *Bulletin of the Board of Celtic Studies* 8: 188–201.

Robertson, Anne S. 1950. "A Hoard of *Denarii* from Handley, Dorset." *Numismatic Chronicle*, 6th Series, 39–40: 311–315.

Robertson, Anne S. 1956–1957. "A Hoard of Roman Silver Coins from Briglands, Rumbling Bridge, Kinross-Shire." *Proceedings of the Society of Antiquaries of Scotland* 90: 241–246.

Tuckett, T. 1992. "Bletchley, Buckinghamshire." In *Coin Hoards from Roman Britain*. Vol. 9, edited by Roger Bland, 50–64. London.

Western Europe

1981. *Trésors Monétaires III*. Paris: Bibliothèque Nationale de France. [Viuz-Faverges Hoard: 33–76]

FMRD I.2, no. 2116 (Kirchmattig).

FMRD I.6, no. 6020 (Stockstadt III).

FMRD IV.5, no. 5028 (Obererbach).

FMRD VI.1.1, no. 1004, 1–3 (Cologne).

Regling, Kurt. 1912. "Beschreibung der Denare des Schatzes von Middels Osterloog." *Zeitschrift für Numismatik* 29: 207–241.

van Es, Willem Albertus. 1960. *De romeinse muntvondsten uit de drie noordelijke provincies*. Groningen: Scripta Academica Groningana. [Bargercompascuum Hoard: 106–112]

Italy and North Africa

Marion, Jean. 1978. "Les trésors monétaires de Volubilis et de Banasa." *Antiquités Africaines* 12: 179–215.

Rizzoli, Luigi. 1914. "Castagnaro (Verona) tesoretto monetale rinvenuto in predio del Sig. Luigi Fiocco a Menà." *Rivista Italiana di Numismatica* 27: 349–364.

Danube

Andor, M. 1935–1936. "Kurd-gyulaiji római éremlelet." *Numizmatikai Közlöny* 34–35: 77–78

Brunšmid, Josep. 1910–1911. "Nekoliko našašća novaca na skupu Hrvatskoj I Slavoniji." *Viestnik Hrvatskoga Archeoloskoga Drustva* 2: 241–277.

Chiţescu, Maria, and Minodora Ursache. 1968. "Tezaurul de denari romani imperiali descoperit la Simioneşti (Jud. Neamţ)." *Studii şi Cercetări de Numismatică* 4: 385–391.

Elemér, J. 1924–1925. "A tiszanagyréevi római éremelet." *Numizmatikai Közlöny* 23–24: 38–40.

FMRÖ III.1, 201–203.

FMRSl I, no. 91/2.

Jiroudkova, D. 1957. "Dva poklady rimskych denaru z Balakau." *Numismaticky Sbornik* 4: 49–72.

Jungwirth, Helmut. 1967. "Der Münzschatzfund von Erla." *Numismatische Zeitschrift* 82: 26–48.

Krzyżanowska, Aleksandra. 1976. *Skarb denarów rzymskich z Drzewicza.* Warsaw: Zakład Narodowy im. Ossolińskich.

Mihailescu-Birliba, Virgil. 1968. "Noi descoperiri de tezaure imperial romane la piatra neamţ." *Carpica* 1: 209–231.

Mihailescu-Birliba, Virgil. 1969. "Noi descoperiri de tezure imperial romane la piatra neamţ." *Carpica* 2: 157–178.

Mihailescu-Birliba, Virgil. 1972–1973. "Tezaurul de denari romani imperiali de la Puriceni." *Memoria Antiquitatis* 4–5: 125–130.

Mihailescu-Birliba, Virgil. 1977. *Tezaurul de la Magura.* Bucharest: Muzeul Judeţean de Istorie şi Artă.

Mihailescu-Birliba, Virgil. 1980. "Tezaurul de denari romani imperiali descoperit la Mastacan." *Studii şi Cercetări de Numismatică* 7: 83–93.

Mitkowa-Szubert, Kunka. 1989. *The Nietulisko Małe Hoards of Roman Denarii.* Warsaw: State Archaeological Museum.

Molnár, István, and Iudita Winkler. 1965. "Tezaurul de monede romane de la Sălaşuri." *Acta Musei Napocensis* 2: 269–294.

Ödön, Gohl. 1905. "A mocsoládi éremlelet." *Numizmatikai Közlöny* 4: 75–79.

Ondrouch, Vojtěch. 1934. *Der römische Denarfund von Vyškovce aus der Frühkaiserzeit.* Bratislava: Učená spoločnosť Šafaříkova.

Pál, Harsányi. 1908–1909. "Visán." *Numizmatikai Közlöny* 7–8: 120.

Popilian, Gheorghe, and Ion Stan-Mirceşti. "Tezaurul de monede romane imperial de la Butoieşti (Jud. Mehedinţi)." *Studii şi Cercetări de Numismatică* 9: 37–42.

Preda, Constantin. 1957. "Tezaurul monetar de la Dîmbău, Reg. Stalin, şi tulburările pricinuite de Daci în anul 143, sub Antonin Piul." *Studii şi Cercetări de Numismatică* 1: 113–131.

Preda, Constantin. 1974. "Tezaurul monetar din epoca romană descoperit la Girla Mare (Jud. Mehedinţi)." *Historica* 3: 67–91.

Regling, Kurt. 1908. "Römischer Denarfund von Lengowo." *Zeitschrift für Numismatik* 26: 304–316.

Severeanu, George. 1935. "Tezaurul monetar din Sascut din epoca imperiului roman." *Bucurestii* 2: 218–232.

Skowronek, Stefan. 1965. "Znalezisko denarów rzymskich z Przewodowa." *Wiadomości Numizmatyczne* 9: 203–208

Wruck, Waldemar. 1937. "Der Denarfund von Osiek (Mursa)." *Deutsche Münzblätter* 12: 289–293 and 311–317.

The East

Bendall, Simon. 1966. "An Eastern Hoard of Roman Imperial Silver." *Numismatic Chronicle*, 7th Series, 6: 165–170.

Casey, P. J. 1978. "Acarnania." *Coin Hoards.* Vol. 4, 33. London: Royal Numismatic Society.

Cesano, Lorenza. 1925. "Nuovi ripostigli di denari di argento dell'impero romano." *Annali dell'Istituto Italiano di Numismatica* 5: 52–72.

Katalin, Bíróné Sey. 1986. "A keceli eremlelet." *Cumania* 9: 27–71.

Lightfoot, C. S., ed. 1991. *Recent Turkish Coin Hoards and Numismatic Studies*. British Institute of Archaeology at Ankara Monograph 12. Oxford: Oxbow.

Metcalf, William E. 1975. "The Tell Kalak Hoard and Trajan's Arabian Mint." *American Numismatic Society Museum Notes* 20: 39–108.

Metcalf, William E. 1979. "A Roman Hoard from Cyprus." *Numismatic Chronicle*, 7th Series, 19: 26–35.

Milik, Joseph Thadée, and Henri Seyrig. 1958. "Trésor monétaire de Murabba'ât." *Revue Numismatique*, 6th series, 1: 11–26.

Pál, Harsányi. 1915. "Barabura." *Numizmatikai Közlöny* 14: 70.

Svoronos, I. N. "Eleutheropolis." *Journal International d'Archéologie Numismatique* 10: 230–248.

Weber, Shirley H. 1932. *An Egyptian Hoard of the Second Century AD* Numismatic Notes and Monographs 54. New York: American Numismatic Society.

Note: For the single finds of silver coins, the same inventories in Appendix 4 (for base-metal coins) were consulted.

APPENDIX 4 | Identifiable Base-Metal Coins and Their Regional
Distribution: Hoards and Excavations

T HESE CHARTS PROVIDE AN IMPRESSION of survival rates for Nerva's base-metal
denominations according to finds. As brass and copper coinage had a more limited
mobility than precious-metal coinage, and many factors could affect the movement of
coin, one must be careful of seeing regional patterns of distribution as reflective of type-
based audience targeting. In order to remove as much bias as possible from the sample,
only hoard, excavation coins, and single finds are included. Many inventories, especially
FMRL and *FMRU*, draw from local collections. Any coin from a collection without a
known find spot is excluded from the tabulations below. Most coins in the inventories
are single finds or excavation coins and many would have been in circulation for decades
after Nerva's death, causing wear on the coins. As a result, the catalogers often provide
general type identifications. For example, an *as* depicting Aequitas is often identified as
"*RIC* II: nos. 51/77/94" or, more simply, "51 type." Identifications such as these identify
the reverse iconography and the emperor, but do not attribute it to a specific emission. This
problem caused by the excavation coins, exacerbated by Nerva's short reign and relatively
small volume of coinage compared with Domitian or Trajan, makes the calculation of the
relative prominence of individual base-metal types in the various emissions difficult; the
numbers of base-metal coins securely attributed to a specific emission are so small that
calculations would be statistically insignificant and any conclusions based on them would
be tenuous. Therefore, coins from the various emissions are grouped together according
to type.

1. *Sestertii*

TYPE	RIC II	AUST.	CRO.	ENGL.	FR.	GERM.	HUNG.	IT., ROME	IT., VENETO	LUX.	NETH.	ROMANIA	SLOV.	SWITZ.	TOTAL	PERCENT
Adlocutio	50	—	—	—	—	—	—	—	—	—	—	—	—	—	0	0.00
Annona	52, 68, 78	—	—	—	1	—	—	—	—	—	—	—	—	—	1	0.34
Concordia Exercituum	54, 70, 80, 96, 108	2	—	2	10	4	—	—	1	—	—	1	1	—	21	7.07
Congiarium	56, 57, 71	—	—	—	2	2	—	1	—	—	—	—	—	—	5	1.68
Fiscus Iudaicus	58–59, 72, 82	1	—	—	6	7	3	—	—	—	—	—	—	1	18	6.06
Fortuna Augusti	60, 73, 83, 98, 105	15	2	8	47	14	—	3	1	—	1	—	2	—	93	31.31
Fortuna P R	62, 85	2	—	1	4	11	—	1	—	—	—	—	—	1	20	6.73
Libertas Publica	64, 76, 86, 100, 106	10	—	5	47	14	1	4	—	—	—	—	2	1	84	28.28
Pax Aug	66, 88, 102	—	—	—	5	5	—	—	—	—	—	1	1	—	12	4.04
Providentia Senatus	90	—	—	—	1	1	—	—	—	—	—	—	—	—	2	0.67
Roma Renascens	67, 91	—	—	1	2	2	—	—	—	—	—	—	—	—	5	1.68
Plebei Urbanae Frumento Constituto	89, 103	—	—	3	2	—	—	—	—	—	—	—	—	—	5	1.68
Vehiculatione Italiae Remissa	93, 104	2	—	2	5	4	—	1	—	1	—	—	—	—	15	5.05
restored types for Divus Augustus	127, 135, 136, 137	—	—	—	13	1	—	2	—	—	—	—	—	—	16	5.39
Totals		**32**	**2**	**22**	**145**	**65**	**4**	**12**	**2**	**1**	**1**	**2**	**6**	**3**	**297**	**100**

2. *Dupondii*

TYPE	*RIC* II	AUST.	ENGL.	FR.	GERM.	HUNG.	IT., ROME	IT., VENETO	ROMANIA	SLOV.	SWITZ.	TOTAL	PERCENT
Concordia Exercituum	55, 81, 97	2	2	3	10	—	—	1	—	1	—	19	11.38
Fortuna Augusti	61, 74, 75, 84, 99, 101	29	4	7	32	2	2	1	1	7	—	85	50.90
Iustitia Augusti	63	—	1	—	1	—	—	—	—	—	—	2	1.20
Libertas Publica	65, 87, 101	10	8	2	26	—	3	—	—	3	1	53	31.74
rudder on globe (Divus Augustus)	131, 132	2	1	1	3	—	1[1]	—	—	—	—	8	4.79
Totals		**43**	**16**	**13**	**72**	**2**	**6**	**2**	**1**	**11**	**1**	**167**	**100**

[1] This coin is cataloged as an *as* in the SSU I Rome finds, although the type appears only on *dupondii* and must be this denomination.

3. Asses

TYPE	RIC II	AUST.	CRO.	ENGL.	GERM.	HUNG.	IT., ROME	IT., VENETO	LUX.	NETH.	POL.	ROMANIA	SLOV.	SWITZ.	TOTAL	PERCENT
Aequitas Augusti	51, 77, 94	41	1	10	73	—	3	1	2	1	1	4	8	1	146	20.19
Concordia Exercituum (hands only)	53, 69, 79, 95	30	2	2	60	2	9	2	—	—	—	3	14	2	126	17.43
Concordia Exercituum (hands on standard and prow)	80	—	—	—	7	1	5	—	—	—	—	—	—	—	13	1.80
Total clasped-hands types	53, 69, 79, 95 + 80	[30]	[2]	[2]	[67]	[3]	[14]	[2]	—	—	—	[3]	[14]	[2]	[139]	[19.22]
Fortuna Augusti	60, 73, 83, 98, 105	66	2	7	113	5	8	5	2	1	—	2	13	1	225	31.12
Libertas Publica	64, 76, 86, 100	49	2	7	98	2	14	6	2	—	—	2	13	3	198	27.39
Neptuno Circenses Constitut	p. 228*	—	—	1	—	—	—	—	—	—	—	—	—	—	1	0.14
eagle on thunderbolt (Divus Augustus)	128	—	—	—	1	—	—	—	—	—	—	—	—	—	1	0.14
eagle on globe (Divus Augustus)	129	2	1	—	1	—	—	—	—	—	—	—	—	—	4	0.55
winged thunderbolt (Divus Augustus)	130	2	—	—	1	—	2	—	—	—	—	—	1	—	6	0.83
Ara Providentiae (Divus Augustus)	133, 134	2	—	—	—	—	—	1	—	—	—	—	—	—	3	0.41
Total restored types	128—134	[6]	[1]	[—]	[3]	[—]	[2]	[1]	[—]	[—]	[—]	[—]	[1]	[—]	[14]	1.93
Totals		**192**	**8**	**27**	**354**	**10**	**41**	**15**	**6**	**2**	**1**	**11**	**49**	**7**	**723**	**100**

4. *Quadrantes*

TYPE	*RIC* II	AUST.	GERM.	HUNG.	IT., ROME	TOTAL	PERCENT
Modius/winged caduceus	109—113	4	1	1	17	23	95.83
Juno/rudder on globe	114	—	—	—	1	1	4.17
Totals		**4**	**1**	**1**	**18**	**24**	**100**

5. Relative Frequency of Reverse Types According to Denomination

TYPE	SESTERTII		DUPONDII		ASSES	
	PERCENTAGE	NUMBER	PERCENTAGE	NUMBER	PERCENTAGE	NUMBER
FORTVNA AVGVST(I)	31.31	93	50.90	85	31.12	225
LIBERTAS PVBLICA	28.28	84	31.74	53	27.39	198
CONCORDIA EXERCITVVM	7.07	21	11.38	19	19.22	139
FORTVNA POPVLI ROMAN(I)	6.73	20	—	—	—	—
Fiscus Iudaicus type	6.06	18	—	—	—	—
restored types for Deified Augustus	5.39	16	4.79	8	1.93	14
Vehiculatio type	5.05	15	—	—	—	—
PAX AVG(VSTI)	4.04	12	—	—	—	—
Frumentum type	1.68	5	—	—	—	—
Congiarium type	1.68	5	—	—	—	—
ROMA RENASCENS	1.68	5	—	—	—	—
PROVIDENTIA SENATVS	0.67	2	—	—	—	—
ANNONA AVGVST(I)	0.34	1	—	—	—	—
IVSTITIA AVGVST(I)	—	—	1.20	2	—	—
AEQVITAS AVGVST(I)	—	—	—	—	20.19	146
Neptune type	—	—	—	—	0.14	1
Totals	**100**	**297**	**100**	**167**	**100**	**723**

Sources for Sample Areas

Austria: *FMRÖ, dFMRÖ.*
Croatia: *FMRHr.*
England: PAS.
France: Robert Étienne and Marguerite Rachet. 1984. *Le trésor de Garonne: Essai sur la circulation monétaire en Aquitaine á la fin du règne d'Antonin le Pieux, 159–161.* Bordeaux: Fédération Historique du Sud-Ouest.
Germany: *FMRD.*
Hungary: *FMRU.*
Italy, Rome: SSU I, II.
Italy, Veneto Region: *RMR Ve.*
Luxembourg: *FMRL.*
Netherlands: *FMRN.*
Poland: *FMRP.*
Romania: *dFMRÖ* (includes a search option for Romania).
Slovenia: *FMRSl.*
Switzerland: *IFS.*

BIBLIOGRAPHY

Abdy, Richard, and Nicholas Harling. 2005. "Two Important New Roman Coins." *Numismatic Chronicle* 165: 175–178.

Arena, Valentina. 2012. *Libertas and the Practice of Politics in the Late Roman Republic.* Cambridge: Cambridge University Press.

Arya, Darius Andre. 2002. "The Goddess Fortuna in Imperial Rome: Cult, Art, Text." PhD dissertation, University of Texas at Austin.

Baldson, J. P. V. D. 1934. *The Emperor Gaius (Caligula).* Oxford: Clarendon Press.

Barbato, Marta. 2014. "Flavian Typology: The Evidence from the *sottosuolo urbano* of Rome." In *"Art in the Round": New Approaches to Ancient Coin Iconography,* edited by Nathan T. Elkins and Stefan Krmnicek, 173–180. Tübinger Archäologische Forschungen 16. Rahden: Marie Leidorf.

Barbato, Marta. 2015. "The Emperors of the Flavian Dynasty (AD 69–96)." In *The Julio-Claudian and Flavian Coins from Rome's Municipal Urban Excavations: Observations on Coin Circulation in the Cities of Latium Vetus and Campania in the First Century AD,* edited by Maria Cristina Molinari, 70–98. Polymnia, Numismatica Antica e Medievale, Studi 6. Trieste: Edizioni Università di Trieste.

Barrett, Anthony A. 1989. *Caligula: The Corruption of Power.* New Haven, CT and London: Yale University Press.

Barrett, Anthony A. 1998. "Caligula's Quadrans Issue." *Latomus* 57: 846–852.

Bartsch, Shadi. 2012. "The Art of Sincerity: Pliny's *Panegyricus.*" In *Latin Panegyric,* edited by Roger Rees, 148–193. Oxford Readings in Classical Studies. Oxford and New York: Oxford University Press.

Beckmann, Martin. 2009. "The Significance of Roman Imperial Coin Types." *Klio* 91: 144–161.

Beckmann, Martin. 2012. "Trajan and Hadrian." In *The Oxford Handbook of Greek and Roman Coinage,* edited by William E. Metcalf, 405–422. Oxford and New York: Oxford University Press.

Beckmann, Martin. 2015. "The Attribute of Liberalitas and its Use in the *Congiarium.*" *American Journal of Numismatics,* 2nd Series, 27: 189–198.

Belloni, Gian Guido. 1974. "Significati storico-politici delle figurazioni e delle scritte delle monete da Augusto a Traiano (Zecche di Roma e 'imperatorie')." *Aufstieg und Niedergang der Römischen Welt* 2, no. 1: 997–1144.

Beer, Jeff. 2009. "Shepard Fairey: Obey Obama." In *Obey: Supply and Demand: The Art of Shepard Fairey*, edited by Shepard Fairey, Roger Gastman, Steven Heller, Carlo McCormick, Henry Rollins, Jeff Beer, Helen Stickler, Ken Taylor, and Rob Walker, 270–275. Berkeley, CA: Gingko.

Bennett, Julian. 2001. *Trajan: Optimus Princeps*. 2nd edition. Bloomington and Indianapolis: Indiana University Press.

Béranger, Jean. 1953. *Recherches sur l'aspect idéologique du principat*. Schweizerische Beiträge zur Altertumswissenschaft 6. Basel: F. Reinhardt.

Bergemann, Johannes. 1990. *Römische Reiterstatuen. Ehrendenkmäler im öffentlichen Bereich*. Mainz: Philipp von Zabern.

Bergmann, Marianne. 1998. *Die Strahlen der Herrscher. Theomorphes Herrscherbild und politische Symbolik im Hellenismus und in der römischen Kaiserzeit*. Mainz: Philipp von Zabern.

Bergmann, Marianne, and Paul Zanker. 1981. "'Damnatio Memoriae,' Umgearbeitete Nero- und Domitiansporträts. Zur Ikonographie der flavischen Kaiser und des Nerva." *Jahrbuch des Deutschen Archäologischen Instituts* 96: 317–412.

Bernhardt, Rainer. 1980 "Die Immunitas der Freistädte." *Historia* 29: 190–207.

Berriman, Andrew, and Malcolm Todd. 2001. "A Very Roman Coup: The Hidden War of Imperial Succession, AD 96–98." *Historia* 50: 312–331.

Bertoldi, Maria Elena. 1997. *Antike Münzfunde aus der Stadt Rom (1870–1902): Il problema delle provenienze*. Studien zu Fundmünzen der Antike 14. Berlin: Mann.

Bianco, Enrico. 1968. "Indirizzi programmatici e propagandistici nella monetazione di Vespasiano." *Rivista Italiana di Numismatica* 16: 145–224.

Billington, Sandra. 1996. "Fors Fortuna in Ancient Rome." In *The Concept of the Goddess*, edited by Sandra Billington and Miranda Green, 129–140. London and New York: Routledge.

Bingham, Sandra. 2013. *The Praetorian Guard: A History of Rome's Elite Special Forces*. Waco, TX: Baylor University Press.

Borriello, Maria Rosaria, Renata Cantilena, Enrico Guglielmo, Paolo Martellotti, Stefania Adamo Muscettola, Enrica Pozzi, and Paolo Rubino. 1987. *Domiziano/ Nerva. La statua equestre da Miseno. Una proposta di ricomposizione*. Naples: G. Macchiaroli.

Bourne, Frank C. 1960. "The Roman Alimentary Program and Italian Agriculture." *Transactions and Proceedings of the American Philological Association* 91: 47–75.

Brennan, T. Corey. 2000. "Principes and Plebs: Nerva's Reign as a Turning Point?" *American Journal of Ancient History* 15: 40–66.

Brilliant, Richard. 2007. "Forwards and Backwards in the Historiography of Roman Art." *Journal of Roman Archaeology* 20: 7–24.

Bruce, I. A. F. 1964. "Nerva and the *Fiscus Iudaicus*." *Palestine Exploration Quarterly* 96: 34–45.

Brunt, P. A. 1988. *The Fall of the Roman Republic and Related Essays*. Oxford: Oxford University Press.

Buraselis, Kostas. 2000. *Kos between Hellenism and Rome: Studies on the Political, Institutional and Social History of Kos from ca. the Middle Second Century BC until Late Antiquity*. Philadelphia, PA: American Philosophical Society.

Burnett, Andrew. 1977. "The Authority to Coin in the Late Republic and Early Empire." *Numismatic Chronicle* 137: 37–63.

Burnett, Andrew. 1987. *Coinage in the Roman World*. London: Seaby.

Butcher, Kevin, and Matthew Ponting. 1995. "Rome and the East: Production of Roman Provincial Silver Coinage for Caesarea in Cappadocia under Vespasian, AD 69–79." *Oxford Journal of Archaeology* 14.1: 63–77.

Butcher, Kevin, and Matthew Ponting. 2014. *The Metallurgy of Roman Silver Coinage: From the Reform of Nero to the Reform of Trajan*. Cambridge and New York: Cambridge University Press.

Buttrey, S. E., and T. V. Buttrey. 1997. "Calculating Ancient Coin Production Again." *American Journal of Numismatics*, 2nd Series, 9: 113–135.

Buttrey, T. V. 1972. "Vespasian as Moneyer." *Numismatic Chronicle*, 7th Series, 12: 89–109.

Buttrey, T. V. 1993. "Calculating Ancient Coin Production: Facts and Fantasies." *Numismatic Chronicle* 153: 335–351.

Buttrey, T. V. 1994. "Calculating Ancient Coin Production II: Why it Cannot Be Done." *Numismatic Chronicle* 154: 341–352.

Buttrey, T. V. 2007. "Domitian, the Rhinoceros, and the Date of Martial's '*Liber de Spectaculis*.'" *Journal of Roman Studies* 97: 101–112.

Campbell, J. B. 1984. *The Emperor and the Roman Army, 31 BC–AD 235*. Oxford: Oxford University Press.

Campbell, J. B. 1994. *The Roman Army, 31 BC–AD 337: A Sourcebook*. London and New York: Routledge.

Carlson, Carl W. A. 1969. "The 'Laetitia Temporum' Reverses of the Severan Dynasty." *Journal of the Society for Ancient Numismatics* 3: 9–11.

Carlson, Deborah N. 2007. "Mast-Step Coins among the Romans." *International Journal of Nautical Archaeology* 36, no. 2: 317–324.

Carradice, Ian. 1983. *Coinage and Finances in the Reign of Domitian, AD 81–96*. BAR International Series 5. Oxford: British Archaeological Reports.

Cavedoni, Celestino. 1855. "Osservazioni sopra alcune monete di Romani Imperatori." *Bullettino Archeologico Napolitano* 80 (September): 41–48.

Champeaux, Jacqueline. 1987. *FORTVNA. Recherches sur le culte de la Fortune à Rome et dans le monde romain des origines à la mort de César II: Les transformations de Fortuna sous la République*. Collection de l'École Française de Rome 64. Rome: École Française de Rome.

Charlesworth, Martin Percival. 1936. "Providentia and Aeternitas." *Harvard Theological Review* 29: 107–132.

Cheung, Ada. 1998–1999. "The Political Significance of Roman Imperial Coin Types." *Schweizer Münzblätter* 48–49: 53–61.

Claes, Liesbeth. 2014. "A Note on the Coin Type Selection by the *a rationibus*." *Latomus* 73: 164–173.

Clark, Anna J. 2007. *Divine Qualities: Cult and Community in Republican Rome*. Oxford and New York: Oxford University Press.

Coarelli, Filippo. 1968. "*Navalia*, Tarentum e la topografia del Campo Marzio meridionale." *Studi di Topografia Romana. Quaderni dell'Istituto di Topografia Antica nell'Università di Roma* 5: 27–37.

Cohen, Henry. 1882. *Description historique des monnaies frappées sous l'Empire romain comunément appelées Médailles imperiales II.* 2nd edition. Paris: Rollin et Feuardent.

Coleman, Kathleen M. 2000. "Latin Literature after AD 96: Change or Continuity?" *American Journal of Ancient History* 15: 19–39.

Coleman, Kathleen M., ed. 2006. *Martial: Liber Spectaculorum.* Oxford and New York: Oxford University Press.

Collins, Andrew W. 2009. "The Palace Revolution: The Assassination of Domitian and the Accession of Nerva." *Phoenix* 63: 73–106.

Cox, Sarah E. 2005. "The Mark of the Successor: Tribunician Power and the Ara Providentia under Tiberius and Vespasian." *Numismatica e Antichità Classiche* 34: 251–270.

Crawford, Michael H. 1974. *Roman Republican Coinage.* 2 vols. Cambridge: Cambridge University Press.

Crawford, Michael H. 1983. "Roman Imperial Coin Types and the Formation of Public Opinion." In *Studies in Numismatic Method Presented to Philip Grierson*, edited by C. N. L. Brooke, B. H. I. H. Stewart, J. G. Pollard, and T. R. Volk, 47–64. Cambridge: Cambridge University Press.

Daltrop, Georg, Ulrich Hausmann, and Max Wegner. 1966. *Die Flavier. Vespasian, Titus, Domitian, Nerva, Julia Titi, Domitilla, Domitia.* Das römische Herrscherbild 2.1. Berlin: Mann.

D'Ambra, Eve. 1993. *Private Lives, Imperial Virtues: The Frieze of the Forum Transitorium in Rome.* Princeton, NJ: Princeton University Press.

Davies, Penelope J. E. 2012. "The Personal and the Political: The Roman World." In *Classical Archaeology*, edited by Susan E. Alcock and Robin Osborne, 316–347. 2nd edition. Malden, MA: Wiley-Blackwell.

de Callataÿ, François. 1995. "Calculating Ancient Coin Production: Seeking a Balance." *Numismatic Chronicle* 155: 289–311.

De Gregori, Sabina. 2011. *Shepard Fairey in arte Obey: La vita e le opera del re della Poster Art.* Rome: Castelvecchi.

de Loye, Georges. 1984. "Le *as* du Nerva au type 'Neptuno.'" *Revue Numismatique*, 6th series, 26: 95–103.

del Rivero, Casto M. 1927. "Las monedas de Nerva. Bosquejo de un nuevo repertorio de numismática romana imperial." In *Asociación Española para el Progreso de las Ciencias, Congreso de Cádiz*, 173–179. Madrid: Huelves.

Depeyrot, Georges. 2004. *La propaganda monétaire (64–235) et le trésor de Marcianopolis (251).* Collection Moneta 39. Wetteren: Moneta.

Duncan-Jones, Richard P. 1982. *The Economy of the Roman Empire: Quantitative Studies.* 2nd edition. Cambridge: Cambridge University Press.

Duncan-Jones, Richard P. 1989. "Mobility and Immobility of Coin in the Roman Empire." *Annali dell'Istituto Italiano di Numismatica* 36: 121–137.

Duncan-Jones, Richard P. 1990. *Structure and Scale in the Roman Economy.* Cambridge: Cambridge University Press.

Duncan-Jones, Richard P. 1994. *Money and Government in the Roman Empire.* Cambridge: Cambridge University Press.

Duncan-Jones, Richard P. 1999. "The Monetization of the Roman Empire: Regional Variations in the Supply of Coin Types." In *Roman Coins and Public Life under the Empire*, edited by George M. Paul and Michael Ierardi, 61–82. E. Togo Salmon Papers II. Ann Arbor: University of Michigan Press.

Duncan-Jones, Richard P. 2005. "Implications of Roman Coinage: Debates and Differences." *Klio* 87: 459–487.

Eck, Werner. 2002. "An Emperor is Made: Senatorial Politics and Trajan's Adoption by Nerva in 97." In *Philosophy and Power in the Graeco-Roman World: Essays in Honour of Miriam Griffin*, edited by Gillian Clark and Tessa Rajak, 211–226. Oxford: Oxford University Press.

Eckhel, Joseph. 1796. *Doctrina Numorum Veterum II*. Vienna: Frederick Volke.

Elkins, Nathan T. 2006. "The Flavian Colosseum *Sestertii*: Currency or Largess?" *Numismatic Chronicle* 166: 211–221.

Elkins, Nathan T. 2009a. "Coins, Contexts, and Iconographic Approach for the 21st Century." In *Coins in Context I: New Perspectives for the Interpretation of Coin Finds*, edited by Hans-Markus von Kaenel and Fleur Kemmers, 25–46. Studien zu Fundmünzen der Antike 23. Mainz: Philipp von Zabern.

Elkins, Nathan T. 2009b. "What Are They Doing Here? Flavian Colosseum *Sestertii* from Archaeological Contexts in Hessen and the Taunus-Wetterau *Limes* (with an Addendum to *NC* 2006)." *Numismatic Chronicle* 169: 199–204.

Elkins, Nathan T. 2011. "Monuments on the Move: Architectural Coin Types and Audience Targeting in the Flavian and Trajanic Periods." In *Proceedings of the XIVth International Numismatic Congress, Glasgow 2009*, edited by Nicholas Holmes, 645–656. Glasgow: University of Glasgow.

Elkins, Nathan T. 2013. "A Note on Late Roman Art: The Provincial Origins of Camp Gate and Baldachin Iconography on the Late Imperial Coinage." *American Journal of Numismatics*, 2nd Series, 25: 283–302.

Elkins, Nathan T. 2014a. "The Procession and Placement of Imperial Cult Images in the Colosseum." *Papers of the British School at Rome* 82: 73–107.

Elkins, Nathan T. 2014b. "Taxes, Liberty, and the *Quadrantes* of Caligula." *Numismatic Chronicle* 174: 111–117.

Elkins, Nathan T. 2015. *Monuments in Miniature: Architecture on Roman Coinage*. Numismatic Studies 29. New York: American Numismatic Society.

Elkins, Nathan T. 2017a. "The Circulation of Nerva's Neptune Coins in Britannia." In *Fundmünzen—Trouvailles monétaires—Coin Finds: Studien für Hans-Christoph Noeske*, edited by Jérémie Chameroy and Stefan Krmnicek. Tübingen: University of Tübingen Press.

Elkins, Nathan T. 2017b. "Aequitas and Iustitia on the Coinage of Nerva: A Case of Visual Panegyric." *Numismatic Chronicle* 177.

Ellul, Jacques. 1973. *Propaganda: The Formation of Men's Attitudes*. Translated by Konrad Kellen and Jean Lerner. New York: Vintage.

Elsner, Jaś. 1994. "Constructing Decadence: The Representation of Nero as Imperial Builder." In *Reflections of Nero: Culture, History, and Representation*, edited by Jaś Elsner and Jamie Masters, 112–127. Chapel Hill, NC, and London: University of North Carolina Press.

Étienne, Robert, and Marguerite Rachet. 1984. *Le trésor de Garonne: Essai sur la circulation monétaire en Aquitaine à la fin du règne d'Antonin le Pieux, 159–161*. Bordeaux: Fédération Historique du Sud-Ouest.

Fairey, Shepard. 2009. "The Birth of Hope." In *Art for Obama: Designing Manifest Hope and the Campaign for Change*, edited by Shepard Fairey and Jennifer Gross, 7–11. New York: Harry N. Abrams.

Fearnley, Hannah. 2003. "Reading the Imperial Revolution: Martial, *Epigrams* 10." In *Flavian Rome: Culture, Image, Text*, edited by A. J. Boyle and W. J. Dominik, 613–635. Leiden, Boston, and Cologne: Brill.

Fears, J. Rufus. 1981. "The Cult of Virtues and Roman Imperial Ideology." *Aufstieg und Niedergang der Römischen Welt* 2, no. 17.2: 827–948.

Flaig, Egon. 2002. "La fin de la popularité. Néron et la plèbe à la fin du règne." In *Neronia VI: Rome à l'èpoque néronienne*, edited by Jean-Michel Croisille and Yves Perrin, 361–374. Collection Latomus 268. Brussels: Peeters.

Flaig, Egon. 2010. "How the Emperor Nero Lost Acceptance in Rome." In *The Emperor and Rome: Space, Representation, and Ritual*, edited by Björn C. Ewald and Carlos F. Noreña, 275–288. Yale Classical Studies 35. Cambridge: Cambridge University Press.

Flower, Harriet I. 2006. *The Art of Forgetting: Disgrace and Oblivion in Roman Political Culture*. Chapel Hill, NC: University of North Carolina Press.

Forbis, Elizabeth. 1996. *Municipal Virtues in the Roman Empire: The Evidence of Italian Honorary Inscriptions*. Stuttgart and Leipizig: B. G. Teubner.

Freudenburg, Kirk. 2001. *Satires of Rome: Threatening Poses from Lucilius to Juvenal*. Cambridge and New York: Cambridge University Press.

Fuchs, Günter. 1969. *Architekturdarstellungen auf römischen Münzen der Republik und der frühen Kaiserzeit*. Antike Münzen und geschnittene Steine 1. Berlin: Walter de Gruyter.

Gagé, Jean. 1952. "Vespasien et la mémoire de Galba." *Revue des Études Anciennes* 54: 290–315.

Gallia, Andrew B. 2012. *Remembering the Roman Republic: Culture, Politics, and History under the Principate*. Cambridge and New York: Cambridge University Press.

Gambash, Gil. 2015. *Rome and Provincial Resistance*. Routledge Monographs in Classical Studies 21. London and New York: Routledge.

Garzetti, Albino. 1950. *Nerva*. Studi pubblicati dall'Istituto Italiano per la storia antica 7. Rome: Angelo Signorelli.

Garzetti, Albino. 1974. *From Tiberius to the Antonines: A History of the Roman Empire, AD 14–192*. Translated by J. R. Foster. London: Methuen.

Gelzer, Mattias. 1968. *Caesar: Politician and Statesman*. Translated by Peter Needham. Cambridge, MA: Harvard University Press.

Giard, Jean-Baptiste. 1998. *Monnaies de l'Empire romain III. Du soulèvement de 68 après J.-C. à Nerva*. Paris: Bibliothèque nationale de France et Poinsignon Numismatique.

Gibson, Bruce. 2011. "Contemporary Contexts." In *Pliny's Praise: The Panegyricus in the Roman World*, edited by Paul Roche, 104–124. Cambridge: Cambridge University Press.

Gilles, Kar-Josef. 2013. *Der römische Goldmünzschatz aus der Feldstraße in Trier. Trierer Zeitschrift Beiheft* 34. Trier: Ausstellungskatalog Rheinisches Landesmuseum.

Girard, Jean-Louis. 1981. "Domitien et Minerve, une predilection impériale." *Aufstieg und Niedergang der Römischen Welt* 2, no. 17.1: 233–245.

Goodman, Martin. 2005. "The *Fiscus Iudaicus* and Gentile Attitudes to Judaism in Flavian Rome." In *Flavius Josephus and Flavian Rome*, edited by Jonathan Edmondson, Steve Mason, and James Rives, 167–177. Oxford and New York: Oxford University Press.

Goodman, Martin. 2007. "The Meaning of 'FISCI IUDAICI CALUMNIA SUBLATA' on the Coinage of Nerva." In *Studies in Josephus and the Varieties of Ancient Judaism: Louis H. Feldman Jubilee Volume*, edited by Shaye J. D. Cohen and Joshua J. Schwartz, 81–89. Leiden, Boston, and Cologne: Brill.

Gorecki, Joachim. 1975. "Studien zur Sitte der Münzbeigabe in römerzeitlichen Körpergräbern zwischen Rhein, Mosel und Somme." *Berichte der Römisch-Germanischen Kommission* 56: 179–467.

Gowing, Alain M. 2005. *Empire and Memory: The Representation of the Roman Republic in Imperial Culture*. Roman Literature and its Contexts. Cambridge and New York: Cambridge University Press.

Grainger, John D. 2003. *Nerva and the Roman Succession Crisis of AD 96–99*. London and New York: Routledge.

Grassl, Herbert. 1973. *Untersuchungen zum Vierkaiserjahr 68/69 n. Chr. Ein Beitrag zur Ideologie und Sozialstruktur des frühen Prinzipats*. Vienna: Verband der Wissenschaftlichen Gesellschaften Osterreichs Verlag.

Greer, Russel Mortimer. 1936. "Second Thoughts on the Imperial Succession from Nerva to Commodus." *Transactions and Proceedings of the American Philological Association* 67: 47–54.

Grenade, Pierre. 1961. *Essai sur les origines du Principat. Investiture et renouvellement des pouvoirs impériaux*. Paris: Bibliothèque des Écoles Françaises d'Athènes et de Rome.

Griffin, Miriam. 2000. "Nerva to Hadrian." In *The Cambridge Ancient History*. Vol. 11, *The High Empire, AD 70–192*, edited by Alan K. Bowman, Peter Garnsey, and Dominic Rathbone, 84–131. 2nd edition. Cambridge and New York: Cambridge University Press.

Gros, Walter H. 1981. "Augustus als Vorbild." *Aufstieg und Niedergang der Römischen Welt* 2, no. 12.2: 599–611.

Gross, Jennifer. 2009. "The Evolution of a Revolution." In *Art for Obama: Designing Manifest Hope and the Campaign for Change*, edited by Shepard Fairey and Jennifer Gross, 13–15. New York: Harry N. Abrams.

Hamberg, Per Gustaf. 1945. *Studies in Roman Imperial Art with Special Reference to the State Reliefs of the Second Century*. Uppsala: Almqvist and Wiksells.

Hammond, Mason. 1963. "Res olim dissociabiles: Principatus ac libertas. Liberty under the Early Roman Empire." *Harvard Studies in Classical Philology* 67: 93–113.

Hannestad, Niels. 1988. *Roman Art and Imperial Policy*. Aarhus: Aarhus University Press.

Harvey, Brian K. 2002. "The *dies imperii* of Nerva." *Ancient History Bulletin* 16: 44–56.

Haselberger, Lothar, David Gilman Romano, and Elisha Ann Dumser, eds. 2002. *Mapping Augustan Rome. Journal of Roman Archaeology* supplement 50. Portsmouth, RI: Journal of Roman Archaeology.

Hassal, Mark, and Henry Hurst. 1999. "Soldier and Civilian: A Debate on the Bank of the Severn." In *The Coloniae of Roman Britain: New Studies and a Review. Papers of the Conference Held at Gloucester on 5–6 July, 1997*, edited by Henry Hurst, 181–189. *Journal of Roman Archaeology* supplement 36. Portsmouth, RI: Journal of Roman Archaeology.

Heemstra, Marius. 2010. *The Fiscus Judaicus and the Parting of the Ways*. Wissenschaftliche Untersuchung zum Neuen Testament, 2. Reihe, 277. Tübingen: Mohr Siebeck.

Heemstra, Marius. 2012. "The Interpretation and Wider Context of Nerva's Fiscus Judaicus Sestertius." In *Judaea and Rome in Coins, 65 BCE–135 CE. Papers Presented at the International Conference Hosted by Spink, 13th–14th September 2010*, edited by David M. Jacobson and Nikos Kokkinos, 187–201. London: Spink.

Hekster, Olivier. 2003. "Coins and Messages: Audience Targeting on Coins of Different Denominations?" In *The Representation and Perception of Roman Imperial Power: Proceedings of the Third Workshop of the International Network Impact of Empire (Roman Empire, c. 200 BC–AD 476), Netherlands Institute in Rome, March 20–23, 2002*, edited by Lukas de Blois, Paul Erdkamp, Olivier Hekster, Gerda de Kleijn, and Stephan Mols, 20–33. Impact of Empire 3. Leiden, Boston, and Cologne: Brill.

Hellegouarc'h, Joseph. 1963. *Le vocabulaire latin des relations et des partis politiques sous la République*. Paris: Belles Lettres.

Henderson, Bernard William. 1903. *The Life and Principate of the Emperor Nero*. London: Methuen.

Hendin, David. 2010. *Guide to Biblical Coins*. 5th edition. New York: Amphora.

Hersh, Charles A., and Alan Walker. 1984. "The Mesagne Hoard." *American Numismatic Society Museum Notes* 29: 103–134.

Hill, Philip. 1989. *The Monuments of Ancient Rome as Coin Types*. London: Numismatic Fine Arts International.

Hoffer, Stanley E. 2006. "Divine Comedy? Accession Propaganda in Pliny, 'Epistles' 10.1–2 and the 'Panegyric.'" *Journal of Roman Studies* 96: 73–87.

Hobley, Andrew Stephen. 1998. *An Examination of Roman Bronze Coin Distribution in the Western Empire, AD 81–192*. BAR International Series 688. Oxford: British Archaeological Reports.

Hölkeskamp, Karl-J. 2005. "Images of Power: Memory, Myth and Monuments in the Roman Republic." *Scripta Classica Israelica* 24: 249–71.

Hölscher, Tonio. 1980. "Die Geschichtsauffassung in der römischen Repräsentationskunst." *Jahrbuch des Deutschen Archäologischen Instituts* 95: 265–321.

Hölscher, Tonio. 1982. "Die Bedeutung der Münzen für das Verständnis der politischen Repräsentationskunst der späten römischen Republik." In *Proceedings of the 9th International Numismatic Congress of Numismatics, Berne, September 1979*, edited by Tony Hackens and Raymond Weiller, 269–282. Louvain-la-Neuve, Luxembourg: Association Internationale des Numismates Professionels.

Hölscher, Tonio. 1984. *Staatsdenkmal und Publikum. Vom Untergang der Republik bis zur Festigung des Kaisertums in Rom*. Konstanz: Universitätsverlag Konstanz.

Hölscher, Tonio. 2000. "Bildwerke: Darstellungen, Funktionen, Botschaften." In *Klassische Archäologie. Eine Einführung*, edited by Adolf H. Borbein, Tonio Hölscher, and Paul Zanker, 147–165. Berlin: Reimer.

Hölscher, Tonio. 2014. "Historical Representations of the Roman Republic: The Repertory of Coinage in Comparison with Other Art Media." In *"Art in the Round": New Approaches to Ancient Coin Iconography*, edited by Nathan T. Elkins and Stefan Krmnicek, 23–37. Tübinger Archäologische Forschungen 16. Rahden: Marie Leidorf.

Hughes, Jessica. 2009. "Personifications and the Ancient Viewer: The Case of the Hadrianeum 'Nations.'" *Art History* 30.2: 1–20.

Humphrey, John H. 1986. *Roman Circuses: Arenas for Chariot Racing*. London: Batsford.

Hurst, Henry. 1976. "Gloucester (Glevum): A Colonia in the West Country." In *The Roman West Country: Classical Culture and Celtic Society*, edited by Keith Branigan and P. J. Fowler, 63–80. London: David and Charles.

Hurst, Henry. 1988. "Gloucester (Glevum)." In *Fortress into City: The Consolidation of Roman Britain in the First Century AD*, edited by Graham Webster, 48–73. London: Batsford.

Jentoft-Nilsen, Marit R. 1985. "Diana on Roman Coins." PhD dissertation, University of Southern California, Los Angeles.

Jones, A. H. M. 1956. "Numismatics and History." In *Essays in Roman Coinage Presented to Harold Mattingly*, edited by R. A. G. Carson and C. H. V. Sutherland, 13–33. Oxford: Oxford University Press.

Jones, Brian W. 1979. *Domitian and the Senatorial Order*. Memoirs of the American Philosophical Society 132. Philadelphia, PA: American Philosophical Society.

Jones, Brian W. 1992. *The Emperor Domitian*. London and New York: Routledge.

Jucker, Hans. 1982. "Die Bildnistrafen gegen den toten Caligula." In *Praestant Interna. Festschrift für Ulrich Hausmann*, edited by Bettina von Freytag gen Löringhoff, Dietrich Mannsperger, and Friedheim Prayon, 110–118. Tübingen: E. Wasmuth.

Kay, Nigel M. 1985. *Martial, Book XI: A Commentary*. London: Duckworth.

Keane, Catherine. 2012. "Historian and Satirist: Tacitus and Juvenal." In *A Companion to Tacitus*, edited by Victoria Emma Pagán, 403–427. Malden, MA, and Oxford: Wiley-Blackwell.

Kemmers, Fleur. 2003. "Quadrantes from Nijmegen: Small Change in a Frontier Province." *Schweizerische Numismatische Rundschau* 82: 17–34.

Kemmers, Fleur. 2005. "Not at Random: Evidence for a Regionalised Coin Supply?" In *Proceedings of the Fourteenth Annual Theoretical Roman Archaeology Conference, Durham 2004*, edited by James Bruhn, Ben Croxford, and Dimitris Grigoropoulos, 39–49. Oxford: Oxbow.

Kemmers, Fleur. 2006. *Coins for a Legion: An Analysis of the Coin Finds from the Augustan Legionary Fortress and Flavian* canabae legionis *at Nijmegen*. Studien zu Fundmünzen der Antike 21. Mainz: Philipp von Zabern.

Kemmers, Fleur. 2009. "Sender or Receiver? Contexts of Coin Supply and Coin Use." In *Coins in Context I: New Perspectives for the Interpretation of Coin Finds*, edited by Hans-Markus von Kaenel and Fleur Kemmers, 137–156. Studien zu Fundmünzen der Antike 23. Mainz: Philipp von Zabern.

Kemmers, Fleur. 2014. "Buying Loyalty: Targeted Iconography and the Distribution of Cash to the Legions." In *De l'or pour les braves! Soldes, armées et circulation monétaire dans le monde romain*, edited by Michel Reddé, 229–241. Scripta Antiqua 69. Bordeaux: Ausonius.

Kienast, Dietmar. 2011. *Römische Kaisertabelle. Grundzüge einer römischen Kaiserchronologie*. 5th unaltered edition, after the 2nd revised edition in 1996. Darmstadt: Wissenschaftliche Buchgesellschaft.

King, Cathy E. 2007. *Roman Quinarii from the Republic to Diocletian and the Tetrarchy*. Oxford: Ashmolean Museum Publications.

Klawans, Zander H. 1977. *Imitations and Inventions of Roman Coins: Renaissance Medals of Julius Caesar and the Roman Empire*. Santa Monica, CA: Society for International Numismatics.

Kleiner, Diana E. E. 1992. *Roman Sculpture*. New Haven, CT, and London: Yale University Press.

Koenig, Franz E. 1999. "Les monnaies." In *La nécropole gallo-romaine d'Avenches "En Chaplix." Fouilles, 1987–1992*. Vol. 2, *Étude du mobilier*, edited by Daniel Castella, Chantal Martin Pruvot, Heidi Amrein, Anika Duvauchelle, and Franz E. Koenig, 427–462. Lausanne: Cahiers d'archéologie romande.

Kolb, Anne. 2000. *Transport und Nachrichtentransfer im römischen Reich. Klio* Beihefte, neue Folge, 2. Berlin: Walter de Gruyter.

Kolb, Anne. 2015. "Communications and Mobility in the Roman Empire." In *The Oxford Handbook of Roman Epigraphy*, edited by Christer Bruun and Jonathan Edmondson, 649–670. Oxford: Oxford University Press.

Komnick, Holger. 2000. "Die flavischen Fundmünzen aus dem Bereich des 'sottosuolo urbano' der Stadt Rom: Eine Vergleichsanalyse." In *XII. Internationaler Numismatischer Kongress, Berlin 1997, Akten—Proceedings—Actes I*, edited by Bernd Kluge and Bernhard Weisser, 544–551. Berlin: Staatliche Mussen zu Berlin.

Komnick, Holger. 2001. *Die Restitutionsmünzen der frühen Kaiserzeit. Aspekte der Kaiserlegitimation*. Berlin: Walter de Gruyter.

Kraay, Colin M. 1949. "The Coinage of Vindex and Galba, AD 68, and the Continuity of the Augustan Principate." *Numismatic Chronicle*, 6th Series, 9: 129–149.

Kraay, Colin M. 1956. *The Aes Coinage of Galba*. American Numismatic Society Numismatic Notes and Monographs 133. New York: American Numismatic Society.

Kraay, Colin M. 1978. "The Bronze Coinage of Vespasian: Classification and Attribution." In *Scripta Nummaria Romana: Essays Presented to Humphrey Sutherland*, edited by R. A. G. Carson and Colin M. Kraay, 47–57. London: Spink.

Kraft, Konrad. 1962. "S(enatus) C(onsulto)." *Jahrbuch für Numismatik und Geldgeschichte* 12: 7–49.

Krmnicek, Stefan, and Nathan T. Elkins. 2014. "Dinosaurs, Cocks, and Coins: An Introduction to 'Art in the Round.'" In *"Art in the Round": New Approaches to Ancient Coin Iconography*, edited by Nathan T. Elkins and Stefan Krmnicek, 7–22. Tübinger Archäologische Forschungen 16. Rahden: Marie Leidorf.

Kubitschek, Wilhelm. 1933. "Nervas römischen Münzen." *Anzeiger der Österreichischen Akademie der Wissenschaften in Wien (Philosophisch-historischen Klasse)* 70: 4–25.

Lamp, Kathleen S. 2013. *A City of Marble: The Rhetoric of Augustan Rome*. Columbia: University of South Carolina Press.

Lange, Heinrich. 1932. "Die Wörter AEQVITAS und IVSTITIA auf römischen Münzen." *Zeitschrift der Savigny-Stiftung für Rechtsgeschichte, Romantische Abteilung* 52: 296–314.

Lanna, Fabiana, and Maria Cristina Molinari. 2015. "The Finds." In *The Julio-Claudian and Flavian Coins from Rome's Municipal Urban Excavations: Observations on Coin Circulation in the Cities of Latium Vetus and Campania in the First Century AD*, edited by Maria Cristina Molinari, 11–15. Polymnia, Numismatica Antica e Medievale, Studi 6. Trieste: Edizioni Università di Trieste.

Levick, Barbara. 1982. "Propaganda and Imperial Coinage." *Antichthon* 16: 104–116.

Levick, Barbara. 1990. *Claudius*. New Haven, CT and London: Yale University Press.

Levick, Barbara. 1999a. "Messages on the Roman Coinage: Types and Inscriptions." In *Roman Coins and Public Life under the Empire*, edited by George M. Paul

and Michael Ierardi, 41–60. E. Togo Salmon Papers II. Ann Arbor: University of Michigan Press.

Levick, Barbara. 1999b. *Vespasian*. London and New York: Routledge.

Levick, Barbara. 1999c. *Tiberius the Politician*. Rev. edition. London and New York: Routledge.

Lichocka, Barbara. 1974. *Justitia sur les monnaies impériales romaines*. Travaux du Centre d'Archéologie Méditerranéenne de l'Académie Polonaise des Sciences 15. Warsaw: Éditions Scientifique de Pologne.

Liegle, Josef. 1935. "Pietas." *Zeitschrift für Numismatik* 42: 59–100.

Lintott, Andrew. 1999. *The Constitution of the Roman Republic*. Oxford and New York: Oxford University Press.

Lummel, Peter. 1991. *"Zielgruppen" römischer Staatskunst. Die Münzen der Kaiser Augustus bis Trajan und die trajanischen Staatsreliefs*. Quellen und Forschungen zur antiken Welt 6. Munich: Tuduv.

Lyasse, Emmanuel. 2003. "La notion de *libertas* dans le discours politique romain, d'Auguste à Trajan." *Ktèma* 28: 63–69.

MacCormack, Sabine. 2012. "Imagery in Panegyrics." In *Latin Panegyric*, edited by Roger Rees, 240–250. Oxford Readings in Classical Studies. Oxford and New York: Oxford University Press.

MacDonald, George. 1934. "A Hoard of Roman *Denarii* from Scotland." *Numismatic Chronicle*, 5th Series, 14: 1–30.

Magi, Filippo. 1945. *I rilievi flavi del Palazzo della Cancelleria*. Rome: Presso la Pontificia Accademia Romana di Archeologi.

Manders, Erika. 2012. *Coining Images of Power: Patterns in the Representation of Roman Emperors on Imperial Coinage, AD 193–284*. Impact of Empire 15. Leiden and Boston: Brill.

Mannsperger, Brigitte. 1974. "Libertas—Honos—Felicitas: Zur Prägung des Münzmeisters Palikanus." *Chiron* 4: 327–342.

Mannsperger, Dietrich. 1974. "ROM ET AVG. Die Selbstdarstellung des Kaisertums in der römischen Reichsprägung." *Aufstieg und Niedergang der Römischen Welt* 2, no. 1: 919–996.

Marzano, Annalisa. 2009. "Trajanic Building Projects on Base-Metal Denominations and Audience Targeting." *Papers of the British School at Rome* 77: 125–158.

Mastrorosa, Ida Gilda. 2012. "La *Fortuna populi Romani* e l'ascesa egemonica di Roma." In *Persona Ficta: La personificazione allegorica nell cultura antica fra letteratura, retorica e iconographia*, edited by Gabriella Moretti and Alice Bonandini, 301–324. Trent: Università degli Studi di Trento.

Mattingly, Harold. 1977. *Roman Coins from the Earliest Times to the Fall of the Western Empire*. Reprint of the corrected 2nd edition, 1962. London: Methuen.

Mayer, Emanuel. 2002. *Rom ist dort, wo der Kaiser ist. Untersuchungen zu den Staatsdenkmälern des dezentralisierten Reiches von Diocletian bis zu Theodosius II*. Römisch-Germanisches Zentralmuseum Forschungsinstitut für Vor- und Frühgeschichte, Monographien 53. Mainz: Verlag des Römisch-Germanischen Zentralmuseums.

Mayer, Emanuel. 2010. "Propaganda, Staged Applause, or Local Politics? Public Monuments from Augustus to Septimius Severus." In *The Emperor and Rome: Space,*

Representation, and Ritual, edited by Björn C. Ewald and Carlos F. Noreña, 111–134. Yale Classical Studies 35. Cambridge and New York: Cambridge University Press.

Mellor, Ronald. 1993. *Tacitus*. London and New York: Routledge.

Mellor, Ronald. 2010. *Tacitus' Annals*. Oxford Approaches to Classical Literature. Oxford and New York: Oxford University Press.

Merlin, Alfred. 1906a. *Les revers monétaires de l'empéreur Nerva (18 septembre 96–27 janvier 98)*. Paris: Ancienne Librairie Thorin et Fils.

Merlin, Alfred. 1906b. "Le grand bronze de Nerva, *Tutela Italiae*." *Revue Numismatique*, 4th Series, 2: 298–301.

Metcalf, William E. 1993. "Whose *Liberalitas*? Propaganda and Audience in the Early Roman Empire." *Rivista Italiana di Numismatica* 95: 337–346.

Metcalf, William E. 1996. *The Silver Coinage of Cappadocia, Vespasian–Commodus*. Numismatic Notes and Monographs 166. New York: American Numismatic Society.

Metcalf, William E. 2004. "Mommsen and Numismatics in the 21st Century." In *Geldgeschichte vs. Numismatik. Theodor Mommsen und die antike Münze*, edited by Hans-Markus von Kaenel, Maria R.-Alföldi, Ulrike Peter, and Holger Komnick, 295–302. Griechisches Münzwerk. Berlin: Akademie.

Méthy, Nicole. 2000. "Éloge rhétorique et propagande politique sous le Haut-Empire. L'exemple du *Panégyrique de Trajan*." *Mélanges de l'École française de Rome. Antiquité* 112.1: 365–411.

Millar, Fergus. 1992. *The Emperor in the Roman World*. 2nd edition. London: Duckworth.

Mittag, Peter Franz. 2010. *Römische Medaillons: Caesar bis Hadrian*. Stuttgart: Franz Steiner.

Molinari, Maria C. 2002. "Alcune riflessioni sui ritrovamenti di medaglionie di grandi bronzi provinciali a Roma." *Rivista Italiana di Numismatica* 103: 203–217.

Mommsen, Theodor. 1844. *Die römische Tribus in administrativer Beziehung*. Altona: Johann Friedrich Hammerich.

Mommsen, Theodor. 1860. *Geschichte des römischen Münzwesens*. Berlin: Weidmann.

Mommsen, Theodor. 1878. "Der letzte Kampf der Republik." *Hermes* 13: 90–105.

Mommsen, Theodor. 1887. *Römisches Staatsrecht III.1*. Leipzig: Hirzel.

Morawiecki, Lesław. 1977. "The Symbolism of Minerva on the Coins of Domitianus." *Klio* 59: 185–193.

Morelli, Ulisse. 2014. *Domiziano. Fine di una dinastia*. Philippika, Altertumswissenschaftliche Abhandlungen; Contributions to the Study Ancient World Cultures 71. Wiesbaden: Harrassowitz.

Morford, Mark P. O. 1992. "*Iubes Esse Liberos*: Pliny's *Panegyricus* and Liberty." *American Journal of Philology* 113.4: 575–593.

Morgan, Gwyn. 2006. *69 AD: The Year of the Four Emperors*. Oxford and New York: Oxford University Press.

Morselli, Chiara, and Edoardo Tortorici, eds. 1990. *Curia, Forum Iulium, Forum Transitorium*. Rome: De Luca.

Mouchmov, Nicolas A. 1934. *Le trésor numismatique de Reka-Devnia (Marcianopolis)*. Annuaire du Musée National Bulgare, supplement 5. Sofia: Imprimerie de l'État.

Murison, Charles L. 1993. *Galba, Otho and Vitellius: Careers and Controversies*. Hildesheim, Zurich, and New York: Georg Olms.

Murison, Charles L. 2003. "M. Cocceius Nerva and the Flavians." *Transactions of the American Philological Association* 133: 147–157.

Nauta, Ruurd R. 2002. *Poetry for Patrons: Literary Communication in the Age of Domitian*. Leiden, Boston, and Cologne: Brill.

Noeske, Hans-Christoph. 1979. "Bemerkungen zur Problematik der Siedlungsfund." In *Ergebnisse des FMRD-Colloquiums vom 8.–13. Februar 1976 in Frankfurt am Main und Bad Homburg v.d. H.*, edited by Maria R.-Alföldi, 157–165. Studien zu Fundmünzen der Antike 1. Berlin: Mann.

Nony, Daniel. 1986. *Caligula*. Paris: Fayard.

Nony, Daniel. 1987. "Nerva et les apparences de la légitimité." In *Mélanges de numismatique offerts à Pierre Bastien à l'occasion de son 75e anniversaire (1987)*, edited by Hélène Huvelin, Michel Christol, and Georges Gautier, 51–63. Wetteren: Edition NR.

Noreña, Carlos F. 1999. Review of Hobley 1998. *American Journal of Numismatics*, 2nd Series, 9: 160–164.

Noreña, Carlos F. 2001. "The Communication of the Emperor's Virtues." *Journal of Roman Studies* 91: 146–168.

Noreña, Carlos F. 2011a. *Imperial Ideals in the Roman West: Representation, Circulation, Power*. Cambridge and New York: Cambridge University Press.

Noreña, Carlos F. 2011b. "Self-Fashioning in the *Panegyricus*." In *Pliny's Praise: The Panegyricus in the Roman World*, edited by Paul Roche, 29–44. Cambridge and New York: Cambridge University Press.

Paribeni, Roberto. 1927. *Optimus Princeps: Saggio sulla storia e sui tempi dell'imperatore Traiano*. Messina: G. Principato.

Peachin, Michael. 1986. "The *Procurator Monetae*." *Numismatic Chronicle* 146: 94–106.

Peachin, Michael. 2004. *Frontinus and the* curae *of the* curator aquarum. Stuttgart: Franz Steiner.

Penwill, John. 2015. "Compulsory Freedom: Literature in Trajan's Rome." In *The Art of Veiled Speech: Self-Censorship from Aristophanes to Hobbes*, edited by Han Baltussen and Peter J. Davis, 176–208. Philadelphia: University of Pennsylvania Press.

Perassi, Claudia. 2008. "Il sesterzio di Domiziano dal criptoportico del *Capitolium*: Una deposizione intenzionale." In *L'area del Capitolium di Verona. Ricerche storiche e archeologiche*, edited by Giuliana Cavalieri Manasse, 583–589. Padua: Ministero per i Beni e le Attività Culturali Soprintendenza per i Beni Archeologici del Veneto.

Pernot, Laurent. 2015. *Epideictic Rhetoric: Questioning the Stakes of Ancient Praise*. Austin: University of Texas Press.

Peter, Markus. 1996. "Bemerkungen zur Kleingeldversorgung der westlichen Provinzen im 2. Jahrhundert." In *Coin Finds and Coin Use in the Roman World: The Thirteenth Oxford Symposium on Coinage and Monetary History, 25.–27.3.1993*, edited by Cathy E. King and David G. Wigg, 309–320. Studien zu Fundmünzen der Antike 10. Berlin: Mann.

Pflaum, Hans-Georg. 1950. *Les procurateurs èquestres sous le Haut-Empire romain*. Paris: Librairie d'Amérique et d'Orient.

Pflaum, Hans-Georg. 1960–1961. *Les carrières procuratoriennes èquestres sous le Haut-Empire romain*. Paris: P. Geuthner.

Pighi, Giovanni Battista. 1965. *De Ludis Saecularibus Populi Romani Quiritum. Libri Sex*. Amsterdam: P. Schippers.

Platner, Samuel Ball, and Thomas Ashby. 1926. *A Topographical Dictionary of Ancient Rome*. Oxford: Oxford University Press.

Pollini, John. 2012. *From Republic to Empire: Rhetoric, Religion, and Power in the Visual Culture of Ancient Rome*. Norman: University of Oklahoma Press.

R.-Alföldi, Maria. 1991. "Fundstelle Rom." In *Geld aus dem antiken Rom: "Assem habeas, assem valeas—hast Du was, bist Du was"*, edited by Silvana Balbi de Caro, Dirk Backendorf, Holger Komnick, Eva-Brigitte Mertzdorff, Hans-Christoph Noeske, Maria R.-Alföldi, Helmut Schubert, and David Wigg, 7–8. Frankfurt am Main: Stadt Frankfurt Dez. Kultur und Wissenschaft.

R.-Alföldi, Maria. 1999. *Bild und Bildersprache der römischen Kaiser. Beispiele und Analysen*. Mainz: Philipp von Zabern.

Raaflaub, Kurt A. 1987. "Grundzüge, Ziele und Ideen der Opposition gegen die Kaiser im 1. Jh. n. Chr.: Versuch einer Standortbestimmung." In *Opposition et résistances à l'Empire d'Auguste à Trajan: Neuf exposés suivis de discussions*, edited by Adalberto Giovannini and Denis van Berchem, 1–65. Geneva: Fondation Hardt.

Ramage, Edwin S. 1983. "The Denigration of Predecessor under Claudius, Galba, and Vespasian." *Historia* 32: 201–14.

Ramage, Edwin S. 1989. "Juvenal and the Establishment: Denigration of Predecessor in the 'Satires.'" *Aufstieg und Niedergang der Römischen Welt* 2, no. 33.1: 640–707.

Ramage, Nancy H., and Andrew Ramage. 2009. *Roman Art*. 5th edition. Upper Saddle River, NJ: Pearson.

Rich, J. W. 1998. "Augustus's Parthian Honours, the Temple of Mars Ultor and the Arch in the Forum Romanum." *Papers of the British School at Rome* 53: 71–128.

Rich, J. W., and J. H. C. Williams. 1999. "*Leges et Ivra P. R. Restitvit*: A New Aureus of Octavian and the Settlement of 28–27 BC." *Numismatic Chronicle* 159: 169–213.

Richardson, Lawrence. 1992. *A New Topographical Dictionary of Ancient Rome*. Baltimore, MD: Johns Hopkins University Press.

Rickman, Geoffrey. 1980. *The Corn Supply of Ancient Rome*. Oxford: Oxford University Press.

Rimmel, Victoria. 2008. *Martial's Rome: Empire and the Ideology of Epigram*. Cambridge: Cambridge University Press.

Rogers, Perry M. 1984. "Domitian and the Finances of State." *Historia* 33: 60–78.

Rogers, Robert Samuel. 1943. *Studies in the Reign of Tiberius: Some Imperial Virtues of Tiberius and Drusus Julius Caesar*. Baltimore, MD: Johns Hopkins University Press.

Roller, Matthew B. 2001. *Constructing Autocracy: Aristocrats and Emperors in Julio-Claudian Rome*. Princeton, NJ: Princeton University Press.

Roman, Luke. 2014. *Poetic Autonomy in Ancient Rome*. Oxford and New York: Oxford University Press.

Rowan, Clare. 2011a. *Under Divine Auspices: Divine Ideology and the Visualisation of Imperial Power in the Severan Period*. Cambridge and New York: Cambridge University Press.

Rowan, Clare. 2011b. "The Public Image of the Severan Women." *Papers of the British School at Rome* 79: 241–273.

Rowan, Clare. 2013a. Review of Manders 2012. *Classical Review* 63.2: 550–552.

Rowan, Clare. 2013b. "Imaging the Golden Age: The Coinage of Antoninus Pius." *Papers of the British School at Rome* 81: 211–246.

Sailor, Dylan. 2008. *Writing and Empire in Tacitus*. Cambridge and New York: Cambridge University Press.

Salamone, Grazia. 2004. *L'imperatore e l'esercito. Tipi monetali di età romano-imperiale*. Semata e Signa 2. Reggio Calabria : Falzea.

Schäfer, Thomas. 1989. *Imperii Insignia. Sella Curulus und Fasces: Zur Repräsentation römischer Magistrate.* Mainz: Philipp von Zabern.

Schiller, Hermann. 1872. *Geschichte des römischen Kaiserreichs unter der Regierung des Nero.* Berlin: Weidmann.

Schmidt-Dick, Franziska. 2002. *Typenatlas der römischen Reichsprägung von Augustus bis Aemilianus I. Weibliche Darstellungen. Numismatische Zeitschrift* 110. Vienna: Verlag der Österreichischen Akademie der Wissenschaften.

Schmidt-Dick, Franziska. 2008. "Vom Congiarium zur Liberalitas." In *Festschrift für Günther Dembski zum 65. Geburtstag I,* edited by Michael Alram and Heinz Winter, 103–113. *Numismatische Zeitschrift* 116/117. Vienna: Verlag der Österreichischen Akademie der Wissenschaften.

Schneider, Erika. 2012. "The Politics of Tagging: Shepard Fairey's Obama." In *The Iconic Obama, 2007–2009: Essays on Media Representations of the Candidate and the New President,* edited by Nicholas A. Yanes and Derrais Carter, 97–109. Jefferson, NC: McFarland.

Schowalter, Daniel N. 1993. *The Emperor and the Gods: Images from the Time of Trajan.* Harvard Dissertations in Religion 28. Minneapolis, MN: Augsburg Fortress.

Schubert, Helmut. 1984. *Römische Fundmünzen aus Nida-Heddernheim.* Archäologische Reihe 2. Frankfurt am Main: Stadt Frankfurt Dez. Kultur und Wissenschaft.

Seelentag, Gunnar. 2004. *Taten und Tugenden Traians. Herrschaftsdarstellung im Principat.* Hermes Einzelschriften 91. Stuttgart: Franz Steiner.

Seelentag, Gunnar. 2008. "Der Kaiser als Fürsorger: Die italische Alimentarinstitution." *Historia* 57: 208–241.

Sellwood, D. G. 1963. "Some Experiments in Greek Minting Technique." *Numismatic Chronicle,* 7th Series, 3: 217–231.

Shapiro, Harvey Alan. 1993. *Personifications in Greek Art: The Representation of Abstract Concepts, 600–400 BC* Zurich: Akanthus.

Shotter, David C. A. 1978a. "Roman Historians and the Roman Coinage." *Greece and Rome* 25: 156–168.

Shotter, David C. A. 1978b. "Principatus ac Libertas." *Ancient Society* 9: 235–255.

Shotter, David C. A. 1983. "The Principate of Nerva: Some Observations on the Coin Evidence." *Historia* 32: 215–226.

Shotter, David C. A. 2013. A Rare Find: A Neptune *As* of the Roman Emperor, Nerva." *Numismatic Chronicle* 173: 85–97.

Simon, Erika. 1960. "Zu den flavisichen Reliefs von der Cancelleria." *Jahrbuch des Deutschen Archäologischen Instituts* 75: 134–156.

Smith, Christopher, and Ralph Covino, eds. 2011. *Praise and Blame in Roman Republican Rhetoric.* Swansea: Classical Press of Wales.

Spinazzola, Vittorio. 1907. *L'anfiteatro flavio. Storia degli scavi ed ultime scoperte, 1590–1895.* Naples: Riccardo Marghieri.

Spinola, Giandomenico. 1990. *Il «congiarium» in età imperiale. Aspetti iconografici e topografici.* Rome: G. Bretschneider.

Spisak, Art L. 2007. *Martial: A Social Guide.* London: Bloomsbury.

Steinbock, Bernd. 2014. "Coin Types and Latin Panegyrics as Means of Imperial Communication." In *"Art in the Round": New Approaches to Ancient Coin Iconography,* edited by Nathan T. Elkins and Stefan Krmnicek, 51–67. Tübinger Archäologische Forschungen 16. Rahden: Marie Leidorf.

Stewart, Peter. 2008. *The Social History of Roman Art.* Cambridge and New York: Cambridge University Press.

Strack, Paul L. 1930. *Untersuchungen zur Geschichte der Kaiser Nerva, Traian und Hadrian. Untersuchungen zur römischen Reichsprägung Trains in den Jahren 98 bis 100.* Stuttgart: Kohlhammer.

Strack, Paul L. 1931. *Untersuchungen zur römischen Reichsprägung des zweiten Jahrhunderts I. Die Reichsprägung zur Zeit des Traian.* Stuttgart: Kohlhammer.

Strunk, Thomas E. 2016. *History After Liberty: Tacitus on Tyrants, Sycophants, and Republicans.* Ann Arbor: University of Michigan Press.

Stylow, Armin. U. 1971. "Die Quadranten des Caligula als Propagandamünzen." *Chiron* 1: 285–90.

Stylow, Armin. U. 1972. "Libertas und Liberalitas: Untersuchungen zur innenpolitischen Propaganda der Römer." PhD dissertation, Ludwig-Maximilians-Universität, Munich.

Sullivan, J. P. 1991. *Martial, the Unexpected Classic: A Literary and Historical Study.* Cambridge: Cambridge University Press.

Sutherland, C. H. V. 1935. "The State of the Imperial Treasury at the Death of Domitian." *Journal of Roman Studies* 25: 150–162.

Sutherland, C. H. V. 1951. *Coinage in Roman Imperial Policy.* London.

Sutherland, C. H. V. 1959. "The Intelligibility of Roman Imperial Coin Types." *Journal of Roman Studies* 49: 46–55.

Sutherland, C. H. V. 1970. *The Cistophori of Augustus.* Royal Numismatic Society Special Publication no. 5. London: Royal Numismatic Society.

Sutherland, C. H. V. 1974. *Roman Coins.* London.

Sutherland, C. H. V. 1986. "Compliment or Complement? Dr Levick on Imperial Coin Types." *Numismatic Chronicle* 146: 85–93.

Sutherland, C. H. V. 1987. *Roman History and Coinage, 44 BC–AD 69: Fifty Points of Relation from Julius Caesar to Vespasian.* Oxford: Oxford University Press.

Syme, Ronald. 1930. "The Imperial Finances under Domitian, Nerva and Trajan." *Journal of Roman Studies* 20: 55–70.

Syme, Ronald. 1939. *The Roman Revolution.* Oxford: Oxford University Press.

Syme, Ronald. 1958. *Tacitus.* 2 vols. Oxford: Oxford University Press.

Syme, Ronald. 1982. "The Marriage of Rubellius Blandus." *American Journal of Philology* 103: 62–85.

Szaivert, Eva. 1978. "Die Münzprägung des Kaisers Nerva in Rom. Ein Beitrag zur Systemanalyse." PhD dissertation, University of Vienna.

Talbert, Richard J. A. 1996. "The Senate and Senatorial and Equestrian Posts" In *The Cambridge Ancient History X: The Augustan Empire, 43 BC–AD 69,* edited by Alan K. Bowman, Edward Champlin, and Andrew Lintott, 324–343. Cambridge and New York: Cambridge University Press.

Thornton, M. K., and R. L Thornton. 1989. *Julio-Claudian Building Programs: A Quantitative Study in Political Management.* Mundelein, IL: Bolchazy-Carducci.

Thüry, Günther E. 2016. *Die antike Münze als Fundgegenstand: Kategorien numismaticher Funde und ihre Interpretation.* Oxford: Archaeopress.

Torelli, Mario. 1982. *Typology and Structure of Roman Historical Reliefs.* Ann Arbor: University of Michigan Press.

Torelli, Mario. 1997. "'Ex his castra, ex his tribus replebuntur': The Marble Panegyric on the Arch of Trajan at Beneventum." In *The Interpretation of Architectural Sculpture in Greece and Rome*, edited by Diana Buitron-Oliver, 145–177. Washington, DC: National Gallery of Art.

Toynbee, Jocelyn M. C. 1956. "Picture Language in Roman Art and Coinage." In *Essays in Roman Coinage Presented to Harold Mattingly*, edited by R. A. G. Carson and C. H. V. Sutherland, 205–226. Oxford: Oxford University Press.

Toynbee, Jocelyn M. C. 1957. *Flavian Reliefs from the Palazzo della Cancelleria in Rome*. London: Oxford University Press.

Toynbee, Jocelyn M. C. 1986. *Roman Medallions*. Reprint of the 1944 edition with an introduction by William E. Metcalf. Numismatic Studies 5. New York: American Numismatic Society.

Tuck, Steven L. 2005. "The Origins of Roman Imperial Hunting Imagery: Domitian and the Redefinition of Virtus under the Principate." *Greece and Rome* 52: 221–245.

van Berchem, Denis. 1939. *Les distributions de blé et d'argent à la plèbe romaine sous l'Empire*. Geneva: Georg.

van Berchem, Denis. 1941–1942. "Les 'clients' de la plèbe romaine." *Rendiconti della Pontificia Accademia Romana di Archaeologia* 18: 183–190.

Varner, Eric R. 2004. *Mutilation and Transformation: Damnatio Memoriae and Roman Imperial Portraiture*. Leiden, Boston, and Cologne: Brill.

Vermeule, Cornelius Clarkson. 1959. *The Goddess Roma in the Art of the Roman Empire*. London: Spink.

Veyne, Paul. 1976. *Le pain et le cirque. Sociologie historique d'un pluralisme politique*. Paris: Seuil.

Voelkel, Laura B. 1953. "The Selection of Coin Types during the Reign of the Emperor Domitian." In *Studies Presented to David Moore Robinson on His Seventieth Birthday*, edited by George E. Mylonas and Doris Raymond, vol. 2, 243–247. St. Louis, MO: Washington University.

von Kaenel, Hans-Markus. 1984. "Roma—Moneta dal Tevere. L'imperatore Claudio I." *Bollettino di Numismatica* 2–3: 85–325.

von Kaenel, Hans-Markus. 1986. *Münzprägung und Münzbildnis des Claudius*. Antike Münze und geschnittene Steine 9. Berlin: Walter de Gruyter.

Wallace-Hadrill, Andrew. 1981. "Galba's Aequitas." *Numismatic Chronicle* 141: 20–39.

Wallace-Hadrill, Andrew. 1983. *Suetonius: The Scholar and His Caesars*. New Haven, CT, and London: Yale University Press.

Wallace-Hadrill, Andrew. 1986. "Image and Authority in the Coinage of Augustus." *Journal of Roman Studies* 76: 66–87.

Walton, Philippa Jane. 2012. *Rethinking Roman Britain: Coinage and Archaeology*. Wetteren: Moneta.

Wegner, Max. 1939. *Die Herrscherbildnisse in antoninischer Zeit*. Das römische Herrscherbild 2.4. Berlin: Mann.

Wegner, Max. 1956. *Hadrian, Plotina, Marciana, Matidia, Sabina*. Das römische Herrscherbild 2.3. Berlin: Mann.

Weil, Jacqueline. 2005. "Personifkationen. Medium kaiserlicher Selbstdarstellung." In *Moneta Augusti. Römische Münzen der Kaiserzeit und Spätantike im Akademischen*

Münzkabinett der Friedrich-Schiller-Universität Jena, edited by Angelika Geyer, 79–95. Jaener Hefte zur Klassichen Archäologie 6. Jena: Glaux.

Weinstock, Stefan. 1971. *Divus Julius*. Oxford: Oxford University Press.

Whitton, C. L. 2010. "Pliny, *Epistles* 8.14: Senate, Slavery and the *Agricola*." *Journal of Roman Studies* 100: 118–139.

Wiczay, C. Michael. 1814. *Mvsei Hedervarii in Hungaria numos antiquos Graecos et Latinos descriptsit anecdotos vel parum cognitos etiam cupreis tabulis*. Vienna: Mechitaristarum.

Williams, Margaret H. 2013. "Jews and Christians at Rome: An Early Parting of the Ways." In *Partings: How Judaism and Christianity Became Two*, edited by Hershel Shanks, 151–178. Washington, DC: Biblical Archaeology Society.

Wilkinson, Sam. 2005. *Caligula*. London and New York: Routledge.

Willrich, Hugo. 1903. "Caligula." *Klio* 3: 397–470.

Wirszubski, Chaim. 1950. *Libertas as a Political Idea at Rome during the Late Republic and Early Principate*. Cambridge: Cambridge University Press.

Wolters, Reinhard. 1999. *Nummi Signati: Untersuchungen zur römischen Münzprägung und Geldwirtschaft*. Vestigia. Beiträge zur alten Geschichte 49. Munich: C. H. Beck.

Wolters, Reinhard. 2003. "Die Geschwindigkeit der Zeit und die Gefahr der Bilder. Münzbilder und Münzpropaganda in der römischen Kaiserzeit." In *Propaganda— Selbstdarstellung—Repräsentation im römischen Kaiserreich des 1. Jhs. n. Chr.*, edited by Gregor Weber and Martin Zimmermann, 175–204. Historia Einzelschriften 164. Stuttgart: Franz Steiner.

Wolters, Reinhard. 2004. "Prägungen des Kaisers vs. Prägungen des Senats. Mommsens 'Dyarchie-These' und die antike Numismatik." In *Geldgeschichte vs. Numismatik. Theodor Mommsen und die antike Münze*, edited by Hans-Markus von Kaenel, Maria R.-Alföldi, Ulrike Peter, and Holger Komnick, 247–263. Griechisches Münzwerk. Berlin: Akademie.

Wolters, Reinhard. 2012. "The Julio-Claudians." In *The Oxford Handbook of Greek and Roman Coinage*, edited by William E. Metcalf, 335–355. Oxford: Oxford University Press.

Wolters, Reinhard, and Martin Ziegert. 2014. "Umbrüche: Die Reichsprägung Neros und Domitians im Vergleich." In *Nero und Domitian. Mediale Diskurse der Herrscherrepräsentation im Vergleich*, edited by Sophia Bönisch-Meyer, Lisa Cordes, Verena Schulz, Anne Wolsfeld, and Martin Ziegert, 43–81. Classica Monacensia, Münchener Studien zur Klassichen Philologie 46. Tübingen: Narr Francke Attempto.

Wood, David. 2010. "Caligula's Quadrans." *Numismatic Chronicle* 170: 99–103.

Woodman, A. J., and C. S. Kraus. 2014. *Tacitus: Agricola*. Cambridge and New York: Cambridge University Press.

Woytek, Bernhard. 2008a. "CIRCENS CONST. Ein unikaler Sestertz Traians aus dem Jahr 98 n. Chr. und sein typologisches Umfeld." In *Festschrift für Günther Dembski zum 65. Geburtstag I*, edited by Michael Alram and Heinz Winter, 115–131. *Numismatische Zeitschrift* 116/117. Vienna: Verlag der Österreichischen Akademie der Wissenschaften.

Woytek, Bernhard. 2008b. "Die Cistophore der Kaiser Nerva und Traian (mit einem systematischen Anhang zu typologisch verwandtem traianischem Provinzialsilber)." *Schweizerische Numismatische Rundschau* 87: 69–125.

Woytek, Bernhard. 2010. *Die Reichsprägung des Kaisers Traianus (98–117)*. 2 vols. Moneta Imperii Romani 14. Vienna: Österreichischen Akademie der Wissenschaften.

Woytek, Bernhard. 2013. *"Signatores* in der römischen Münzstätte; CIL VI 44 und die numismatische Evidenz." *Chiron* 43: 243–284.

Yarrow, Liv Mariah. 2013. "Heracles, Coinage and the West: Three Hellenistic Case-Studies." In *The Hellenistic West: Rethinking the Ancient Mediterranean*, edited by Jonathan R. W. Prag and Josephine Crawley Quinn, 348–366. Cambridge and New York: Cambridge University Press.

Yavetz, Zvi. 1969. *Plebs and Princeps*. Oxford: Clarendon Press.

Yavetz, Zvi. 1987. "The Urban Plebs in the days of the Flavians, Nerva and Trajan." In *Opposition et résistances à l'Empire d'Auguste à Trajan: Neuf exposés suivis de discussions*, edited by Adalberto Giovannini and Denis van Berchem, 135–186. Geneva: Fondation Hardt.

Zanker, Paul. 1988. *The Power of Images in the Age of Augustus*. Translated by Alan Shapiro. Ann Arbor: University of Michigan Press.

Zanker, Paul. 2000. "Bild-Räume und Betrachter im kaiserzeitlichen Rom." In *Klassische Archäologie. Eine Einführung*, edited by Adolf H. Borbein, Tonio Hölscher, and Paul Zanker, 205–226. Berlin: Reimer.

Zanker, Paul. 2010. *Roman Art*. Translated by Henry Heitmann-Gordon. Los Angeles, CA: J. Paul Getty Museum.

Zehnacker, Hubert. 1973. *Moneta. Recherches sur l'organisation et l'art des émissions monétaires de la République romaine (289–31 av. J.-C.)*. 2 vols. Bibliothèque des Écoles Françaises d'Athènes et de Rome 222. Rome: Bibliothèque des Écoles Françaises d'Athènes et de Rome.

Zehnacker, Hubert. 1987. "Tensions et contradictions dans l'Empire au Ier siècle. Les témoignages numismatiques." In *Opposition et résistances à l'Empire d'Auguste à Trajan. Neuf exposés suivis de discussions*, edited by Adalberto Giovannini and Denis van Berchem, 321–362. Geneva: Fondation Hardt.

Zimmerman, Martin. 1995. "Die 'Restitutio Honorum' Galbas." *Historia* 44: 56–82.

INDEX

effectiveness of, 4, 103, 154
importance of different emissions,
19 (*see also* emissions of Nerva's
coinage)
importance of old coins remaining in
circulation, 5, 19
intelligibility of, 5–6, 22–23, 44,
102–103, 154
reach of, 16–18, 23, 103, 133–134,
150, 154

reactions to, 5, 11, 22–23, 103
See also circulation of imperial
coinage
prevalence of, 4
See also iconography
Vitellius, 42, 46n72, 89, 128

wheat, 56, 58–59, 61n28, 69, 72, 75,
156, 161
wreath, 30–31, 126, 129–130